ART/WORK

———— Everything You Need to Know (and Do) As You Pursue Your Art Career

Heather Darcy Bhandari
Jonathan Melber

Free Press
New York London Toronto Sydney New Delhi

This publication contains the opinions and ideas of its authors. It is intended to provide helpful and informative material on the subjects addressed in the publication. It is sold with the understanding that neither the authors nor publisher is engaged in rendering legal or any other kind of personal professional services in the book. The reader should consult his or her attorney or other competent professional before adopting any of the suggestions in this book or drawing inferences from it. The strategies outlined in this book may not be suitable for every individual, and are not guaranteed or warranted to produce any particular results.

The authors and publisher specifically disclaim all responsibility for any liability, loss, or risk, personal or otherwise, which is incurred as a consequence, directly or indirectly, of the use and application of any of the contents of this book.

Free Press

An imprint of Simon & Schuster, Inc.
1230 Avenue of the Americas
New York, NY 10020

This Free Press trade paperback edition October 2017

FREE PRESS and colophon are trademarks of Simon & Schuster, Inc.

For information about special discounts for bulk purchases, please contact Simon & Schuster Special Sales at 1-866-506-1949 or business@simonandschuster.com.

The Simon & Schuster Speakers Bureau can bring authors to your live event. For more information or to book an event contact the Simon & Schuster Speakers Bureau at 1-866-248-3049 or visit our website at www.simonspeakers.com.

Interior design by GREENBLAT-WEXLER

Illustrations by Kammy Roulner

Manufactured in the United States of America

10 9 8 7

Library of Congress Cataloging-in-Publication Data is available.

ISBN 978-1-5011-4616-9
ISBN 978-1-4165-7238-1 (ebook)

————— To Ava, Brij and Darcy, Linda and Kevin, Barbara and Dan, Marissa, Erin, Ari, Rishi, and Alexis.

————— And to George Boorujy, a good friend, a great artist, and the inspiration for this book.

CONTENTS

ART/WORK

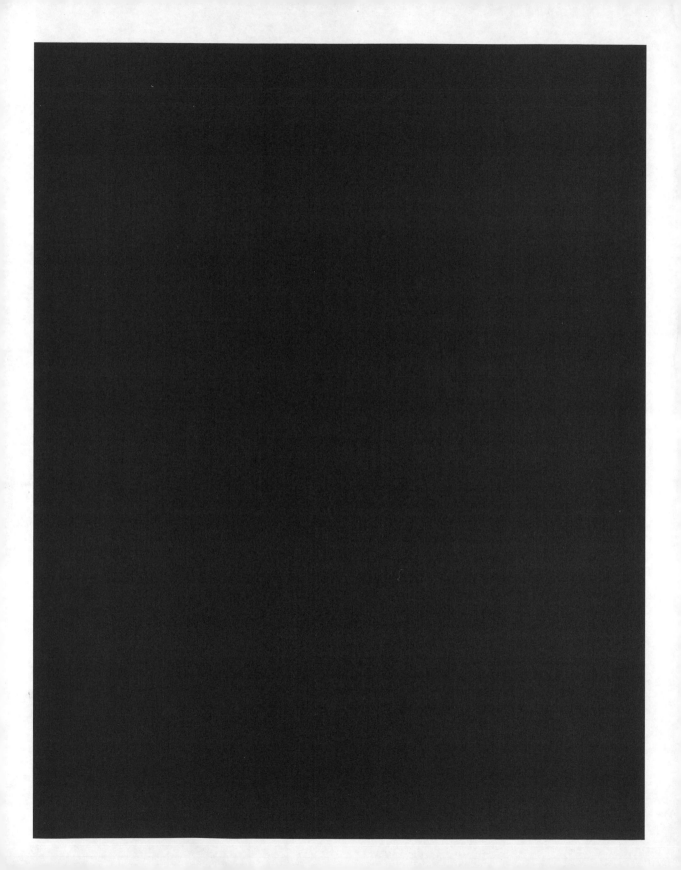

CHAPTER 1
The Big Picture

—————— "Artists' first responsibilities are to themselves and their own work." **Lauren Ross, curator, Richmond, VA**

—————— "It's not the job of other people to tell you that you're ready. That never crossed my mind. I felt I'm going to be the judge of whether this is ready or not.

"You're part of a network of artists and you feed off each other. You don't have to have a big gallerist telling you you're a genius. You can see how your friends are reacting and whether your friends are telling their friends, even though you didn't ask them to." **Jane Hammond, artist, New York, NY**

The art world is full of people who like saying "there are no rules in the art world," which is only sort of true. There's certainly nothing written in stone (there's barely anything written on paper). And sure, what you do in the studio is entirely up to you; there aren't any rules about what you choose to make or how you make it. But there *are* general customs in the art world, and widespread expectations among arts professionals, which you should know before you head out of the studio and start meeting these people.

The customs have changed, too. It used to be a given, for example, that you would need many years of studio time before a gallery would look at your work. And making money was pretty much out of the question. Today, galleries compete over the newest talent to come out of school, even trying to scoop up MFA students before they've graduated. That's not to say everyone needs a commercial gallery. But because there's a real possibility to earn income as an emerging artist, you have to confront issues, and understand how the art world works, in a way that emerging artists never had to before.

Of course, you don't have to follow custom or accept other people's expectations. We're not prescribing a bunch of rules that you need to follow. If you want to buck the system, go right ahead. Do the *wrong* thing. Do *your* thing. Just do it on purpose, not by accident, and know why you're doing it.

Also, what worked for someone else may not work for you. You have to weigh the information and recommendations in this book according to your personality, your goals, your art. Aiming for a big New York gallery, for example, is very different from establishing a regional practice in a smaller city or selling your work directly from your studio. Maybe you're not trying to *sell* anything. No priority is better or worse—it's *your* definition of success that matters and no one else's—and each one calls for a different approach.

Who are we to be telling you all this? We have about thirty years between us of experience working in and around the arts, one of us as a nonprofit *and* for-profit gallery director, curator, and arts consultant; the other as an arts-and-entertainment lawyer and business-development director for an online gallery. Over the years a lot of our artist friends have asked us a lot of the same questions—about career choices, business issues, and legal problems.

————————"When you look at the history of art, you see a history of mavericks—people doing the wrong thing. I wish that I saw more artists doing the wrong thing. That's really more in the spirit of art that I love."

Fred Tomaselli, artist, Brooklyn, NY

—————— "Every five years the art world here in
*New York is almost a completely different place. You can be swept up into it. And you can also be pushed completely out of it. It's fluid and malleable. But most importantly, to me, it means that you can invent it." **Matthew Deleget, artist, curator, educator, founder, Minus Space, Brooklyn, NY***

*—————— "I understand there are perceived, and real, power dynamics in the art world, but the artist is the critical center of all we do. In a larger sense, they are the driving force that will matter in history—there is nothing I can do without an artist. At the same time, in the immediate process, I don't feel any more or less important to what feels like a large organic system where we're all trying to achieve the same thing (in the best-case scenario). I know it's complicated, but if you treat it that way, you can encourage real exchange that produces good shows and good work." **Shamim Momin, director/curator, LAND, Los Angeles, CA; former curator, Whitney Museum of American Art, New York, NY***

*—————— "Being a curator is using pattern recognition. You see one thing happening here and another thing happening there and you start to sense a new swelling wave of something going on. You build an exhibition around it to take a pulse of the current moment. For me, it is something pertinent or relevant that I want to pin down in a show. It could be a single artist or a group of artists. It's like throwing down the gauntlet and saying, 'This is important and we should pay attention to it—we should champion or recognize these artists.'" **Michael Darling, chief curator, Museum of Contemporary Art, Chicago, IL***

After a while, something obvious (in hindsight) dawned on us. Unlike other creative professionals, artists typically don't have agents or managers to deal with these issues for them. They have to do it all themselves, at least until they're very successful. Galleries are supposed to act like agents for their artists, but not all of them live up to that standard. And even the best ones still have to balance the needs of their artists with the desires of their collectors—a conflict of interest that simply doesn't exist for agents in other creative fields.

So we thought it would be useful to write a book that tells artists how to act as their own agents and managers—a book that answers all those questions people keep asking us.

We knew that the only way to do these topics any justice was to find out what other arts professionals had to say about them. For the first edition, we interviewed nearly one hundred people across the country—gallerists, curators, accountants, lawyers, and, of course, artists—and spent the better part of a year synthesizing their opinions, and ours. Eight years later, we reconnected with many of them to see how their views had evolved, and talked to over forty more people. Their quotes appear in the margins throughout this book, representing the most commonly held—and occasionally diverging—views in the art world.

QUICK TOUR OF THE ART WORLD

There are a lot of people in the art world who play crucial roles in how your art is made, shown, understood, sold, and remembered. First, there are all the people who can help you develop your art, your ideas, and your goals: other *artists,* your *professors,* the directors and staff at *residencies* and *foundations* that support artists.

There are the *framers, printers, fabricators,* and other *production* people whose skills you may need to tap (or learn) to finish your work. *Art handlers, art shippers,* and *art-specific storage staff* make sure your work is treated with the utmost care.

Curators (from the Latin meaning "to take care") choose the work for group and solo exhibitions. They usually have an

academic background, with a master's or PhD in art history, an MFA, or a degree in curatorial studies. The ones on staff at museums or nonprofits are called *institutional curators*. *Independent curators* freelance, putting together their own exhibitions or collaborating with museums, commercial galleries, nonprofits, and alternative spaces. There are also *private curators* who work for corporations or big *collectors,* maintaining and developing their collections.

Art advisors and art consultants help individual collectors, corporations, and institutions buy work, for either a fee or a percentage of the work's price. Some of them focus on emerging artists and may want to visit your studio or introduce you to their clients.

Dealers show your work and try to sell it. They tend to specialize in either the *primary art market,* meaning art sold for the first time, or the *secondary art market,* meaning resale. Primary market dealers often represent living artists and manage their careers. Secondary market dealers sell work that's already been bought at least once. They don't usually work with artists; they usually deal directly with collectors, artist estates, and other dealers.

Many primary market dealers call themselves *gallerists,* to emphasize their roles as curators, collaborators, managers, and producers. Others stick with "dealer" because they don't want to downplay the commercial aspect of selling art. (We'll use the term *gallerist* throughout this book, although we think the distinction is only as meaningful as you want it to be.)

—————— *"The art world is full of invention and reinvention of personas. Invention and reinvention of roles as this beautiful model for the rest of the world. That's where its great beauty is."* **Michael Joo, artist, Brooklyn, NY**

—————— *"None of us exists without the artists. You have a pyramid. There are only so many dealers, critics, etc. Artists are the biggest portion. The base."* **Tony Wight, manager, Spencer Fine Art Services; former director, Tony Wight Gallery, Chicago, IL**

—————— *"When graduating from art school, you're leaving with a cohort of people who will be advancing in the art world alongside of you and you honestly don't have any idea where they're going to end up. Some may leave the art world entirely. Others might be the next big gallerist, curator, or critic. You don't really know, so maintaining and fostering your relationships is really important."* **Matthew Deleget, artist, curator, educator, founder, Minus Space, Brooklyn, NY**

SMOKE!

———— *"There is art and then there is the art market. For me, they are separate."* **Fred Tomaselli, artist, Brooklyn, NY**

———— *"I feel artists are at the cutting edge of everything created by humans in our society. I would love for artists, young and old, to remember that for the Art World to exist, the first thing that is necessary is art. No gallerist, museum director, preparator, or museum guard would have a job without an artwork having been created.*

"Without remembering this, artists can lose sight of their power and worth. We begin to believe that the art world came first and that we need to change, appropriate, adjust, or edit ourselves and our work to fit into this world. This does not need to happen, and should not happen." **Stephanie Diamond, artist, New York, NY**

Whether nonprofit, alternative, or commercial, most venues have some kind of staff to run the space. The organizational structure and employee titles vary but the main tasks include:

Archivist: cataloging all images, press, and written materials.

Art handler (or "preparator"): packing, shipping, and storing the work that moves through the venue; installing and deinstalling shows. Works closely with the Registrar.

Artist support: keeping in touch with you and understanding your goals, coordinating production, advising you on career decisions, liaising between you, the rest of the staff, and outside entities.

Bookkeeper/Finance: accounting, paying the bills.

Communications/Press: distributing press releases, pitching media outlets, overseeing marketing, advertising, social media, and other promotional activities.

Curator/Exhibition Coordinator: selecting artists for the program, collaborating with artists, selecting work for shows, organizing and installing shows, preparing written materials for shows, applying to art fairs.

Designer: crafting all graphics and layouts, including those in printed materials and online.

Development: (nonprofit venues) raising money through individual giving, corporate sponsorship, grants, and other funding sources; initiating and sustaining relationships with donors and supporters.

Director: overseeing everything and everyone. May also own the gallery. In small galleries, the owner/director might do everything. Larger galleries might have several directors and employ dozens of people.

Education: (nonprofit venues) engaging and teaching students, the community, and other audiences about the gallery's programs, artists, and overall mission.

——————— "The art world is not the monolithic monster it can seem to be. Sure, it has a lot of monstrous parts, but it's just people with different interests and viewpoints. As an artist, you are one part, and you decide how you interact with the rest. It's not 'your work meets the art world monster.'"

Bill Davenport, artist, critic, Houston, TX

—————— *"I've made a lot of mistakes but I don't regret them because I've learned from them. There is no rule book on how to be an artist, and everyone is different, you just have to wing it and do the best you can!"* **Spencer Finch, artist, Brooklyn, NY**

—————— *"I think that, as an artist, being successful is being successful for yourself and being happy. I think you always have to keep pushing yourself. Try not to fall into just producing what people say they want from you. Don't be afraid to take a risk."* **Kelly Klaasmeyer, artist, writer, critic,** Houston Press; *former editor of glasstire.com, Houston, TX*

—————— *"You have got to figure out what you love and what you care about. If you really want to make art and you want to be an artist, you need to figure out how to do it. And you need to figure out how to work with the people in this system rather than dissing the system."* **Kerry Inman, Inman Gallery, Houston, TX**

—————— *"You have to try to separate your practice from your career—recognizing that it overlaps with your career, but they are two different entities that have to be managed differently. You have to decide what kind of career you want to have and what kind of practice you are going to have."* **Joseph Havel, artist, director, Core Program, Houston, TX**

Gallerina: greeting visitors, answering phones, administrative tasks. (Yes, the guys are called "gallerinas," too.)

Manager: basically the head of operations, managing the space and equipment.

Registrar: tracking the location, condition, price, and status of every work that moves through the gallery; filling out, negotiating, and enforcing consignment and loan agreements; overseeing shipping.

Sales: (commercial venues) staying in touch with collectors, finding new collectors, previewing your work, describing it to visitors, following up with leads, handling sales transactions.

Then there are a whole bunch of people whom you may come across but not work with directly:

Art critics write about shows—if you're lucky they'll write about yours. Whereas their job is obviously to assess the art they see, there are also *reporters* and *bloggers* who cover the art world from a critical, news, or personal perspective. (And, of course, the *publishers* and their staffs at art magazines and newspapers.)

Art fair directors and their staffs manage the numerous art fairs that take place around the world every year.

The basic function of *auction houses* is to take work from collectors looking to sell and auction it to the highest bidder, for a percentage of the final sale price. They also provide services for collectors such as valuation, placement, and private sales. Some have expanded their role into traditional gallery terrain—not necessarily to the delight of commercial gallerists—showcasing new work and making primary art market sales.

Conservators preserve and restore artwork. *Appraisers* determine a work's market value, usually to calculate insurance or set prices. Some artists' estates have *authentication boards* to rule on the authenticity of works attributed to them.

WHERE YOU COME IN

No matter where you are in your career, we think you will find this book helpful. It covers everything from tracking your inventory to installing a show; from designing your website to drafting an invoice; from paying your taxes to protecting your copyright; from landing a gallery to raising funds yourself. The book includes forms, charts, and sample agreements that you're likely to need during your career. And it's bright yellow, which, as you probably know, is the best color.

We organized the chapters in roughly the order of issues you'll encounter as you begin your career, but with the idea that you will skip around a lot. There's an index and we'll tell you where to look whenever we mention something that's explained in another chapter, so don't feel compelled to read through cover-to-cover the way you would with a novel.

Now just to be clear, we're not telling you how to make art. This book is a tool to help you build a sustainable career. We're also not telling you that if you do everything we say, your success is guaranteed. But whatever your potential, this book should help you realize it.

——————— "Find something that is really meaningful to you—that's the most important thing at the end of the day. Even if everything goes well, there are still those moments when you see through it all. Once you see through the fame, money, and social life and ask yourself, 'What is this all about? What does it mean to me?' it's great if you can see your work clearly and what you see is important to you.

"That same thing goes on the other side. When you're wondering why you go through all this hell and you're struggling, at least you see that you really enjoy what you do, you are fulfilled by what you make, and you believe in it." **Charles Long, artist, Mount Baldy, CA**

——————— "The professional art world is built on relationships. Social relationships drive sales, drive coverage, drive all sorts of things. At the same time, they can only do so much. You can do a lot more with a great work of art than you can crappy art." **Paddy Johnson, founder, Artfcity.com**

CHAPTER 2
—————————Groundwork

As an artist, you have more independence than most professionals ever experience. *Everything* you do is up to you, from where you live to what you make to when you work. All that independence demands a good dose of self-reliance and structure, which is why it's useful to think of yourself as an entrepreneur. That doesn't mean treating your work as if it's a "product." It means recognizing that you will have more control over your career when you organize yourself—and your time—as if you were running a business.

In this chapter, we'll go through some of those business issues you face right out of the gate, such as finding studio space, selecting the right day job, registering your copyright, setting up inventory and invoice forms, and paying your taxes. But first, let's figure out what exactly you're setting out to do.

GOALS

You can't give someone directions if they don't know where they're going. When it comes to your career, no one can help you, and you will have a hard time helping yourself, unless you figure out where you want to go. The question is: How do you do that?

And how do you do it without losing spontaneity and freedom and creativity and inspiration, and all the other aspects of being an *artist*? In this section, we will suggest a framework for developing goals that are true to your values and true to yourself.

As you go through these exercises, think about the different ways of exploring a new city. Some people arrive with a detailed schedule and itinerary, having thoroughly researched every museum and park and neighborhood they want to see, and meticulously planned each minute of each day they'll be in town. Other tourists show up with no itinerary at all, preferring to wander aimlessly and see what they happen to discover. Most people fall in between these extremes, scheduling *some* things, but not everything. If you don't plan at all, you might miss the boat (literally, in this analogy); if you plan every second, you will miss other experiences along the way.

——————— "My studio practice is comprised of fits and starts. I don't do it all in one day. For example, today was a day with my kids. Tomorrow is a teaching day followed by a long night in the studio. The next day I have earmarked as a writing day because I have several deadlines fast approaching. Ironically, my time in the studio is regimented and my artwork is structured around repetition. But getting into the studio is a give-and-take each day. Because I am vehemently passionate about art making, criticism, teaching, and visual culture, I always find the time."

Michelle Grabner, artist, educator, critic, curator, Milwaukee, WI

Step 1: Name Your Values

What principles guide your decision-making? You may know off
the top of your head, or you may never actually think about your
values or articulate them; they're just *there*.

If you're not in the habit of expressing your values, answer
these questions: What do you consider critical to being a good
person, or leading a commendable life? What do you stand for?

Here are a few examples of values to get your ideas flowing:
adventure, aggressiveness, authenticity, boldness, consistency,
creativity, empathy, equality, flexibility, generosity, honesty,
independence, integrity, loyalty, privacy, prosperity, resilience,
security, serenity, shrewdness, solitude, spontaneity, tolerance,
transparency, trust, winning.

Write down at least five values you care most about. They may
be among those listed above or entirely different. They're *your*
values, not ours (and no one's looking) so be honest with yourself
about what yours are.

1.
2.
3.
4.
5.

Step 2: Articulate Your Motivation, Purpose, and "Vision"

Many workshops and seminars will separate these concepts into
three distinct steps, and if doing so makes this exercise easier,
then by all means go for it. We will talk about them together
because we think the concepts overlap quite a bit, and don't want
you to spend time worrying about whether something falls into
one category or another.

Broadly speaking, your *motivation* is what currently drives
you. What are you passionate about? *Why* are you an artist? Your
purpose is what you want to *do* with your art, or perhaps more
accurately, what you want your art to *do*. What kind of impact do
you see your work having? Your *vision* is what you see in the
future. What sort of life do you imagine for yourself? What sort of
role do you envision for your art?

Again, no one's looking. Don't worry about how it sounds, or
whether it's too big or too small or too unrealistic or too

anything. Whatever drives you, whatever you feel is the reason you're setting out on this path, wherever you see yourself down the road: that's the right answer.

Step 3: Set Goals

Your goals, taken together, are what you have to do in order to achieve your purpose, to carry out your motivation. If you continually set the right short-term and long-term goals over the years, and complete all of the steps those goals require, then you should eventually realize your vision. At the same time, it's not a one-way, linear process. Your motivation may change, affecting your purpose. Your vision for yourself may evolve, dictating a different set of goals. And so on.

One of the better-known sets of criteria for effective goal-setting is called "SMART," which stands for Specific, Measureable, Attainable, Relevant, and Time-bound. We'll go over each concept.

Specific
Specificity requires you to answer as many "W" questions as you can: who, what, when, where, why? Be as detailed as you can.

- ~~"I want to complete new work."~~ → "I want to create three site-specific sculptures in the park closest to my house, to interact with passersby over the upcoming holiday weekend."

- ~~"I want an exhibition."~~ → "I want a show in a nonprofit gallery in Los Angeles with a strong video program and like-minded artists."

Measurable
If you can't quantify it, then it's not an effective goal. It might still be a goal, but you'll have a hard time figuring out whether you've achieved it.

Attainable
Only you will know if you have a realistic chance of achieving a particular goal. Don't set your sights so high that you never get there.

Relevant
Do your goals align with your motivation and your purpose? Are they in line with one another? It's fine to set a goal to move to

—————— *"There is nothing like doing something on your own to make people want you. That's something people don't realize. When commercial galleries are the only thing artists are looking to, there's this impression that gallerists are going to make their lives better and they have all the power, instead of 'Okay, I'm going to do this project and it's going to be exciting and engaging to me and I'm going to meet people and maybe I'll sell some work and maybe I won't.' You have to decide how you want to exist as an artist and what is reasonable. Goal-setting is a crucial part of it."* **Christa Blatchford, artist, CEO, Joan Mitchell Foundation, New York, NY**

Spain and make art, and it's fine to set a goal to secure a NYFA grant for sculpture, but you can't pursue both goals at the same time, because you have to live in New York State to be eligible for a NYFA grant.

Time-bound
Always set deadlines. You can adjust a deadline along the way if you need, but if you don't have one to begin with, you are far less likely to accomplish your objective.

Remember that your goals must also reflect your values. If they don't, then either something's off with the goals you've set, or you haven't been honest with yourself about your values.

Before you go on to any other part of this book, take the next fifteen to twenty minutes and set a few medium-term goals. Imagine a five-year reunion with everyone you know today. Where do you live? Where do you work? What kind of art do you make? How do you fund it? Where do you show it? How well known is it? Who is your audience? How big is your audience? Answering those questions should help you see what your medium-term goals are.

—————— "There are many ways to be an artist. Ask yourself: Why am I an artist? By having a deeper sense of your own motivation and knowing with whom you want to engage, you can illuminate the direction of your work and where to expand your network."

William Penrose, executive director, NURTUREart, Brooklyn, NY

Five Year Goals:

Now create a road map toward your five-year goals. What milestones will you need to have accomplished one year before the reunion (Year 4) to achieve your five-year goals?

What milestones will you need to have accomplished in Year 3 in order to hit the Year 4 milestones?

Same question for two years from now, to be ready for Year 3.

Same question for next year.

Same question for *this* year. Set five goals for nine months from now:

1.
2.
3.
4.
5.

. . . and six months from now:

1.

2.

3.

4.

5.

. . . and three months from now:

1.

2.

3.

4.

5.

Tweak the road map above until it makes sense to you. It should feel challenging, yet attainable. There's no need to set goals less than three months out. We're talking big picture here. Weekly tasks and to-do lists help keep you on track, but they are often too detailed to reflect the bigger issues effectively.

Depending on your personality, it might help to talk about your goals with others. For many people, saying a goal out loud to a friend or colleague can make them feel accountable to that person. For others, it's more motivating to *not* talk about a goal until they've achieved it.

At each milestone in your timeline, evaluate how things have gone. Which intermediate goals did you accomplish? How were you able to do that? Which milestones did you not hit? Why? At each milestone, you should adjust your road map as needed, based on your evaluation. Don't just push a milestone into the next time period, or abandon it altogether, without thinking about it and understanding what happened (or didn't happen).

And reward yourself along the way. Really big achievements are easy to celebrate but smaller goals need love too.

BALANCING YOUR TIME

The best thing you can do for your practice when you're starting out is to get in the studio right away. This is not a revolutionary concept—obviously if you're making work for a living you need to *make the work*—but it can be surprisingly difficult advice to follow. Most people have bosses who crack the whip. You, on the

"Artists must think about time in the longer term—few people get picked up by a gallery very fast. You must think of your time in the studio as an investment. You have to think of the layers of your time. As an artist, each layer may ultimately be illuminating and help the work." **Tamara Gayer, artist, Brooklyn, NY**

"Artists tend to think project by project; we start a piece, finish it, and push it off to move on to the next one. The creative process becomes about getting a piece done for a show, a gallery, or a collector instead of for our own need to create. It is imperative to see our creations in a larger context instead of smaller, disparate projects." **Mayela Rodriguez, artist, Berkeley, CA**

"I make work whenever and wherever I can. I work on projects in the classes that I teach, I have finished drawings while making dinner, and edited videos while bottle-feeding my children. I have a theory that any act that moves a project forward should be considered studio time. This includes buying supplies, making lists of potential projects, or even clearing out your space so it is ready to work the following day. Artists often beat themselves up about not being in the studio. The reality is that we may never have as much focused studio time as we had in grad school. I feel that while I do not produce as much as I once did, my work has gotten better because I have more time to reflect on it." **Joseph Smolinski, artist, New Haven, CT**

―――――――― *"Space is the biggest, most important thing. If you are a painter or a sculptor, you need to get a space. Photographs and videos can be made out of a studio apartment, but big paintings, no. I got a big space, divided it and got tenants. I paid less than one-fifth of the rent because I set it up. I didn't know that I knew how to build walls, do plumbing, or build a kitchen until I did it."* **Michael Yoder, artist, Philadelphia, PA**

―――――――― *"Somehow I had this idea that if I had to go to another place to make my art, I would never get it done. I would never know when to go and when to leave and I would eat up two hours a day going and coming. I've always had a studio in my home. I've always had soup going in the kitchen and work going in the studio at the same time. I had a hunch about it initially and now I wouldn't have it any other way."* **Jane Hammond, artist, New York, NY**

other hand, *are* your boss. No one else is going to force you into the studio.

Small wonder, then, that many successful artists designate regular blocks of studio time and don't change them. That means treating studio time like the job that it is. It means going to the studio when you're not feeling creative. It means going to the studio even when a friend's visiting. If you can't work on your art—let's say you're waiting for some materials to arrive—there are always plenty of administrative items to tend to. (This book is full of them!)

We're not saying the same schedule works for everyone. Maybe you're more creative pulling a few all-nighters every week than sitting in your studio from nine to five every day. Your practice must be rigorous, but it must also fit your personality. Identify your tendencies early on—when are you most productive? how long before you start to lose focus?—and incorporate them into your schedule.

Your "practice," by the way, includes *everything* you do for your art. It's not just what happens when you're physically in your studio. Getting supplies, reading, and thinking about your art are all meaningful aspects of your practice.

The sooner you can get into whatever schedule you choose, the better. Some artists give themselves a while to decompress after art school or their last show. But by the time they decide to get back to work, they have to squeeze studio time around whatever job and social life they've settled into. Rather than forcing studio time into an already set schedule, organize your job and social life around studio time from the beginning.

THE HOME STUDIO: IF YOU LIVED HERE, YOU'D BE IN THE STUDIO BY NOW

The nice thing about a home studio is that it's right there, in your home. Going to work literally takes no time at all. But a home studio will only work for you if you are disciplined and focused. So do a little soul-searching. Can you ignore your TV? Will it distract you if your children are in the next room? Are you disciplined enough to work when your bed is only a few feet away? (Probably good to do a little wallet searching, too. If you

can't afford a separate studio, well, at least that's one decision you don't have to spend time figuring out.)

Before deciding whether a home studio is the way to go, think about the kind of space your artwork demands. Would a home studio allow you to work on the scale you need to, or would it limit you? While you need to be realistic about your budget, you also need to be serious about your career—which means not letting your studio dictate the size of your art or the materials you use. For example, should your sculpture be larger than the size of the room allows? Should your drawings be paintings, but you're afraid to get paint on the floor?

If you have a basement or garage or extra room that you can turn into a studio and that's all the space you need, great. But if you live in a cramped apartment and don't have room at home to make the work you really want to, get a separate studio.

Of course, your space *can* influence your work. Sometimes the constraints of your studio will push you in new directions that actually improve your art. That happens when the space affects the *concept* behind your work, not just its size or media; or when you're forced to change something that ends up improving how you present your work.

THE SEPARATE STUDIO: SOMETIMES YOU NEED A LITTLE SPACE

This is the way to go if you need a formal separation between work time and downtime, or if you don't have the conditions at home to make your art. But remember that even with a big studio you still have to be careful not to let the space dictate the size of your work. Art is not a goldfish. It shouldn't just grow with the size of your studio. Don't make an artwork bigger than it needs to be just because you have the extra space or forget to edit because you have empty storage. Editing and thinking critically about your work are important skills. Give yourself time to reflect and evaluate, but remember not every inch needs to be filled, unless the work meets your standards.

One of the best things about separate studios: they typically come with other artists. Sharing space with artists in a studio building usually means sharing ideas, techniques, even critiques.

Second Studios

It's fairly common for artists in smaller cities to get together with other artists and rent studio space in places like New York and Los Angeles. They split the costs so everyone can keep some work in the second space to show gallerists and collectors who aren't likely to visit them in their hometowns. Or they pool money to get curators and gallerists to come to them. We also know many artists who loan work to friends and family in other cities to hang in their homes, in case someone wants to see the work in person.

———— "*I want to have the freedom to live where I please and still be connected to the world's leading art market. From a business standpoint, it was important to maintain a footprint in the market, and from a life standpoint it is imperative to be able to live untethered. I want to have my cake and eat it, too.*" **Howard Fonda, artist, Portland, OR**

———— "*I met a group of four artist friends who live in Durham/Chapel Hill, North Carolina. They have separate practices, but formed an alliance in which they pool their money to bring in one curator a month. They cover travel, meals, and accommodations and in exchange, the curator conducts separate studio visits with all four in one day. I think this is so savvy. If you live in an area where curators don't come through as often, give them a reason to come.*" **Lauren Ross, curator, Richmond, VA**

*———— "Oftentimes, five or more graduates will move together to a city and rent a space. This is one of the most viable means of surviving the high costs in some cities. As they make connections to galleries and other artists, they create a beautiful network that remains even as they move on from their original living arrangement." **Kevin Jankowski, director, Career Center, Rhode Island School of Design, Providence, RI***

*———— "It's really important to have contact with your peers. Your peers are important conduits for information and ideas. For many artists it works best to work together with other artists: they share studios or have studios down the hall; they talk about ideas with each other; they have a really strong core of peer support." **Andrea Rosen, Andrea Rosen Gallery, New York, NY***

*———— "An active or sustainable practice is still quite narrowly defined in the art world. But social practice is about engagements beyond the studio. My teaching, curating, and studio practices are necessarily intertwined. I have come to define a successful practice by whether I am actively learning and having conversations that fuel a new body of work. I do that all day, every day, and so my practice(s) are sustained and deeply satisfying. It is a challenge not to be defined by the status quo, but after all, artists are supposed to be challenging the rules." **Melissa Potter, artist, curator, writer, Chicago, IL***

*———— "Be proactive. There are no excuses for why your work is not evolving forward. Work can be made in many different ways in many different places—do it!" **Bonnie Collura, artist, Bellefonte, PA***

This can be a boon to your inspiration and creativity. And it's a natural way to stay connected to the art community, which is an essential component of developing as an artist. (More on that later in the chapter.)

Working around other artists also increases the chance of fortuitous encounters, since your neighbors will get visits from curators, collectors, and gallerists. The number-one way gallerists and curators find new artists is through recommendations from the artists they already know. So the odds of being in the right place at the right time increase greatly when you start working in an active studio building.

You can find subsidized studios in every major city. And while *artist loft* sometimes means "expensive condo," there are still warehouses full of artist's studios across the country. If you don't have a studio building in your area, take matters into your own hands and create one. There is probably an art school or art club in your area; connect with the artists there, rent a large space, and divide it into smaller studios. We know a lot of artists who have done this—they ended up with great studio space *and* an income stream to boot.

DON'T CALL IT A STUDIO

If you don't make objects, or you consider yourself a "post-studio artist," maybe you don't need a studio at all, but just a space of some sort to put all your *stuff*. And to think, and to organize, and to focus. Many post-studio artists do share space in studios and offices, and apply for residencies (with studios) in search of cross-pollination, dialogue, and focus.

THE DAY JOB

Unfortunately—and unfairly, in our opinion—a number of arts professionals are biased against artists who have day jobs. They say that they're only interested in emerging artists who are "committed" to their practice, as if artists shouldn't also be committed to food and shelter.

Want to know a dirty little secret? *Every* artist has a day job (almost). We're not just talking about BFA grads at the beginning of their careers, but successful artists at big-city galleries. Established artists at well-known blue-chip galleries may not need day jobs, but very few emerging artists, or even midcareer artists, can live off their art alone. So don't buy into the myth that you're not a good artist, or a successful artist, or a "real" artist, if your art doesn't pay the bills.

While we're at it, here's another little secret: The average income of an artist at an emerging gallery, from sales of artwork, is approximately *ten thousand dollars a year* (after taxes). We were hoping by the time we wrote the second edition, that number would have increased. It hasn't. The big-name artists selling work for hundreds of thousands of dollars are a tiny

The Myth of the Struggling Artist

You don't have to be struggling and poor to make good art. While destitution and anxiety can generate creativity, so can comfort and tranquility. You're not going to lose your inspiration because you took a day job and can suddenly afford health insurance.

The point isn't that you should strive to make a lot of money; it's that whether you do or not is unrelated to the quality of the art you make.

IT'S MY HOMAGE TO BRANCUSI'S ENDLESS COLUMN.

PEACHES ¢.99

fraction of the art world. And the seven-figure-plus numbers you read in the news are almost always from secondary-market sales where the artist makes nothing.

In deciding what kind of day (or night) job you should get, ask yourself how much money you need to *live* (not just survive). Do you need stimulation or inspiration from your day job? Do you want to interact with other artists at work?

We recommend finding a day job that will somehow add to your practice. Maybe working where you'll get discounts on your materials (art supply store, lumberyard, photography lab) or access to your subject matter (botanical garden, science lab, community center). Or where you'll hone your craft: commercial photographer, printer, framer, illustrator, costume builder, stylist, set builder, faux finisher, artist's assistant.

That last one—working as an artist's assistant—can make for excellent training. You see how a successful artist runs his or her studio; you meet other artists in similar places in their careers; you learn new techniques; you get a lot of practice working with the medium. It can also lead to new connections and new opportunities.

Be aware, though, that this kind of work can mess with your head—and your hand. After months of spending eight hours a day painting for someone else, you could feel pretty drained when it comes to your own studio time. And then there's the constant reminder that you're spending most of your time working on someone else's ideas. At some point you may have to face the difficult choice between a steady job and developing your own practice. Know your limits. Some artists can handle this kind of work for many years; others don't last a month.

Teaching is probably the most popular day job because it is an extremely rewarding way to develop your practice. (It also appears to be the only line of work tolerated by commercial gallerists who don't want artists working day jobs.) You share your knowledge and experience with a group of enthusiastic artists; you learn more about your subject matter than you knew before; you revisit the fundamentals of your discipline. That said, teaching isn't for everyone. Just because you can do something doesn't mean you know how to teach it. It requires a completely different set of skills, a significant amount of preparation, and a ton of energy. If you're not going to inspire your students and be inspired by them, you're not going to enjoy the experience.

———————— "Here are the four types of jobs: Type 1: TIME. I can work on my artwork at work because my job is so easy. Type 2: PEOPLE. I meet collaborators and have exciting conversations. Type 3: MONEY. I make enough money to work three to four days a week. Type 4: TOOLS. I have access to the tools/equipment I need for my own work."

Caroline Woolard, artist, Brooklyn, NY

——————— "I can count maybe five or six artists who live off their art. It's a very small percentage. Basically, how, as an artist, can you figure out ways to generate income that have nothing to do with your work? Obviously a lot of us make money teaching, but it is good to have other sources of income. My husband and I, for example, invested in cheap rental property because we are good at fixing things and fixing things up. That's what's going to keep you in the studio. Either you are independently wealthy—and there are a lot who are in the art world—or you need to find some way of making money that is not art-related." **Francesca Fuchs, artist, Houston, TX**

——————— "The key question is what makes you really happy? The farther you get away from that, the worse it is. Artist to art handler is not a big separation. Artist to Wall Street or plumber is a big separation." **George Adams, George Adams Gallery, New York, NY**

——————— "Don't jump into anything too quickly. I have always felt you are better off having a day job and going slowly rather than jumping into a situation that will be detrimental in the future. Not all artists feel that way, but it was certainly something Felix Gonzalez-Torres was adamant about. You never want to compromise the development of your work because you are under pressure." **Andrea Rosen, Andrea Rosen Gallery, New York, NY**

——————— "I mixed color for the first couple of months I worked in Jeff Koons's studio, so I can get to a color pretty immediately. You spend so much time—forty hours a week—mixing color and it has to be perfect. Sometimes you mix colors for two years. Sometimes you mix colors for three months. There were twenty-three painters, the same number of sculptors, and ten to fifteen office people. I think many of the artists have a hard time making their own work, but I know they are all trying." **Sarah Chuldenko, artist, Los Angeles, CA**

——————— "An old-fashioned master-and-student atelier system can work. Paul McCarthy and Charlie Ray's studios are hotbed feeding grounds for young artists. The young artists see the ambition and the work, while the older artists recognize the young artists who are smart. It's like a farm system of sorts." **Michael Darling, chief curator, Museum of Contemporary Art, Chicago, IL**

——————— "I was an assistant to Terry Winters. That was a really fantastic job for me and I highly recommend artist assistantships. It was great to be around Terry when I was fresh out of school and trying to figure out how to have a career, how to develop my studio practice, and how to sustain my investigation. He's been an inspiring person to have worked for and our friendship continues to this day.

"I've had many assistants and I hope the experience was as beneficial for them as it was for me. Aware of their challenges, I find myself encouraging them, looking at their work and making introductions if I can. I share with them my knowledge of materials and techniques (often reciprocal) and I make them sandwiches. I worked in a deli in art school, so I know how to make a good sandwich." **Charles Long, artist, Mount Baldy, CA**

——————— "After school, I moved to downtown Los Angeles. Everyone had a day job. There was no market there, so artists were free to do whatever they wanted because they weren't going to sell anything whether they wanted to sell out or not. There was a great feeling of experimentation in the air. Paul McCarthy was doing performances down there and he was a contractor on the side. That was how I expected life as an artist to be.

"We all make compromises every day to get by. I didn't quit my day job until I was thirty-five. But if you are making compromises in your art to get ahead in the art world, you sacrifice the most important aspect of your life." **Fred Tomaselli, artist, Brooklyn, NY**

———— "When I was new to the city, art handling was a good way to meet other artists and gallerists. In a short time, I had worked at about six spaces. So it has a networking aspect that could probably only be compared to being faculty at a university." **Chris Ballantyne, artist, Brooklyn, NY**

———— "At the end of the day it's about being engaged enough to be happy to go to work, but not so involved that it affects my art practice. I also need the flexibility to disappear to residencies and have my job waiting for me on my return. I often think that I could make a lot more money using some of my more valuable skills like video editing or photography, but these are so linked with my art practice that they could affect my enjoyment and enthusiasm for it.

"Oddly enough, working at a gallery has very little to do with being an artist, though it has proved very helpful in understanding all aspects of the gallery world. I am a useless schmoozer, so being in Chelsea every week kept me in touch with some art opportunities and gallery people that I would find myself totally cut off from if I were doing something else." **Rob Carter, artist, Richmond, VA**

———— "I think it's essential to have a variety of day jobs. As an artist, you want to focus on your work, but it is also important to have an understanding of different venues and to learn what happens behind the scenes. Knowing the multiple facets of the art world is essential because you acquire an appreciation and an understanding of all the hard work that goes into it." **Hillary Wiedemann, artist, Chicago; former codirector, Royal NoneSuch gallery, Oakland, CA**

———— "Artists are pressured to appear 100% committed to their art-making practice as full-time makers, and to pretend that they don't wear a million different hats. At the risk of being viewed as a 'master of none,' I believe that artists grow smarter and stronger when they take on additional roles within the arts community. Everyone benefits when artists work together as curators, gallerists, writers, promoters, art collectors, and advocates for one another." **Cara Ober, artist, editor, bmoreart .com, Baltimore, MD**

———— "A good job for an artist is something where you can control your hours and have time in the studio. Many artists have worked here while they were in school, but they don't usually last long. The people who last long give themselves to the project one hundred percent." **Knight Landesman, publisher, Artforum**

———— "When times are hard, the artists who only have their art envy the people who have a good teaching job or a well-paid skill that they can fall back on so they don't need to sell their work. But the truth is—when you have an onerous amount of day-job work, it's hard to convince yourself you're a real artist because you're distracted by so many other things." **Jane Hammond, artist, New York, NY**

———— "It doesn't matter if I'm teaching or doing administration or curating a show or writing an interview or selling work out of the gallery or working in the studio—it's all the exact same thing. I see it all through the lens of being an artist." **Matthew Deleget, artist, curator, educator, founder, Minus Space, Brooklyn, NY**

Art handling at a gallery or museum is a favorite day job for many artists, and not just because you learn how to professionally pack and ship art. You meet a lot of people in the art world and work directly with gallerists and curators. You get to see firsthand how shows are organized. Since many of these positions aren't full-time, you can set your hours. And the access can't be beat: all the curators we spoke with—even the most sought-after, time-pressed museum stars—said they would happily look at the portfolio of an art handler they had worked with. (While workshops and classes are popping up around the country, the training is usually on the job, so the only way to really learn how to do it is to get the job.)

While other art world jobs can fuel your practice, you need to be realistic about what kind of atmosphere you can function in without losing your drive. Working as a museum guard puts you in an inspiring environment and doesn't sap a lot of mental energy. Sitting behind a gallery desk can do just the opposite. If you really want the gallery experience, make it brief. Learn what you need, meet people, and move on.

There's something to be said for a job that is straightforward and has nothing to do with the art world, such as a restaurant shift. If you go in this direction, look for work that gives you a mental break from your practice and doesn't require a lot of transition time between the job and the studio. And aim high: think expensive restaurants and law firm data, not a diner shift or minimum-wage temp job. The more you make an hour, the less time you have to spend away from your studio.

If you are freelancing, one of the biggest challenges will be getting paid. Invoice regularly, throughout your gig. Discuss ahead of time whether you'll get paid weekly, biweekly, or on some other schedule. And send your final invoice the day you finish the job. Your invoice should include:

1. Date
2. Your name, address, phone number, email
3. Their name, address, phone number, email
4. Dates and description of work performed
5. Rate (by the hour, day, or task) and how it relates to what you did
6. Total owed

7. How and when to pay
8. A thank you is always nice

Note that for any work-for-hire jobs, the employer retains the copyright (that's one of the reasons it's work for hire). He or she will ask you to sign a work-for-hire agreement before you start the job. If the employer agreed to let you retain copyright, then do not sign a work-for-hire agreement, as that will nullify anything to the contrary.

Whatever kind of day job you decide to get, remember that it is just that—your day job. It's not your primary job and it doesn't dictate your identity.

WHO DOESN'T LOVE PAPERWORK?

This is why you became an artist, right? To fill out spreadsheets and tally up receipts every three months? For some people, getting organized and keeping up with the paperwork comes naturally (even neurotically). For the rest of us, it's distracting and boring and not how we want to spend our time. But the more disciplined you are about paperwork from the beginning, the less time you'll ultimately have to spend on it—and the more control you'll have over your career.

Images

Unfortunately, most people will see images of your work and not the work itself, so keep high-quality digital images of all your work. That means an original, unedited image of every piece, as well as detail images of any large, complicated, or textured pieces. Make sure your images look professional. If you're not confident taking your own images, pay someone else to do it for you. Maybe one of your photographer friends will help out for an in-kind trade or a few drinks.

Always shoot or scan at the greatest resolution possible, and connect images—including detail and installation shots—to your inventory records; using the ID number in the file name works

———— "Generally, I want artists to be realistic about what's going to happen and really have control over their careers. Even when an artist has a gallery, it worries me when they say, 'Yeah, my dealer has that. I don't even know what my résumé has on it anymore.' Have your stuff together. Have control of where your work is, what has gone. Have control over your images. Be in charge. It's your career and your life." *Eleanor Williams, art dealer, independent curator, Houston, TX*

———— "Take yourself seriously. No one cares about your work more than you, so do a good job. You can't say, 'It was my client's fault that it looks so bad.' It's up to you to make your work as great as it can be, and to present your best work online (or in an attached pdf in your email) in a way that people you reach out to will understand." *Caroline Woolard, artist, Brooklyn, NY*

———— "I always hear, 'My work is really hard to show in an image.' Of course it is! But you absolutely need to find a way to make it presentable in an image. It's how you first get your work out there. That's true for video and painting and any medium.

"I did sculpture in glass. It's really hard to photograph, so I had to learn how to do it, and when I could not do it myself, I sought out someone who could. If it's impossible for you to photograph, pay that extra money to have a professional do it." *Hillary Wiedemann, artist, Chicago, IL; former codirector, Royal NoneSuch gallery, Oakland, CA*

- Pricing can be by the hour or by the shot. Do not agree to pay any license or "usage" fees; you should be able to use, copy, and distribute these images of your work however you like, for as long as you like.
- Speak up during the shoot and make sure you get the shots/angles/shadows you want.
- Ask for the largest possible uncompressed files, so you can edit them yourself if you like.
- If the photographer color-corrects (and you probably want that), ask upfront whether that's extra.
- Warn the photographer in advance about reflective surfaces, frames, and other complications.
- Check that he or she has the proper equipment for your job (lights, wide-angled lens, etc.).
- Most photographers expect to be credited for their images, and some will require that you credit them as part of their agreement to shoot your work. If you're fine with that, it's certainly nice to do. If you'd rather not, because the images are of *your* work, don't feel pressured into acquiescing. Have the conversation up front: maybe you can compromise with a general credit somewhere on your site, but not include the credit every time you post the photo.

On a related note, faithful reproductions of 2-D works *are not protected by U.S. copyright,* which means the photographer cannot prevent you from copying or using those images. Photographs of a 3-D work, however, or of 2-D work from a distance, at an angle, etc., *are* generally protected by copyright. The thinking (by the courts) is that in the former case, there is nothing "original" about a reproduction—by definition, it is supposed to perfectly replicate the original work without variance. Any other kind of photograph will necessarily contain some originality, because it captures more than just the original work.

well. You can resize each image for press, printing, email, and online. Right now, the ideal resolution and size for press and printing are 300 dpi and 8 x 10 inches. A 72 dpi, 8 x 10 image will do for most other purposes.

The image of your piece should fill the entire frame of the photograph. If it can't—say, for example, you're photographing a narrow painting—then shoot your piece against a neutral background.

Because it is so crucial to make high-quality images of your work, you really need to learn how to retouch and adjust the color of your images with image-editing software such as Photoshop. Don't risk letting poor images sink your chances for a studio visit, grant, or other opportunity. At the same time, doctoring an image so much that you misrepresent your work will only disappoint (or infuriate) the person you're trying to win over.

Document your work at group and solo exhibitions. Usually the venue will do this and give you copies of the images, but don't count on it. Ask ahead of time in case you need to take care of it yourself. And even if the venue will do it for you, look at the images before the show is over in case they're not done the way you want them done (that is, while there's still time to reshoot). If your work includes installation, time-based elements, performance, or moving parts, consider documenting with video, too.

Inventory

Keep a detailed list of every piece you've finished—along with a backup digital file or two. (You can shell out for an existing inventory program, such as GYST, ArtBase, Artsystems, or FileMaker, or use something more basic like Excel.) Some people keep it old-school with an actual notebook, but that's a real pain to search, sort, and update. And impossible to back up.

Whatever format you choose, include the following, along with any other relevant information, for every artwork you make:

—ID number: to reference the piece
—Title, medium, edition size, dimensions or duration
—Year: generally the year you *finished* the piece. If you rework a piece a couple of years later, you might list both the year initially completed and the year reworked as a hyphenated

date (e.g., 2004–2008). If you're a photographer, you may need one column for the year you shot something and a second column for the year you printed it.

—Location: where the piece is now

—Exhibition history: where and when it was exhibited

—Price: if it ever had a listed retail price and/or insurance value in a show and whether it sold

—Framing: whether it is framed and how much that cost

—Production cost: what you paid to have the work made

—Status: available, sold, not for sale, on consignment, loaned, donated

—Sale information: who sold it, who bought it, when, and for how much

—Notes: any clarifying information

—Image: attach all images, including details and installation shots; if you can't do that then at least include a thumbnail

Titles do not have to be witty, explanatory, or revealing (although they *can* be a combination of all three). They need to identify the piece. There is nothing more frustrating to a registrar than one hundred "Untitled" pieces arriving for a show. If you have to call a work *Untitled*, at least add a number or descriptor or *something* (for example: *Untitled [1]* or *Untitled [Red]*). Otherwise you risk your piece becoming Unfound and thus Unreturned after the show.

Under "medium," write down all the materials you used, not just "mixed media." You want the most detailed record possible in case you need to fix, re-create, or explain the work later. If your piece is not a physical object, then instead of medium, size, and dimensions, you'll have to come up with other parameters to describe your work as completely as possible.

Keep a separate record for each piece in an edition and for every artist's proof (AP). For example, if you have an edition of three with two APs, then 1/3, 2/3, 3/3, 1/2AP, and 2/2AP each get their own records in the inventory system or lines on your spreadsheet.

Even if you have a gallery that tracks your inventory, keep a complete record yourself. Be in control.

Sign and date all your finished work. If the piece is in an edition, include the edition number. Signing the back is

What does "edition size" mean?

If you are making more than one of something and they are all exactly the same, you're making an edition. The total number you are going to make is the edition size. You would only be concerned with this if you make photographs, prints, videos, multiple sculptures from the same mold, and some digital works.

Determine edition sizes before you make the work. That way, you can produce all the pieces in the edition at the same time to ensure they are all indeed identical. The same color looks different in "identical" prints and photographs produced at different times or on differently calibrated machines.

Most editions are small: three, five, or six. Artists keep their edition sizes small because very large editions feel more like posters than works of art. That's why there are almost never more than twenty pieces in an edition. Sculptures in particular tend to come in editions of three or fewer. Many artists pick one edition size and stick with it for an entire body of work.

If you want to buck custom and make a huge edition, go right ahead. Just have a good reason—your work is about mass consumption, say, or replication, or identity, or bucking custom. Or you just want to make the work available to a large audience.

Anyone who buys or sells your work will want to know your edition size because it affects value: the higher the edition size, the lower the price of each piece. Tell your collector the edition size before you sell a piece.

IMAGE	INV#	YEAR	TITLE	MEDIUM	DIMENSIONS (INCHES)	EDITION	LOCATION
	1	2018	Untitled 3	graphite on paper	30 x 40		studio
	2	2018	Still-life 2	wood, plastic, found Flamingo feathers	20 x 15 x 5		Mom's house
	3	2018	Landscape 5	HD Digital Video	6:22	1/3	collector name
	4	2018	Landscape 5	HD Digital Video	6:22	2/3	exhibition title
	5	2018	Landscape 5	HD Digital Video	6:22	3/3	studio
	6	2018	Landscape 5	HD Digital Video	6:22	1/1 AP	studio
	7	2017	Untitled	oil on canvas	11 x 14		collector name
	8	2017	Self-Portrait	performance	Site-specific 60–70 minutes		studio: instructions on hard drive; hard copy in flatfile
	9	2017	Still Life	Murano glass beads, nylon thread, canvas	8 x 8 x 2		Friend X house

——————— *"I think the size of the signature is inversely proportional to the quality of the work. The bigger the signature, the suckier the painting is."* **Kelly Klaasmeyer**, *artist, writer, critic,* Houston Press; *former editor of glasstire.com, Houston, TX*

customary (or the bottom, if it's 3-D; the front if it's print). Include the title if you have space. Once you have a gallery, it should use its own label in addition to your signature. Until then, you should label it yourself. Here's a sample:

Artist Name
Landscape 2, 2017
c-print, edition 4/5
20 x 24 inches
ID 35

Artist Name, 20 Pineapple Street, Los Angeles, CA 90001
555-123-4567 info@artistname.art

TOTAL PRICE	FRAME COST	OTHER COST	STATUS	COLLECTOR CONTACT	SOLD BY	EXHIBITION(S)	NOTES
$1600	$400		available				
$3200		$600 casting	available				cast at Foundry X
$800			sold 4/1/19	Collector Name Contact Info	Venue X, Address	"Title" Venue X, Curator, Dates	sold as digital file 4/1/19
$800			on consignment			"Title" Venue Y, Curator, Dates	should be returned by 12/1/19
$800			available				
NFS			NFS				want to keep
$1000			sold 6/1/18	Collector Name, Contact Info	Non-profit Name, Address	Benefit Name, Date	Donation
NFS		travel & time	available			"Title" Venue B, Curator, Dates	paid $300 honorarium plus travel
$1,400		$200 beads	on loan				beads from store Q, date; friend X will keep indefinitely

There are a number of conventions when it comes to signing work:

—Frames, stretchers, and mattes may be separated from the art, so sign the actual work and not an accessory to the work.
—Paintings: Use paint to sign the back.
—Photographs: Sign with a soft pencil, acid-free pen, or china marker. (If you permanently mount a photo, sign the back of the mount.) Don't ever use a Sharpie or permanent marker to sign a photograph. The ink will eventually bleed through the image.
—Drawings: Use whatever drawing material you used for the drawing.

———— "Artists must be in charge of all aspects of their careers. This includes making sure that all work is inventoried and photographed before it leaves the studio. There are many resources available for inventory systems online, or come up with your own that best suits your needs. Photography is crucial, too. Always have your work professionally photographed. If you are not a photographer, find one within your network. If money is an issue think about trading services (or art)." **Steven Sergiovanni, art advisor, curator, New York, NY**

———— "I keep a master list. All my galleries operate slightly differently. I try to get consignment forms or periodic inventory lists so I make certain that what they have is clear in relation to what I have. It's a lot more work and I would love to give it up, but I am the only one able to look out for my own interests." **Joseph Havel, artist, director, Core Program, Houston, TX**

———— "We are working really hard with our artists to create their own tracking systems for their work and to simultaneously keep very accurate records of the artist's sales, loans, etc., ourselves at the gallery. For the artists where we are the primary dealer and have represented the career for a long time, our database is comprehensive and reflects where the work is. That said, artists also have the responsibility to keep track of their work, especially if they are working with more than one gallery and there is no 'primary' gallery that's tracking the coming and going of work. Gallerists are dependent on accurate information from the artists we represent. Therefore, artists should have a system for keeping track of their work in general and edition sizes in particular. At the moment, we are working with several museums on mid-career survey exhibits, and if we (or the artists) didn't have accurate records, the exhibits would be harder to assemble and possibly less representative of the artist's careers." **Catharine Clark, Catharine Clark Gallery, San Francisco, CA**

—3-D work: Sign or etch your signature on the bottom of a sculpture.
—Slick surfaces: Etch or use an archival sticker.
—Textiles: If you can't sign the textile, attach a signed tag.
—Videos: If there is a disk and case, sign them with an archival pen or marker. Or sign the USB drive.

If there is really no way to sign the piece (because it's an installation, for example, or a performance, or digital piece, or whatever), create a "certificate of authenticity" and give it to whoever buys the piece. To prepare a certificate of authenticity, describe the piece in detail on a single piece of paper, list your contact information, and sign and date the document. Here are two templates:

LETTERHEAD

CERTIFICATE OF AUTHENTICITY

IMAGE

ARTIST NAME
Landscape 2, 2018
c-print, edition 4/5
Edition consists of 5 prints and 1 Artist Proof
20 x 24 inches
ID 35

Signature of Artist

This document certifies that the piece described above
is an original artwork by Artist Name.

Artist Name, 20 Pineapple Street, Los Angeles, CA 90001
555-123-4567 www.artistname.net

LETTERHEAD

CERTIFICATE OF AUTHENTICITY

IMAGE

ARTIST NAME
Title, Date
X of edition of Y identical originals (plus 1 Artist Proof)
INV28

Type of work	[e.g., digital video / app / VR / etc.]
Format	[e.g., DVD / USB drive / etc.]
Dimensions	[e.g., screen size / aspect ratio / etc.]
Duration	[e.g., hours: minutes: seconds / perpetual loop]
Audio	[Sound / Silent]
Installation & Viewing	See attached instructions
Year Completed	20__
Items provided with work	[e.g., 1 exhibition copy, 1 archive copy, 1 digital file]

If the technology underlying this work becomes obsolete, the owner may transfer the work to, and display it via, a newer medium or platform, in the way that most closely emulates the intended installation and viewing experience.

The artist's master is for backup purposes only and will not be exhibited or disseminated. Neither the artist nor the buyer will alter this work, alter other originals of this edition, prepare any further originals of this work, or allow other originals to be prepared.

Signature of Artist

Artist Name, 20 Pineapple Street, Los Angeles, CA 90001
555-123-4567 www.artistname.net

Registering Your Copyright

When you make something original, you automatically own the copyright to it, meaning no one else can copy it without your permission. (There are exceptions to this rule, but that's the overall gist.) You don't need to register your copyright, in other words, to be protected by copyright law. But it's pretty cheap to register and you're much better off if you do.

As this book goes to press, it's only thirty-five dollars to register your copyright if you register online. (It's eighty-five dollars if you use snail mail.) And you can register an entire body of work at once; you don't have to pay separately for each image as long as you title the images by the series title and not individual titles. File the Form VA (that's for "visual arts"). The U.S. Copyright Office's website has user-friendly instructions on how to file and long, helpful lists of frequently asked questions.

So why are you much better off if you file?

Let's say a gallery puts one of your drawings in a group show and a year later you walk into a store and see an exact reproduction of your drawing printed on a stack of T-shirts. Whoever made those shirts violated your copyright (or "infringed" it) and the law entitles you to stop them, or get paid for the shirts if you're okay with them being out there. Of course, there's no problem if you don't mind the shirts and can work something out with the shirtmaker, such as getting credit or getting part of the profits. But if you do mind those shirts being sold, or the shirtmaker won't give you the time of day, then the only way to protect your copyright is with a lawyer. And lawyers aren't cheap. Even hiring one to write a nasty "cease and desist" letter will run you hundreds of dollars; following up on the threat can cost thousands. (As we explain at the end of this chapter, depending on your financial situation, you *may* be able to find a volunteer lawyer to take your case. But you can't count on that.)

Now, the law requires you to register your copyright before you file a lawsuit, so if you *didn't* do that before you discovered those shirts, you'll have to register to bring a case against the shirtmaker. And while you're allowed to register your copyright after someone infringes it, your case will be harder to prove (and therefore more expensive) than it would have been had you

———————— "I tell everyone that posting images on the Internet has little to no protection. It's like saying 'Can I leave my bag in a coffee shop for an hour and it won't get stolen?' No!" **Sergio Muñoz Sarmiento, attorney, artist, educator, Brooklyn, NY**

———————— "You don't have to register your work because you're protected by copyright even if you don't do anything. But if you can, it's a good idea.

"So many times I end up having to say, 'There's no way we can prove damages, and you're going to spend a lot of money and you may not recover enough to make it worth your while. But if you had registered, and we could go for statutory damages and, more importantly, attorneys' fees, then we'd be in much a stronger position.'" **Donn Zaretsky, partner, John Silberman Associates; writer, Art Law Blog, New York, NY**

———————— "If you call me up and tell me so-and-so came in and they have a drawing, I can say 'The drawing they have is X and it was purchased by Y for Z amount.' It's just because I have a little book with Scotch tape and Polaroids that documents every piece I've made. In these notebooks, I have a picture of the piece and a record of the details, who bought it, where it's been shown, if it was in a publication or museum—the history of the piece. It's not very hard to do that!" **Jane Hammond, artist, New York, NY**

———————— "Please document everything. Even if it's on scraps of paper that you throw in a box. And please tell somebody where the box is! We work with the estate of a collector who kept all his correspondence with the artists he supported and collected. These are all carbon copies (the equivalent to a scan today, folks). The information in the letters is very human, warm, informational, and historically important. I guess these days we should all file and back up our email." **Leigh Conner, CONNERSMITH, Washington, D.C.**

registered your copyright before anyone infringed it. Unless you have a lot of money to burn, you can only afford to bring the case if you think you can win at least enough to pay your legal bills. But to do that, you'll have to convince a judge that you suffered "actual damages," meaning the copyright infringement caused you to lose money or diminished the value of your reputation. This is not easy to prove.

If you did register your copyright as soon as you finished your body of work, it'll be easier to prove your case in court; the shirt maker may have to pay your legal bills if you win; and instead of having to prove "actual damages," you'll automatically be entitled to a certain amount of money for each instance of infringement (in other words, for every T-shirt). Not bad for thirty-five dollars.

Press

Save every article written about you—even the ones that only mention you in a list of other artists. Keep a digital file of every article, including the publication name, author, title, date, page number, and URL. You can post articles on your website or include them in submissions (with proper credit). You should even keep a copy of bad press because you may want it later; you never know. Check out chapter 3 for more on preparing press clips.

Contacts

Keep the email and contact information of everyone who has:

—expressed interest in your work
—visited your studio
—written about you
—shown your work
—sold your work
—bought your work

Add these people to your snail mail and email lists. Follow them on social media. Make sure all your announcements go to curators, collectors, and press, in addition to friends and family.

Always blind carbon copy (BCC) on mass emails. Collectors and curators tend to guard their email addresses—they do not want you sharing them with a bunch of strangers. And galleries can get pretty competitive with one another, so you don't do yourself any favors by broadcasting the names of all the galleries you're interested in. Besides, no one but you needs to know how big your email list is. Bottom line: be discreet.

—————— *"It's a slow game. It's a long game, this getting recognition and attention for the work that you're doing. But at the end of the day, your peer circle and the people immediately outside of that are the people who are going to support you over the long term. You have to value those relationships because those relationships lead to other opportunities."*
Jamillah James, curator, ICA LA, Los Angeles, CA

—————— *"We spend a lot of time keeping our email contact lists up-to-date, keeping especially close tabs on curators and writers. They bounce around jobs a lot. It requires constant attention."*
Matthew Deleget, artist, curator, educator, founder, Minus Space, Brooklyn, NY

It never hurts to gather the contacts of your dream dealers, collectors, curators, and press contacts in case you have a reason to reach out to them about something—but adding people outside the categories above to anything beside select social media may be inappropriate unless your project is about annoying strangers. The idea is to grow your list organically, starting with friends and family and slowly expanding as you meet more people. A random gallery's mailing list wouldn't help you as much as the list you've created of people who already know you and your practice. Tell them to share when appropriate.

See chapter 4 for more on email marketing.

Receipts and Expenses

Keep your receipts. You'll be glad you did when it's time to file your tax return. (Just for the record: *file your tax return.*) Your receipts will also help you price your work, since they reflect all of your costs.

Hold on to the receipts for anything directly related to your career, such as:

—Supplies, materials, and equipment
—Framing, printing, and production
—Documentation of your work
—Studio rent and utilities
—Refreshments for open studios
—Meals with art world colleagues
—Travel to shows, fairs, and other art world events
—Food and accommodations at art world events out of town
—Subscriptions to art magazines and periodicals
—Museum memberships
—Books on art or any topic related to your work
—Courses on art or any topic related to your work
—Residencies
—Submission fees
—Website and business cards

———— *"The government gives you a lot of tax advantages, as it gives all businesses. In exchange, it wants you to be businesslike. You might not think of your studio as a business, but the government does."* **Joy Harvey, tax preparer, New York, NY**

———— *"The IRS has a bunch of criteria on whether your studio is a business or a hobby. But the two that are most important are: if you intend to make a profit, and if you run your activity in a businesslike manner. There is an unwritten rule that you should make some kind of a profit three out of every five years. If you don't, carrying on the activity in a businesslike manner is compelling. That's having a separate bank account, business cards, letterhead, stationary, maybe even a business telephone number, and definitely accurate records."* **Jessica Lanzillotti, accountant, Everyman Theater, Baltimore, MD**

———— *"I love when accountants say, 'Oh, being an artist is a hobby.' And I'm like, 'Oh, really?' 'What's your degree in?' 'Oh, I have a Master's in Fine Art.' 'What else do you do?' 'I starve.' How is that a hobby? A hobby maybe if I decide to raise and race horses and I'm an accountant. But an artist who's making art does not have a hobby. That's their job."* **James Walters, CPA, Walters & Skylar LLP, Los Angeles, CA**

—Shipping
—Postage and postcards
—Car expenses
—Work done by assistants or vendors

If you have a car and use it for anything art-related, keep track of your art-related mileage. Your accountant will use that mileage to figure out how much of your car expenses you can deduct from your taxes.

When you hire people to assist you in the studio, you can deduct from your taxes the amount you pay them for their help. Make sure you get their full names, addresses, and Social Security numbers. Have them fill out a Form 1099 and file them with the government. (You can find the form on the IRS's website or buy a user-friendly packet of them—with instructions and preaddressed envelopes—from an office supplies store.)

Tell them right from the beginning that you're reporting the amount you pay them so they know it's not under the table.

When in doubt, keep it and consult your accountant later. If you don't plan on getting an accountant, read the last section of this chapter, where we tell you to get an accountant.

Because your income as an artist isn't steady, it's better to file your taxes quarterly. This requires you to project your annual income, which you do based on your current, quarterly income. So you'll save yourself major headaches four times a year if you take a little extra time each month and track your income and expenses in a spreadsheet that does the math for you. Make one worksheet for your income (whether related to art or not) and one for your art-related expenses. Divide each worksheet into categories that make sense for you, given the kind of work you do and the kind of expenses you have. If you only make paintings and drawings, for example, and you have a part-time job as a graphic designer, your income sheet should have a column for paintings, a column for drawings, a column for day job, and a "total" column, like this:

INCOME				
DATE	DRAWINGS	PAINTINGS	DAY JOB	TOTAL
2/28	$250	—	—	$250
3/15	—	—	$2400	$2400
3/22	$200 $1400	$4300	—	$5900
TOTAL	$1850	$4300	$2400	$8550

For your expenses chart, include the major categories of your expenses that correspond to what you'll tell the government when you file your taxes. Depending on your volume it may be worth buying an accounting app or program.

ART EXPENSES						
DATE	STUDIO	MATERIALS	TRAVEL	SHIPPING	FOOD AND ENTERTAINMENT	TOTAL
2/9		$95			$30	$125
2/27	$700	$320				$1020
3/5			$105	$50	$45	$200
3/27	$700					$700
4/5			$105	$50		$155
TOTAL	$1400	$415	$210	$100	$75	$2200

Add categories if you have other types of expenses and leave off categories that you don't need. The point is to track your actual expenses in a clean and easy way, not to think up as many hypothetical categories as possible.

When it comes time to file, your accountant will transfer the information on your chart to a "Schedule C" (for self-employment), so you can also just use the categories from a Schedule C if you want. You don't have to, though; think of them as "suggested" categories. Here is a list of those categories, with the most relevant ones bolded:

—**Advertising**
—**Car and truck expenses**
—Commissions and fees
—**Contract labor**
—Depletion
—**Depreciation** (that is, of the value of equipment)
—Employee benefit programs
—**Insurance**
—**Mortgage**
—Legal and professional services
—**Office expenses**

——————— "Sometimes we find that artists don't file tax returns to show their losses from their art business! They think they're losing money because they didn't sell any art so they don't file a tax return. But, in fact, if they file a tax return and show that loss, they can carry it forward and use it in future years when they make money. The other thing is that they think that they just owe federal and state taxes, but they many times owe social security, which can be quite substantial." *James Walters, CPA, Walters & Skylar LLP, Los Angeles, CA*

——————— "Schedule Cs are the highest audited item by the IRS. In most cases, if the expenses are legit, it's not a problem. Everything artists do, except maybe eating, is probably something to do with the art, to be honest with you." *James Walters, CPA, Walters & Skylar LLP, Los Angeles, CA*

——————— "A lot of artists think that the business use of home is only applicable if you own your home—mortgage interest, condo fees, utilities, repairs, maintenance, insurance. But it's also applicable to renters." *Jessica Lanzillotti, accountant, Everyman Theater, Baltimore, MD*

—Pension and profit-sharing plans
—**Rent or lease**
—Repairs and maintenance
—**Supplies**
—Taxes and licenses
—**Travel, meals, and entertainment**
—**Utilities**
—Wages
—**Other**

We recommend getting a separate credit card for your art expenses and charging all your art-related purchases with it. That way the credit card company will keep track of your expenses as well. Just remember to keep your receipts as backup. (This system only works if you always make your payments. Debt is beyond the scope of this book: we don't want to get into it, and neither do you.)

Invoices

Set up an invoice form that you can quickly fill out and print as needed. Keeping invoices for every piece you sell is the easiest way to track your sales. It also shows your new collector that you're serious (even if it's your mom). Don't forget to keep a copy for yourself.

If you have a gallery, it will take care of sales for you and you should stop selling your art yourself unless your gallery tells you it's okay. (More on that in chapters 5 and 13.)

We made a couple of sample invoices for you, which you'll find at the end of this section. While you can use our samples as they are, you should think of them as basic templates to tailor to your style. See our explanations of each item we include and decide for yourself what you want to use and what you don't.

Basic Invoice
A bare-bones invoice needs these items:

1. Date
2. Your name, studio address, work phone, and email
3. Your collector's name, address, phone number, and email
4. Title, date, medium, dimensions or duration, and edition
5. Price, shipping, sales tax, and total
6. How and when to pay

We recommend adding a thumbnail image of the work and its inventory number. Thirty years later when you're gathering your pieces for a retrospective, you won't be scratching your head trying to remember what "Untitled (vernacular)" was. Some galleries also include interesting provenance details—that is, the piece was in this show or that magazine.

Payment Terms
Sometimes collectors forget that you actually *need* the money. Don't be afraid to suggest a time frame:

Payment is due within 30 days of receiving this invoice.

Feel free to specify method of payment. If you use PayPal, Venmo, or similar mobile or online payment service, list it along with your account name.

Extras
There are a bunch of other things you can put on an invoice to clarify expectations. Whether to include them is mostly a matter of personal style, since you need to balance protecting yourself, on the one hand, against demanding "too much" from someone you hope will buy more work from you later.

Even if you don't write these items into your invoices, you should understand the issues surrounding them and get comfortable talking about them. It's the only way to avoid unhappy surprises later down the line.

Legal Title

Legal title doesn't refer to the name of an artwork but rather who owns it. Say a collector visits your studio, falls in love with a $700 drawing, and buys it from you on the spot (with cash, no less). The second she gives you the money, the collector becomes the owner and legal title "passes" from you to her—that is, if she pays you the full $700.

In the real world, of course, few people pay right away. And if you're partially paid—she gives you $350 now and plans to pay you another $350 in a month—you only keep title to the drawing for as long as you actually hold on to it (that is, keep it in your studio or home or wherever). By letting your collector take the piece away, you're giving her legal title to it—even though she hasn't fully paid you! She still owes you $350, but you don't own the piece anymore.

It is easy (and lawful) to get around this default title rule. All you have to do is state on your invoice:

Title will not pass until full payment is received.

To make it more direct, you can write:

Title will not pass to you until I receive full payment.

Either of these sentences makes clear that you are not letting your collector become the owner of the piece—even if she's already taken it home—until she's paid for it in full.

Another straightforward way to prevent title passing before you're fully paid is to keep the work until you're fully paid. Many galleries choose to do this, stating on their invoices:

The work will not be delivered until full payment is received.

Again, to be more direct you can state:

I will not deliver the work until I receive full payment.

This is more of a symbolic protection than a strictly legal one, in the sense that it's only as effective as you are willing to act on

————— "It's your art, but there are a couple of areas, like taxes, where your freedom can be taken away and the protection of the art is really important. All of your effort, even if it's not sticking it to the man or running counter to the culture, is a way of maintaining independence. If you keep all your records and maintain a general knowledge of everything, it's a certain type of independence."

Michael Joo, artist, Brooklyn, NY

it. Sometimes the excitement of selling work—or the desire to please a collector—can easily overpower any notion of protecting yourself from hypothetical trouble down the road.

The idea in either case is to avoid a situation where you don't have your piece anymore and your collector is dragging her feet in paying you for it (with nothing but her conscience as motivation to pay).

Insurance

Art gets damaged during shipping all the time, and when it does, guess who wants to pay for it? No one. We've heard some *nasty* stories about collectors blaming artists and galleries for damage that happened after work was shipped—and by "blaming," we mean hiring a lawyer and threatening a lawsuit.

The way to deal with that is to make it clear up front who has to cover such accidents (in legalese, who "bears the risk of loss") by adding this line to your invoice:

Insurance in transit is the purchaser's responsibility. (Or, "As the buyer, you are responsible for insurance in transit.")

Of course, packing your art well minimizes the risk of damage. See chapter 9 for practical packing and shipping tips.

Shows

Collectors understand that there may be a time in the future when you want to include sold work in a show. Some artists like to make this explicit in their invoices, with something along these lines:

You agree to loan this piece for exhibition at a museum, gallery, or similar space.

Adding this to an invoice is touchy because it places a future burden on the collector. Many gallerists, for example, feel strongly that once a collector buys an artwork, she should be allowed to do (or not to do) whatever she wants with it.

Others think that it is appropriate to raise the topic in a conversation, so the collector knows it's a possibility, but too aggressive to put anything in writing. As a practical matter, a

collector who doesn't want to lend work to a show because she doesn't want to risk damage to the work (or for any other reason) isn't going to lend the work—regardless of what you wrote in your invoice.

According to most gallerists, collectors are typically quite willing to lend work to an exhibition when the institution pays for shipping and insurance (this is standard) and they are acknowledged in either a brochure or wall label. The only time collectors pass on such opportunities is when the work is fragile and the risk of damage is high. In those cases, the work probably shouldn't travel anyway.

Copyright

When you sell an artwork to a collector, you're only selling the piece—not the copyright to it. To stick with our example, that means your collector owns the $700 drawing and can hang it wherever she wants, give it to whomever she wants, etc. But she can't use it to make mugs and posters to hock online; she can't sell a copy of the drawing to a clothing company; she can't put the image on her business cards. Only you can do those kinds of things, if you want to, because you have the copyright to the artwork you make—and you keep that copyright after you sell the work.

This is true whether you say anything about it or not in an invoice, but some artists and gallerists add a note just to make sure the collector understands what she's buying (and what she's not buying). Something along these lines:

I retain full copyright in the work.

Resale

Someday down the road, your collector may want to sell your piece. As we explain more fully in chapter 13, depending on where you live, you might be entitled to part of the resale price. Or you may just want the chance to buy your piece back.

Because many new collectors either do not understand the repercussions of resale on an artist's career or do not know the expectations upon resale, some galleries add something like this to their invoices:

I reserve the right of first refusal if the work becomes available. (Or, "I reserve the right of first refusal if you decide to sell the work.")

A friendlier—but more ambiguous—approach:

Please let me know if you are going to resell this piece.

Acknowledgment

Finally, you want your collectors to agree to whatever items you've put in your invoice. You can do this either by including a

signature line at the bottom and asking them to sign the invoice (keep a copy of the signed invoice for yourself) or by adding this line to the bottom of the page:

Receipt of payment acts as acknowledgment of these terms. (Or, "By paying the amount listed above, you agree to the terms in this invoice.")

Extra Extras!
The terms above are the common elements of an invoice; your work may call for others. The idea is to set expectations. If the piece is ephemeral, for example, and not meant to last forever, you probably want to mention that in the invoice. If it needs watering, unusual cleaning, or unique care, this is the place to refer to those special care instructions (the actual detailed instructions can be on a separate sheet). For some works, the collector isn't buying an object at all, but rather an idea, or the ability to install something site-specific in the future.

Talk to your collectors about these issues ahead of time. An invoice shouldn't be the first place they learn about unique conditions, or the possibility that the work they're about to buy has a limited life span.

See pages 50–51 for two sample invoices. The first one has the bare minimum and the second is an example of how you can add more terms.

By the way, don't sell everything you have. Keep at least one piece from each body of work; resist pressure to sell your artist proofs. Being able to look at your old work (and not just an image of it) lets you see how you've developed. It can anchor your perspective and inform your current work. It may also be worth something someday.

——— *"Artists should always hold work back. Always keep examples of your work from different periods."* **George Adams, George Adams Gallery, New York, NY**

——— *"I see artists selling their last artist proof. To the right institution it may be okay if that's what you want, but you may want to hold on to it for ten to twenty years. I am right now looking at work by artists who have pieces from the '60s and '70s that they held on to. I've had artists tell me they keep one piece out of every show and I think it's a smart thing to do."* **Anne Ellegood, senior curator, Hammer Museum, Los Angeles, CA**

——— *"They must hold work back! It's very important to keep at least one artwork from every series. It's their pension fund and their history. They need to have work in their studio that is not for sale. Ever. It's good for them and their visitors to see the progression and the transitions. Money may seem more important than keeping artwork in the short term, but holding work back in the long term is very important."* **Micaela Giovannotti, curator, consultant, New York, NY**

January 15, 2018

Sold to:
Collector Name
4567 Sunshine Blvd
Los Angeles, CA 90210
collectorname@gmail.com
310.555.5555

Invoice # 00100

IMAGE

Artist Name
Landscape 2, 2017
c-print, edition 4/5
20 x 24 inches
ID 35

$ _____

subtotal _____

shipping _____

tax _____

Payment is due within 30 days of receiving this invoice by check or Venmo.
Thank you!

total $ _____

LETTERHEAD
Contact Information

January 15, 2018

Sold to:
Collector Name
4567 Sunshine Blvd
Los Angeles, CA 90210
collectorname@gmail.com
310.555.5555

Invoice # 00100

IMAGE

Artist Name
Landscape 2, 2017
c-print, edition 4/5
20 x 24 inches
ID 35

$ _____

subtotal _____

shipping _____

tax _____

total $ _____

Payment is due within 30 days of receiving this invoice by check or Venmo. The work will not be delivered, and title will not pass, until I receive full payment.

As the buyer, you are responsible for insurance in transit. I retain full copyright in the work. You agree to loan this piece for exhibition at a museum, gallery, or similar space.

I reserve the right of first refusal if you decide to sell the work. By paying the amount listed above, you agree to the terms in this invoice.

Thank you!

HELP!

Some things you really shouldn't do yourself. Open-heart surgery, for example. So it is with insurance, taxes, and legal problems.

Renter's/Homeowner's Insurance

This may not seem like an absolute necessity but you should treat it like one. It is not very expensive and if you ever need it you will feel like it saved your life. It basically covers all the stuff in your apartment or studio. If you're a victim of theft, fire, or a few other calamities, the insurance company cuts you a big enough check to replace everything that's gone. This will never bring back your lost artwork but it will cover your equipment and supplies. If you have a sales record, it could also get back the retail value of the lost work.

Be sure your policy is for "replacement value," which means that if the brushes you bought two years ago for $30 now cost $45, your policy gives you $45 (since that's how much it is to replace the old items).

Also make sure they know you are insuring artwork. Many companies will do it, but you have to purchase a special rider for artwork and get an appraisal from a local gallery or arts professional. Other companies specialize in art insurance (usually serving galleries, institutions, and collections) and may actually be cheaper and easier to deal with. Get quotes from several places.

Taxes

A lot of artists cringe at the idea of paying someone to do their taxes. But a good accountant will *save* you money. (And time, and frustration.) The IRS considers you a self-employed freelancer, which makes your taxes more complicated because it requires extra reporting forms and itemized lists. Just figuring out which forms you need to submit can be a time-consuming and confounding exercise, never mind actually trying to calculate a year's worth of deductible expenses. And if you sell directly from your studio, you need an accountant to help you determine when to charge sales tax, how much to charge, and how often to report it. (The rules and rates vary state to state, and even neighborhood to neighborhood within a city. While much of the information is available online, it is hard to find and harder to parse.)

There are accountants who work primarily with creative

——————— *"It's very hard to generalize with taxes. There is so much variety. In my mind, the biggest thing for artists, no matter what part of the arts they are in, is to understand that they are going to have to pay taxes even when they earn very little." **Joy Harvey, tax preparer, New York, NY***

——————— *"I think you have a choice to let your taxes run your life or run it yourself. If something wonderful happens and you suddenly have a lot of income from your art, go and pay an accountant, sit down and talk with them. You can muddle through and guess when things look the same from last year, but when something wonderful happens, let it be wonderful and don't let it ruin your life." **Joy Harvey, tax preparer, New York, NY***

——————— *"Let me give you some buzzwords to put in your head so that when you hear them, you'll call a CPA: you should set up an LLC, S Corp., you should incorporate, you're a hobby." **James Walters, CPA, Walters & Skylar LLP, Los Angeles, CA***

——————— *"People who don't specialize in artist taxes don't always fully understand the breadth of the work. You can write an accountant's fee into your grant, and you can write it off on your taxes because it's a business expense." **Jessica Lanzillotti, accountant, Everyman Theater, Baltimore, MD***

MY ACCOUNTANT SUGGESTED THAT I MAKE PAINTINGS THAT NO ONE WILL BUY SO I CAN WRITE THEM OFF AS A TAX DEDUCTION

————— "If you're an artist wanting to make a living off of your artistic practice, you have to think of it like opening up a restaurant or a coffee shop. 'What are my liabilities?' It's unfortunate because most artists don't have the funding to be thinking preemptively. But you have to now—it's part of the game unless you're going to work a different model. But those artists are very few and far between." **Sergio Muñoz Sarmiento, attorney, artist, educator, Brooklyn, NY**

————— "If you run a small business (and every artist runs a small business), you have to speak with an attorney. If you are not speaking with an attorney, it means you are not running your business and everything you do—from corporate work to contract work to your IP—goes unchecked and leaves you open for risk." **Adam Holofcener, artist, executive director, Maryland Volunteer Lawyers for the Arts, Baltimore, MD**

————— "If you are the type of artist to say, 'I want a gallery, I want sales, I want representation, I want art fairs . . . ,' you're going to need a lawyer because there are so many things to think about. Compensation and protecting your work would probably be at the top of the list. Number two is that they need to educate themselves. They know what it means to be an artist philosophically, but now what does it mean to be a pragmatic business person?" **Sergio Muñoz Sarmiento, attorney, artist, educator, Brooklyn, NY**

people—artists, actors, writers, entertainers—and who will therefore understand your situation, know the proper deductions you can take, explain how much you need to earn in sales to write off certain expenses, and generally maximize your after-tax income without running afoul of the IRS. Ask your artist friends who they use; look for accountants in your area who specialize in the creative fields. While many national chains advertise low rates for standard tax returns, they can easily end up more expensive for artists because of the number of specialized forms needed.

Legal Problems

If you get entangled in a legal dispute, get a lawyer. Do not try to handle the situation by yourself. (*Do* try to avoid legal disputes altogether, by resolving disagreements before they get out of control. But if someone serves you with legal papers, it's time to get help from a professional.) You should also seek legal advice when it comes to contracts, leases, or any other arrangements that may land you in trouble if you don't do them right in the first place.

One of the silver linings to being a struggling artist is that you may qualify for free legal assistance (also called "pro bono" legal assistance). In bigger cities, you can often find volunteer lawyers for the arts willing to help artists look over a contract or get out of a jam. If there isn't a VLA organization in your city, you may still be able to find pro bono help through the bar association.

STAYING CONNECTED

It is vital to stay connected with the art community. You need to know what's out there and to view it in person whenever possible. Visit galleries and museums every month, subscribe to at least one contemporary art publication, and talk to artists, curators, gallerists, and critics about what they're working on. Just as important is getting regular feedback on your work—and the best feedback comes from your peers.

—————— "We underestimate generosity and how that can build community." **Deana Haggag, president and CEO, United States Artists; former executive director, The Contemporary, Baltimore, MD**

—————— "Artists need to see shows they like and shows they don't like. So many artists won't see something because they don't think they'll like it or they think theirs is better. You need to see everything! You need to know why yours is better. See everything and figure out where you fit in and why you fit in." **Steven Sergiovanni, art advisor, curator, New York, NY**

—————— "Stay focused on creating your work. At certain stages in your creative process, it is often helpful to have other artists, curators, and writers in your studio; that dialogue can be part of a generative process. Of course, some of your time will likely be spent at your friends' openings and gatherings, supporting their work as they would yours. That ratio should be respected, not inverted, and with that balance, often things can happen." **Sarah Lewis, author, curator, assistant professor at Harvard University, Cambridge MA; former member of President Obama's Art Policy Committee**

—————— "Never underestimate the power of the artist network." **Kerry Inman, Inman Gallery, Houston, TX**

—————— "Your work needs to be strong and come first and be clear, and you need to know exactly what you're doing, or at least have some direction. But clearly, as a young artist, you have to really understand the way the art world social machine works." **Tim Blum, Blum & Poe, Los Angeles, CA**

—————— "It is very important for artists to become involved in their community. That will help them figure out who they are. Go to shows. Meet people. Make connections to people doing grassroots projects. Be friends with your peers who are just starting galleries, curating independently, getting their PhDs in art history, starting to write for a local magazine, or just starting a blog. Being friends with other people doing work in your art community at an emerging level means your careers will grow together. Today's graduate students are tomorrow's commercial gallerists, curators in major institutions, or serious academics." **Shannon Stratton, William and Mildred Lasdon chief curator, Museum of Arts and Design, New York, NY; founder, former director, Threewalls, Chicago, IL**

————— "Start with the community you know, who knows you, who's interested in whatever it is that you've put together with your work or your gallery space or your magazine or your band or your performance series. Start with who you know and build from there.

"I think it's about working in a way that's true to yourself and that allows things to happen naturally, with bits of prodding to bring new people into contact with what you do." **Peter Eleey, curator, PS1 Contemporary Art Center, Queens, NY; former curator, Walker Art Center, Minneapolis, MN**

————— "I think the idea that artists are competing against each other is a fallacy and it actually doesn't help them. I'm sure there are intense competitions between artists, but every artist has a different career. We all have a different trajectory. I share information because I am not competing with them." **Leah Oates, artist, curator, writer, Brooklyn, NY**

Professional opportunities in the art world almost always come out of personal connections, and community—almost by definition—is the way to make them. That's not a prescription for superficial networking or obnoxious self-promotion, neither of which will get you anywhere. It means realizing that the chance to get a piece into a group show or meet a gallerist will probably come through someone you know and respect, who knows and respects you.

Depending on your temperament, building community can feel daunting, artificial, or fun. There's no need to subject yourself to awkward conversation at stuffy cocktail parties. Just keep in touch with your friends and professors from art school, attend local openings, and be open to meeting new people at events. (If you're shy, bring a friend along. It's easier to break your way into conversation when you have a sidekick, and then you can talk about each other's work instead of your own.) See chapters 5–7 for more ways to build your own community.

CHECKLIST: GROUNDWORK

—SCHEDULE
—STUDIO
—DAY JOB
—IMAGE FILES
—INVENTORY
—REGISTER COPYRIGHT
—PRESS CLIPS
—CONTACTS LIST AND MANAGEMENT SYSTEM
—RECEIPTS
—INVOICE FORM—SALES
—INVOICE FORM—FREELANCE WORK
—RENTER'S/HOMEOWNER'S INSURANCE
—ACCOUNTANT

CHAPTER 3
———————— Submission Materials

People in the art world *love* seeing art in person. It's why they do what they do. Still, there are many reasons they'd rather see a submission first. Here are a few:

—*Time*. Many submission reviews are consolidated and scheduled. If everyone reviewed work in person every day, there wouldn't be time to do anything else.

—*Logistics*. Rarely is one person the sole decision maker. Usually a few people need to get together to make important evaluations.

—*Sensitivity*. Most arts professionals want to digest the work and give it a few moments to sink in before stating an opinion. Having you there forces a rash judgment.

And now a few reasons why *you* shouldn't want anyone to look at unsolicited, original artwork:

—*Perception*. Walking into a gallery with unique artwork creates the illusion that you don't care if your pieces get damaged. Curators, gallerists, and collectors think of artwork as precious. You should, too.

—*Loss*. If you bring actual artwork and leave it for someone to review, you may never see it again. Accidents do happen.

—*Self-respect*. Do you really want to hear what they think when you arrive unannounced and give them no time to prepare?

Just about every professional opportunity you come across will begin with some sort of submission. Residency programs and foundations require specific application materials; galleries often ask for "your documentation"; a curator may just want to see a few images of your current work. Whatever the request, you'll need to submit at least some of the following items: images, a résumé, press clippings, a statement, and a cover letter. Rarely, if ever, will someone ask to see actual artwork as the introduction to your practice. That's why your submission is supposed to give as accurate an idea of you and your work as anyone could get without doing a studio visit.

Because most of these materials take time to prepare well, you should start working on them now and keep them up to date as your career progresses. Don't wait on this! Your submission will often be the first impression you make, the first exposure someone will have to your work, the first chance to start a relationship. Creating solid, professional submission materials will therefore save you a lot of time and stress down the road. Sometimes you'll learn of an opportunity at the last minute and will need to rush an application out the door. Or you might meet a curator who unexpectedly asks to see your work. This is *not* the time to compose an artist statement from scratch or confirm the spelling of all the names in your résumé.

Expect to tailor every submission for every situation, since each one will be different. Even if you're applying for the same residency for the third year in a row, for example, you'll need to update your images to show how your work has developed. While most places ask for digital submissions, a few still prefer physical ones, so you should have both ready to go.

Here are the most common components of a submission for exhibition spaces, galleries, residencies, and almost anywhere else you'll be sending work. See chapter 6 for additional materials you may need to submit when applying for grants, project-specific opportunities, residencies, and more.

—————— "Respond to applications *directly*. Don't be general, and don't use a generic response. Instead, be specific about your work and how the program would support you (and how you might give back to the program). Approach your application like you would approach your own creative project. No two applications are alike, and your application should be an extension of your own work."

William Penrose, executive director, NURTUREart, Brooklyn, NY

IMAGES AND CLIPS (WORK SAMPLES)

When someone visits your studio, your art is what matters most. So too with a portfolio: when a jury reviews your application, the images of your work are by far the most important part.

Images of 2-D and 3-D Work

You already have images of all your pieces because you read chapter 2. Now you need to pick ten to twenty images of your best work. If the work's surface is important—say you make very intricate or three-dimensional pieces—we recommend creating a portfolio with a mix of full shots and detail images. If the scale and context of the work is important, consider selecting a few installation shots.

Include current work only (that is, finished pieces from your most recent body of work). If older work is necessary for context, include one or two older pieces. But in the vast majority of cases, your current work will create the strongest package. People want to see that you are in the studio right now.

Once you have your images, learn how to resize them on your computer and adjust the resolution. You should keep at least two sizes of each image on your computer, ready to go:

1. A 300 dpi, 8 x 10 inch image, at least 1,200 x 1,800 pixels, which you'll use for printing and sending to the press.
2. A 72 dpi, 8 x 10 image that you can email, put on a disk, upload, post to your website (see chapter 4), and show people on your computer (see "Studio in a Box" in chapter 5). Exact requirements will vary site by site.

Ideal file sizes will change, of course, as email and Internet capabilities grow.

Don't forget to label every digital image. Include a number, your name, and the title of the piece. The number should correspond with an image list and control the order in which the images are seen (e.g., 01_Melber_Sky; 02_Melber_Earth). Regardless of how you save your files, include all basic labeling information in the body of an email to which they are attached, or

What do I send if they're not specific?

Sometimes curators and gallerists will just say "send me your work" without explaining what that means. If you're too shy to ask, you can assume they expect ten to twenty images, a résumé, press clips (if you have them), and a cover letter.

All of this should be on your website (see chapter 4), so it should suffice to send a thoughtful email that serves as a cover letter, along with a link to your website. Always attach one image in the email. Choose your strongest or most recognizable image.

It's common to refer to original artwork as a portfolio, but when people ask you to send over your portfolio they mean your basic submission materials, not your original work. Same deal if someone asks you to send them "your documentation."

Always list dimensions as *height* x *width* x *depth*.

What are not appropriate to send as images?

Snapshots, photocopies, head shots, brochures, and postcards. Only send what they ask for.

in a corresponding image list: title, year, medium, dimensions or duration, and edition size (if applicable).

While these are general guidelines, *read* and *ask* before you submit anything, whether over email or directly to a website, and submit the exact size, resolution, and file type that you're told to. Max out dimensions and resolution, but never go over. Make sure you enter all labeling information correctly, test your files with a friend or another email account before sending them, and wherever possible preview your work before publishing it to a site. You don't want to send people attachments they can't open or let frustrating technical difficulties distract them from the most important thing—your work.

For complicated installations, video, kinetic works, sound pieces, performances, and time-based projects, submit video clips wherever allowed. For everything else, your still images will have to suffice.

Moving Images

If you are a performance artist or "new media" artist whose work is kinetic or based in sound, video, or film, have both stills (if applicable) and clips ready to send. Unfortunately, this makes your job harder than it is for artists making 2-D and 3-D work. The conventions aren't uniform, so it's more difficult to anticipate what, exactly, you'll need for any given submission. Nevertheless, there are a few things you can do in advance.

Since most applications ask for one to three video clips, narrowing down your work to your three best pieces and uploading them to a private video-hosting site (such as Vimeo) is a good start.

You can also prepare several different versions of those three pieces and bet that you'll eventually end up submitting all of them to one place or another. The still image that represents each piece in a DVD's menu, or the title frame at the start of a clip, is the first impression your viewer will have of your work, so choose striking images and purposeful, professional-looking fonts. We recommend putting any titling, crediting, or other important textual information at the beginning of the video, where it is most likely to be seen.

Presenting Images in a Digital Folder (via the Cloud, a Thumb Drive, a Disk, etc.)

—Put your images and image list in one folder. Keep your résumé, artist statement, and press clippings in a folder separate from your images.

—Control the order in which your images are viewed. You can do this by beginning each file name with a number (01_Bhandari_Landscape, 02_Bhandari_Landscape, etc.). Alternatively—though by no means necessary—is to create a PDF or PowerPoint presentation. This allows you to determine the order of images and combine them with text, while minimizing what the viewer has to do to engage your work.

—Remember to edit. Although your folder may have a lot of space in it, do not feel compelled to fill it up. Show that you know how to edit and you know how to follow directions. The rule of thumb is ten to twenty images.

—Test the folder before you hand it over. You wouldn't believe how many digital submissions don't work because of various technical glitches. Never assume the recipient will contact you for a replacement.

——————— *"I can think of some really wonderful artists who have not been accepted to the program because they take really terrible images of their work. Remember we are judging images, not judging work. If you are going through three hundred people's work and somebody has taken really crappy images, it takes too much sympathy to read the application and it just disappears."* **Joseph Havel, artist, director, Core Program, Houston, TX**

——————— *"I tell students to submit their best images, which is not always their best work. I've sat on many panels and know that they're looking at hundreds of images in a day. Before they can seriously consider your work, you will need to get them to stop clicking the projector. You need to have great images. Maybe you can sneak in a crucial piece that doesn't reproduce well (maybe it has an amazing story and you can sneak that story in) but it's very important to have strong images."* **Charles Long, artist, Mount Baldy, CA**

——————— *"Documentation is critical! And documentation is different from inventory, which is different from the archive. I advise artists to build documentation practices into all of their project budgets. Documentation is a part of your work as an artist. A fuller documentation strategy will include documenting work for your own inventory, for submitting work samples in applications, and for featuring your work in promotional material. The 'look' of your work in each of these categories might be different, especially if you're working in time-based media."* **William Penrose, executive director, NURTUREart, Brooklyn, NY**

Most typically, an application will ask you to edit your works down to three-minute clips. Having a three-minute version ready now will save you a huge headache later. (If your piece is less than three minutes, sit back and relax.)

Some applications ask for a highlight reel, which is the most labor-intensive submission of all. It means compiling works in a single file, usually up to five minutes long. The length of each highlighted work is up to you, as are the transitions between pieces. Still, keep it simple and clean. Transitions should not detract from the clips, and should clearly differentiate one from the next.

When you submit a video file, make a title frame before the video starts. Let the viewer see the length of the reel before it begins. And let the viewer fast-forward. A lot of artists lock their videos, aggravating a lot of curators and gallerists who have to watch a lot of videos.

Finally, ask what equipment the place uses to play video and make sure you adhere to their technical specifications. Think about which clips work best on which formats; you might submit a different clip depending on what format they'll be using. For instance, whether the jury will watch a video projection, together, or whether each member will view clips on a laptop, may influence your selection of materials.

Physical Images

For a physical submission, the general rule of thumb is to print the highest-quality images on the paper that makes your work look best. Does your work look better on matte or glossy paper? Textured or smooth? These are simple decisions that could significantly impact how your work is read. But, as with everything else, the size and layout depend on what's asked for. Include your name, title, year, medium, dimensions (or duration), and edition size (if applicable) somewhere on the page with each image, or on an attached image list. We recommend trying to combine the text and image on one page if you can do it well. This eliminates another piece of paper and the risk that it will get separated from the images.

ARTIST NAME
IMAGE LIST

1. *Landscape 2,* 2017
 c-print, edition of 5
 20 x 24 inches

2. *Untitled,* 2017
 DVD, edition of 3
 5:20

3. *Landscape 5,* 2017
 DVD, edition of 3
 6:22

4. *Community,* 2017
 graphite on paper
 30 x 40 inches
 map of the movement filmed in *Untitled*

5. *Community Response,* 2017
 graphite on paper
 30 x 40 inches
 map of the movement filmed in *Landscape 5*

IMAGE

1.
Artist Name
Landscape 2, 2017
c-print, edition of 5
20 x 24 inches

Think about how you will present your images to someone. In a folder? In a binder or sleeves? Don't let your presentation fall apart at the last minute! Take some time deciding what the images go in. It doesn't have to be fancy or expensive. Just allow the work to look its best and relate to the rest of your package.

Include a disk with the same images so that people who like what they see in the printout can look at your digital files for better color and detail.

While printing images may seem old fashioned, some venues have reverted to the old way of doing things to set themselves apart. We're all so overloaded with digital information that a nice printout or catalog can be a welcome relief. *This is not for everyone and should be done judiciously.*

———— *"Artists always ask me what the curators want to see. I'm always confused by that question. They want to see your work represented well. Just be honest with your work and yourself."* **Hillary Wiedemann, artist, Chicago; former codirector, Royal NoneSuch gallery, Oakland, CA**

RÉSUMÉ

Your résumé should list all your relevant *art* work; if it's not related to your art it doesn't belong on your résumé. Keep it clean, succinct, consistent, and easy to read. If you're at the beginning of your career, keep it to one page. No matter how much you want to cram in, don't let the font drop below 10-point. It's just too hard to read.

Before you worry about page limits, though, start by making a master résumé, or CV, which you can then tailor to specific opportunities (and shorten, if necessary). Look at artist résumés on gallery websites and see what style they use; that's the style the gallery is used to. Also look at the résumés of established artists you respect. Feel free to mimic their formatting.

And *no typos*. Seriously. Your résumé has to look professional because you're trying to show that you're a professional. So ask someone to proofread your résumé and fix those typos before you start sending anything out. An extra space between words is a typo. If you separate items with a comma, and then decide halfway down the page to separate them with a slash/that's also a typo. If you use Sentence Case for one heading and ALL CAPS for another heading, guess what? Typo.

Here are the most common sections of an artist résumé:

Contact Information

Think "need-to-know basis" here. You're not being interviewed on TV, you're just making sure the reader knows who you are and how to find you. List your name, address, phone numbers, email, and website (you really, really want the person to find you). A lot of artists list their birthplace, year of birth, and where they're "based." Those are optional.

Do not include a picture of yourself unless it is a part of your work. This is not an acting gig; a picture is just distracting and silly. Even if you're drop-dead gorgeous.

To harp on a theme, consistency matters. Pick the way you want your name to be listed and stick with it every time, down to the nickname or middle initial or whatever you want in there.

Education

Year, degree, school, city, state.

Whatever order you choose, match it to the other sections. If you start with the year here, start with the year everywhere. Don't list high school (unless you're in high school!). Post–high school education, study abroad, college, and graduate degrees only. Also, no need to list course work or your GPA. This is not a job application. (Except that it is, but you know what we mean.)

Solo Exhibitions

Year, title of show, venue, city, state.

List shows in reverse chronological order, beginning with any confirmed future exhibitions.

It's not just about quantity. People want to see whether you're a good fit for their program given where you are in your trajectory. Have you shown at exhibition spaces with similar programs? Look at the résumés of a venue's artists. Have you shown at venues that show artists of a similar caliber? Pay attention to this when you're tailoring your résumé for a specific space and edit your exhibitions list accordingly. If you're applying to a nonprofit, for instance, you should pull every other nonprofit exhibition to the top of each year and highlight your involvement in your cover letter.

If you've had fewer than four solo shows, call this section "Selected Exhibitions" or simply "Exhibitions" and put all your shows here (instead of separating group shows in a "Group Exhibitions" section) and just indicate which shows (if any) were solo exhibitions.

Group Exhibitions

Year, title of show, curator or juror, venue, city, state.

When you're starting out, people want to see that you're active and involved. It's generally better to have a bunch of shows at lesser-known places than only one show, three years ago, at a higher-profile venue.

Most Common Résumé Mistakes

—Inconsistent commas. Are you putting a comma before the last item in a list? For example: I make paintings, drawings, and video. Or are you *not* doing that. Whichever way you go, be consistent throughout.

—Chronological order. Your sections should be in *reverse* chronological order: most recent items first.

—Missing contact information.

—Implying something happened when it didn't (yet). If something is upcoming or anticipated, say so. Write "anticipated," "upcoming," or "expected" after the entry.

—Missing state or country. The location might be obvious to you, but not everyone else, especially if there's more than one place with the same name (e.g., the city of "Portland"). If you start showing internationally, always list the country (including U.S. shows) to keep everything clear.

Don't write a "goal" or "objective" on your résumé. It's an old convention from corporate America that nobody bothers with anymore because your goal is obvious: to get whatever it is you're submitting your résumé for.

What's the difference between a CV and a résumé?
A CV is a general, all-inclusive recitation of one's career. A résumé is a shorter, tailored version. You'll use a résumé for submissions.

As your career progresses, think of this section as a "best of" list rather than a comprehensive encyclopedia of your group shows. Include interesting curators and mention any catalogs that were produced from the shows. Don't be afraid to lop off shows in lesser-known venues as you add new ones. Big-city commercial galleries in particular are not going to be impressed with "open submission" shows or exhibitions at retail stores, cafés, and the like. Those are good for exposure and sales, and they may be all you have at first. If that's the case, omit the word *café* or *restaurant* unless it's part of the space's official name and look around for alternative, noncommercial venues to add some variety to your résumé. (See chapter 7 for more on finding venues.)

Residencies

Year, name, city, state.
 Double-check the spelling!

Awards, Grants, and Fellowships

Year, name, description.
 If something isn't obvious from its title, explain what it is in a few words. An award may be well known in your area but not elsewhere.

Other Ideas for Headings

There are many ways to categorize and organize what you've done: Performances, Collaborations, Public Commissions, Publications as Author, Lectures, Visiting Artist Programs, etc. Don't feel constrained by the sections we enumerate in this chapter. Go with what makes the most sense for your work and your accomplishments.

Press

Author, "Title," *Publication Name,* Location, Date, Section and/or page.
Author, "Title," Blog or Website Name, Date, URL.

————————"I look to see if an artist has exhibited in what I consider galleries of a kindred spirit. This requires the artist doing some research to pick the right ones to highlight. Check to see what art fairs the gallery does, and who also participates in those fairs that you've exhibited with. There's no guarantee you won't include someone the gallery doesn't like, but the odds of that are not so great."

Edward Winkleman, cofounder, Moving Image Art Fair; author, former director, Winkleman Gallery, New York, NY

For television or radio appearances, list the host, title of show, segment title, station name, and date.

Be discriminating about what you include here. Online press is also press. A well-respected art blog or online magazine is press. Your cousin's Tweet is not press.

Collections

Name, city, state.

Don't bother unless your work is in serious collections, such as a museum's or a famous collector's. It's perfectly fine to have a résumé without a "Collections" section. In fact, some find it tacky to include regardless of prestige. Instead, we recommend keeping a list to distribute on request; maybe mention a few significant collections in your bio.

Related Experience

This section often serves as a catchall for interesting entries that don't quite fit in other sections or find themselves alone in a category. "Related" means related to your practice. Is it? Obviously waiting tables isn't related, but neither is art handling. Even teaching ceramics isn't related if you're a video artist. Maybe if your videos are about ceramics, but you get the idea. Have you curated an exhibition? That could work. Again, this is not a job application so only include work experience that is truly *related*.

Like "collections," this section is optional.

While you should stick to the order of the first three sections, since those are what people are most interested in and expect to see at the top, you can rearrange, combine, and rename other sections in whatever way makes sense given where you are in your career. And the one-page rule flies out the window once you have more than one page of good material. Here are a few sample résumés to give you an idea.

Do not email Word versions of your résumé, because the formatting may reset when someone else opens the file on another computer, undoing your hard work of making everything line up. Save as a PDF (or some other unalterable format) and then send it out.

```
┌─────────────────────────────────────────────┐
│                  LETTERHEAD                   │
│             contact info and website          │
│                                               │
│  **Artist Name**                              │
│  Born Year, Location                          │
│  Lives and works in City, ST                  │
│                                               │
│  EDUCATION                                    │
│                                               │
│  Year      Degree, University, City, State    │
│  Year      Degree, University, City, State    │
│                                               │
│  SELECTED EXHIBITIONS                         │
│                                               │
│  Year      *Title*, Venue, City, ST (solo)    │
│            *Title*, curated by Important Curator, Venue, City, ST │
│            *Title*, Venue, City, ST           │
│                                               │
│  Year      *Title*, Venue, City, ST           │
│            *Title*, Venue, City, ST           │
│            *Title*, Venue, City, ST (catalog) │
│            *Title*, Venue, City, ST           │
│                                               │
│  Year      *Title*, Venue, City, ST (solo)    │
│            *Title*, Venue, City, ST           │
│                                               │
│  Year      *Title*, Venue, City, ST           │
└─────────────────────────────────────────────┘
```

```
┌─────────────────────────────────────────────┐
│  PUBLICATIONS                                 │
│                                               │
│  Year      Last Name, First Name, *Title*, Publication, Date, Page │
│            Last Name, First Name, *Title*, Publication, Date, Page │
│                                               │
│  Year      Catalog Title, Publisher          │
│                                               │
│  Year      Catalog Title, Self-published     │
│                                               │
│  AWARDS AND RESIDENCIES                       │
│                                               │
│  Year      Title or Description, City, ST     │
│  Year      Title or Description, City, ST     │
│                                               │
│                                               │
└─────────────────────────────────────────────┘
```

How creative should I get with my materials?

It all comes down to presenting a clear, clean, and honest submission. It must be complete, organized, and easy to read. And there's nothing wrong with making it beautiful. That doesn't mean you have to spend a lot of money on the packaging, design your own font, or spray everything with perfume. (In fact perfume is a particularly bad idea.) It just means making the viewing experience as pleasurable and interesting as possible without distracting gimmicks. If you try too hard, you will look like you are overcompensating for poor-quality work.

—————— *"I think it is good to have something professionally put together and subtle. If it gets too cheesy or aggressive, it feels like used-car sales. I think it can detract from the work."* **Kelly Klaasmeyer, artist, writer, critic, Houston Press; former editor of glasstire.com, Houston, TX**

—————— *"A crayoned note on lined paper does nothing for us. And we've gotten that! Do your homework and send a nice package."* **Sara Jo Romero, Schroeder Romero Editions, New York, NY**

LETTERHEAD
Name, Contact Information, and Website

Artist Name
Lives and works in City, ST

Selected Solo and Two-Person Exhibitions

Year *Title,* Venue, City, ST (solo)

Year *Title,* Venue, City, ST (solo) (catalog)
 Title, Venue, City, ST

Year *Title,* Venue, City, ST

Selected Group Exhibitions

Year *Title,* Venue, City, ST (upcoming)
 Title, Venue, City, ST, curated by Important Curator
 Title, Venue, City, ST

Year *Title,* Venue, City, ST (catalog)
 Title, Venue, City, ST
 Title, Venue, City, ST
 Title, Venue, City, ST

Year *Title,* Venue, City, ST
 Title, Venue, City, ST

Year *Title,* Venue, City, ST
 Title, Venue, City, ST

Bibliography

Year Last Name, First Name, *Title,* Publication, Date, Page
 Last Name, First Name, *Title,* Publication, Date, Page

Year Last Name, First Name, *Title,* Publication, Date, Page
 Last Name, First Name, *Title,* Website, Web Address/URL, Exact Date
 Last Name, First Name, *Title,* Publication, Date, Page

Awards and Residencies

Year Title or Description, City, ST
Year Title or Description, City, ST
Year Title or Description, City, ST

Catalogs

Year Title, Publisher
Year Title, Publisher

Education

Year Degree, University, City, State
Year Degree, University, City, State

Teaching

Year Position, Department, University, City, State
Year Position, Department, University, City, State

LETTERHEAD
Contact Information

ARTIST NAME
Born City, State

EDUCATION

Year
Degree, University, City, ST

SOLO EXHIBITIONS

Year
"Title," Venue, City, State

Year
"Title," Venue, City, State
"Title," Venue, City, State

Year
"Title," Venue, City, Country

Year
"Title," Venue, City, State

SELECTED GROUP EXHIBITIONS

Year
"Title," Venue, City, State
"Title," Venue, City, State
"Title," Venue, City, State

Year
"Title," Venue, City, State
"Title," Venue, City, State (curated by Curator Name)
"Title," Venue, City, State
"Title," Venue, City, State

PERFORMANCES

Year
"Title," Collaborator, Venue, City, State
"Title," Venue, City, State

Year
"Title," Venue, City, State (curated by Curator Name)
"Title," Venue, City, State
"Title," Venue, City, State

SELECTED BIBLIOGRAPHY

Year
Last Name, First Name. "Title," Publication, Exact Date, page
Last Name, First Name. "Title," Publication, Exact Date, page
Last Name, First Name. "Title," Publication, Exact Date, page

Year
"Catalog Title," Publisher.
Last Name, First Name. "Title," Publication, Exact Date, page

Year
Last Name, First Name. "Title," Publication, Exact Date, page
"Title," Website, Web Address/URL, Exact Date.
Last Name, First Name. "Title," Publication, Exact Date, page

AWARDS/GRANTS

Year
Award/Grant/Fellowship
Year
Residency, City, State
Year
Award/Grant/Fellowship

COLLECTIONS

Collection Name or Collector Name, Location
Collection Name or Collector Name, Location
Collection Name or Collector Name, Location
Collection Name or Collector Name, Location

CURATORIAL PROJECTS

Year
"Title," Venue, City, State
Year
"Title," co-curated with Curator Name, Venue, City, State
Year
"Title," Venue, City, State

Example Artist Biographies

New

(Artist Name) was born in (Year) in (Town, State, or Country). In (Year), she received her (degree) in (subject) at (University). (Last Name) has already been included in various important exhibitions including ("Title") at (Venue, City, State) and ("Title") at (Venue, City, State). This year, she will attend (Residency or Special Program). Upcoming shows include ("Title") at (Venue, City, State). (Last Name) currently lives and works in (City, State).

Emerging

(Artist Name) lives and works in (City, State) and was a (Year) recipient of a (Grant/Scholarship/Something Important). He has exhibited in solo exhibitions at (Venue, City, State) and (Venue, City, State). His numerous group exhibitions include ("Title") at (Venue, City, State) and ("Title") at (Venue, City, State). (Last name) was honored with the (Title of Grant/Award) in (Year). Public Collections include (Name) and (Name). He is currently working on (describe work in a few words) for ("Title") at (Venue, City, State) in (Year).

Midcareer

(Artist Name) received her BFA in (Year) from (University) and her MFA in (Year) from (University). She was a member of the (Art/Art History/other) faculty at (University) for the last (#) years. (Last Name)'s work has been written about in (Publication), (Publication), and (Publication). She has been actively involved in guest residencies and lectures (Nationally/Internationally). Her works are included in the public collections of (collection), (collection), and (collection). Solo exhibition venues include (Venue, City, State), (Venue, City, State), and (Venue, City, State). Group exhibition highlights include ("Title") at (Venue, City, State) and ("Title") at (Venue, City, State). Her work will be on view at (Venue, City, State) in (Month of Year).

Speaking of formatting, you will be much happier in the long run if you set up a table in Word, or use Excel, Illustrator, or a similar program that lets you set up a template. You don't want to be stuck readjusting spacing and formatting every time you update your résumé with new information.

BIOGRAPHY

A short narrative version of your CV (usually 100 to 250 words), where you summarize the important points. Include personal details, key periods in your training, and highlights of your career. If your bio is very short, feel free to include a few brief sentences describing your work.

It's common for biographies to be in the third person because they're used for press releases and other promotions.

PRESS CLIPS

Make a press clip for any article that mentions you—even if it's one sentence from a group show review. For printed articles, scan the title bar from the publication's first page, which has the publication's name and date of the article. Combine that with a scan of the article's full text, using Photoshop or similar software, and save as a new high-resolution PDF or image file.

The same idea applies to online articles: Whether you take a screenshot or print the entire browser page as a PDF, make sure you capture the publication title, publication date, author byline, and any other relevant information that would help someone look the article up if he or she wanted to. Clean up the image so it looks professional, by cropping out anything unrelated (ads, other articles, etc.) and lining everything up if you had to assemble multiple screenshots or pages.

Keep originals and copies of any catalogs and brochures that include your work. Be selective about whom you send originals to, since you'll have a limited number and it's not really necessary for every submission. High-quality digital versions should suffice in most situations.

——————— "The good news is all press is good press, whether it's a neighborhood newsletter, a friend's blog, or the local newspaper or hipster 'zine. For an artist building a career, press is important. It generates interest, exposes the work to a new audience, proves relevance, and serves as a historical record, so that your labors are remembered." **Cara Ober, artist, editor, bmoreart.com, Baltimore, MD**

——————— "An article in Artforum will always be an article in Artforum. But an Artforum critic's pick is pretty good. The hierarchy of print and online might not change, but I think it's going to become way more lopsided. There will be a hundred times more online content about art than there will be print content." **Benjamin Sutton, news editor, Hyperallergic**

——————— "Press is press. What a gallerist is looking for here is: One, are people writing about your work and Two, who is writing about your work. Just because a talented writer writes about you online rather than in print doesn't change either of those." **Edward Winkleman, cofounder, Moving Image Art Fair; author, former director, Winkleman Gallery, New York, NY**

——————— "I'd lie to you if I told you it wasn't upsetting to have someone say your work sucked. I try to be philosophical and say that good art has never been about being popular. You can rationalize why it's not such a bad thing, but it still stings. It's like when someone tells you your work is ugly, they're saying you are ugly. You're still like, 'Oh, gee, I'm sorry that I'm ugly.' You take it personally." **Fred Tomaselli, artist, Brooklyn, NY**

——————— "I think the lack of press is worse than bad press. If you are making work no one cares much about, that's a much bigger problem. For an artist's career to be very well respected and discussed, you need all the signifiers of quality to kick in: curators, critics, galleries, and collectors. That includes coverage in the art magazines." **Knight Landesman, publisher, Artforum**

——————— "There are many, many contexts where the first introduction people have to your work is the written word. What you write about your work ends up in press releases and reviews. If you can write, it gives you so much more control." **Edward Winkleman, cofounder, Moving Image Art Fair; author, former director, Winkleman Gallery, New York, NY**

——————— "Do I read artist statements? No! I don't know who came up with that idea, either. Why make the work if you're going to write the statement about it?

"Everyone wants things to be packaged and predigested so there is very little effort on the part of the viewer to come to terms with it. For me, much of the work remains ambiguous and I don't expect it to offer up answers immediately." **Shane Campbell, Shane Campbell Gallery, Chicago, IL**

Should you include bad press? People are divided on this one. We pretty much agree with the old adage that says there's no such thing as bad press. Our rule of thumb is to include all press—even negative press—unless the review is a total train wreck, either because it is extremely critical (as in, "that show was an unmitigated disaster" or "this artist has no talent whatsoever") or because it fundamentally misrepresents your work.

In assessing how negative a negative review is, try to be aware of how sensitive you are and be careful not to interpret a mixed review as an extremely negative one. The fact that a critic didn't like your favorite piece in a show, for example, is not a reason to exclude the review from your résumé, especially if the rest of the article was complimentary. Remember that it is very difficult to get any press in the first place, so it's a big deal if your work is commanding attention—regardless of the critic's conclusion.

ARTIST STATEMENT

When you apply for a residency, grant, or academic program, you will almost always need to submit some kind of statement. If there is one universal truth in the art world, it is that everyone dreads writing an artist statement. And plenty of gallerists will tell you they never read them. So why do you have to write one? Especially now, before anyone's asked for one?

Because a lot of people in the art world *do* read them, such as curators and selection committee jurors. And they take them seriously.

The reason to write one now is that it takes most people a long time to come up with something they like. The process is painful enough, frankly, without a deadline looming. If you start it now, you can put it down and take a break without feeling the pressure to finish; after a few days, you can pick it back up with a fresh start. Even after you've "finished," you may reread it a month later and decide to rewrite some parts. And the cold, hard truth is that you will, eventually, have to submit one. Better to have a solid, general statement that you can tailor to specific

opportunities as they arise than to scramble at the last minute to write one from scratch while putting everything else in your application together.

Keeping the function of an artist statement in mind will help you write one. Your eventual reader will look to your statement to get a better understanding of *what* you are trying to do in your work and *why*. That doesn't mean positing a comprehensive theory of your place in art history or psychoanalyzing your motivation—attempting either can be bad for your health (and worse for your statement). You just want to describe, as simply as possible, what it is that you do, or show, or say, with your art, and what it is that makes you interested in doing, showing, or saying that. If there is something unique or important to you about your process, talk about that, too.

Sometimes artists complain that it is impossible to convey the true nature of their work through images. Well, this is one of the only places where you get to explain, *first person*, what's missing. In that way, an effective artist statement is essentially a concise, written version of the conversation that might take place during a studio visit. Your statement is a chance to introduce that person to your art. Just remember that your reader is often going to be someone who didn't get a degree in studio art, who has never tried to do what you're doing, whose idea of what's "obvious" is very different from your own.

Also keep in mind the length: one hundred to three hundred words. That's less than one page of this book. Never go over a page.

There are many ways to tackle a writing project, so adjust our advice to your style. The best way, we think, to end up with a good artist statement is to follow these steps:

1. *Brainstorm.*
 Jot down all your ideas in whatever order you think of them. The point is to get all your ideas on paper until you've thought of every aspect that's important or related—you'll cut down later, so let the ideas flow at this stage. Be yourself and think hard about where the work is coming from. Use all the W's—who, what, when, where, why—and, especially for process-oriented work, the "how."

————— *"Eventually someone is going to request an artist statement, whether it is required for a grant application or someone is writing a press release for an upcoming exhibition. My suggestion is to start with something basic—a few sentences—and then tailor it as needed. It is important to give the party requesting a statement exactly what they are asking for. This most often involves simple and clean language. If the request is for something descriptive, writing something poetic is shooting yourself in the foot. Start with language that articulates the foundation of your beliefs and practice. Then elaborate; cut; redo. If it's unclear what someone is looking for in a statement, ask the person to clarify. And don't be afraid to ask for an example."* **Michelle Grabner, artist, educator, critic, curator, Milwaukee, WI**

————— *"I've told a few artist friends to get somebody else to write their artist statements. If they have a writer friend or somebody that they can trade a drawing for a press release or a statement, they should."* **Benjamin Sutton, news editor, Hyperallergic**

————— *"A poorly written artist statement is not a significant turnoff because visual artists are not always good writers. They should not be summarily dismissed because they can't write well about their work. I think that idea is absurd."* **Dexter Wimberly, executive director, Aljira, Newark, NJ**

————— *"You can work in drastically different mediums, but it needs to be clear that it's still from the same brain."* **Denise Markonish, curator, MASS MoCA, North Adams, MA**

———————— "You're good at what you are good at. Writers are not asked to be visual artists; no one is asking that visual artists become highfalutin writers for their artist statements. The goal of your artist statement is to clarify and state your intentions. Do not add florid language and overthink it. The jargon isn't necessary or desirable. Most of the time, especially for emerging artists, it can create a stumbling block between your reader and your work." **Sarah Lewis, author, curator, assistant professor at Harvard University; former member of President Obama's Arts Policy Committee**

———————— "No amount of poor padding with theory is going to make work look any more convincing or intriguing than it already is. I look at everybody's images first. Then I go to project statements. Then I read the artist statement. I am looking for plain language: 'I am doing this and I am going to do this thing with it.'" **Shannon Stratton, William and Mildred Lasdon chief curator, Museum of Arts and Design, New York, NY; founder, former director, Threewalls, Chicago, IL**

———————— "Last year, I applied for a grant and I didn't get it because my artist's statement was 'insufficiently earnest.' I resented having to write the statement at all, so I made it sarcastic and funny and I lost the grant because of that. So, if you want to succeed, don't do something stupid like that and piss people off." **Bill Davenport, artist, critic, Houston, TX**

———————— "If more artists wrote honest artist statements, they would be more meaningful. I often find that they write what they think the art world wants to hear. Which is never what I want to hear." **Denise Markonish, curator, MASS MoCA, North Adams, MA**

2. *Outline.*

Look at all the words and ideas you have on paper and put them into an order, a structure, that makes sense to you. Not everything from your brainstorm needs to end up in your outline. Only a small percentage of what you've jotted down will get to the heart of what you're doing.

3. *Draft.*

Take your outline of ideas and turn each line into a full sentence, tying them together into paragraphs. Don't worry about how things sound at this point; just bang out the sentences quickly and as naturally as you can.

4. *Edit.*

This is when you worry about how things sound. Get rid of jargon. Trust us here: even the most complicated and profound concepts can be explained clearly, without relying on jargon. And three syllables are not always better than two. You're not out to impress people with your vocabulary (or your thesaurus). If you want to impress them, come up with a direct, honest description that leaves your readers feeling

I CUT DOWN MY ARTIST STATEMENT TO JUST 175 PAGES.

like they understand more about your work than they did before reading your statement. One very effective way to start editing is to read your statement out loud to someone who knows you well enough to say whether it sounds like *you*.

5. If you're not happy, begin again!

6. *Proofread.*
 By the time you get to this step, you will have reread your statement so many times that you cannot possibly expect to hunt down every typo. Ask someone to do it for you. Put it down for a week, then proof it again yourself.

7. *Don't skip step 6.*

As your work evolves, you should update your artist statement so it's true to what you're doing now, not five years ago (or even six months ago).

We are not including sample artist statements because your statement needs to reflect what is unique about *your* work and be written in *your* voice. Reading other people's statements won't help you achieve either goal. Following the instructions above, however, will.

Or, you can get someone else to write your statement for you. A writer friend is the obvious choice, but an artist friend who understands your work may have an easier time writing your statement than his or her own.

Even when you are coming up empty, thinking about your statement makes you think about the work. It makes you think about your influences, your peers, your place in art history, your process, and your goals. These are all good things that will improve your practice.

Give Us a Break

We now present a short list of phrases that plague artist statements every year. Do yourself (and your reader) a favor and don't use them. It's not that these kinds of phrases aren't sincere. They just won't help anyone understand your work or your intentions.

"My work is intuitive."
"My work is about the macro and micro."
"My work is about the organic and synthetic."
"My work is a personal journey."
"My work is about my experiences."
"I pour my soul into each piece."
"I've been drawing since I was three years old."

If you find yourself identifying with these sentences, or you've written one (gasp!), think about the underlying reasons for the statements. Almost every artist could say that his or her work is "intuitive" or a "personal journey," so what makes your process or journey different? What inspires you? If you dig deeper, you might find a way to explain the overall sentiment in a more personal and original way.

That said, under no circumstances should you claim, as we have seen in some artist statements, that "My work is unlike anything that's been done before." All work is like *something* that's been done before. Know the history and context surrounding your work. People want to know how you're taking what's been done and making it your own.

COVER LETTER

You should always write a cover letter when you submit materials, whether they ask for it or not. (We'll explain how to write a cover letter when applying for a grant or residency in chapter 6.) This is your chance to demonstrate how much you know about the program and why you, in particular, belong in it. Go through a mini version of the same process you used for your artist statement—brainstorm, outline, draft, edit—to write your cover letter. Similar guidelines apply: be direct and simple and avoid metaphysical complexity and pseudointellectual jargon.

For email submissions, the body of your email acts as your cover letter so it should follow the basic format below (without the addresses). *Never* CC a bunch of people with the same submission. Send your submissions one at a time, using people's full names (never "Sir or Madam" or "To Whom It May Concern"). If you think emailing a form letter to a bunch of people at once will save you time, you might as well save even more time and not send anything at all.

Tips when writing a cover letter:

—Show passion for the space/opportunity.

—If it takes a tremendous effort to think of why you would be good for the venue or the opportunity, maybe it's not that great of a fit after all.

—Highlight the most important entries in your résumé.

—Never use "I hope to" when you can say "I will." Or "I try to" when you can demonstrate that you *do*. Be confident. Instead of "I hope to hear from you," say "I look forward to hearing from you." Etc.

—Use the active voice, not the passive. Bad: "The piece *was completed* in April." Good: "*I completed* the piece in April." Avoid "to be" whenever possible, and pull the action out of nouns and adjectives where it tends to hide in passive sentences.

—Address how you will add to what they're doing. What interesting dialogue will your work contribute to/inspire? Be specific! Name other artists they show and how your work relates.

```
                              LETTERHEAD

Date

Contact Name
Venue Name
50 Cranberry Street
Louisville, KY 12345

Dear Contact Name:

Start by saying who you are and what you want. If you share an acquaintance with the
person you're writing to, mention the name of the acquaintance.

Explain why you think you're a good fit for the venue. Show the venue that you under-
stand what it is and what it does. Say what makes you interesting and how you will
contribute. Say "Thank you for the opportunity" or something along those lines.

Sincerely,
Sign your name
Type your name

              Artist Name, 20 Pineapple Street, Los Angeles, CA 90001
                             www.artistname.net
```

———————— "I am looking for nouns. Nouns and verbs. Anything that starts off too flowery, I crumple up and throw away." **Leigh Conner, CONNERSMITH, Washington, D.C.**

———————— "I will read artist statements but artists don't have to be great writers. Actually, many of them are terrible writers, which is fine, since that's not the primary "language" of theirs that I'm listening to. If they have taken the time to write a text, I will read it and it can often be quite useful, though artists shouldn't be overly concerned with crafting a perfect, publishable piece.

"While it's great that art schools spend more time teaching practicalities, sometimes it can backfire and all the statements begin to sound the same. I prefer how different the conversations can be. Much like being friends with someone, they don't tell you how to be friends with them. They act a certain way and you know." **Shamim Momin, director/curator, LAND, Los Angeles, CA; former curator, Whitney Museum of American Art, New York, NY**

———————— "One of the nice things that we are sometimes fortunate to do is sit on panels for awards and residencies. Those are invaluable opportunities to see things we haven't seen before. I am always curious to see the way an artist articulates what they are doing in the studio visit or as an artist statement that gets briefly read in the half-light of a projected image." **Franklin Sirmans, director, Pérez Art Museum Miami; former curator of contemporary art, Los Angeles County Museum of Art; former curator of the Menil Collection, Houston, TX**

TIMING

Be smart about when you send in a submission. Most gallery folks have Sundays and Mondays off, so if you send something at 10 p.m. on a Saturday night, your email will be buried by Tuesday morning when they're back at work. Look at the venue's schedule so you don't email the staff the day of an opening (or the day after), when no one will look at your submission and your email will quickly fall to the bottom of everyone's inbox. The same principle applies to art fairs: find out which ones the venue participates in and hold off during the days just before and after. (Obviously, if someone asks you to send in your materials on or by a certain date, that trumps these general guidelines.)

Galleries tend to have more group shows in the summer and are therefore most open to considering new artists in late winter through early spring, when those shows are planned. If you hear through the grapevine about a particular theme for a show that a gallery or curator is working on and it relates to your work, go ahead and send them an email. But read chapter 7 first.

DO I HAVE TO LIVE IN A LARGE CITY TO BE SUCCESSFUL?

The short answer is *no.*

While those cities have obvious advantages and produce the most famous artists, they represent only one part of the contemporary art world. You can make your work just about anywhere. The key is to be aware of what is going on throughout the country, regardless of where you live, and to appreciate your local audience and early supporters no matter where you end up.

As one gallerist put it, "If you are making art and making a living, be happy about it for crying out loud!"

——————— "The most exciting things going on in this country for me are taking place in cities such as Raleigh, Louisville, Seattle, Milwaukee, Minneapolis, Houston. These are the places where I think most of the interesting art is happening. Without having crushing overhead and pressure, you find that more ambitious projects can actually see the light of day.

I think that it's very wise to just simply say, 'Maybe I could just make a scene.'" **Dexter Wimberly, executive director, Aljira, Newark, NJ**

——————— "One of the things that's key to remember is that you're not looking to attract only local people to your studio, no matter where you are. Even if you're based in an artistic center like New York, you still want curators from all over to visit you because your most significant shows might very well take place elsewhere. You have to think about it holistically." **Lauren Ross, curator, Richmond, VA**

——————— "Living outside an art center can be isolating. I work every day to maintain my contacts in various 'art centers' and to try to identify new audiences and venues for my work so that I am not so reliant on a specific locale or audience. One perk is that space is cheaper and more abundant. I get more work done living in central Pennsylvania than I ever did in New York, and my work is better. Now that I am also working on curatorial projects, I find that staying connected can take lots of different forms. Curating artists whose work I respect into shows requires me to keep in touch and, in turn, creates additional opportunities." **Ann Tarantino, artist, State College, PA**

——————— "Baltimore is an affordable place where space is copious and studios are decadently large. I know a number of great artists who are living the dream of part-time employment, which funds their home, a studio, and enough studio time to develop a practice." **Cara Ober, artist, editor, bmoreart.com, Baltimore, MD**

——————— "I think of local art scenes as living ecosystems that need many elements to thrive: a combination of schools with great art programs, galleries, alternative spaces, museums, and—let's face it, you need money because with money comes philanthropy and a collector base. If there's no collector base, there probably won't be galleries. If there are no art programs, there probably won't be teaching jobs. You also want a community of working artists who are going through the same thing that you're going through."

"When there's a good art scene, it ripples out through the rest of the city to the point where people who are not directly involved in the art world appreciate culture and it becomes part of the city's identity. Cities that have really good systems like that include Chicago, San Francisco, and Houston, but so few of them are affordable places to live. I'm happy to see less expensive cities like Kansas City, Baltimore, Richmond, and Buffalo rising in prominence." **Lauren Ross, curator, Richmond, VA**

——————— "Don't do something because you think it's what you should do. For example, if you don't have the urge to be in New York, don't go because you're not going make the most of it. The first year out of school is *$%^& hard. One minute everyone's giving you feedback and all of a sudden you're in a vacuum. As hokey as it sounds, you have to ask: What is the best way for you to nurture yourself as an artist? If that means going back to your hometown and making a ton of stuff, then do that." **Denise Markonish, curator, MASS MoCA, North Adams, MA**

——————— "I love that artists once pioneered neighborhoods in Manhattan and Brooklyn, living in big spaces at low cost. We all know this isn't possible anymore. More and more artists are faced with the impossibly high cost of living in New York. I bought property upstate, two hours from the city, because space at low cost is still available." **Joshua Abelow, artist, Harris, New York, NY**

CHECKLIST: SUBMISSION MATERIALS

—WORK SAMPLES
—RÉSUMÉ
—BIOGRAPHY
—PRESS CLIPS
—ARTIST STATEMENT
—COVER LETTER

CHAPTER 4

Promotion

———————— "The reality is, as an artist, you work to develop a vocabulary. You work to develop a touch, a look, an aesthetic. That's branding. If I say Sol LeWitt, David Hammons, Andy Warhol, you have a picture in your mind of what the work looks like and how it makes you feel. Viewers, curators, dealers, critics are looking for that brand, that fingerprint." **Larry Ossei-Mensah, independent curator; cofounder, ARTNOIR, New York, NY**

———————— "Talking about branding doesn't have to be gross. Your personal brand is really just what you want people to know you for. You want that to be consistent and you want people to trust you. And you want to think about how you display that brand in all the places you are. That's all that it is." **Eleanor Williams, art dealer, independent curator, Houston, TX**

———————— "When I say the word 'marketing,' it's a shortcut for clear communication. I like to think about it as if you're a small radio station putting out a crystal clear signal at a very specific frequency. And you're looking for people who will tune into that broadcast. The problem with most marketing is that it amounts to a whole lot of noise—you're just broadcasting without knowing what your goals are, who your audience is, who you're trying to reach, what you're trying to communicate about, and in general, what you're trying to accomplish. And when there's static on the radio, people turn it off." **Matthew Deleget, artist, curator, educator, founder, Minus Space, Brooklyn, NY**

In Chapter 2, we encouraged you to *organize* yourself as if you were running a business. In this chapter, we'll talk about promoting yourself as a business would. And yes, we know that sounds *gross* to a lot of you.

When we wrote the first edition of this book, we took great pains to avoid using words like "marketing" and "branding," because it can be disheartening—even offensive—to hear artwork talked about as if it were some random consumer product you need to advertise and promote. Art is *culture*, not a brand of toothpaste.

But here's the thing: If you want your work to be experienced by other people, then you need to understand how to reach those people. Promoting yourself, marketing your work, growing your audience—these are ultimately elements of the same endeavor.

So, over the years, we've come to realize that it's better to call this stuff what it is: When you put up a website, you're marketing your work; when you hand out business cards or post something about your studio, you're promoting yourself. And that's okay. There are many ways to get your work the attention it deserves while staying true to your core values.

As with everything else we've talked about, you can opt in or out entirely; you can (and should) approach these tactics your own way; and if something doesn't feel right, then, hey, no problem. Skip it.

WEBSITES

Most art world professionals consider it unacceptable not to have a website. Galleries, curators, collectors, the press, and the general public rely on artist websites to quickly find accurate, up-to-date information about the artists they're interested in. Unlike social media and other communication platforms, your website is a place where viewers can spend focused time, and find concrete information on your work, in your own words, in the style and format of your choice.

A basic artist website is easy to put together and cheap to maintain. It's the best way to make your work accessible to a wide audience. And it's the only place, aside from your studio, where you have total control over how people see your work. Take advantage of this opportunity to add context to your work and present it in the right way. If you have a gallery, don't just rely on its website, which likely uses the same style for every artist. Make your own.

If you don't know how to set up a website, take a class or get a friend to do it for you. Given the number of companies that provide free and inexpensive platforms to host simple sites, there's really no excuse not to have one.

Domain Names and Search Engine Optimization

The first step toward a professional online presence is registering a domain name. Today, the vast majority of artists choose .com or .net domains, although with the proliferation of top-level domain extensions (including .art) we expect artists to start branching out sooner than later.

In selecting a domain name, go with something easy to say, easy to spell, and easy to find. If possible, make it easy to *remember*. And think long term. It takes time to build awareness and community around a website. Generally speaking, you probably won't want to have to change the name of your site or start a new one, losing all that momentum, because you named your first site after a specific body of work and now you've moved on to a new body of work. In most cases, your actual name will be the best option.

By an "easy to find" domain name, we mean one that will show up in search results, which as you probably know is a very tall order. Some ways to improve search results: Choose a domain name that matches what you think people will put into the search bar ("key words") when looking for you or the categories of art your work falls into; use many key words in the text and metadata of your site; make your headings searchable; label all the images on your site with additional key words; link to

Website Terms for Beginners (No Judgments)
A *domain name* is what you would say out loud if you were telling someone the name of a website, e.g. "nytimes.com" or "artsy.net."

A *URL* is the long string of letters that only your grandparents would say out loud: "https://www. artsy.net."

————— "Having a website now is a must, not only for artists but really for any professional working independently in the field. Being social-media savvy is also mandatory. Instagram, in particular, can initiate sales and other projects. I keep hearing the same feedback from artists at any point in their careers. An artist cannot rely on anyone else to feature his or her work." **Micaela Giovannotti, curator, consultant, New York, NY**

————— "If I talk to five curators in Texas, for example, and they give me names of artists unfa-miliar to me, I need something to reference. Ideally I would get packages from everyone, but with the kind of severely limited time we are often subjected to, it's rarely possible. So websites can be—and are becoming ever more—useful." **Shamim Momin, director/curator, LAND, Los Angeles, CA; former curator, Whitney Museum of American Art, New York, NY**

————— "I will not entertain an actual portfolio from a walk-in. Leave your stuff in the car and let's go through your website. I keep it under ten minutes. If you don't have a website, build one and send it to me." **Eleanor Williams, art dealer, independent curator, Houston, TX**

————— "It's very helpful for me now, while I'm working independently, to go directly to an artist's website and review all of their material there, without having to search through various exhibi-tors sites (which are often older, clunky, and more corporate)." **Ben Heywood, independent consul-tant, Seattle, WA; former director, Soap Factory, Minneapolis, MN**

other sites that you can get to link back to you; and update your content regularly (even if it's just adding or editing text). Keep in mind that search engines cannot read text that is photographed, i.e., within an image file (at least not in mid 2017; that could change by the time you read this chapter).

What Goes on the Site

You don't know who's going to look at your website and therefore can't tailor it the way you would, say, a gallery submission. So choose content you would be comfortable showing anyone.

Think seriously about your artwork before you design your site. What colors and layouts are best suited to what you do as an artist? Minimal art, for example, lends itself to a minimal site. If your work is heavily informed by a theory or movement or era, maybe your site should be, too. Check out the sites of artists, galleries, and nonprofits you admire and see what works and what doesn't. Explore website builders on Squarespace, Weebly, Wix, WordPress, OtherPeoplesPixels, Indexhibit, and other sites that offer templates. See which ones offer a "mobile friendly" option, since a lot of people will end up looking at your site on their phones. Even if you plan to build your own site, check out what options already exist and think about what bells and whistles you want to add.

Many website-building platforms offer e-commerce options. So if you plan on selling your work directly (or selling anything else on your site), compare those features before deciding which platform works best for you.

Make your site easy to navigate. You want your visitors focusing on whatever it is they're looking for, not on the difficulty they're having finding it.

Keep your site up to date—not just your CV, but *everything*: images, press, shows, bio, contact. Listing an "upcoming show" that ended two years ago looks unprofessional. And it can give someone the impression you aren't working on anything now.

Keep unrelated commercial work off your artist website. Many artists—particularly illustrators and photographers—have "day jobs" making commercial artwork. If you fall in this cate-gory, keep that work on a separate website that isn't easily

mistaken for your artist website. We know a painter, for example, who does commercial portraits on the side; she uses her maiden name for her artist website and her married name for her commercial site. Using a company name for your commercial site also does the trick.

That said, plenty of artists purposefully blur the line between commercial and fine art (à la Murakami) or reject that distinction altogether (like Warhol). If you're one of them, there's no need to separate your commercial work from your fine art—and doing so could actually undermine your message.

Home Page

This is your first impression, so make it count—in whatever way you want it to. The home page should include your name, an image (of your work—not you!) (unless your work is self-portraiture!), and navigational buttons for the other pages.

It's also a good idea to use your home page to announce upcoming shows, post recent press, and link to any social-networking pages, blogs, or other online projects you want to highlight. Still, keep it clean. If you have a ton of news and upcoming events, either put that info in a dropdown menu or mouse-over, or just build a "news" page.

Images and Clips

Your artwork, of course, is the most important part of your website, so use your best images. And don't post everything you've ever done—curate your site the way you'd curate a studio visit. Put some thought into how you want people to experience your work for the first time. Do you want them to see one work at a time? Multiple works at once? Current work in one section and past work in another?

You *must* include your most recent work. Whether you include older work is a case-by-case question. Most artists present several bodies of work, clearly organized by medium, series, year, or some other heading specific to the work, but not *all* their work since forever. If you find yourself posting images from decades ago, or images you're not confident about, ask yourself why. How does that work inform what you're doing today? Is it truly necessary to include every piece you've ever made, or would

"Having a website is like breathing. I would always tell someone to privilege having a website over having an Instagram account, because a website is such a different experience that suggests a more serious take on one's career." **Jamillah James, curator, ICA LA, Los Angeles, CA**

"You still need a website. If I'm working on a project and I'm doing some quick research and I need a quote or information from the artist, social media's not going to give me that." **Larry Ossei-Mensah, independent curator; cofounder, ARTNOIR, New York, NY**

"The worst thing a gallery or an artist could do is not update their website. That's the worst. 'Oh Look! 2006!'" **Kelly Klaasmeyer, artist, writer, critic,** Houston Press; *former editor of glasstire.com, Houston, TX*

it be more appropriate to put older work in an "archive" section of your site, or leave them off altogether? Can you tell that that's a leading question by the way we're asking it?

Arts professionals appreciate the ability to edit, to cull, to curate. Show them you know how to edit your own work, that you understand when less is more.

We recommend allowing viewers to enlarge your images so they can see as much detail and texture as possible. Just use low-resolution JPEGs for the site (72 dpi) so the pages load quickly. Many galleries like to make high-resolution images available on their sites in addition to the low-res ones (as opposed to saying "high-resolution images available on request").

Include the same information for your images that you did for your submissions: title, year, medium, dimensions or duration, and edition (if applicable). This is also where you can add a brief description to any images you think need one.

A lot of artists post installation shots in a separate section, or disperse them appropriately, since they give visitors a sense of scale. It doesn't matter whether the photos are from your studio or an exhibition; use the ones that look the best.

For videos and performances, we recommend posting clips rather than complete works. Invite people to contact you for the full-length version; this gives you some control over where your videos go and how they're viewed. It also boosts your email list. If you have trouble posting video to your site, embed the video using a video-hosting website. Vimeo, for instance, has clear instructions on how to do this.

Contact

Make it easy for people to get in touch with you. List your gallery's contact information if you are represented and ask them to do the same. If you are not represented, provide the quickest way for visitors to contact you directly (email, mobile, whatever you're comfortable putting out there for the world to know). You should also link to your social media profiles and any other sites and apps within your professional capacity.

If you fear spamming bots, post a picture of your email address or spell it out. For example: artworkbook [at] gmail.com. Avoid contact forms, which can come across as impersonal and

off-putting. If you don't want to hand out your main email address to strangers, create a separate email account just for your website.

Set up a way for people to join your mailing list. This is where a form is fine (and standard practice).

The idea behind your contact page is to connect personally with your audience. Remember how we just told you not to put a picture of yourself on the homepage? You can put one here—of yourself, your studio, you *in* your studio, or maybe something more personal like a pet. Whatever works for you.

CV/Bio

Place your narrative biography at the top of the page, with your CV below. Everything we talked about in chapter 3 concerning your bio and résumé applies here, except that for your website you can post a CV—meaning it's fine to include more information

——————— *"I think the Web makes it easier for people to make their own choices and make their own judgments about somebody's work. Presenting something that is clean, a dot over the top, funny, interesting or quirky conveys a point-of-view. It conveys who you are as a person and an artist."* **Kelly Klaasmeyer, artist, writer, critic,** Houston Press; *former editor of glasstire.com, Houston, TX*

——————— *"No one's work is made for the general public. No artist I know reaches 100% of the people in the art world. Instead you want to try and seek out and find the tribe that you belong to as an artist."* **Matthew Deleget, artist, curator, educator, founder, Minus Space, Brooklyn, NY**

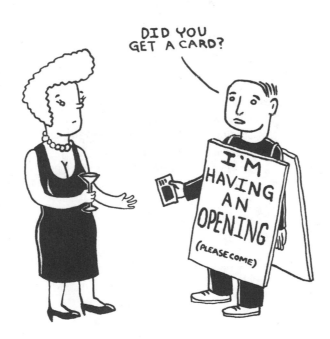

on this version than you might when sending a submission. But you still need to edit. And you still need to keep your nonart jobs outta there! The only exception is if you're applying to teach art, in which case you'll want to list past teaching positions under "Work Experience," toward the end of your CV.

Take advantage of the website format by creating links from the items in your CV to other pages with more information. For past group shows, for example, see if the gallery still has a live page with installation shots and link to it from that line in your CV. If you have press, link from the articles listed in your CV to the actual articles on your press page with the full text. Just remember to keep the links current, and make sure they open a new window. You never want to take people away from your site entirely.

Make sure your CV is visible on the screen. Also create a link so that someone can download the document and print it cleanly—a PDF is best.

Text Is the New Press
A lot of artists title their press-clips page "text" because it's a broader term than "press." Under "text," you can list excerpts from a catalog or press release, post your own writing about the work, and include any press or reviews you like.

Obviously you'll want to post any positive articles or reviews that focus on you. For pieces that only mention you briefly, such as group-show reviews, you can just post the excerpt that talks about you as long as you link to the full article. Remember to credit the article and the author the same way you do in your résumé and press clippings.

If you have a lot of press, there's no need to post all of it. List your most glowing reviews and most impressive publications. Keep it clean and easy to read.

Again, check that everything prints well.

Artist Statement (Optional)

While plenty of artists choose to post their artist statements, we only recommend doing so when it is integral to understanding your work (for example, conceptual work or a unique process may require explanation). That's because you will write your strongest artist statement when you have a goal in mind and you know whom you're writing to, such as when you apply for a grant. It is harder to come up with an effective statement when you're addressing the world at large. And most people go to your website to look at your work and CV, anyway. Those who want to read your artist statement are typically people who will ask for it as part of an application or submission.

That said, you can add plenty of background information about your work throughout your site, which, done well, can achieve the same goal as an artist statement. Think short, project-specific statements that clarify and inform your work. You don't need to tell people *what* they can already see for themselves; instead explain the "why" (or the "how," if that's relevant).

Links (Optional)

Another way to reveal yourself to your visitors and add context to your work is through a list of links, which creates an impression the same way a "favorite books" list does. Link to artists you love; galleries you admire; venues you've shown in; magazines and blogs you read. Get reciprocal links whenever you can.

Password-Protected Areas (Optional)

Galleries and art advisors usually set up password-protected areas on their sites where their clients can access confidential information, see works not available to the general public, or look up prices. This could make sense for you if you find yourself emailing the same thing again and again but wouldn't want to make it available on your site for just anyone to see (directions to your studio, say, or high-res images, or pricing information).

Sticky Marketing

Think about the apps you check *every* day. What about the ones you only look at once or twice a month. What's the difference?

An app or site or blog that people check all the time, or stay on for long periods, is "sticky."

Sticky marketing refers to the broad set of principles and tactics companies implement to turn a digital venue people don't visit often into their daily routine. How to do that is the subject of many books, and beyond the scope of ours. In the most general sense, it's about content that is *new* (i.e., continuously updating, refreshing your site); *unique* (otherwise why would someone need to come to *your* site); *compelling* (i.e., that resonates with visitors at a deep emotional level); *shareable* (let them spread the word for you). And a site that is *interactive* (find a way to engage with your visitors, or provide a forum for them to engage with each other) and *clear* (make it easy for visitors to understand what they're looking at, how to navigate, etc.).

The concept doesn't just apply to your website. Artists have given away artwork to the winners of digital scavenger hunts they created, or to their thousandth Instagram follower. One artist we know designed her business card as a punch card: after you see her ten times, she takes you out for coffee.

Additional Ideas

We highly encourage you to think about other information or context that a viewer may like. We've seen headings on websites such as "Mistakes," "Nostalgia," "Grandma," and "Theory." None of those referred to a specific body of work. Instead, they informed the reading of the site as a whole. Do what works for you.

The Price Isn't Right

Rather than list prices on your website, say something like "contact me (or my gallery) for price information." There are a couple reasons for this.

Galleries expect pricing to be collaborative and it's easier to raise (or lower) your prices if you haven't already announced to the world what you intend to charge for your work. And when you have a gallery, you do not want to create the impression that people can buy directly from you.

Equally important, the point of your website is to expose people to your work. You want visitors to understand your art, to learn more about you, to come to a show. Prices are distracting. They pull your visitors away from appreciating your art for its own sake and force them to think about whether they want to buy it.

That said, feel free to list prices if you're selling directly and not interested in gallery representation, or you're selling other related items such as T-shirts, cards, or totes.

BLOGS

Artist blogs are almost as popular as artist websites and often act as the perfect compliment to a site. They're easier to launch because there is no specific protocol or expectation of content and so many companies provide free (or inexpensive) templates.

Not all art "needs" a blog, obviously, so you shouldn't feel compelled to start one, especially if you work in a more traditional medium. They are particularly effective for process-oriented, time-based, and community-based art—or anything where images alone cannot convey the full scope of the concept.

Keep these points in mind if you decide to go blogging:

—People are going to look at this. (We know, who woulda thought?) Don't upload anything that could embarrass you later. And don't badmouth anyone. Gossip travels fast enough in the art world without you going on the record that so and-so is a sleaze. Vent to your friends in private, not to the world on your blog.

—Proofread before you post. Just because a blog is informal doesn't mean people stop caring whether you spell their names right. Some people even care whether you spell regular words right, too.

——————— "There's something to be said about having a website and a comprehensive presentation of your work. But social media has viable platforms where dealers, collectors, and curators are searching for artists because the reality is you can't be everywhere. You can't go to every art fair, every MFA open studio—it's just impossible. Social Media is also how I keep up with what's happening in the rest of the world. I'm lucky that I can travel sometimes, but most of the time these tools equip me with the necessary information to understand what's happening in those spaces and why artists are choosing to do certain projects.

"Social media should only be an introduction. It's what's going to entice people to want to learn more about what you're doing as an artist." **Larry Ossei-Mensah, independent curator; cofounder, ARTNOIR, New York, NY**

——————— "We're very, very active in social media, and indeed do find artists and what artists are interested in via social media almost as much as we do via offline conversations with artists, dealers, and collectors." **Edward Winkleman, cofounder, Moving Image Art Fair; author, former director, Winkleman Gallery, New York, NY**

——————— "Social media plays a big role in my work—from communicating about works-in-progress and events, to soliciting feedback or engaging people in a process. I also find it useful for research and connecting with influencers who can help affect and promote my work." **Eve Mosher, artist, Brooklyn, NY**

—You don't have to blog every day, though to keep visitors coming back there should probably be some method to the madness so they know when to expect more.

—You don't have to use words. Pictures are worth . . . well, you know.

SOCIAL MEDIA AND OTHER DIGITAL PLATFORMS

We have no idea which site or app will be *the* place to show your work by the time you read this book. As we finish the second edition in mid 2017, the most popular apps for artists to connect and promote their work are Instagram, Facebook, Twitter, and Tumblr. LinkedIn is effective for basic networking and landing important introductions to people you might otherwise never reach. And it feels like everyone under thirty uses Snapchat, although its ephemeral, video-centric model isn't ideal for presenting most types of artwork.

Whatever the trend, whatever the technological innovation, whatever the buzzy label, our advice is ultimately the same: build a presence wherever you think it makes sense to; engage with the community on those platforms; and nurture your network by reciprocating the support of your connections (followers, fans, friends, whatever).

And, you know, *common sense.* Take our suggestions in the "Blogs" section above: maybe proofreading isn't as critical for a platform like Snapchat, where your message disappears the next day anyway; maybe you *do* need to post more often on Twitter than you would for an old-fashioned blog. Understand the norms of each platform and the expectations of its users, so you can most effectively show your work and connect with others. (No matter what the platform, you should only post high-quality images that best represent your work or the story you're telling.)

Some things to think about when you're deciding where you want to be active on social media, and in what way:

Advantages

—Free marketing!

—You control the message, the timing, how you and your work appear.

—Easier to reach a wider audience, more quickly, than anything you could do in person.

—Lots of opportunities to support friends and grow a community.

—Designed to announce, activate, show, and sell.

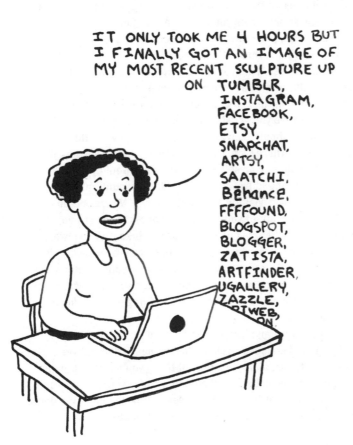

IT ONLY TOOK ME 4 HOURS BUT I FINALLY GOT AN IMAGE OF MY MOST RECENT SCULPTURE UP ON TUMBLR, INSTAGRAM, FACEBOOK, ETSY, SNAPCHAT, ARTSY, SAATCHI, Béhance, FFFFOUND, BLOGSPOT, BLOGGER, ZATISTA, ARTFINDER, UGALLERY, ZAZZLE, ...

—————— *"I posted a Photoshopped mock-up image on social media about a 'dream project' I would love to make. Shortly after, a curator I had met contacted me, asking about the possibility of making a similar piece in a space she was curating in Texas. The project took shape and I designed, created, and installed what I now see as my first step at making work at human scale and in the public realm."* **Ann Tarantino, artist, State College, PA**

—————— *"Instagram, more so than Facebook and Twitter, can be a really good tool for artists and a really, really good way to get their work out. I know artist friends who post work-in-progress photos of their studio and what they're doing and that can be really fun. 'This piece is going to be in the show in two months.' Stuff like that can be really successful."* **Benjamin Sutton, news editor, Hyperallergic**

—————— *"I don't see anything productive coming from generic 'bulk' relationships. It's great to have those huge numbers of followers on social media, but if you're not communicating with them in a ongoing, meaningful, and personalized way, I don't think it's going to matter if you have ten or ten thousand followers. If you have ten or fifteen or twenty-five meaningful and committed relationships, you're going to get a lot farther with your work."* **Matthew Deleget, artist, curator, educator, founder, Minus Space, Brooklyn, NY**

—————— *"With art, it's not really about the number of followers, but the quality of followers. So it's about how connected those people are, how much they come back, how much they think about it, and if they are in a position to make projects happen. So, I think the art world is very different from popular culture because you can be very obscure and still be successful."* **Rafaël Rozendaal, artist, New York, NY**

"LinkedIn has become an essential part of the career strategies we provide to artists and designers. Many fine artists don't realize the depth of contacts that exist in this resource from gallery owners and curators to directors of arts organizations and even MacArthur Fellows from the fine arts." **Kevin Jankowski, director, Career Center, Rhode Island School of Design, Providence, RI**

"So much of the art world and the market is geared toward a cycle where every year and a half/two years you have a solo show. Social media really disrupts that. Now you see one work at a time, or a couple of works at a time. Whatever the artist's pace." **Benjamin Sutton, news editor, Hyperallergic**

Challenges

—"Easy for you" means easy for everyone else; there's a lot of noise and clutter to break through; and everyone will be competing with you for attention.

—Informal, casual environment can lull you into doing and saying unprofessional things, which are then out there for all to see.

—Massive time suck, if you're not careful about managing your schedule.

—Takes a good deal of strategy and upkeep to be effective.

Ideal frequency and volume—how much to post, how often—depends as much on your personality and the type of art you make as it does on the platform you're using. Rough guidelines for the biggest platforms you might be using in 2017: Instagram—one pic a day; Twitter—several tweets a day; Facebook—at least three or four posts per week; Snapchat and Instagram stories—really varies based on what you're sharing about your day and what type of audience you're trying to build. *When* you post matters, too. Is your audience in London and you're in LA? Save your posts for when they're awake.

Your posts should convey a distinct point of view. Not sure what to put out there? Start with what you know: What would you tell someone about yourself at a party? What would you show a curator who dropped by your studio? Where would you take friends or relatives visiting from out of town? Maybe you post a step-by-step account of your creative process in the studio; or a catalog of all the art in your region; or you take your followers with you on a gallery crawl (or just a pub crawl). Interview all your artist friends, or your old professors, or your mentors, and post a new Q&A each week. If all those ideas sound cheesy to you, *great*! Do something else entirely. (Or nothing at all, which is always an option.)

Finally, "share and share alike." Social media is not a one-directional endeavor. Friend, follow, heart, like, retweet, repost, react, etc., all the people out there you respect. Support the organizations, artists, and administrators you admire. You get a front-row seat to everything *they're* talking about and doing, and, you never know, they might just reciprocate.

PAID ADVERTISING (ALSO CALLED "PAID MEDIA")

Promote your post! Get more followers! All it takes is a small fee!

This is #NotWorthIt for individual artists, most of the time. Like 95% of the time. You're better off spending your money on materials, travel to art fairs, web hosting, business and show cards, etc.

Venues, on the other hand, buy print and online ads; paying to boost social media posts is just another part of a multiplatform advertising plan. If you're working with a venue on a show or project, ask what their "paid media" budget is and whether it includes anything on social media. See where your own social media presence might plug into it and how you can coordinate messaging across your various accounts.

MAILING LISTS

For now, email is the most appropriate and professional way to communicate with your audience. Social media invites and announcements are equally important, and often more effective for reaching friends and colleagues, but the fact remains that email is the cornerstone of business communication, and you're running a business.

Use email to personally thank visitors for coming to your studio, to respond promptly when a curator or collector asks you for something, to reach out to someone if you have a question, etc. For larger-scale outreach, show announcements, and other genuinely big news, consider using a bulk email marketing service. While the original setup can be time-consuming, it's a huge time saver overall. Many services offer a free version of their software that is probably robust enough for your needs: designing a template with text and images or video, scheduling future emails, tracking "open rates" and "click-through rates," and making it simple for people to unsubscribe. (You *know* how annoying it is when a company spams you and won't let you unsubscribe easily—so don't do that unto others.) One way to avoid being spammy and triggering a lot of "unsubscribes" is to limit your blasts to four to six times a year.

There are dozens of companies providing these services. A few we happen to like are Emma, TinyLetter, MailChimp, iContact,

—————— "The squeaky wheel gets the most attention. Whether they are annoying you or not, they get the most attention. I am not telling artists to bother me because I do shut down at a certain point (there is a balance to it), but what I really like are artists who have control of their careers and send out a quarterly update. I love it. I love hearing what they are doing—for example, 'I did this residency last month and here are a few images.' I don't want a novel, just something I can read in a few minutes."
Eleanor Williams, art dealer, independent curator, Houston, TX

—————— "There are certain artists who may not fit or artists who I like and think—God, if there's ever a chance. I enjoy it when those artists put together really nice, thoughtful, newslettery-type emails. Those are great.

"You never know. You don't want to lose track of certain people. You really like their work, but there's just not a good spot in the rotation. But if they're in a local show, you'll be thrilled for the gallery and you'll want to go to keep track of their career."
Steve Zavattero, cofounder/director, stARTup Art Fair; former gallery owner, San Francisco, CA

—————— "Say 'thank you' often and to many. It reveals your worth and how you value others."
Bonnie Collura, artist, Bellefonte, PA

Mad Mimi, Cakemail, Sailthru; even Google has its own app that integrates with your Gmail contacts. Each has its own pros and cons, so take the time to read up on the different features and decide what you need; read reviews of them; practice using them before you go all-in. Once you load all your contacts and set up your templates and invest all the time in learning a service's interface, you will *really* not want to start all over if you end up disliking a feature or wishing it could do something it can't.

All that said, don't underestimate the power of snail mail. Sending a hand-written thank-you note or a lovingly crafted card will surely get attention and often gratitude. It's more personal, and the effort it takes makes a real impression. Some galleries talk about "going retro" and sending paper packages and invites to important curators or press, to stand out from all the digital noise.

A lot of artists think tiny cards are cute. They're not. They're annoying, because they're easy to lose, because they're tiny.

BUSINESS CARDS

Gallerists and curators agree that business cards are a necessity. This makes sense: They help people remember your name, your next show, and where to find your work online without having to memorize anything. And you look more professional when you hand out a card than if you have to enter your info on their phone. Your card should be the size of a traditional business card, with your name and website on it. If you are active and professional on social media, you should also include those handles. And if you really want to make an impression, use a detail from one of your works on the back of the card. Some companies will let you run a variety of images in a "deck" of business cards.

If you don't have a business card, use a show announcement. Or, what the hell, use a napkin—just have your info printed on it ahead of time.

APPROACHING PRESS

Media attention can have a major impact on your career. A thoughtful review, or even a short mention in a magazine, can push traffic to your shows, your website, your social media accounts, your studio. Getting critics and art bloggers to notice

———————"I'm a big fan of business cards. If I go to an artist's studio and they have a business card or post-card with their name, representative image, and contact info, it's so much easier to remember the person and the work, and to stay in touch."

Melissa Levin, vice president, Artists Estates and Foundations, Art Agency, Partners, New York, NY; former vice president, cultural programs, LMCC

you is tough, and whether they choose to write about you is out of your hands. There are a few things you can do to increase your chances of someone actually reading your press release.

1. Gather email addresses and social media handles of every writer you *think* would like your work (digital, print, freelance, all of 'em). Not editors in chief, unless you know them personally, but managing editors, content editors, and writers are all fair game.

2. Get to know them (from afar). Follow all of their social media accounts. Read everything they've written about other artists, the art world, and whatever topics are relevant to your practice. Yeah, we know, that's a lot! The more familiar you are with a writer's style and taste, the better you will be at tailoring your message to him or her. Doesn't hurt to share their articles with your followers, either.

3. When you have something to announce, such as an exhibition or event, write a press release. See the box in the margin for tips on how to do that. If the venue will write its own press release, use that; don't write another one for the same show.

4. Email the press release to your press list. Include a personal note when you email any press person you've met, or who has written about you before, or who you *really* hope attends the show. You can use your email marketing service to send out one blast to the rest of your list. "Long lead" press, such as glossy magazines, need at least three months heads-up; print publications, newspapers, and blogs should get about six weeks; and you'll want to send out reminders to blogs and other digital platforms about two weeks before the event.

5. Post your press release on your website, your social media accounts, and anywhere you have a digital presence. Ask your friends, especially your art world colleagues, to post it as well.

There is a fine line between persistent and pushy. Stay on the persistent side. And always write a thank-you note when someone mentions you.

Writing a press release

This shouldn't be daunting. Pretend you run into some old friend and want to invite them to your show. What do they *need* to know? Anything else you *want* them to know?

—Name of the show, location, dates, specific time of opening party, if there is one.

—A little more detail about the theme of the show, how much work of yours is in it, what your work is about. Be clear and concise and don't use jargon. Assume your friend did not go to art school.

—A little background on you and your work over the last few years. Most releases end with a narrative bio (discussed in chapter 3).

—Your contact info, which can be at the top or the bottom, as long as it's in bold and easy to find at a glance.

The text should be half a page max. Make it easy to read on a mobile device. Don't worry about making it "look" like a press release, because that *look* is from before the Internet existed. Add a compelling image at the top, and feel free to add more images after the text.

——————— *"If it's somebody that I've never heard of, showing in a gallery I've never heard of, often it's the image that hooks me in and gets me reading the press release. I like a header image and then more images just below the text, in a press-release format." Benjamin Sutton, news editor, Hyperallergic*

CHECKLIST: PROMOTION

—WEBSITE
—Social media PROFILE
—MAILING LIST MANAGEMENT SYSTEM
—BUSINESS CARD
—PRESS LIST

——————— "Hyperallergic, in general, and I, specifi-cally, are aware of the outsized noise that certain sectors of the art community make, so we're gener-ally trying to look beyond the big galleries and cover artist-run spaces and places outside of Chelsea or outside of New York." **Benjamin Sutton, news editor, Hyperallergic**

——————— "The one thing that always gets me is when an artist proves they read my publication and values what I do. If they mention a specific article, what it means to them, and it doesn't come off as total bullshit, I am much more likely to make an attempt to cover their project, even if I don't love the work." **Cara Ober, artist, editor, bmoreart.com, Baltimore, MD**

——————— "If I don't get a press release, there is no way for me to know about whatever it is. Somebody has to tell me about it." **Paddy Johnson, founder, Artfcity.com**

——————— "There's definitely still something to be said for mailing a postcard or a press release, now that so few galleries do that. I think that we've reached that point where email has so surpassed physical mail that physical mail is kind of exciting." **Benjamin Sutton, news editor, Hyperallergic**

CHAPTER 5
Opening Your Studio

—————— "You can't just close yourself off in your studio and never talk to other people because, a) your work won't mature in any way if you're working in a vacuum, and b) the art world is a social space." **Jamillah James, curator, ICA LA, Los Angeles, CA**

—————— "There are two important aspects to sustaining your arts career over a long period: 1) Never stop making—even if it is just keeping a sketchbook, always make work and 2) Build a community of support, if you have a strong network you will grow and thrive, host dinners and crits, go out to see work together, keep dialogue happening." **Eve Mosher, artist, Brooklyn, NY**

—————— "When you reach a point where you have something that is reasonably resolved, that you feel good about, you should invite your friends into your studio. Start trying to articulate what the work is about and see how other people react to it. Then, I think it's helpful to invite other people you know casually, or less well, but whom you also trust; who maybe have shown interest in the work before. The value of structuring it that way is that you get more and more comfortable with how to present the work and your relationship to it.

"Those people will tell their friends. When someone you don't know hears about it, follows up on it, gives you a ring and comes by, you've already settled into the nature of that encounter and that interaction. By then, hopefully, you've become more comfortable with it and you understand more of how you operate in that situation." **Peter Eleey, curator, PS1 Contemporary Art Center, Queens, NY; former curator, Walker Art Center, Minneapolis, MN**

Almost every important step in your career will trace back to some kind of studio visit, even if you don't have a traditional studio. It could be a curator considering your work for a show; a collector looking to buy your work; a gallerist interested in taking you on; an artist giving you feedback. Even residency and grant jurors have the capability to sway a vote if they've done a studio visit with you in the past.

These people want to see your work in person and they expect you to explain what you're doing. They want to learn about your process, to understand your inspirations and intentions. Curators want to know the background behind your work and whether their interpretation of it aligns with yours. Collectors need context. Gallerists will want to see whether they can put you in front of their collectors and, even more important, whether they will be able to explain your work to their collectors themselves.

All of which is to say that the sooner you get comfortable hosting people in your studio, the better. It's nerve-racking to present your work to a stranger when the stakes are high, so start practicing now. Talk about your work with your peers. Bring your non-art friends to your studio and show them around. The more you do it, the more natural it will feel and the less daunting it will become.

STUDIO GROUPS

Honest feedback is hard to find if you're not in school. You don't have regular crits; you don't have professors with office hours; the gallerists and curators visiting your studio want to learn about what you're doing, not critique it. So you have to seek out feedback from your peers.

One of the best ways to cultivate regular feedback is to start a studio group: get a bunch of your artist friends together and take turns visiting each other's studios (you can include other arts professionals, of course, for different perspectives). A studio group can be a real source of inspiration and guidance. And, through your friends in the group, you're likely to meet other

artists and curators who understand you and want to work with you in the future. One studio group in Brooklyn makes everyone bring a guest to each meeting, ensuring diverse feedback and an ever-expanding network.

GROUP VISITS

A wide range of companies and organizations like to offer studio visits as "special access" perks for donors or clients, or just fun events for employees. There are many ways that agreeing to a group visit can be worthwhile. It's good practice for hosting in your studio, speaking publicly about your work, answering questions from strangers, etc. If a museum is bringing by a group of active members, you may end up meeting a future collector, or even getting a show out of the visit. But be savvy about what you're signing up for: How much time and effort will you need to put into a group visit, and what are you realistically getting out of it?

If the leader of the group is charging participants a fee to attend, or if some random company is organizing the visit as an employee bonus, don't be shy about asking to be paid for your time. Some groups will pay up front and others will offer you "exposure." Exposure to arts professionals and patrons is one thing, but if a bank, for instance, is organizing the visit as a networking opportunity with no guarantee that its attendees are interested in art, you should be compensated for your efforts.

Before the group arrives, ask the organizer for the list of attendees and talk about what happens if someone wants to buy a work, either that day or in the future. Does the leader want to be paid a percentage for making the connection? (Art consultants will.) Is the sale entirely yours, as would be appropriate in the bank-networking scenario? Maybe a nonprofit expects a percentage of the sale to go toward its fund-raising effort?

In the cases when the organizer/organization expects a percentage, write out the specifics in advance, including exact numbers, who will pay tax, who is in charge of shipping, and how long the agreement is in effect. We would expect art consultants

———— "My first studio visits in New York were with artists I was meeting in the bar, shooting pool with. Same thing happens now and I don't think it's ever been different, since the beginning of any kind of visual arts community, really. Invite someone to your cave to come check out your cave paintings!

"So it's your peers first and anyone who's interested who displays enthusiasm at all. In the end, they may not go into the arts or have the tools to discuss it, but that is always the beginning. You are creating a network that will become the next generation." **Michael Joo, artist, Brooklyn, NY**

———— "The Crit Group (a communal organization of which I have been a member) is a great way to guarantee intellectual engagement beyond the idiosyncrasies of the art world. Everyone gets to know each other." **David Gibson, writer, curator, advisor, publisher, The Gibson Report, New York, NY**

———— "Several years ago, I was part of a group of nine or ten people who would go to a studio every Wednesday. I saw work I had never seen before. One visit was at a point when I was not psyched about my work. A body of work came from that visit—a product of a conversation that night." **Michael Yoder, artist, Philadelphia, PA**

———— "I don't believe the word 'networking' existed. I was single for all those years and it's lonely to be alone all day and all night, painting. Having people over to see and talk about my work and going to their studios once a week wasn't a job. It was a pleasure." **Jane Hammond, artist, New York, NY**

to take between 20 and 50% of the sale, based on their level of involvement in your career. A nonprofit donation should depend on how close you are to the cause and could range from 10% all the way up to 50%. Whatever the arrangement, prominently display your business cards and mailing list during the visit, and make sure you get the contact info of anyone who shows interest in your work.

OPEN STUDIOS

Every year, cities and towns across the country host "open studios" programs. San Francisco's Open Studios, organized by a local nonprofit called ArtSpan, was the first of its kind when it began over forty years ago. Another nonprofit, Artspace, organizes a similar program in New Haven. There's Art-a-Whirl in Minneapolis; Bushwick Open Studios in Brooklyn, New York; HopArts for artists living in southern Rhode Island; and, chances are, some kind of open studios where you live, too.

Participating in open studios lets you practice your studio-visit skills and build an audience while you're at it. Since anyone can walk through the door, you'll learn how to field unexpected questions and get used to seeing a wider range of reactions to your work than you've probably been getting.

Ask your friends or search online to find out which organizations host open studios near you. Make sure you register ahead of time and get on the map if there's an official one.

And you can always create your own open studios. Some of the most popular open studios were founded by artists who all lived in the same building, and artists who felt isolated. Start small with a cocktail party for your friends, or rope in a few neighbors and invite the public into your studios. Or start huge and organize a weekend-long open studios for your whole town. You'll expand your community, meet other artists and arts professionals, and get your work out there.

Setting Up

Getting ready for group visits and open studios is straightforward. You're basically turning your studio into a mini gallery space that should entice people to step inside and linger over your work. Push all your supplies and everyday clutter into a closet or a corner, clean the walls, and curate your space.

Curating Your Work

Since you don't know exactly who will come to open studios, it's smart to hang pieces from a few different bodies of work. We don't recommend showing more than three bodies of work because you'll have a harder time conveying the depth of your practice. Hide the rest of your work in an easily accessible spot so you can show anyone who wants to see more.

Make it easy and enjoyable for people to see the work and the coherence among the different pieces. Put pieces from the same body of work together. Separate different bodies of work. And don't overhang. Unless your work is about complete saturation of the senses, it will need room to breathe to be appreciated. Overhanging can overwhelm, confuse, and ultimately turn off your audience.

Hide your unfinished work—unless you have a very good reason to show people a work in progress. Your visitors are likely to walk out with the wrong idea if you're too busy to explain an unfinished piece and what direction it's taking.

Once you've selected the pieces you want to show, arrange them on the floor around the room before you actually install or hang anything. Put cardboard or foam under each piece so the bottom edge does not get damaged. Then rearrange, and rearrange again, until you find the configuration you like best. Now you're ready to install.

Remember that the way you light your work can radically alter how your visitors read it. So light it the way you want it seen—even if that means you have to borrow or buy clamp lights to do it.

After installing, have a friend walk through and give you a second opinion. Other people—particularly artists—notice things you don't because you're so close to the work.

—————— "I like when an artist has a body of work that seems cohesive. I get thrown off with lots of bodies of work on one visit. Don't show me everything you've ever done. You need to be in the moment. Not the future or the past." **Steven Sergiovanni, art advisor, curator, New York, NY**

Consider placing labels on the walls and putting out check-lists (the way galleries do), with or without prices. Those are easy ways to convey basic title information and other background you want people to know about each piece. They give your visitors something to refer to as they walk around the room and will tend to slow them down and focus their attention on your work, as long as you make them in a clean and professional format, so as not to compete with the work itself.

Finally, have your website up and running in your studio for visitors who want to see more of your work. If they're really interested in something they see, by all means pull the actual pieces out from storage.

Hanging Flat Work

The standard height for hanging flat work is 57 inches from the ground to the center of the work. Some curators prefer slightly higher or lower—the range is from 55 to 62 inches—but more than an inch in either direction makes a pretty dramatic differ-ence. Of course, the point of your work may dictate a radically different height.

Once you pick a height, stick with it. Consistency in hanging height unifies a room.

Be careful how closely you hang your pieces. People will assume that two pieces hung right next to each "go together" as parts of a single piece.

Hang paintings from the stretcher bars. Hang framed work from a wire attached to the frame. (When you hang it from the top edge of the frame, the weight of the work may pull the sides down and away from the top edge, damaging the frame.)

You can use a cleat system or D-rings to hang heavy, mounted, or framed pieces. A cleat system is a combination of low-profile, interlocking wood or aluminum wedges that hold an object in place:

CLEAT SYSTEM:

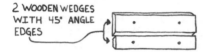

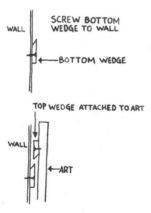

Cut two wedges at 45-degree angles. Screw one wedge into the wall and attach the other to the back of the piece. Slide the work onto the wedge in the wall.

Can't decide what to display? These questions might help.

—Which pieces are your favorites?

—Which pieces can you talk about best?

—Which pieces show a real breakthrough?

—Which pieces make sense together and tell a coherent story?

—Which pieces have you gotten the best response to? Why?

—Can you show a range of sizes and materials and still look organized?

—Can you simply show your current body of work (and have older pieces handy)?

—Can you explain why you've chosen the pieces you have?

Most Common Questions During Studio Visits

—Where are you from? How long have you been making art?

—Where did you go to school? (This tells them who you've studied with and hints at other interests.)

—How did you make this?

—Why did you choose those materials? That size?

—Why are you making it? Is it an ongoing project?

—What artists are you looking at?

—What/Who are your influences? (Not everyone is expecting you to name other artists. They know any subject could play a role.)

—Ideally, how would it be shown?

—What came right before?

—What's next?

Some artists hang simple, unassuming shelves where framed works can sit, which makes it easy to rotate if something sells or they want to refresh an installation.

If you're not allowed to make holes in the wall, get some reusable sticky hooks. (3M makes a variety of sizes that hold quite a bit of weight.) Just follow the instructions carefully so the paintings don't drop to the floor one hour later.

Always level the work with a proper level; don't rely on your eye alone. One crooked piece will distract from the entire presentation.

When hanging work by screws or nails, you can make minor adjustments to level a piece by banging the hardware up or down. If that doesn't work, try sticking Fun-Tak or a wad of paper on top of the screw that is too low. This way you don't have to make new holes.

Sculptures and Installations

Think about how people will walk through the space. Make it easy to navigate. Placing a sculpture or installation too close to the door can end up blocking the entrance and discouraging people from coming in.

If your sculpture is supposed to be viewed on a pedestal or plinth, take the time to build one. Putting a sculpture on a dirty table next to your tools looks unprofessional and can create the impression that you don't care about your work. A proper pedestal, on the other hand, presents the sculpture in the best light.

Don't be afraid to post a sign politely asking visitors to leave backpacks and large bags by the door.

Sound and Video

If you have more than one piece with sound, hook them up to headphones so people can concentrate on each one. Playing multiple pieces over speakers can cancel out their impact. And it will drive some of your visitors crazy.

If a piece requires darkness, stand outside the door with your takeaways and info sheets. This is more conducive to conversation with you, and keeps your visitors from rummaging around in the dark, interrupting the viewing experience.

Studios Devoid of Objects

You can still participate in open studios even if you have nothing to hang, screen, or place on a pedestal. Performances are common. Many artists find ways to document and present their work with preparatory sketches, digital renderings, photographs, time-lapse videos, audio, detritus, and even text. The important thing is to be clear with your visitors about which materials comprise the "art" versus the materials comprising the *documentation* of the art. If you're honestly not sure where to draw that line, see how people respond to what's on display—and don't be afraid to ask them what they think. Curators and gallerists, in particular, may have good suggestions, having worked with similar types of art in the past.

Keep in mind that for these kinds of studio visits, you'll most likely end up doing a lot more talking and explaining than your painter counterparts, so be prepared for that.

——————— *"It's a brave thing to allow someone into your studio. But if you're going to allow them in, you must be prepared to give a little bit. You can't think that you've allowed them in and that's the extent of it."* **Jasper Sharp, curator, Kunsthistorisches Museum, Vienna, Austria**

——————— *"A bad studio visit is when the person is thinking about something other than the art. Either the conditions are not comfortable or something else is going on. Everything should be focusing their attention on the work."* **Edward Winkleman, cofounder, Moving Image Art Fair; author, former director, Winkleman Gallery, New York, NY**

Hosting

Your goal during open studios is to get as many people to come inside your studio as you can. Engage people as they come in. Make the space welcoming and comfortable. Above all, make sure *you* are comfortable. Keep a chair nearby so you're not standing the whole time.

Some artists like to put out drinks, snacks, and chairs, a fail-proof way to get people to stay a while. Others don't (for that very reason). Either way, it's nice to at least have water available.

Contact List

Put out a sign-in book (or better yet, a laptop or tablet) that asks for names, email addresses, phone numbers, and contact information for whatever social media platforms you use. This is a fantastic way to kick-start your contact list with people who have seen your work. And it makes it easier to follow up with anyone who inquires about a specific piece.

One gallery trick you should borrow is to jot down a few

—————— "It's hard to get people to your studio, but it's way harder to get them back a second time if you don't wow them the first time. You should wait until you feel you're ready and you have a really impressive group of pieces."

Jane Hammond, artist, New York, NY

words in the sign-in book after people leave (or to write a few notes on the back of their business cards and staple them into the book). Just something to help you remember your visitors—which pieces they liked, what you talked about, what they're interested in.

A day or two after the open studio ends, write a brief "thank you for coming" to everyone who signed your contact list (individualized notes or bcc only). This ensures they have your email address and a link to your website. If they asked for anything during their visit, this is the time to send it if you haven't already.

Talking About Your Work

Try to explain what you're doing in less than two minutes. That doesn't seem like much time, but in a crowded studio it may be all the time you have. (Later in this chapter we'll go over talking about your work during a curator's or gallerist's studio visit.) The challenge is to find ways to discuss your work with people of significantly different levels of art appreciation. Remember that people are always interested in uncommon materials, processes, and background information they can only learn from you. Ask if people have questions and try to get a conversation going, as that will be more interesting and enjoyable for everyone. Ultimately, there's no magic guideline, other than keeping your audience in mind as you talk. Over time you'll naturally develop a feel for what works with different people.

Takeaways

Now that you have people coming in, you want them to stay interested long after they're gone. Have something for them to take when they leave, such as a business card or show card—anything that has your website, contact info, social-media handles, and an image or two. Make it obvious that they're there for the taking so that your visitors can find them without asking.

You might even leave out press releases to future shows or have catalogs for sale in case someone is really interested in your work.

Playing the Dealer

A few tips for talking with a collector when you don't have a gallery:

—It's good to allow for different interpretations of your work without letting the collector walk all over you. To that end, tell the collector what you were thinking when you made the piece, but try not to limit other readings.

—Asking which pieces the collector likes and why can help you learn more about the collector's perspective, find interesting points of discussion, and even discover a new way to look at your work.

—Don't be afraid to say no. If your work is meant to hang a certain way, for example, don't be shy about saying so.

—Never say that you don't like one of your pieces or that one is worse than another. You could be talking about the one piece the collector likes. If you dislike a piece that much, don't show it in the first place.

—If you don't want to sell one of your pieces, mark it "not for sale." Don't price it in the stratosphere as a way to dissuade buyers. Occasionally we see artists do this; the only effect it has is to undermine the pricing of their other work.

PRICING AND SELLING YOUR WORK YOURSELF

If a gallery represents you, it will set your prices and handle your sales (with your input). All you have to do is get the contact information of anyone interested in buying your work and pass it on to your gallery. It's also a good idea to give your gallery's contact information to the collector, since not all galleries move as quickly as their artists would like them to. The best way to handle this is by cc'ing your gallery rep when you send the collector a thank-you email. This solidifies your personal relationship, while signaling that you and your gallery work as a team.

And because you're a team, you should never sell your work directly to a collector without your gallery's permission. You may feel like you did all the work setting up your space for open studios and landing a collector your gallerist didn't know, but that's not how representation works. There are many, many things your gallery does to earn its half of your sales (see chapter 13 for the laundry list) and those things don't disappear just because you got a lead during open studios. This is not an issue to take lightly. Gallerists have dropped artists who were selling behind their backs.

If you are not represented, you get to set your own prices. This isn't an easy thing to do, which is why you really need to do it *before* you open your studio to the public. You don't want to be forced to price your work off the cuff when someone surprises you and actually decides to buy it. Nor do you want to put your potential collector in the awkward position of having to suggest a fair price.

Newer artists frequently undervalue their prices out of humility or overvalue them in light of the tremendous amount of work and emotion that went into them. To minimize these tendencies, you have to separate the value *you* place on the work from its ultimate price. What you think a piece is worth should factor into the price you set for it, but there are other factors, too:

—your price and sales history
—what the piece is made of
—fixed costs—fabrication, printing, framing, expensive materials
—how long the piece took to make
—how big the piece is—larger typically means more expensive

——————— "I price my work by talking to people and going to find out how much things are in galleries. If I'm making the same number of prints and the artist's résumé is similar to my résumé, I'll charge about the same. My work should be less than an artist's work who's shown more than me. So it's based on what we're making—if it's the same—and what our cachet is." **Stephanie Diamond, artist, New York, NY**

——————— "The late '80s and early '90s boom and then recession ruined artists' careers. The price of work was escalating too high from one show to the next. You can't go down." **Steven Sergiovanni, art advisor, curator, New York, NY**

——————— "Keep your prices fairly close to what you've sold at in the past—whether or not you had a gallery—with maybe a 10% discount. If someone buys a lot, then maybe a 20% discount. No more, because you will tick people off if you lower your prices. It will be an issue for anyone who has bought your work in the past." **Andrea Pollan, owner, Curator's Office, Washington, D.C.**

———————— "We price based on how much it cost to make the work, what the demand is, and where the pricing is at the moment. It depends—if you are an unrepresented artist in your studio, how many pieces do you make? Should you sell them and move on to make the next pieces? Once you get a gallery, you can work on the integrity of the sale." **Mary Leigh Cherry, Cherry and Martin, Los Angeles, CA**

———————— "The first time I felt like a professional artist was when a dealer came through for a studio visit. She said, 'First I want to buy this one, this one, this one, and this one for myself.' Then she asked how much they were and I had no idea. I couldn't tell her too much because I wanted her to buy them. I couldn't tell her too little because I didn't want to seem green. I ended up asking her what she thought was fair. In retrospect, I was lucky she gave me a fair price." **Stas Orlovski, artist, Los Angeles, CA**

———————— "I take exorbitant production costs into account. However, we had an installation a while back and the artist paid incredible production costs. He spent over $20,000 but he was willing to sell it for not much more just to have it in the world. You have to be realistic. It's a gut feeling. Weigh those factors and be aware of what everyone else in the market is doing." **Monique Meloche, moniquemeloche gallery, Chicago, IL**

—how big the edition is—larger always means less expensive
—whether the piece was part of a notable exhibition
—how many pieces you make in a year
—what your résumé looks like—the more solo exhibitions and museum shows you have, the higher your prices should be

Go to galleries and art fairs to get a sense of the range of prices out there for work that is roughly comparable to yours. Look at the artists' résumés to see where they are in their careers. But remember that work is more expensive when an artist is represented by a gallery because of the gallery's efforts to promote the artist and develop his or her career (and the fact that a commercial gallery takes 50%). You should not price your work as high if you do not have representation, even if it's "just as good."

Once you've sold a number of pieces, pricing becomes easier because you'll always price relative to your past sales. But this is still tricky. When you let your prices rise too fast, you risk pricing out your collectors, which in turn can force you to lower your prices. But you never want to be in a position where you have to lower your prices, because the art world is extremely unkind to artists whose prices have fallen. Speculation spreads that their careers are over, making it harder to sell work, fueling more speculation—a vicious cycle that can take years to reverse. That's why slow price increases are always better than big jumps (we promise!).

Start low, without doing a disservice to time and materials, and establish a sales record before making incremental increases.

Discounts on Direct Sales

It is standard to give museums a 20% discount on any sale (sometimes it's even higher than that). Galleries do this all the time because museums are (a) nonprofits and (b) the best long-term home for most artwork. Art advisors typically get discounts between 10 and 20% if you're working with a gallery, but they may try for up to 50% if they're negotiating directly with you. (Often, they'll charge their clients the full retail price, pay the gallery the discounted price, and keep the difference as a

————————— "Value is an interesting part of art. Pricing is a long-term goal and that's the thing to talk about. It depends on what kind of artist you want to be. In this market, you can be a short-term artist and know how to play a certain role, or there is a longer-term perspective. There are many ways to be important, with modest prices, and have a great influence on other artists, affect society, be an interesting person, use your position for social consciousness, and lead a really interesting life."

Andrea Rosen, Andrea Rosen Gallery, New York, NY

—————— "You have colleagues and you do favors for colleagues. A submission with a curator or critic's name on it definitely gets a fuller review. Those visits can be awkward because they are a favor. The worst is when I've discovered I am one in a long line of studio visits. Ten other people are doing the same favor." **Mary Leigh Cherry, Cherry and Martin, Los Angeles, CA**

—————— "There are two reasons why curators often hesitate and don't want to explain what their motivations are. First, we might not have any specific motivations, save curiosity. Second, when I am working on something specific, I try to be cautious. I don't want to set up an expectation with an artist which may not ultimately work out. I'm not interested in leading someone down a path of thinking about the way a work can be exhibited in our space, for example, until I have thought through the basics of that myself." **Peter Eleey, curator, PS1 Contemporary Art Center, Queens, NY; former curator, Walker Art Center, Minneapolis, MN**

—————— "I prefer to see a good amount of work before I meet an artist. Not to decide whether I want to see them, but out of respect for them. I want to have something to say and often things take time to shape in your mind." **Jasper Sharp, curator, Kunsthistorisches Museum, Vienna, Austria**

—————— "I 'find' artists from a multitude of sources, mostly by keeping a large network of first-hand contacts active and staying updated on who is doing what. I try to visit open studios and work in collaboration with BFA/MFA and residency programs as much as possible because that is an opportunity to meet a lot of artists at once. Residencies have the added value of drawing in international artists." **Marco Antonini, program specialist, Pew Center for Arts and Heritage, Philadelphia, PA**

fee.) Beyond that, there aren't any standards—despite what you might be told by a collector who "always" gets a 10% discount.

Many artists, mimicking galleries, give discounts to collectors who buy more than one piece. Some artists give everyone a 10% discount because it sounds fair and makes all their collectors feel special. (The artists we know who do this tend to factor that discount into their original pricing, but don't tell anyone.) Some artists only give discounts to family and friends. So it's up to you—but unless you're selling to a museum, a nonprofit institution, or an art consultant, you shouldn't be talked into more than a 10% discount on an ordinary sale.

Don't Forget the Paperwork

When you make a sale out of your studio, either because you don't have a gallery or your gallery gave you permission, be ready to invoice the collector immediately if they're going to pay and take the work with them. Even if they're not taking the work that day, you should send the invoice within twenty-four hours. If you don't have a form ready to print or email, go back to chapter 2 and make one. And put in place an organized system for saving all your invoices.

INDIVIDUAL STUDIO VISITS

There are three basic reasons curators or gallerists would want to visit your studio: they are doing general research and want to see what you (and other artists) have been up to lately; they are searching for artists to include in a specific show or to add to their gallery program; or they are doing a favor for you or someone who knows you.

These reasons can overlap and you won't necessarily know which one led to a particular studio visit. Some curators and gallerists will tell you point-blank so as not to mislead you. Others won't, so as not to raise your expectations. Ultimately, the reason for a specific visit isn't that important from your perspective, because your goal is the same regardless: to give your visitor the best impression of your work that you can in the time you have.

Preparing for the Visit

Getting ready for an individual studio visit is easier than it is for open studios, since you know who's coming and can prepare specifically for that person. You also don't need to turn your studio into a gallery space the way you do for open studios because curators and gallerists want to see what your studio looks like on a normal day.

But you still need to curate your work and present it thoughtfully. Show your best work and your most recent work (ideally the same thing). Apply the same curatorial principles from the open studios section above, keeping in mind that you have more control during an individual studio visit. Plan on directing your visitors' attention to the work you want to show, in the order you want it seen.

Research your visitor before the studio visit. (Your visitor will likely have spent time researching you, too.) Even if you already know the person, you should look up what he or she has been doing lately. You'll feel more confident during the visit and you may get a better idea of why the person is interested in your work at that particular time. You'll also see the kinds of shows and institutions your visitor has been involved with, which is an important factor in deciding whether you want to work together in the future.

Hosting

During a studio visit, you want your visitor to focus on your work and little else. Put yourself in your visitor's shoes and think about how to minimize any distractions. If your studio is a sixth-floor walk-up, offer some water. If it's the middle of winter, have some tea ready and maybe a place for your visitor to hang his or her coat. If you have pets, ask if the visitor is allergic (preferably before the visit). If it's during lunch or dinner time, offer a snack. Simple hospitality works best. Going over the top with an elaborate buffet just creates another distraction.

And while you want to treat your visitor as you would a guest in your home, common courtesy runs both ways. Expect your guest to treat you with respect, too.

—————— *"I want the artist to be prepared and I want them to have things ready for me to see. I don't want them saying 'Oh wait, let me dig that out of the back storage room.'*

"I'm going to follow their lead in terms of earlier work. Sometimes I will ask to see earlier work because I am looking at a current work and I want to have context for it. So I want them to be prepared and have a sense of what they want to show me. It shouldn't be too much. No one can process twenty-five years of a career in an hour or so." **Anne Ellegood, senior curator, Hammer Museum, Los Angeles, CA**

Talking About Your Work

There's no real debate on this one: you have to be able to talk about your work during a studio visit. That doesn't mean you need sound like a professional orator but you *do* have to figure out how to articulate what you're doing and why.

Gallerists and curators understand artwork more deeply when they know the influences and motivations that led to it. They want to know where you get your ideas; how you conceive of your projects; what your processes are. So be prepared to tell them.

At the same time, be flexible with how "hands-on" you are during a studio visit, because people have very different styles. One curator we talked to lamented the fact that he always has to listen to a rehearsed presentation when he walks in the door. Another said he expects the artist to dive right in and doesn't like it if he has to ask about the work before his host starts talking. Some curators prefer to assess what they see in silence; others ask a ton of questions. Stay loose and adapt your presentation to your visitor's style.

And just to echo a sentiment from the last section, don't say you don't like something you made. If you really don't like it, don't show it. Studio visits can last as little as twenty minutes, so focus your presentation on what you think you're doing well.

It's Not a Crit

While a good studio visit usually involves an interesting conversation, it is not an art school critique. Curators and gallerists visit your studio to learn about your work, not critique it for you. And you shouldn't want them to, anyway, because they may have agendas that don't align with your artistic intentions. That's why the ones who do give crit-style feedback during studio visits develop (bad) reputations for directing artists' work to fulfill their own goals.

To get the kind of feedback you used to get in crits, go to your peers, mentors, and former professors.

Takeaways

If the visit went well, offer materials such as show cards, press releases, or catalogs, but don't be insulted if someone doesn't

want to carry anything home. You can tell them you have digital versions of everything on your website (see chapter 4).

After the Visit

The first thing to do after a studio visit is to get out of the studio. See a movie, take a walk, meet up with friends, whatever you like to do to relax. Don't rush back to work. Let the conversation you just had percolate a while. Maybe you shouldn't be influenced by the way the person reacted to your work, or maybe you should. Give yourself time to figure that out.

We recommend sending a short thank-you email to your visitor, along with some images, a link to your website, and any materials the person asked for. While not everyone expects this, it's another way to show that you're interested, serious, and easy to work with. Following up with a physical thank-you card that includes an image of your work and your website can go a long way, especially with the 40+ crowd.

Don't be surprised if you don't hear back from the person for a long time. People in the art world tend not to rush. Even when a curator comes away from a visit thinking the work is perfect for a show, he or she will usually need to collaborate with colleagues and directors before making any final decisions. This can literally take years. And, as we discuss more fully in chapter 8, there are lots of reasons a curator or gallerist may not end up including an artist's work in a show, regardless of whether the person loves the work.

The healthiest way to deal with this is to continue making your work and occasionally send updates to the person who visited your studio.

———— "When I was researching my 'Oh, Canada' show, I did four hundred studio visits across Canada. There was one artist I visited who was really interesting but wasn't quite ready yet. I told him to keep me posted on what he was doing. He ended up going to Bard and I visited him there and now he's in my current show. It took seven years. It's not always that long, but it tends to range anywhere from three to ten years before I can work with someone I like." *Denise Markonish, curator, MASS MoCA, North Adams, MA*

———— "Whether you are going to get something out of it or not is irrelevant. When they come in and see your work and they get excited, you get excited." *Bill Davenport, artist, critic, Houston, TX*

———— "If somebody pays for a catalog, send them a copy! If a curator does a studio visit with you and you guys have a great conversation, send them an email or a note. 'Thank you so much.'" You know, those are simple ways to stay connected with people." *Deana Haggag, president and CEO, United States Artists; former executive director, The Contemporary, Baltimore, MD*

STUDIO IN A BOX

It's becoming more and more common for artists to bring their studios to visitors, instead of the other way around, by giving virtual studio tours on their laptops. This is a good option if your studio is really far away, or if there is nothing in your studio because, for example, you work with sound, site-specific installations, or performance. (By the way, if the reason there is nothing in your studio is that your work is in an exhibition, take your visitor

——————— *"If you have nothing in your studio, having visuals is key—it sounds moronic, but some people forget to think about this. If I truck all the way to Pasadena and there is nothing in the studio and we could have done the visit elsewhere that would have allowed me two more visits that day, I definitely find that inconsiderate."* **Shamim Momin, director/ curator, LAND, Los Angeles, CA; former curator, Whitney Museum of American Art, New York, NY**

——————— *"We have traveled for studio visits, but most international artists are used to doing a studio visit in a box. It's when the artist has a PowerPoint on their laptop and a few samples. They literally travel to you and do the visit with you. If you are on the international circuit, you learn you have to do this. You learn what will resonate."* **Edward Winkleman, cofounder, Moving Image Art Fair; author, former director, Winkleman Gallery, New York, NY**

——————— *"I sincerely believe that most artistic practices can make a valid first impression through a well-edited and presented PDF (especially if you are there in person to talk about it), so do not underestimate the importance of having good screen materials and do not overestimate the importance of having a permanent studio."* **Marco Antonini, program specialist, Pew Center for Arts and Heritage, Philadelphia, PA**

to the show, not your empty studio. If it's because you haven't made anything in a while, maybe this isn't the best time for a visit.)

Your presentation can be a simple slide show of your work that you narrate in person. Maybe you include some detail shots, installation photos from past exhibitions, or studio views. Keep it to a digestible length—around ten minutes—and practice your presentation before you actually sit down with a gallerist or curator and deliver it. Curate your presentation the same way you would for an actual visit. It should be smooth and organized, with an emphasis on the work.

Remember to be flexible and adapt to your visitor.

While we think it's almost always better to present your work in person, whether at your studio or on your laptop, sometimes that's not possible. Your would-be visitor may live thousands of miles away, or, for whatever reason, be harder to lock down for an in-person meeting even when you're offering to go to them. In those cases, it's fine to do your studio visit over video chat. The same principles apply: keep your "presentation" to ten minutes or so, and practice *a lot*. These visits can be phenomenally awkward, so try one with a friend or a family member before you do it professionally. Place your work thoughtfully to minimize camera motion and maximize light. Keep the camera stationary when you are simply talking. Depending on the type of work you do, it may make sense to send your visitor some images in advance that you can walk them through during your video chat, in addition to showing them live footage of your studio.

Be ready for technical problems. For in-person visits, back everything up in the cloud; bring your charger and have a thumb drive on hand (with Mac- and PC-compatible file formats) that you can use on the other person's computer if all else fails. With video chats, make sure you ask beforehand which platform your visitor prefers, and learn the interface if it's not one you use regularly. Have a Plan B, a Plan C, and Plans D through Z before throwing in the towel. For example, if Skype isn't working, you'll switch to Google, etc.; if nothing seems to work, you'll both ditch your laptops and try a platform on your phones; if all else fails, you'll send your visitor the backup presentation/images (which you put together just for this sort of contingency) and call them the old-fashioned way, to deliver your voice-over by phone. Remember, it's not about everything going perfectly, it's about how well you're prepared to handle things going wrong. If you're prepared and keep your sense of humor, you'll be *okay*!

PORTFOLIO REVIEWS

Another crucial form of feedback is the portfolio review, where you meet with a curator, gallerist, or other arts professional to discuss an aspect of your practice. Many arts organizations (and even the occasional gallery) will hold them throughout the year. The review could focus on the quality of your work, your ability to present it, or the effectiveness of your website and submission materials. A few tips for going to a portfolio review:

—The host organization will announce the focus and format of its upcoming review so you can prepare accordingly. These parameters are typically strict: fifteen minutes really do end after fifteen minutes. Think about what you want from the review and why. The more specific your questions are, the more helpful their feedback will be. Prioritize your goals in case you don't have time to get to every one. Look up the reviewers' backgrounds to get the most out of your time with them.

—Don't forget to listen. If you talk the whole time, you won't get any feedback—which is presumably what you're there for.

—Never bring original art to a portfolio review. You'll waste precious time unwrapping and displaying it, not to mention the risk of damage. Bring images—your best images. You want to spend your time talking about the work, not explaining what's wrong with the images. And make sure you indicate the size and materials of each work.

—One body of work is usually all you'll have time for, so pick what you want the most feedback on and stick to that.

—Bring your statement and résumé, since reviewers are usually willing to give feedback on those, too, if there's time.

—Bring a takeaway, such as a business card, for the reviewer in case you're asked for one. And always get theirs. If the review was positive, ask if you can add him or her to your mailing list.

More Advice for Portfolio Reviews

Clint Willour, retired curator, Galveston Arts Center, Galveston, Texas:

1. Do your homework and know who I am and why I'm doing this.
2. Don't show me fifteen images in fifteen minutes and then tell me you have three more bodies of work when they announce that we have five minutes left in the review session.
3. If you talk for the entire session, it doesn't leave much time for my comments, does it? And listen to what I say. Just because I don't respond to one picture doesn't mean I hate your work.
4. Don't hand me a pair of white gloves and tell me how to handle your prints. There's a reason they asked me to review portfolios.
5. Always have some materials with at least one image to leave with me if I ask for it.
6. Always ask if I would like to have the packet of materials that you are about to give me. Sometimes I won't. And please don't add me to your email blast list without asking me.
7. Don't apologize for being disorganized. Get your shit together and you won't have to.
8. Don't show me work that I've seen before. I have an image memory that would scare the pants off of you.
9. And speaking of that, don't show me a photo of your naked crotch and ask me what I think of it. (Believe me, this happens way more often than you would think.)
10. At the end of our session, don't ask me what I can do for you. I just did it.
11. And just so you'll know, I've only made three people cry and torn up one photograph in the twenty-two years I've been doing this and I've made hundreds of lifelong friends in the process.

Courtesy of glasstire.com

—————— "It can be like going on a date. Sometimes you leave a visit and you think, God! That was so fun! Didn't we have a great time? I think he likes me. Then, you never hear from him again and you're like—was I the only one sitting at the dinner table?

"In general, maybe I am less formal than others, but I don't expect a formal acknowledgment after a studio visit. If there were good ideas generated or there was a nice rapport and a tête-à-tête, then that's probably a conversation you will want to continue with that artist." **Anne Ellegood, senior curator, Hammer Museum, Los Angeles, CA**

—————— "Do not make assumptions about the amount of time the visitor has to dedicate to you. Be flexible. Just like when on a date, if you see that the conversation is about to die out, be the one to (graciously, gently) choreograph the visit's wrap-up. What you are doing in a studio visit is not trying to get work shown anywhere; rather, you are building a personal relationship/exchange that will facilitate that." **Marco Antonini, program specialist, Pew Center for Arts and Heritage, Philadelphia, PA**

—————— "You have to have an intention, you always do. When I get my students to talk about intention, I'm asking them to try to get clear about what they are doing. It takes courage to do that—to reveal your intentions fully. When you see any work of art, you are often trying to find an answer to this question: 'Why am I being asked to look at this?' If an artist is investing their life to do it, whether or not they've found the exact words, they have a reason. Have the courage to let it be known." **Sarah Lewis, author, curator, assistant professor at Harvard University, Cambridge MA; former member of President Obama's Art Policy Committee**

—————— "I have been on visits when the artist is trying to tell me what to think about the work and that gets kind of irritating, when they are not willing to entertain questions or feedback and they are trying to impose on me one way to think about the work." **John Rasmussen, director, Midway Contemporary Art Center, Minneapolis, MN**

—————— "I ask lots of questions during studio visits; some of my colleagues apparently do not: I find this surprising. They are so aware of their grand role, of their responsibility to the art world, as if brain surgery were at stake. I think it is much more interesting to have a dialogue on a studio visit. There are things you just cannot get unless you ask questions." **Joachim Pissaro, curator, professor, art historian, former Museum of Modern Art curator, New York, NY**

—————— "Know how to talk about your work. If you can't, we can't. It has to be concise. If there is a heavy-duty concept involved, there has to be an easy way to explain it in a couple of sentences. If we've got someone important in here, we have to be able to explain it in five minutes because they are going to get bored and walk away. If we have longer, we can go into details, but we need to be able to summarize the important aspects of the work quickly." **Lisa Schroeder and Sara Jo Romero, Schroeder Romero Editions, New York, NY**

—————— "During the follow-up process, I think you really have to gauge the personality of the person who came and whether they would be open to it. A lot of times I will tell artists to update me and they tell me where their work is going with new images and new work. In other cases, if the gallerist or curator doesn't say anything, don't push it." **Amy Smith-Stewart, curator, Aldrich Museum of Contemporary Art, Ridgefield, CT**

—————— "I don't want to just see the work. I want to talk with the artists to get a more complete idea of what they are thinking and what the work is about. And I expect to have a proper business relationship with them. I want to know they are mature and responsible." **Rosamund Felsen, Rosamund Felsen Gallery, Glendale, CA**

—————— "Studio visits with people in graduate school are tough. They expect a full critique and I am just there to look at work. We can talk about how things are working or not working, but I am not there to give a critique. I am there to see if the work will fit into a show." **Andrea Pollan, owner, Curator's Office, Washington, D.C.**

—————— "Articulating what they're doing is important. They don't have to be great public speakers, but they do need to be able to explain themselves. And that can be in so many different ways. But it has to come across clear because if you're having a dialogue about whatever they're making and they can't respond with any kind of social, historical, or psychological reasoning that's clear, then forget it." **Tim Blum, Blum & Poe, Los Angeles, CA**

—————— "Lead the studio visit: you have control. Know what you want them to take away. It is one message if it is a dealer. Another if it is a collector. Another if it is a curator. Know what you want out of the studio visit. Craft your narrative around it." **Edward Winkleman, cofounder, Moving Image Art Fair; author, former director, Winkleman Gallery, New York, NY**

—————— "A first studio visit is like a first date. Just have a great conversation. Remember, I'm at a studio because I'm already interested in an artist's work. If I can have a great conversation with you, this is going to go somewhere." **Denise Markonish, curator, MASS MoCA, North Adams, MA**

—————— "I think a curator has a huge responsibility walking into your incredibly intimate space where you make the most important thing in the world to you. It's our job to navigate that sensitively and professionally so that you feel comfortable. To me it is less about making it perfect; treat it the way you would when you want someone to be comfortable in your house with your friends. I don't like it when it is too formal and polished, frankly, and I really do love the fact that everyone is such a freak." **Shamim Momin, director/curator, LAND, Los Angeles; former curator, Whitney Museum of American Art, New York, NY**

—————— "It turns me off the most when artists are clueless about other work that might look like theirs or laid the groundwork for what their work is doing. I get excited when an artist knows the tradition in which they are working. I get excited when I hear an artist talking about another artist's work. It shows a passion for art that isn't about being an art star. They do not have to be eloquent, but something must be communicated. It shows there is an active intelligence." **Michael Darling, chief curator, Museum of Contemporary Art, Chicago, IL**

—————— "Talk about both finished and in-progress pieces. A studio visit can be a great time to get early feedback on the direction of a new work or series. How you choose the works depends on who the visitor is (e.g., someone familiar with the whole trajectory of the work or not, someone interested in a specific body of work, etc.). Talk about your work with honesty." **Marco Antonini, program specialist, Pew Center for Arts and Heritage, Philadelphia, PA**

—————— "The studio visit is always research for a curator to see what's happening, what's going on, to file things away. It does not mean that an opportunity is going to be forthcoming, so don't go into a studio visit with that in mind, or with any expectation. Just make sure that you're prepared for it." **Jamillah James, curator, ICA LA, Los Angeles, CA**

CHAPTER 6
———————— Sustaining Your Practice
(with Money and Stuff)

—————— *"It is the artist's job to articulate what we need—financially, emotionally, socially—from the art world and beyond. When we advocate for ourselves, we are advocating for all artists."* **Stephanie Diamond, artist, New York, NY**

—————— *"I don't have a single artist friend or family member who is creating work alone. They're also teaching. They're working in arts organizations. They're doing other things, even outside of the art-specific industry. Artists are the most diverse-thinking people I've ever met, so I can't imagine why they wouldn't want to apply that same strength to a fund-raising strategy."* **Sarah Corpron, acting director of business services, NYFA, Brooklyn, NY**

—————— *"You have to diversify income in a way that works for you so that you're not feeling like everything is dependent on getting one grant or hitting one crowd-funding goal. Because then, what's your Plan B? Grants or prizes are 'nice-to-haves,' they can't be 'need-to haves.'"* **Eleanor Whitney, writer, educator, creative programmer, New York, NY**

—————— *"I've had the great pleasure of working with Creative Capital's Professional Development Program since about 2008. And I'm also teaching in the MFA Fine Arts Department at the School of Visual Arts. My studio work also produces income, which is a combination of art sales, speaker fees, visiting artist or curator gigs, writing, etc. These kinds of activities—mainly within academia or the nonprofit realm—really align with my values and the kind of artist and person I want to be."* **Matthew Deleget, artist, curator, educator, founder, Minus Space, Brooklyn, NY**

This will sound obvious, but to make your art, you need some combination of *money, time,* and *community.* In this chapter, we'll go over a few ways to find all three.

When it comes to money: *"Diversify your income."* Don't rely solely on grants or direct sales to fund your work, because they aren't predictable and they are out of your control. (Also, hope is not a strategy.) Pull together a variety of potential revenue sources: contributed, bartered, in-kind, earned, and that super fun day job we discussed in chapter 2.

CONTRIBUTED SUPPORT: GRANTS AND RESIDENCIES

Contributed support means cash or stuff you're given for "nothing," as opposed to *earned support,* which you have to work for. Of course, most forms of contributed support require significant time and effort on your part, since you have to apply for them, so, like that famous lunch, they're not really *free.*

That said, there are thousands of programs across the country whose sole mission is to support artists. These programs typically give awards to a number of artists each year after a nomination or application-based competition.

Cash

Cash includes grants and other monetary awards. Most cash programs award grants for specific projects only. These grants are "restricted," in that you can only use them for expenses related directly to the project you propose. Some cash programs award fellowships and "unrestricted" grants. They give you money just because they believe in you and trust that financial stability allows a more robust practice—meaning you can spend that money freely on art supplies or food or whatever you like. If you don't have to sweat the cost of rent or health insurance, the theory goes, you are more likely to focus on your work. These awards range from a few hundred dollars to the more than $600,000 MacArthur "genius grant." With an unrestricted grant,

you can spend the money on anything (nonprofits call this "general operating support").

A few organizations also offer "emergency grants" to artists facing unexpected catastrophe such as fire, flood, eviction, or serious medical emergency.

Stuff

Stuff is everything other than cash: materials, residency programs, studio programs, equipment access, etc. Basically anything that involves something other than money, even if some of these programs include cash stipends.

Residency programs are the most popular programs providing space and time. They're a great way to build community, develop your practice, or learn new techniques. Typically, you live and work with a group of other artists in a supportive setting from one week to more than a year. Some residencies are very hands-on and social: you'll attend lectures, show your work to visiting curators, and get career mentoring from the staff. Other residencies are designed to let you focus on your work or yourself without distraction. Those are good when you need uninterrupted production time, or just space for reflection and self-care. Even residencies that don't provide private space may offer production support or excellent networking opportunities. You can find residencies in bustling city centers, on rural farmland, and in the mountains. They even have them in the Caribbean.

Studio programs (or "space programs") are similar to residencies, except that you don't usually live there during the program—you get private or shared studio space. They're mostly found in urban areas where real estate is expensive, or in spaces where the organization's mission is to support local artists. If you're having trouble finding affordable studio space, or crave human contact and community while you're in the studio, these programs are a godsend. Some space programs offer regular workshops, open studios, mentoring, and other guidance, much like a residency program.

——————"The difference between a residency and working in your home studio is more than just dedicated time and space. Residencies offer an opportunity to expand your own resources, whether in the form of community, support, access to equipment, collaborators, or presentation of your work. And to develop one's creative practice in a new context."

"Artist residencies are research and development labs for the arts. Places to take creative risks, to test new directions, and to create the psychic space needed to dive deep." **Flannery Patton, artist, communications director, Alliance of Artist Communities, Providence, RI**

————————"There is an incredible range of residency opportunities from more traditional artist retreats to a growing number of programs embedded within other types of institutions (universities, museums, government offices, bio field stations, cargo ships, public parks, and more). While some residencies are aimed at supporting one type of practice, over 70% are multidisciplinary, bringing together creative thinkers across disciplines." **Flannery Patton, artist, communications director, Alliance of Artist Communities, Providence, RI**

————————"A successful residency is determined by many different factors. One is an artist's capacity to respond to the opportunities that are offered. Each artist is different but those who are able to seize existing opportunities (however small they are) and engage with the staff and other artists in residency are often those who benefit the most." **Nathalie Anglés, founder, director, Residency Unlimited, Brooklyn, NY**

————————"The Arctic Circle residency expedition to Svalbard, Norway (a mountainous archipelago in the Arctic Ocean near the North Pole), allowed me to conduct extensive field research to feed my works production. I traveled with scientists, writers, and other artists aboard the SV Antigua, a three-masted Dutch barkentine sailing vessel. The camaraderie and exchange of ideas this program provided was very rewarding and made the journey of a lifetime." **Blane De St. Croix, artist, Brooklyn, NY**

————————"If you want to have a long career in the arts, you have to manage all the business aspects of your practice, really manage your 'brand,' and take time to take care of yourself. It can feel like a luxury, but health is not a luxury. You can't make your work if you're stressed out, if you're injured, if you're sick. There's this myth of the suffering artist who can't take care of themselves—or the really driven artist who's just going to push through. Where does that get us at the end of the day?" **Eleanor Whitney, writer, educator, creative programmer, New York, NY**

————————"I did a number of residencies earlier in my career and they were all incredibly important experiences. I was able to step back and focus on my work outside of the regular responsibilities and distractions of daily life. Most importantly I met remarkable people, some of whom became lifelong friends. Residences disrupt one's routine and for me that was a good thing. When I reflect back at my time at Skowhegan, Yaddo, and Art Omi, I appreciate what a profound impact those experiences had on my personal and professional life." **Stas Orlovski, artist, Los Angeles, CA**

————————"Residencies are a window on what's happening and they provide networks and contacts to the artist so he/she can grow. Hopefully the artists learn how to discuss their work—because they are going to be doing that a lot with colleagues and visitors—and learn practical issues around their work. For instance, they will not produce something bigger than what fits in their limited studio or use materials they cannot buy in the area. They have to present something that is representative of what they do within the constraints of the residency. There are a lot of things to sort out." **Micaela Giovannotti, curator, consultant, New York, NY**

——————"The first two things that I would advise an artist to consider before embarking on any fund-raising strategy are: how much time they can realistically commit to it and what their personality is inclined toward.

"A lot of artists jump into any fund-raising, assuming it'll happen fast. Crowd funding takes time. It takes a lot more time than you think it takes. You should be planning out a crowd-funding campaign at least three months in advance of launch. With individual donors it takes time because you're building relationships. And unless you happen to be one of those individuals who's been actively building relationships all along, it's something you really need to be thoughtful about. And then grant funding takes time. Evaluate your *real* time frame."

Sarah Corpron, acting director of business services, NYFA, Brooklyn, NY

—————— "We always recommend looking at the overall costs of attending (including travel to the residency, time taken away from work, shipping costs) compared with what the residency provides. A program that charges a small fee—but includes meals, housing, transportation, and strong staff support—may cost less overall than a program that is free but only includes housing. In addition many residencies that charge fees also have full or partial scholarships available or offer partial subsidies through work exchange." *Flannery Patton, artist, communications director, Alliance of Artist Communities, Providence, RI*

Other programs offer artists the use of expensive equipment such as printing presses, sound-recording studios, or photography labs. And there are a smattering of programs that award apprenticeships, commissions, or relatively small stipends for "inexpensive" supplies such as paint.

Not all stuff is 100% free, by the way. It might be subsidized or heavily discounted, requiring you to come up with the rest. On a website such as the Alliance of Artist Communities, you can search hundreds of vetted residencies. Some pay you to go, while others charge. Don't write off the ones that charge fees. Look carefully at what they provide. A residency charging a few hundred dollars a month could include travel, all your meals, a studio, and an apartment where you can bring your dog, while a "free" residency may not include travel and food, may not allow pets, etc., ultimately costing you much more than a few hundred bucks (financially and emotionally). Likewise, a print-shop program that *pays* you to work briefly with a master printer may seem "obviously" better than a program that *charges* you a subsidized rate to use the equipment, but long-term access to expensive equipment could enable you to make more, higher-quality pieces faster—which might be a better outcome for your practice.

A COUPLE OF IMPORTANT CONSIDERATIONS BEFORE YOU APPLY FOR CONTRIBUTED SUPPORT

Don't apply to anything until you've done your research. You don't want to end up in a rustic cabin with writers when you should be in an urban studio alone. Or attached to a funder who expects your project to be executed exactly as described when you know the parameters will change with community input. Thorough "prospecting," as it's called in the grant world, involves clarifying your needs and identifying like-minded supporters.

Important Consideration #1: You

There are thousands of public, private, and corporate sources of support for artists in the United States, all running a variety of programs. *Maybe* fifteen of these programs will fit you at any given time in your career, because each program has its own mission; each one aims to support particular types of artists, or types of art, or regions of the country, or other demographic categories. It is a waste of your time and energy—and will prove extremely discouraging—to apply to every funding source you come across. To figure out which ones make sense to apply to, think hard about:

What You're Doing
—What do you make?
—What subjects does your art relate to? Think inside and outside the art world.
—What are you trying to accomplish through your art?
—Who is your audience?
—What effect do you want your art to have on your audience?
—Where do you think you fit into recent art history?
—What and who are your artistic influences?
—Are you affiliated with any organizations that support the arts?
—What is your demographic?
—What are your values?

——————— "More and more foundations focused on scientific, theoretical, or humanities ideas are funding arts projects. If you're an artist, you want to be looking at the arts funders, but you also want to be looking at these issue-area funders to see how they could support your work. I have heard from people that work at those foundations that by even receiving those applications, they've had to really think about what they support. They didn't believe they had an arts/culture focus, but in fact, they're able to find a way to make it happen." **Lisa Dent, director, resources and awards, Creative Capital, New York, NY**

——————— "Much socially engaged art is interdisciplinary. I find the art world responds better to this terminology. My practice has expanded over time to include other social sciences. These collaborations afforded me access to brainpower, equipment, techniques, and even funding I would not have had otherwise." **Melissa Potter, artist, curator, writer, Chicago, IL**

———————— "We cannot live off of grants because they are not sustainable. Give me something that will enable me to live and work with ease and comfort. Give me something that will allow me to practice for the rest of my life so I don't need five day jobs and have to work out of my living room. Give me health insurance instead. Give me a place to work and live." **Stephanie Diamond, artist, New York, NY**

———————— "I apply for grants because they keep me less dependent on the commercial system. That has been important for me all along: finding ways where I won't have to sacrifice the quality of my work by making repeats or more saleable pieces. In the early days it was my day job—now grants and teaching keep me a better artist." **Charles Long, artist, Mount Baldy, CA**

What You Want to Do
—What are your goals for the next ten, five, three years?
—What do you want to make?
—How do you want to develop your practice?
—In what directions do you want to go?
—Is there a medium you haven't worked in yet but want to?
—What kind of environment do you want to work in?
—Do you want to interact with people inside or outside the art community? Both?
—What specific project or body of work do you want to tackle next?

What You Need
—Does anything stand between you and the art you want to make?
—How much time do you need to complete the project?
—How much money do you need?
—Do you need studio space?
 . . . access to expensive equipment?
 . . . materials or fabrication?
 . . . training or practice in a particular technique?
 . . . assistants?
 . . . mentoring?
 . . . a place to live?
 . . . other artists to collaborate with?
 . . . total solitude?
—*When* do you need each form of support?

Important Consideration #2: Them

You will be a happier, more effective applicant when you understand how programs work, what they offer, to whom, and why. Foundations, government agencies, and corporate sponsors are very different types of funding bodies. You need to research and understand their missions, motivations, and expectations before you approach them.

Residencies, foundations, and other entities that run award programs are usually set up as nonprofit organizations (also known as "501(c)(3)s") because of the tax benefits that come

with nonprofit status. Individuals, estates, families, and companies that create foundations or philanthropic arms can use them to lower their overall taxes, as can individuals who donate to them. The people who start these foundations generally care a great deal about art. They understand that without support, many artists couldn't make their art at all, either because they're not established enough to play a role in the art market or because their work is not intended for, or suited to, the art market. They also recognize artists can be good partners in achieving a mission. Sometimes the mission is related to art and sometimes it is not.

These organizations run the gamut from small endowments with very specific missions to enormous umbrella organizations dispensing millions of dollars a year. Some are extremely efficient and well run; others are less formal in their structure or, frankly, less consistent in their decision making. Knowing the size and reputation of the foundation you're applying to will help you calibrate your expectations.

Unlike private funding sources that are not required to reveal their budgets and structure, the law requires nonprofit organizations to disclose a good deal of information about themselves to the public. Therefore, you should be able to find out everything you need to know about a program before deciding to apply to it. Bigger programs have websites with frequently asked questions or other user-friendly guidelines that tell you what they're looking for. Smaller programs don't post as much information on their websites (some don't even have websites), but if you search online for a particular program you might find it mentioned in local news articles, described in institution brochures and annual reports, or listed in the résumés of past recipients.

Every nonprofit has to file a "Form 990" with the IRS, disclosing relevant financial data, the awards it has granted, its officers, its trustees, and other details that give you a sense of how the organization operates. A Form 990 is not the most user-friendly document in the world (surprise!) but it may be the only source of information about the program you're looking into.

The Foundation Center (foundationcenter.org) is a phenomenal resource for researching granting bodies. It provides detailed financial information about funders, including an

Nonprofit organizations have to go through a similar application process to secure their funding.

*——— "When approaching foundations, it is important to find the right fit instead of trying to mold your programming around the foundation's mission. Early in our history, we received support from St. Paul's Jerome Foundation midway through an exhibition season. Unfortunately, since we had submitted our proposal, our list of exhibiting artists had changed to the point that our season no longer fit within Jerome's guidelines. Rather than readjust our season, we had to make a difficult decision to return the grant and stick to our lineup of exhibitions. It was a $5,000 grant and at that point our budget was only $30,000 for the year, so it was substantial, but we decided it was not worth changing around the program. That was a major decision because it really changed the way we thought about our commitment to our mission and programming." **John Rasmussen, director, Midway Contemporary Art Center, Minneapolis, MN***

——————— "I applied for a Fulbright grant to work in Brazil because I wanted to travel, meet new people, and make work in different contexts. I picked Brazil because of my interest in water and the country's history of water-resource challenges. I wasn't sure how an artist applying for a major research grant would be received, but I found that the Fulbright commission was interested in the tie-ins to public policy, environmental issues, and the geopolitical landscape." **Ann Tarantino, artist, State College, PA**

——————— "FIREWALL pop-up internet café is the most exciting project I've produced thus far thanks to the Franklin Furnace Fund. Their seed grant initiated my search for additional funding, which eventually opened doors to grants from the Asian Women Giving Circle and the Lower Manhattan Cultural Council. FIREWALL was a cross-disciplinary collaboration with multiple partners I found through a combination of word of mouth, cold emailing, and naive fearlessness." **Joyce Yu-Jean Lee, artist, Brooklyn, NY**

——————— "Every grant is important, not just in financial terms, but as a sign of encouragement for one to keep doing what they're doing. Recognition on the local/national level by your peers and other arts professionals provides a certain amount of validation to keep plugging away in the studio." **Stas Orlovski, artist, Los Angeles, CA**

exhaustive database of Form 990s, as well as trend reports, educational materials, and training courses. Another comprehensive resource is the New York Foundation for the Arts (NYFA). One of its goals is to identify and describe every arts-related award program in the country, and it's making great headway: there are thousands of programs in the NYFA Source database and it's constantly growing. You can access it for free at nyfa.org and use the search functions to zero in on the cluster of places most likely to offer the kind of support you're looking for. In addition to large databases, look out for local listings, social media posts, Facebook groups, "opportunity deadline" calendars, and the like to keep up on opportunities that may be applicable to you (now or in the future). Many nonprofits and individual artists make it their responsibility to disseminate this type of information.

The federal government lists its grants on grants.gov. You can find state and city government grants online by looking up your local council on the arts and department of cultural affairs. Check the websites of public spaces, such as airports, government buildings, and libraries, to find commissions and other funding opportunities.

You can also find funding *outside* the art world. A foundation may hand out grants related to the subject matter of your art, for example, even if they're not specifically geared toward artists. Foundations in the sciences and the humanities are particularly good places to look, as some of them are interested in new ways to visualize scientific principles and tackle cross-disciplinary subjects. The National Science Foundation, for example, has an artist residency in Antarctica.

There are also opportunities with corporate sponsors, from your local paint or liquor store to Fortune 500 companies. They usually involve a brand donating its product in exchange for logo placement on your press release, or at the open bar, or the raffle table or whatever. (Again, there's no such thing as free beer.)

Harder to find are corporate cash awards. Local stores and banks may be open to subsidizing your project (either directly or through the venue) if the mission of their corporate-giving program aligns with your work.

Take your time researching programs. Set aside a few afternoons and dig in. It's worth it. Instead of hearing about

——————— "When we talk about granting and grant prospecting in workshops, we talk about the fact that, as a visual artist, you need to think about what you need. Most people think they need cash, but cash doesn't happen all that easily. What happens more easily are things like time in a residency or connecting with other people. A lot of programs give you access to people or equipment you may not have otherwise.

"So we encourage people to think about it in the broadest sense. Who am I? What do I really need?"

Christa Blatchford, artist, CEO, Joan Mitchell Foundation, New York, NY

—————— "I think the arts community is very vital here, but we don't have the international buyers like you do in New York. We only have a handful of serious collectors buying contemporary art.

"I don't know how easy it is out there, but most of my friends, when they try, can get some grant money. It's certainly competitive, but you can get it if you try hard enough." **David Salmela, artist, cofounder, Creative Electric Studios, Minneapolis, MN**

—————— "It's really important to apply to a lot of programs but it's also very important to apply to programs where you and your work fit in the best—where you can really make a good case for yourself in whatever limited space you're allowed." **Melissa Levin, vice president, Artists Estates and Foundations, Art Agency, Partners, New York, NY; former vice president, cultural programs, LMCC**

—————— "I don't think that a lot of young artists would even think it a possibility—that they could get an opportunity and turn it down because it doesn't match their values. But you can." **Deana Haggag, president and CEO, United States Artists; former executive director, The Contemporary, Baltimore, MD**

everything last-minute from your friends, you'll know which deadlines are coming up long in advance. And you will have already figured out which programs are the right ones for you and which ones you don't need to worry about this time around.

Here is what to look for when doing your research:

—Type of award.

This is the fastest way to narrow your search. Is it cash or stuff? An apartment in Texas or studio space in New York? Is it only for making new work, or can you use it to show old work (or to continue working on unfinished work)? Will it fund your overall practice, or only a well-defined project?

—Eligibility.

This is the second-fastest way to trim the search. Do they explicitly state their funding priorities, or imply what they are? Does your proposal fit? Is the award only for artists in a specific region, state, or city? Is it for a certain age group, gender, or ethnicity? Is it for artists at a particular place in their careers? Some awards are only for students, others are specifically *not* for students. Some awards rotate disciplines: last year for theater, this year for dance, next year for visual arts.

—Mission/Reputation.

We hinted at this above. Every for-profit and nonprofit entity and government agency has a mission, a reputation, and motives that need to align with your work for the entity to support you (and that should align with your values if you're going to approach it in the first place). Some opportunities clearly offer prestige and will likely lead to more support, while other circumstances could redefine the reading of your work (or your entire practice) long after the support ends. This could be positive or negative, so be thoughtful when exploring each opportunity.

—Size.

How much money is the grant? How long is the residency?

—Frequency.
How many times a year do they give out awards? Some programs dole out awards a few times a year; others are once a year or even once every few years.

—Deadlines.
Do you have enough time to apply this round? Or will your application be much stronger if you put more time into it and apply for the next deadline?

—Turnaround.
How much time between the deadline and the award? How often does the selection committee meet?

—Alumni.
Who were last year's recipients? You can usually find a list of grantees/fellows/awardees/residents on an organization's website. Go to these artists' websites to see their work and their résumés. Is your career in the same place, give or take a few years? Be realistic about what the program is looking for.

—Expectations/Requirements.
What do they expect of you if you get the award? Nothing? A public presentation? Quantifiable "results?" Receipts? A portion of the work you make? Sometimes the post-award requirements will change the way you think about an opportunity.

HOW TO APPLY

Two words: *follow directions.*
 That's basically it. Yes, we have more to say in this section, but none of it is as important as those two words. Award programs actually do mean what they say in their instructions. If a residency announces on its website that "we are not accepting any applications until next March," don't send your application in before March! When a form states, "include six work samples," *include six work samples.* Not seven, not five, not forty-five. Six.

If You Don't Answer ALL the Questions, You're Not Following the Directions

A surprising number of artists think it's okay to leave some questions on their application blank—as if answering were optional—or to write "see answer to Number 3, above" when they think two questions are asking the same thing.

Don't be one of these artists. There are selection committees out there that will *disqualify* you for it.

Whether two questions overlap is simply not a debate you want to have with the selection committee. The people who wrote those questions are not trying to waste your time any more than they are their own. So you can safely assume that they don't think the questions are redundant, even if you do. And since they're the ones who will decide whether you are accepted or rejected, it's best to just roll with it and answer their questions. All of 'em.

—————— *"I am surprised by how many artists don't put together grant calendars. Through Gmail or whatever you use, create alerts for the deadlines of all the applications or residencies that you want to apply to. It's what you need to do as part of being an artist these days—being on top of multiple funding opportunities."* **Lisa Dent, director, resources and awards, Creative Capital, New York, NY**

No one is trying to cramp your style or compromise your individuality here. They're just trying to be fair to the other artists by comparing the same set of materials from everyone. They also want to see that you take the program seriously. Show them you understand that this is a professional endeavor, not some casual roll of the dice.

Many programs will tell you what they focus on when evaluating applications. Of all the directions to follow, these are the most important. They're not as easy to spot because they're not necessarily written in the form of explicit directions but rather as "funding priorities" or "criteria." You might see something like this: "Artists' Fellowships are chosen based on the single criterion of work that demonstrates a compelling vision as defined by the assembled panel's collective opinion." Note the words *single criterion*. They're telling you up front that there's only one thing that matters: "work that demonstrates a compelling vision." This program will make a qualitative assessment of your work, period. You therefore need to spend the most time on that part of the application and submit the best-quality images you can.

Compare that to a foundation looking for projects with "socially relevant outcomes" or a "community response." These words mean you need to show a *result,* such as raising social awareness, enriching a political discussion, or triggering community activity. There's an organization, for example, that funds "works and projects that advance gender equity in our cultural, artistic, intellectual and political spheres, and that provide a forum for broader discussions of the urgent social justice issues of our day." *How* your project would attempt to accomplish this result is just as important to the committee as the quality of your work.

Chart Work

If you're serious about applying for these types of awards, you *must* create a chart that tracks the progress of your applications, along with calendar alerts to remind you of upcoming deadlines. Don't try to keep it all in your head. Include basic information about the program, the type of application, important dates, contact information, and anything else you find helpful to have in one place:

	APPLICATION PROGRESS							
ORGANIZATION	AWARD	APPLICATION	**DEADLINE**	SUBMITTED	RESPONSE	FOLLOW-UP	CONTACT	POST-AWARD REPORTING
NYFA nyfa.org	$7,000	online	**1/15/18**	1/6/18	pending, expected early March	left vm 3/30/18	jason (212) 555-1234 j@nfya.org	public lecture before 4/19
FarmArt farm.art	residency	paper 3 copies	**2/15/18 postmarked**	2/5/18	accepted 3/15/18	thank you 3/21/18	beverly (555) 234-5678 bev@farm.art	none required
Little Boxes littleboxes.com	materials + $500	online	**11/30/17 by 5 p.m.**	11/15/17	rejected 1/15/18	thank you 1/20/18, feedback 1/31/18	sarah sbh@littleboxes.com	logo on release
Airport Council of the Arts — ap3.gov	$25,000	online	**rolling**		every 3 months		cliff cliff@ap3.gov	public walkthrough receipts, final budget

—*Organization.*

The name and website link are enough, though it can't hurt to list a mailing address.

—*Award.*

What it is (stuff or cash).

—*Application.*

Note whether it's a physical application, online application, project proposal, or something else. This is where you can also list the specific materials you need to submit (for example, résumé, three work samples, two letters of recommendation) and check them off as you complete them. If that clutters up your worksheet or calendar entry too much, make a checklist for each application separately.

—*Deadline.*

Programs that accept applications at any time of year have "rolling" or "ongoing" deadlines. For programs with exact deadlines, be careful to note whether the deadline is a "post-

——————— *"Most applications are very basic. You fill out your name and send twelve images. If you are not even doing that, are you considering yourself as a serious artist?"* **Alessandra Exposito, artist, Queens, NY**

——————— *"When I first started working here, I assumed that my phone would be ringing off the hook. Instead, it was the opposite. Then when applications would come in, I'd think 'Why didn't they reach out and see if this was okay?' You should really read the guidelines. You should also take a look at our website at the other kinds of projects we've supported. If you still have a question, it's really the program officer's job to answer those questions. I mean, that's why we're here."* **Lisa Dent, director, resources and awards, Creative Capital, New York, NY**

mark" date (that is, the post office must stamp your application by that date) or a "delivery" date (the program has to receive your application by then). Most online applications are accepted until midnight, so be sure to note any exceptions.

—*Submitted.*
The date you submitted everything.

—*Response.*
The date they got back to you (and what they said). You might also note when you *expect* a response. You can usually find the date programs send out notification letters on their websites. For programs with rolling deadlines, you can estimate the turn-around time by looking up when the selection committee meets to review applications; if it's not clear, ask the program officer.

—*Follow-up.*
It's nice to write a thank-you note, whether you received the award or not. And, as we discuss later in the chapter, you should take advantage of any feedback a program offers for rejected *and* accepted applications.

—*Contact.*
The name, phone number, and email address of the program officer. A program officer manages the award process from beginning to end: solicitation, review, selection, and notification. This is your point person for questions and feedback—but take a minute and check that you're not asking about something that's already addressed in the application itself or, say, on the website's frequently asked questions (FAQ) page. Not all program officers have a background in art. They may come from some academic field, law, finance, or something related to the foundation's specific mission.

If materials aren't clear, ask how the jury works and how your application will be viewed. Do the jurors look at the work on their laptops in private, or does the whole jury get together for a slide show on a big screen? What will they look at first, your images or your project narrative?

DEMYSTIFYING JURIES PART I

The process of evaluating submissions can look, from the outside, like a black box. It's actually pretty straightforward:

- In most cases, jurors are announced *after* the process is completed. Look at lists of past jurors for clues as to the makeup of a jury for a particular grant or award.
- A jury might be one person or dozens. Some jurors are involved throughout the process; others only at one specific stage along the way.
- Jurors are often art world experts. Depending on the project, however, they might be experts in another field. Potential collaborators, developers, board members, accountants, and other relevant parties could all the have influence on a jury, if not an actual vote.
- The organization will usually decide whether a jury sees images or text first, although sometimes it's as arbitrary as the order you upload your materials (so think about that order). If the project proposal is extremely important or an LOI is required for the first round, the jury will look at your text and not your images.

Say you know the jury will convene to look at all your images as a giant projection. Make sure you submit the highest-resolution images at the largest dimensions allowable. If they're going to look on a laptop, test how the images look on a variety of displays, small and large. If they tell you the jury won't look at any images until a later round, after narrowing the field based on project narratives, you'd better spend *way* more time on that narrative than you were planning. And *describe* your work so the reader can envision it accurately—not just what it's about but actually what it is. One of us has been on many juries and has finished proposals without knowing whether the artist makes paintings or sculpture!

—*Post-Award Reporting.*
List what you're expected to do if you receive the award, along with any deadlines. If you don't do what they ask, there may be consequences that impact the award (and your reputation).

RESIDENCY AND GRANT APPLICATION MATERIALS

You already know from chapter 3 how to put together your work samples (images), résumé, biography, artist statement, and press. You'll need to customize all these items to fit the opportunity, highlighting the most relevant images and information. And, there are a few more items you might need to apply for cash and stuff, which we'll go through now.

Letter of Intent/Inquiry/Interest (LOI)

An LOI is a one- to two-page letter from you to the organization, asking whether it would like you to submit a full application. With certain grants and public projects, you cannot formally apply unless you've sent an LOI and the organization responds yes.

While that may sound like an annoying extra step, consider it a gift. In these cases, the application is usually time consuming, so the organization does not want to put you through the arduous task of completing an entire application (or, to be blunt, have to

DEMYSTIFYING JURIES PART II

- Juries scrutinize *everything* from images to feasibility to your writing style (and yes, they ding you for typos). This is why we tell you to proofread your application more than once, and for a friend or two to proofread it as well.

- These days, jurors will typically look at applications online, and either vote yes/no or rate them on a scale. Some application tools allow jurors to add notes for others to see, which is where having an advocate on the panel can really help (and, conversely, where burning bridges can hurt).

- An organization may ask past recipients to cull an application pool before the jury is brought in to vote on finalists. Or the program administrator might choose his or her favorite applications to present to the jury for a final decision.

- Juries can last a few hours, a full day, or many days. It can take two to four (or more) rounds to get to the finalists. Votes may be public or private. When votes are public, the first few jurors to vote can sway the whole group.

———— *"I've sat on juries with serious curators and very specific metrics, juries that meet several times a year. I've also sat on juries that meet over coffee once a year and don't appear to have any specific metric at all. Just last week I was on a committee where people seemed to just be picking things they liked, saying 'I don't know, how about this?' or 'I kind of like that one.' I tried to bring some focus, saying 'Wait a minute, do we want to talk about any criteria here? What are we going for?'"* **Melissa Potter, artist, curator, writer, Chicago, IL**

———— *"Put energy and care into your work samples. Cue videos to the right moment, hire a professional photographer, select a body of work that demonstrates range but also feels coherent. Often the jury is reviewing only your work samples, with the narrative part of your application only coming into play after you've advanced to the next round. It's critical to have high-quality work samples that speak for themselves."* **Flannery Patton, artist, communications director, Alliance of Artist Communities, Providence, RI**

———— *"Being a juror for shows or grants is a great resource for finding artists."* **Denise Markonish, curator, MASS MoCA, North Adams, MA**

read your application) unless you have a credible chance of receiving the award.

Your LOI should be clear and engaging from the get-go, reflecting your passion while remaining professional. Read *everything* about the organization before you start writing, so that you have time to internalize and reflect its language and mission in your letter. Review its guidelines for the LOI and the parameters of the opportunity. Make sure you meet all of the requirements in both cases. Failing to follow its directions or include requested information will eliminate you in the first round.

If the organization does not provide an outline of what to include, or list questions for you to answer, then go by the following checklist:

—Full contact information in your letterhead. Set it up like a business letter.

—Salutation with a specific name. Avoid "Dear Sir" and "To Whom It May Concern."

GREAT! I'VE BEEN AWARDED A SPOT AT THE BRICK OVEN STUDIO CENTER. NOW I GET TO HAUL ALL OF MY SUPPLIES OUT TO THE MIDDLE OF NOWHERE FOR TWO WEEKS, MAKE A FEW DRAWINGS AND EAT ARTISANAL GRANOLA TWICE A DAY AT A COMMUNAL TABLE.

————————— "In many cases, jurors don't know the artist's work firsthand and won't have a chance to see more of it, apart from what is on-screen for a few minutes. Pick works that represent the full breadth of your practice and interests/concerns."

Marco Antonini, program specialist, Pew Center for Arts and Heritage, Philadelphia, PA

—————— "Get feedback. I often recommend artists share their entire application with friends who are less familiar with their work—some of the feedback and questions can be insightful and guide you where to clarify parts of your application." **William Penrose, executive director, NURTUREart, Brooklyn, NY**

—————— "While I cannot be certain of the selection panel's metrics or how prior fellowships may have influenced the way my grant proposal was viewed, what I do feel helped my proposal stand out was strong writing. Yet, I am not a particularly great writer. When I decided to apply to the Guggenheim Fellowship, time was spent refining the text I had toiled over and getting the best images possible to support my thesis. I revised the proposal over thirty times, getting many different eyes on it." **Bonnie Collura, artist, Bellefonte, PA**

—————— "Just be simple and clear and who you are. And know enough about the thing you are writing for so you address it in some way. We get letters of application from people also applying to teaching positions and it is the same letter. You can hear it. It's been tweaked a little, but it's basically the exact same letter they wrote for the teaching program. It makes us think we are not necessarily the right program for them because they haven't researched us carefully enough." **Joseph Havel, artist, director, Core Program, Houston, TX**

—Succinct, enticing introduction matching your project to its call. If someone reads only this paragraph, they should know what you're doing, what you want, and why you are a good fit for their support. It's a stand-alone, brief summary of your project/proposal that sets the tone for the request.

—Connect your past and present (bio and projects) directly to this proposal. Give a short description of the project: what, how, and who.

—Description of how your project matches its mission or philanthropic goals.

—Statement of need. This is the "why." Why are you working on the project and why is it important? Who benefits? This isn't what *you* need, but why the world needs your project. Some funders love statistics, so use them when appropriate.

—Mention of any other confirmed or expected funding.

—Final request. Summarize your goal and end with something like this (suggested by NYFA): "I hope you find this project of interest and would like to receive a full proposal. If you want to discuss the project in more detail, you can reach me at XXXX. Thank you in advance for your consideration."

—Closing should be a professional "Sincerely" or "Respectfully."

Cover Letter

For any opportunity without an LOI requirement, a cover letter will be the first part of your application, but it's the last part that you should prepare. Your cover letter is similar to an LOI and will serve as the most succinct introduction to your application and your work, so it will be easier to write *after* you've updated your artist statement and finished your detailed project narrative and budget. The jury will have access to a comprehensive application, so you need only highlight the most important parts of your application. Keep it to one page.

Cover letters follow a standard format and tone:

—First, a salutation. Use a name if you are submitting the letter to a specific person. Otherwise, use "Dear Jury Members," "Dear Granting Committee," or mimic whatever terminology has been used in the call. "To Whom It May Concern" and "Dear Sirs" are never an appropriate way to start a cover letter.

—Second, tell them what you want: "I respectfully request your consideration for a grant of $5,000" or "It is an honor to be considered for the XYZ residency program." Or something equally clear and courteous.

—Third, explain what you will do with the money or how you will spend your time at the residency: "With this grant, I will spend three months in Ecuador to complete a new body of photographs" or "During the XYZ residency, I will have the time and facilities I need to edit a new video exploring the effects of urban sprawl" or "I will use my studio at XYZ to host gatherings of community members and fellow artists to discuss the rhetoric surrounding upcoming elections and the power of artists to inspire change."

LETTERHEAD

Date

Name of Program Officer
Granting Organization
50 Gold Street
Bellemont, NY 10456

Dear Name of Program Officer:

I respectfully request your consideration for _____. Briefly explain what you will do if you receive the award. This is essentially a one-sentence summary of your project narrative's Project Description section.

Describe your experience, qualifications and biographical information, as they relate to the organization's priorities. This should summarize the most important points of your project narrative's Background section.

Thank you for your consideration. If you have any questions, please contact me at artistname@artistname.art. I look forward to your response.

Sincerely,

Sign your name
Type your name

Artist Name, 20 Pineapple Street, Los Angeles, CA 90001
www.artistname.art

—Fourth, briefly describe your experience, qualifications, and other biographical information that tells the program why it should accept your application. Emphasize the foundation's priorities and how they reflect your values. We'll discuss this topic more in the Project Narrative on page 153.

—Fifth, if the award is expecting specific outcomes, address how you will achieve them. If it is looking for a project related to social justice or activism, for instance, state who will benefit from your proposal and how. If the opportunity aims to provide you with time, space, and/or resources, let the organization

know how this is important to you at this particular stage in your career.

—End with "Thank you for your consideration." Then open up a dialogue by asking it to contact you with questions. And close professionally.

Project Narrative

Your project narrative is a detailed explanation of your project. As with cover letters, there is a standard structure—though some applications may ask for a particular order or emphasis, in which case you obviously need to follow those instructions. Typically, you'll organize your project narrative like this:

—*Executive summary.*
A concise, one-paragraph summary of the rest of the narrative. It should include your request and briefly describe the project. Do this *after* you've finished the other sections of your narrative. (You can then use your executive summary as a starting point for your cover letter.)

—*Background (or qualifications).*
Explain your interest and experience related to the work you are proposing. The key is to tie your background and experience to the foundation's priorities. This should be straightforward if you went through the Important Considerations exercise at the beginning of this chapter. The reasons that led you to apply to the program in the first place probably have something to do with your background, qualifications, and past work.

—*Project description.*
Explain what your project is. Use the same process you used for your artist statement in chapter 3—brainstorm, outline, draft, edit—to transform your thoughts and motivations into a coherent narrative. Yes, it is easier to describe a specific project than to come up with an artist statement, but it's not *so* easy that you should skip the writing process altogether. And similar guidelines apply: be direct and simple; avoid metaphysical

——————— *"The biggest mistake an artist can make in a narrative is burying the lead. A lot of times artists get so caught up in explaining certain details or explaining the passion behind what they do, that they completely bury the actual 'what.' Within the first sentence, maybe the second sentence, you should clearly say, 'I am creating, for example, works of photography that speak to A, B and C; or works of mixed media that speak to issues surrounding the African diaspora.'"* **Sarah Corpron, acting director of business services, NYFA, Brooklyn, NY**

——————— *"The problem I see most often is the choice to use words that compromise the meaning of the text. Typically, this is the result of the artist wanting to use bigger, more important-sounding words in an effort to promote the work. That can be very destructive to meaning—and is counterproductive to promoting it, too!"* **Paddy Johnson, founder, Artfcity.com**

——————— *"I often say, 'Think Hemingway, not Heidegger.' Clear sentences. Not a lot of adjectives. Not a lot of demonstrative language. Those are the most helpful applications and clearest to jurors."* **Lisa Dent, director, resources and awards, Creative Capital, New York, NY**

——————— *"Texts accompanying a proposal should be as removed as possible from the artist statement format. Keep your introduction open and evocative, leave space to multiple interpretations rather than 'explain' the work. The work should be a hub of incoming-outgoing connections, not a dead end."* **Marco Antonini, program specialist, Pew Center for Arts and Heritage, Philadelphia, PA**

—————— "A real strength of many chosen applications is honesty. There's a clarity in some people's applications that isn't philosophical, academic writing, or jargon. We ask them: Why this award right now? Why does this award make sense for you? And that can be a very personal reason. 'My child is now grown and I have more time. This award will allow me to really dig in.' It can also be, 'I just left an academic position and I . . .' or 'I plan to take time off and I'd like to be supported.'" **Lisa Dent, director, resources and awards, Creative Capital, New York, NY**

—————— "One thing that makes a proposal stand out: the feeling that the artist is not merely asking for a bunch of works she has made to be propped up in a show and displayed. The proposal should communicate a sense of originality and the possibility of long-term aesthetic and intellectual engagement with the work." **Marco Antonini, program specialist, Pew Center for Arts and Heritage, Philadelphia, PA**

complexity and pseudointellectual jargon. State what you want to accomplish in as few words as possible. Don't forget the basics: who, what, where, when, why, and how. Keep in mind the images/ videos/documentation/sound you are sending. Make sure the work samples support the narrative and vice versa.

—Timeline (or schedule).
Give as much detail as the project requires and space allows.

—Audience.
When relevant, state whom your project serves, including approximate numbers and demographics if possible. This will be an educated, somewhat aspirational guess, unless you've completed a similar project in the past.

—Expected outcome.
Discuss your goals and predictions for the project.

—Thanks.
End by thanking the committee for its consideration.

Terms vary from program to program, so pay attention to the vocabulary each program uses and mirror it. If they ask for a "schedule," give them a "schedule," not a "timeline." Using their terms eliminates any potential ambiguity. It makes it easier for a jury to quickly find what it is looking for in your application and focus on the substance of your proposal.

Always separate the executive summary from the rest of the project narrative with a section header. For long narratives, it's helpful to use headers for the other sections, too.

Speaking of length, *mind the page limit.* Don't even think about going over. It's fine if your first draft is too long, because you can cut it down. But leave yourself plenty of time to do that and have someone proofread the final draft before you submit it.

Project Budget

Some applications give you a budget form to fill out, which is great because you don't have to guess what they're looking for. Other applications just ask you to attach a budget and expect you to know what that means. When they do, err on the side of too much information. List all project expenses *and* project income to demonstrate that you've thought through how you're going to fund the project. When you're done, your budget should complement your project narrative.

There are several ways to put together a budget; you don't have to do it our way. If you find one that's more intuitive for you, by all means run with it. No matter what format you choose, be realistic with your expenses and creative with your income streams. Pay people a living wage and think through what it will cost to complete the project—from literal nuts and bolts to the

———— "I still find a lot of artists assume that we want to see a budget only for fifty thousand dollars, because we provide up to fifty thousand dollars. We actually want to see a budget that includes everything that you want to do, even if it's beyond that. It could be a million dollar budget and we only fund fifty thousand dollars. Part of what we want to help you do is expand your network and find the funding that you need for a dream project." **Lisa Dent, director, resources and awards, Creative Capital, New York, NY**

———— "Artists need to think about the expenses they incurred to get that grant and then the expenses they are going to pay with that grant. So many times, I see artists at the end of the year get a 1099 for an award that they hadn't planned for; and then we have to go back and re-create how they spent that money because they weren't truly thinking about it." **Jessica Lanzallotti, accountant, Everyman Theater, Baltimore, MD**

job you may have to quit to get it all done. Some artists lowball their expenses so much that a jury rejects the application out of fear the artist has no idea what he or she is getting into. Or an application is rejected because the artist has relied too heavily on too few income streams. Research all costs and potential income fully.

Here's a basic budget template to get you started:

PROJECT BUDGET		
EXPENSES	AMOUNT	EXPLANATION
personnel		
travel		
equipment		
supplies		
TOTAL EXPENSES		
INCOME	AMOUNT	EXPLANATION
earned income		
contributed income		
in-kind contributions		
TOTAL INCOME		
TOTAL REQUEST		

Project Expenses

—Personnel.
Include any wages you'll pay assistants, website designers, app developers, production people, contractors, accountants, lawyers, or other consultants. Make sure you're paying them at going professional rates. Freelancers have to take a fee based on the value of their work. (You can't pay them a percentage of the award because the size of the award is not related to what they do for you.) In some applications, language states that you can't include yourself under "personnel" and carve out a part of the award as your salary, but you can and should use the award to cover your direct project expenses (see "Travel, equipment, supplies" below). If that language is not present, you *must* pay yourself. An artist's time and effort should be valued. If you don't pay yourself, who will? Creative Capital, for instance, encourages artists to allocate a percentage of their project budget to an "artist fee." Baltimore's Rubys (Artist Project Grants) actually deducts points from an application if an artist has not been paid. You can list it as an "artist fee," or hire yourself as a "producer" or "project manager."

—Amount and explanation.
Put the total expense of an item under "Amount." Show your math in the "Explanation" column by writing out, for example, a consultant's hourly rate, multiplied by the number of hours per day, multiplied by the number of days: "$27/hour x 4 hours/day x 2 days."

—Travel, equipment, supplies.
Most funders cover these kinds of direct project expenses, as long as they're reasonable (you can't start flying first-class, but you can take a taxi to the airport). Do your research here. Call stores; look up ticket prices; confirm rental rates for space and equipment.

—Amount and explanation.
Same as above, only here you'll break down the amount into price per item: "($1.75 per lightbulb) x (450 lightbulbs)" or "($150 per roundtrip train ticket) x (2 trips)."

——————— *"We want artists to be paying themselves. We don't find it's feasible for people to do these projects and do them well if they're not paid. Why would they want to do that?"* **Lisa Dent, director, resources and awards, Creative Capital, New York, NY**

——————— *"The best entrepreneurs in the world are those who realize what they're great at and where their limitations are. I'm great at [blank] to this point, but I can be even better if I collaborate with somebody who's great from that point. If I want to be successful, I may need to think about other people and how to include them, how to manage them, and how to pay them or partner with them."* **Brynna Tucker, BKLYN Incubator manager, Brooklyn Public Library; former career services, Pratt Institute, Brooklyn, NY**

—Other Potential Fields.
Depending on the scope of the project and your medium, you may incur transaction fees, space-rental bills, printing costs, website costs, and a host of other considerations. Streamline your budget as much as possible without leaving anything out.

—Total project expenses.
Add up the Amount column. This is the total cost of your project.

Project Income

—Earned income.
This refers primarily to the income your project will generate (if any). A project that culminates in an exhibition might lead to sales of work, for example. For other ways your project might generate revenue, think like a museum: a public art installation could generate ticket sales, tours, education workshops, merchandise, and concessions. Estimate the revenue from each of these potential sources. This is also where you would put any money you intend to raise for the project with an event or, say, from selling items conceptually related to the project (the bake-sale model). Don't put grants and other awards here; that goes in the next section.

—Contributed (or unearned) income.
List money you received (or will receive) from awards, donations (including crowdfunding campaigns), and corporate sponsor-ships—*including the award you're applying to with this budget.* Since most grants won't cover the full cost of a project, you'll need to cobble together several sources of funding. Put them here to show the program how its grant will fit into the picture. Don't leave out programs you've applied to but haven't heard back from yet—just indicate that the award is "requested" or "pending." (There is nothing wrong with having outstanding award applications in your budget. Programs *want* to see that you're not relying solely on them to get your project off the ground.)

—In-kind contributions.
List the cash value of space, time, or equipment people will donate to your project. (Cash value is what you would have to pay for the item, not what it "costs" the donor to donate it.) As always, show your math in the Explanation column.

—Total project income.
Tally up all the numbers in the Amount column (from the Project Income section only). This is the total income from your project. Ideally, the total income from your project will equal its total cost. A very tiny deficit or surplus is fine, but too big a discrepancy means you have a problem with your budget: either you don't have enough funding to cover the project or you're asking for more than you really need.

—Total request.
This is what you're asking for in your application. It's the same number you already entered under Contributed Income, along with the other grants you have applied for or received. Separating it out at the bottom makes it easier for the selection committee to quickly see the requested amount.

Be careful with any expenses a program says it won't cover. Include them in your budget—but create specific lines in your income section to show that you plan to cover them with another funding source, so it's clear you're not asking the program to pay for something it's already said it wouldn't pay for.

Some awards will allow you to contribute some amount of your own money to a project (if your expenses would otherwise be more than your income) but the percentage must be small. You can either add it to your Contributed Income section, or relay the information to funders in the form of a footnote to the budget. Funders need to know you'll be able to finish a project without incurring debt. A lot of selection committees take your financial situation into consideration, whether it's an explicit criterion for that grant or just a subconscious sense of who needs help most. You don't want to seem so needy that the committee feels you won't be able to finish the project, or appear so wealthy that they feel you don't need the money. Ask the

In-kind contributions should relate to expenses. You'd list donated space as an in-kind contribution, for example, *and* the rent for that space in the expenses section.

Hard to believe, right? After scraping together a bunch of grants just to make a project happen—a project that may not even recoup its own costs—you have to turn around and pay income tax on the funds you raised. Well don't blame us; we're just the messengers.

The federal government considers most grants to be taxable income, meaning you owe a percentage of the grant in taxes the next time you file. You'll probably be able to deduct a lot of that amount thanks to your project expenses—but not all expenses are 100% deductible, so you'll still have to pay something. And if you thought putting together your project budget was complicated, just wait till you try to figure out your line-item deductions! This is why we highly, highly recommend paying for professional tax help. Once your project gets into thousands of dollars, it really is worth the two hundred dollars or so to hire an accountant who can figure it all out for you.

Unfortunately, artists rarely include estimated taxes (or related accountant fees) in their project expenses. If the grant is small, foundations expect artists to use other funds (that is, not grant money) to pay the taxes owed on grants. With large grants, however, you should include accountant fees in the project expenses. And it is customary to add income taxes to your artist fee (the taxes you would pay on your personal income derived from the grant, not the grant as a whole). Once again, ask the program officer for guidance.

——————— *"We do encourage artists to hold back a percentage of the grant for taxes—it's part of the worksheet that we give them. Any year that an artist receives funding from the project, we give them a 1099."* **Lisa Dent, director, resources and awards, Creative Capital, New York, NY**

program officer whether what you're proposing is appropriate for the grant you're seeking.

Some artists find it more intuitive to leave out the amount of the award they're applying for, so that the difference between a project's total income and total expenses equals the amount they're requesting. Say your total expenses are $7,000 and your income is $5,000 before counting the $2,000 grant you're applying for. Instead of listing the $2,000 under Contributed Income, as we suggest above (in which case total income and total expenses both equal $7,000), you would exclude the $2,000 and list total expenses as $7,000, total income as $5,000, and the requested amount as $2,000.

Make your budget with Excel or another spreadsheet program. Word-processing programs are *not* the way to go. If you're uncomfortable with spreadsheets, get comfortable. It takes a lot less time to teach yourself how to set up automatic calculations and other shortcuts than it does to recalculate your budget by hand every time you add some new expense or adjust a particular price estimate.

And make it easy to read. Use a large font, bold the totals, put a box around the Total Request—whatever you think makes it clear and user-friendly. Also, "serif" fonts—the ones with the little hooks and bumps around the edges—are apparently easier on the eyes than "sans serif" fonts (according to NYFA). Whichever font you choose, use it throughout the entire application.

Financial Information

Applications often require a "Statement of Need" or other personal financial information beyond what you include in your project budget, such as income tax returns and bank-account statements. You may also have to estimate your total monthly income and expenses and list how much you make from selling your artwork.

Fee

You might have to pay a fee to help cover the program's administration costs.

Letters of Recommendation

The most effective letters of recommendation come from people who know you and your work well, *and* whose perspective matters to the selection committee. Look through your CV for everyone who has mentored you, or seen, curated, or written about your work. Who is relevant to the award you're applying for? If your project has an academic bent, for example, ask one of your former professors. Or say you're applying for a residency program that emphasizes community participation: an artist or curator who can talk about how active you are in the community would make sense.

Keep your references current. While professors are an obvious place to go for recommendations, the longer you've been out of school, the less relevant their recommendations will be (unless, of course, you stay in touch and they continue to follow your work).

When you ask people to write a recommendation, send them a link to the award you're applying for. Show them your project narrative and images of your latest work. And ask whether they'd like you to give them a list of qualities you want them to emphasize in their letter.

Most important: Give them as much time as possible to write the letter and remind them the week before it is due. If you asked them less than two weeks in advance of the deadline, they may ask you to write the first draft, an awkward but necessary accommodation. When they submit the recommendation, send a thank-you note.

Some applications ask for "additional support materials." These can include brochures, catalogs, or letters of recommendation. If you're proposing a project that's more ambitious than anything you've done in the past, letters of recommendation—or a letter from the venue or community in your proposal—can have a huge impact on the jury.

FISCAL SPONSORS

Many government bodies, and quite a few foundations, give awards to nonprofit organizations, not individuals. To access these grants and any funding source that states it only gives money to those with 501(c)(3) status, you need a "fiscal sponsor": a nonprofit organization that technically applies for the grant on your behalf. In essence, the organization lets you use their nonprofit status to apply for the award. You're still the one who prepares the application, but the fiscal sponsor accepts and distributes money on your behalf and some fiscal sponsors offer technical assistance and financial services during the application process, project duration, and post-project reporting.

Some nonprofits advertise themselves as fiscal sponsors on their websites. And even the ones that don't can become sponsors if you ask them. Keep in mind that to get a fiscal sponsor you may need to go through a separate application process, which can add a good deal of lead time to your project. Some organizations have a formal process that is similar to applying directly for a grant, while others are willing to lend their name and nonprofit status without a lot of paperwork.

Just about any nonprofit organization can act as a fiscal sponsor (it does not have to be an arts organization) if helping your project succeed is in line with its mission. But the best fiscal sponsors are those with experience and name recognition in the funding world. A good place to learn about fiscal sponsorship is the National Network of Fiscal Sponsors website. You can also search the Fiscal Sponsor Directory online. Check the websites of large donor and government organizations, such as the National Endowment for the Arts, and see who their beneficiaries are. Then check which beneficiaries have received grants and then regranted them—voilà your potential fiscal sponsors. Fractured Atlas and the New York Foundation for the Arts are two of the largest fiscal sponsors in the country. Their websites are good places to search for information on fiscal sponsorship and a whole host of other subjects. You can also look to your local nonprofits.

Things to keep in mind when choosing a fiscal sponsor: clarity in communication, responsiveness, financial expertise, and previous experience. Do you trust it? Is it clear on its responsibili-

ties and yours? While it is helping you to access greater funding potential, you will be paying it and helping it achieve its mission. The relationship should be one of mutual benefit.

Once you've found the right fiscal sponsor, you'll need to sign a contract with it before applying for grants or other funding. Make sure you retain creative license and ownership of the project. The contract should also state whether your fiscal sponsor takes an annual fee or a percentage to cover administrative costs (this could be from 3 up to 15% of the money you raise, based on the extent of its services). It may also say something about the organization ensuring that you use the money according to the funder's protocol. Many fiscal sponsors have their own forms. As with all contracts and legal documents, you should take it to a volunteer lawyer for the arts or some other pro bono legal advisor to look over and make sure you're getting what you deserve out of the arrangement.

Remember to include in your project budget any fees you'll have to pay your fiscal sponsor.

One of the biggest benefits to having a fiscal sponsor is that donors (including private individuals) can receive tax credits for giving to your project.

——————— "Getting a fiscal sponsor allowed me to apply for more grants (since many granting organizations can only give to nonprofits) and to solicit tax-deductible donations from individuals. Having NYFA, or another big organization, as your sponsor has the added benefit of providing a sort of 'mark of approval' since their process for determining whether to sponsor a project is fairly rigorous. The process sets you up well to write more grants and their name has recognition with a number of grantors." *Eve Mosher, artist, Brooklyn, NY*

——————— "What we're asking you to prove in the application is that, not only does your project have some kind of public benefit and that it's arts focused, but you have the skill set and resources—or at least access to resources—for you to feasibly execute your goals." *Sarah Corpron, acting director of business services, NYFA, Brooklyn, NY*

NOW WHAT?

Congratulations, you got your application in. Plan on waiting a long time before you'll know whether you were accepted. It can take up to a year for some programs to distribute their awards.

After the application deadline passes, the program officers begin reviewing all the applications. This can take months. First, they return applications that are incomplete or clearly unqualified. Then they compile the rest and eventually present them to the selection committee at a meeting (or series of meetings, depending on how many applications there are). The committee members review the application materials and choose which applicants receive awards. Then they send out letters notifying recipients. Some time after that, the actual awards go out.

Many programs post these dates on their websites so it's a less mysterious process.

———————— *"No one grant is perfect for everyone. It's definitely not a quality assessment. People have to remember that grant bodies are panels of professionals who all have their own set of prerogatives and preferences and it's really quite unusual that you might fit in.*

"I got a couple of residencies in the past, which have all been great, as well as some really helpful grant support, but the first major grants I got after applying to many others, and getting rejected, was a Guggenheim Memorial fellowship in 1998, followed by a Joan Mitchell grant the next year. They really helped me out at a critical moment. It was at a point when I was going to have to change the way I worked or otherwise reassess things. There was a lesson in that for me—the other grants would have been great, but there were some that really helped when I needed it most." **Michael Joo, artist, Brooklyn, NY**

FOLLOW-UP

Once you hear whether or not you've received the award, consider sending a thank-you note to the program officer to acknowledge his or her time, even if you didn't get in. It's another way to show your continued interest in the program.

Some programs offer feedback on applications. Whether you were accepted or rejected, take them up on this offer. (Most people don't). It's the best way to learn what you did right, what you did wrong, and whether it makes sense to reapply. Even if they don't advertise feedback, you can always call the program officer and see whether he or she will discuss your application with you.

And keep in mind that many grant recipients and artists-in-residence had to apply several years in a row before their applications were accepted. We even know of an artist who got into a popular program at a New York museum *on her seventeenth try.* That's obviously the extreme end of the spectrum—if you've been rejected six times you're probably better off directing your energy elsewhere—but so is getting in on your first attempt, given the daunting number of applicants. (To see just how daunting, check out chapter 8, where we talk about rejection.)

CONTRIBUTED SUPPORT: DONORS AND CROWDFUNDING

Believe it or not, there are still art patrons out there. We're not talking Renaissance-style Medici-commission patronage, but there *are* collectors and other philanthropists who believe in an artist so much that they help in whatever ways they can: free space, multiple purchases, commissions, or stipends. In fact, the commercial gallery system of the not-so-distant past was known to pay artists a salary in exchange for a certain number of works per year. This was an advance, mind you, but it kept artists in the studio and away from pesky day jobs.

These patrons are not easy to find. For many artists, groups of individual donors and the phenomenon of crowdfunding have

replaced the monolithic patron. They are by no means a direct equivalent, but multiple web-based platforms have been designed for the sole purpose of funding creative projects through individual donations starting at $1. Some platforms offer membership-like options where patrons can pay an artist monthly, ultimately creating a salary for the artist made up of dozens, if not hundreds, of regularly paid pledges. These payments are gifts, not loans. In exchange, the artist vows to make new work and keep the patrons in the loop, giving behind-the-scenes commentary, special access, and perhaps tokens of their gratitude along the way.

If you can only handle sharing, updating, and communicating with a few people at a time, or your mailing list is small but generous, then you may not need to go the crowdfunding route. Instead, you can identify ways each person on that list could help, and what you would give them for specific dollar amounts, for instance. Reach out through personalized letters, emails, and calls. One person could support a new catalog, another could help with a plane ticket to do important research, another could donate materials, studio space, or time in their spare bedroom so you can create a residency of your own. In exchange, you give them personalized gifts—art or something else—as a thank-you. Even large nonprofits do individual appeals to big supporters, figuring out personalized exchanges that work for both sides.

If your individual donors are few (at least at first) and know you well, treat the relationship professionally. Many patrons are friends or family members who make a significant impact on your ability to make new work. Give them thank-yous and updates the way you would a granting body.

To capitalize on crowdfunding, you must have a larger audience. For any campaign to get fully funded, it should:

—present an engaging, ambitious project/idea/practice
—identify a network of supporters and urge them to share
—address supporters directly through personalized, individual appeals
—share developments, achievements, and tokens of appreciation

——————— "It's not part of our culture to front big amounts of money to creators we love. But the hope is that we can turn back time and bring it back to old-style patronage where if you loved an artist, you paid them. You don't want them to stop what they're doing. You understand the amount of time and the work that it takes." **Taryn Arnold, associate marketing manager, Patreon**

——————— "Having access to grants, private funding, and gallery funding are all things that need to exist. We're not replacing them. I think of Kickstarter as a tool in your toolbox." **Victoria Rogers, director of arts, Kickstarter**

——————— "When I was crowd funding for my book tour, 95% of the people who gave to my project were people that I not only knew and followed on Twitter, but people I reached out to personally and asked them to give. There are some people who really put the time in to discovering new work, but that is not most people, unfortunately." **Eleanor Whitney, writer, educator, creative programmer, New York, NY**

——————— "There's a recipe for a successful campaign. In no order of importance: the new and the innovative, an opportunity for public engagement, a sense of ambition and amazement, and great execution." **Victoria Rogers, director of arts, Kickstarter**

Successful crowdfunding campaigns come out of broad networks of supporters, a sincere appeal, and an equitable exchange. Individual donors do not have to explicitly state their mission statements or funding priorities, but it is important to know that they have them. Your mom's mission may be to support her children, so she will contribute to your crowdfunding campaign. Most other people will need to connect with your values, the content of your work, or your goals. Making your work and your goals explicit helps others help you. They feel a part of the process the more you share and update.

Remember: The vast majority of successful crowdfunding campaigns fund work that addresses a larger public, meaning work that benefits a community versus simply your studio and grocery bill. While we believe most art improves quality of life for everyone simply by existing, you need to think about the specifics of how your work relates to the public good and activates

I CAN'T BELIEVE MY CROWD FUNDING CAMPAIGN FAILED. ALL I ASKED IS THAT EVERYONE OF MY FACEBOOK FRIENDS DONATE $10,000 TOWARD MY GOAL OF HAVING MY GENITALS CAST IN SOLID GOLD.

community involvement. It's your best chance to pull "strangers" into the fold.

After making sure you have a large-enough network and broad-enough public appeal, there are a few other things to consider before deciding which of the crowdfunding platforms to use: how much guidance the website provides, how much traffic it generates, how it distributes money, and how much money it retains. As of 2017, the best sites for artists—Kickstarter, Indiegogo, Patreon—all have extensive FAQs, how-to guides, and advice on how to construct a successful campaign. Read them carefully.

BARTERED AND IN-KIND SUPPORT

A sustainable career often requires the money to pay for materials, equipment, and space. Then there are doctor bills, dentist appointments, yoga classes, web development, travel expenses, writing projects, graphic-design fees, cooking, cleaning, accounting, and a whole host of other things that have to get done in your life. They all involve money, time, or both.

Over the last decade, we've seen a proliferation of artist networks and cultural networks, founded on principles of barter and in-kind support. Ourgoods.org, for instance, encourages artists to list the spaces, skills, and objects they have to trade. They match "needs" with "haves" because they rightly point out "resource sharing is the paradigm of the 21st century." There are other Facebook groups where artists post available materials or offer services in exchange for other services and materials.

Many a project gets completed, teeth get cleaned, and taxes get filed because artists think to barter or request the donation of materials, services, and/or time. There are writers, musicians, graphic designers, web designers, and even programmers, lawyers, and accountants out there working in a way that leaves them unfulfilled. These people may want the things you can provide—be it art, food, space, administrative work, or creative collaboration—in exchange for their services.

By definition, bartering is an exchange. In-kind support should also be an even exchange, even if the donor is the only one offering something tangible. By accepting in-kind support, you

——— *"Think about what you can offer that's exciting to people and not just a token. Everyone has enough tote bags and swag-type things. Involving the public is often what works. Also getting works of art is huge. It's best to be able to give away things that really have value and are only available through the Kickstarter campaign."* **Victoria Rogers, director of arts, Kickstarter**

——— *"The problem with crowd-funding platforms is they are inherently limited to the party atmosphere that has to be created around them. There's a finite framework that it needs to occur in and it's very social-media driven—it's about building hype around these big moments, finishing strong, and meeting your goal. But a lot of these projects continue on and need a more solid base of fund-raising."* **Sarah Corpron, acting director of business services, NYFA, Brooklyn, NY**

are helping donating parties fulfill their mission by attaching their product, materials, space, services, etc., to your project and your goals. Younger artists out there want to volunteer for an exciting project in exchange for experience and a good recommendation. Companies are willing to donate product and materials to projects that fulfill a marketing goal or reach a targeted audience. Graphic designers are willing to work on a website for free or a discounted fee so they can add an interesting project to their portfolio. And many lawyers will build pro bono work into their schedules.

Two things to remember: credit and taxes. Give credit where credit is due. Acknowledgments on your press release, in the credits of your video, or in the captions on your website go a long way. And pay your taxes. The IRS wants you to report the value of the barter or in-kind donation on your taxes, so speak to your accountant about the tax implications of bartering (ideally before you go too far down the road). And maybe trade a piece of art for their services.

EARNED SUPPORT (I.E., INCOME)

Direct Art Sales

In chapter 4, you learned how to design your website and in chapter 5 you learned how to price your work. Put the two together and you have the largest growing way to sell artwork directly to collectors. Depending on your goals for the future, online sales could be an important piece in your overall budget. (If you have a gallery, talk to them about strategy before uploading works or prices to any site.)

Behance and Etsy are two of the most popular sites linking makers to collectors. But there are hundreds of other sites catering to interior designers, new collectors, and general art buyers, such as 20x200 and Uprise Art. Even Amazon and eBay sell art. Self-publishing sites sell catalogs and written components to your practice. Artspace began working directly with artists. And while Artsy still requires you to be affiliated with a gallery to

participate in sales, the trend is moving in the direction of working directly with artist studios.

Read the fine print before uploading any work to an outside site, read all contracts, understand what they're saying about copyright, and consider the percentage the site will take on sales of your work.

Don't underestimate the impact of offline, open studios, personal outreach, and general exposure. Periodically invite your supporters to your studio for a look around and inform past and potential collectors whenever you make new work. (Make sure your news and invites are spaced out so everyone feels involved and not overwhelmed.) Shows in nonprofit spaces may lead to referrals, exhibitions in nonart venues have the potential for new fans, and donating to benefit auctions is good publicity, as long as you're strategic in your donations and guard against giving too much away for free. Always make sure your contact information is visible and there is a way for viewers to sign up for your mailing list when showing in a venue that does not sell work.

Another direct sales technique is the subscription model. We know of several artists who sell subscriptions to benefactors. In exchange for a dollar amount, the donor gets the components of a print portfolio, catalogs, emails, surprise gifts, or something else over the course of the year. It's a good way to solicit money before producing a multi-part project. Or it may be a good hook on a site like Patreon, where you have the option to be paid each time you produce something new.

Every artist has a different practice with different direct sales possibilities. For almost all practices, there is something you *could* sell as long as it stays in line with your work and your values.

Nonart Sales

Then there are the sales of things other than your work: tickets, refreshments, by-products of the work, accessories related to the work, catalogs, books, photographic documentation, ephemera, etc. Think about your work in a larger sense and think about all the ancillary things associated with the work that could be sold.

——————— *"When you say money, people often associate it with two things: reward and status. Anyone who is not interested in the cultural connotations of status and reward think that money is bullshit. But, if you add a third category and think of money as a resource, then you're not 'selling out' to a collector—you're understanding that there's an economic structure that requires you to have key resources to move forward. Money is one of many resources and business is all about resource strategy."* **Brynna Tucker, BKLYN Incubator manager, Brooklyn Public Library; former career services, Pratt Institute, Brooklyn, NY**

——————— *"Even our fiscally sponsored projects do not exist in a completely nonprofit state. Many of the artists also have their own practice and sell their work. They work in a gray area between commercial and nonprofit. That's something I want to push artists to embrace."* **Sarah Corpron, acting director of business services, NYFA, Brooklyn, NY**

—————— *"Why has copyright become such a big issue in art? The answer is, because the art world has become much more of a commercial enterprise. Everybody sees money in reproduction rights and the rampant use of appropriation makes appropriation artists susceptible to lawsuits . . .*

"What licensing also starts to do is to establish that there is a desire for your work. Which, later on, should there ever be a lawsuit, could be very helpful." **Sergio Muñoz Sarmiento, attorney, artist, educator, Brooklyn, NY**

Selling gift-shop items may not be right for everyone, but it made sense for one artist who cut tote bags out of a hundred-foot-long, site-specific Tyvek mural and sold them after the mural came down. The mural had no future home and many people wanted to be part of the project, but could not accommodate such a large work. Tote bags allowed the work to live on, and generate income, after the project ended.

If there is no clear way to incorporate direct sales into your practice now, it may make sense later. Be open to spotting opportunities when they arise. Many well-known artists sell rugs, towels, plates, etc., that use images from their artwork. As long as it makes sense conceptually and financially for you, it is a good idea.

Licensing

A license is a form of permission. When you license an image of yours to someone else, you are permitting that person to use the image in a specific way: to display it, or distribute it, or sell copies of it. These "uses" are protected by copyright, meaning other people are not allowed to use your image in those ways unless you grant them a license to do so. Licenses can be extremely broad ("you can use my image any way you want to, for the next ten years") or extremely narrow ("you can display my image on your phone for twenty-four hours, but you may not copy it or share it with anyone"). Generally speaking, the broader the license, the higher the license fee.

Some artists license their images for book covers, magazine articles, design work, advertising campaigns, and limited-edition products, among other things. Fees can range wildly, from less than $100 to thousands of dollars, depending on the scope of the license, the purpose, and the potential revenue.

There aren't any "rules" about what you have to agree to when you are thinking about licensing an image. It's completely up to you, and a function of what you're comfortable with (although if you can't see eye to eye with the other party, you won't have a deal). Just make sure you are very clear about what *is* permitted and what *isn't*.

Let's say a restaurant wants to use an image of yours on its menu. Questions to consider when deciding how much to charge, and how to limit the scope of your license:

—*Time/Amount*

Is the license forever? (What lawyers call "in perpetuity.") Or is it only for a certain number of years. Or a certain number of menus; i.e., before the restaurant has to pay an additional fee to make more menus with your image.

Is this for a single location or multiple locations? Does the restaurant have plans to expand, in which case maybe it should pay additional fees for additional locations? If the restaurant opens a "next door" concept or a take-out venue, does it have to pay you another fee to use your image, or is that 'included' in the original license fee?

—*Media/Means*

Is the image just for the menus? Can the restaurant also put it on mugs and T-shirts and sell them without paying you? (That's rhetorical.) Can the restaurant use the image on its website? What about in an ad that features the menu? If you agree to let the restaurant "reproduce the image by any means, and in any medium, now known or hereafter devised," you're pretty much allowing it to do whatever it wants for the duration of the license (and potentially after the license expires, depending on how that's written).

What if the restaurant designs a new menu and slaps your image on those—will you care if you think it looks really bad? Do you want to limit the use of your image to the current menu design? Or have "approval" over any use of your image on *different* menus that the restaurant might design later?

—*Creative Input*

Can the restaurant change your image in any way? Maybe you're okay with it making it bigger, as long as the aspect ratio doesn't change—or maybe you're not. What about the color of the background, or placement on the page? Do you want approval over those elements of the menu design?

Speaking of legal problems: If I want to use other people's images in my work, how can I be sure I'm not infringing their copyright?

Unfortunately, you can't—until, that is, you've been hauled into court and vindicated by a judge or jury. Short of that, the safest course is to get legal advice about your specific question. Short of *that*, you're rolling the dice.

A major misconception is that you're in the clear as long as you "change more than 20% of the image" or "enlarge the image by at least 30%" or do anything else with it by *x*%. Not true.

The law generally requires that you "transform" the image, but courts around the country have interpreted that word differently. One court recently said that "transform" refers to the *purpose* behind the change, rather than its physical nature. It's not whether you tripled the size of someone else's photograph, or even turned it into a painting; it's how the purpose behind your work differs from the purpose behind the original. But that's just one court's opinion, and there may be a new standard by the time you read this book.

If you get permission to use the original image, you're home free. That's what licenses are: formal permission slips from copyright owners that allow others to use images protected by copyright. You usually have to pay for a license, though, and you can't force someone to give you one.

The only other safe route is using images already in the "public domain," meaning no one has the copyright to them anymore. Anything published before 1923 is in the public domain, but it is ridiculously complicated to figure out whether something published after 1923 is in the public domain. Once again, you really can't be certain without consulting a lawyer.

—Attribution

Do you want credit? If so, what kind? Just your name? The title of the image? A full copyright notice? Do you care if it's next to the image or are you okay with it appearing somewhere else on the menu? Do you want approval over how the credit looks, or where it's placed?

—Approval

Do you want approval on the physical printing? Will you care if the colors come out slightly differently because of printer settings?

—Exclusivity

Are *you* going to be limited in any way, in terms of what you can do with your image? Does the restaurant want some degree of exclusivity to prevent you, for example, from licensing the image to another restaurant down the street? Maybe the restaurant wants *total* exclusivity, meaning you wouldn't be able to copy, display, or distribute that image (or license it to anyone else) for

I ONLY PAINT PICTURES THAT APPEAL TO A VERY WIDE AUDIENCE SO I CAN LICENSE THEM FOR CALENDARS, MUGS, PUZZLES, FLAGS, GIFTWRAP, DECALS, TEE SHIRTS, HAND BAGS, MOUSE PADS AND ALL SORTS OF TACKY CRAP.

the duration of the restaurant's license—are you okay with that? Is the restaurant paying you enough for that level of ownership?

When you're licensing to a company, it will typically have its own written form to fill out. Take it to a lawyer before you sign, as written licenses have a lot of legalese. (And beware the license that *doesn't* contain legalese—you may be giving away more than you realize). If you're licensing to a small business that doesn't use its own form, you can find legal resources online with sample templates—the *Art Law Journal* has a decent one, for example— but, again, take the template to a lawyer for help and customization. Don't do this at home!

Day Jobs

What you make from your day job falls under Earned Support. See chapter 2 for details and suggestions.

CHAPTER 7
——————— Showing Your Work

————— "I strongly advise artists to take matters into their own hands. Nudge, advocate, innovate, or disrupt the complexion of the art world in whatever way you see fit. Much of the art world as we currently know it was conceived and created by artists in exactly this way." **Matthew Deleget, artist, curator, educator, founder, Minus Space, Brooklyn, NY**

————— "We have an obligation to guide artists toward a fuller idea of what being an artist means. It means participating in your community. It means showing at nonprofits as well as commercial galleries." **Christa Blatchford, artist, CEO, Joan Mitchell Foundation, New York, NY**

————— "Think about the long term. What is going to be the best long-term goal for your work? What's it going to be like in twenty years from now when you've reached mid-career?" **Andrea Rosen, Andrea Rosen Gallery, New York, NY**

————— "Artists today can participate in the art world in various ways, which include garnering support through nonprofits, selling work in the market, organizing opportunities with peer artists, or even taking the work to the streets." **William Penrose, executive director, NURTUREart, Brooklyn, NY**

There are many ways to get your work out there, aside from landing a commercial gallery: online venues, artist-run spaces and collaboratives; nonprofits, art fairs, and venues outside the traditional art world. In this chapter we'll first go through a number of these venues, both physical and digital, and then, for those interested in commercial galleries, talk about how to approach them.

RESEARCH

You can have exquisite images, an impressive résumé, and a flawless statement, but if you send them to the wrong venue you might as well be throwing them out. That's why you need to think seriously about what you want (go back to chapter 2 if you haven't set goals) and look realistically at what is possible given the work you make and where you are in your career. Even if you're a hotshot and there's a lot of interest in your work, you need to take control and educate yourself so you're not just pressured into taking the first opportunity to come your way.

The kinds of questions you asked yourself in chapter 6, when you were searching for residencies and grants, apply equally to finding venues to show your work. A few more things to consider:

—What's the best context for your work?
—How much control do you want over the way your work is shown?
—Do you want to sell your work?
—How much space do you need to show your work?
—Do you need a venue that can assist you financially?
—Who are your current and ideal audiences?
—Who would you need to work with for that opportunity? Do you think you could work well with them? Do you trust them?

Answering these questions (and the ones in chapter 6) should help you narrow down a list of venues. Once you've done that, make a list of all the artists you respect—no matter how far along their careers are—and read their résumés (they're all

—————— "A lot of artists don't do their research as carefully as they should. I always recommend looking at the list of exhibitions on artist résumés posted online. They are a best-kept secret! On each gallery's site, for example, you are looking at twenty blueprints of how each artist has developed their exhibition career. Where have they shown? What residencies have they done? What grants have they received?"

Kevin Jankowski, director, Career Center, Rhode Island School of Design, Providence, RI

Retro Registries

Slide registries (now extinct) and flat files were the precursors to online registries. Flat files are just that: thin, flat drawers where works on paper submitted by artists are kept by venues. While flat files have almost gone the way of slide registries, there are still a few venues that use them—and truly cherish them. Usually those venues will also provide online access to a digital version of their flat files.

——————— *"Each iteration of our flat file program lasts for a full calendar year and includes up to three works each by about thirty-five artists. All ten TSA NY members review every application independently; this gives us all a chance to learn about new artists from across the U.S. and beyond. We've also taken works from the flat file to art fairs and other programming as it comes up. Of course as a physical gallery space we are also believers in the importance of the materiality of work and the artist's hand, and that the 'aura' of the work (to borrow from Walter Benjamin) has to be experienced in person."* **Naomi Reis, artist, New York, NY, and Tokyo, Japan**

——————— *"I often find artists through registries online. You have to be willing to scroll through. One of my early shows was curated by going through all the slide files at NURTUREart in Brooklyn. I took three hours and looked through all of them, making quick judgments and tagging the ones I felt applied to my concept."* **David Gibson, writer, curator, advisor, publisher, The Gibson Report, New York, NY**

online). You'll probably discover a few venues (and residencies and grants) you haven't heard of. Research them to see whether you should add them to your list.

Now look through your contact list to see whether you have any personal connections to the venues you're focusing on. The people you've met—through your education or open studios or your studio group or whatever art event—can be a huge help when it comes to getting an introduction. Even if you don't need an introduction because you're going to initiate something yourself, you'll need supporters and an audience.

That's why it's so important to focus on your current audience. Those are the people who want to help you. If your goal is a San Francisco–based gallery audience, for example, but you're currently most appreciated by your professors in Pennsylvania, then that kind of support translates more easily into a show at a university gallery or a nonprofit first. You can still aim for a specific gallery, or group of galleries, but you'll probably have to take a few steps to get there (unless one of your professors happens to have a connection). When you're just starting out, your friends may be your only audience. In that case, you'll likely have to build your audience and create your own opportunities before you can get in the door somewhere else.

REGISTRIES AND OTHER DIGITAL COLLECTIONS

One way curators and gallerists find new artists is by combing through the wide range of websites and apps that function as registries, portfolios, collections, and the like. Two of the best-known portfolio sites, as of publication of this revised edition, are Behance and Cargo Collective. State and city art councils host online registries of local artists (and sometimes national or international artists), as do many nonprofits. These institutions often use their registries to curate group shows, urging curators—and sometimes requiring them—to include a minimum number of artists from their registry. The U.S. Department of State's Art in Embassies program even has a registry for inclusion in embassy shows around the world. So it is

well worth your time perusing as many registries and portfolio sites as you can find to decide whether you want your work included in any of them.

Every online registry or portfolio site should have submission instructions on its website. Note that some are open to everyone and some are curated, meaning your submission could be rejected. The most helpful sites are searchable and allow you to upload your résumé and other written materials along with your images. Treat these submissions the way you treat your own website: only put up your best work and don't post anything you wouldn't want the entire art world to know about. If the site lets you tag your work, pick search terms that capture the widest possible audience (without misleading people about your work).

Be careful with any registry or similar site that offers to sell your work. Read the Terms of Use and other fine print carefully. Reach out to artists already on the site to see how their experiences have been before participating. In general, you should evaluate these opportunities with the same rigor you would a physical gallery.

ONLINE GALLERIES AND DIY PLATFORMS

Some "online galleries" are just that: galleries online. They represent artists, present regular shows, and sell work to collectors, just as traditional brick-and-mortar galleries do. On the other end of the spectrum, some of these sites function more like registries, taking open submissions but not selling work. Any platform that digitally presents art can call itself an online gallery. In the end, the label doesn't matter so much as whether a particular site fits with your goals. Once again, you have to do your research.

Online galleries are particularly natural venues for digital and video artists to show their work: no translation or reproduction necessary, as there is for painting, sculpture, installation, performance, etc. That's not to say other artists should avoid online galleries, obviously; you will just need to figure out the best way to present your art in a digital format, as you would for any submission process.

————— "The most significant difference between a brick-and-mortar exhibition and one online is the potential reach and longevity of the show. It feels very democratic to me. Anyone around the world with a viewing device and an Internet connection at any time of the day can visit and it can remain up for as long as someone maintains the URL. There are also few costs. It all comes down to your web design and the quality of the pictures." *Sarah Murkett, founder, Murk & Co., New York, NY*

————— "A lot of Humble Arts' exhibitions are digital now. They don't necessarily have them in a physical gallery and that doesn't take away from the clout they have within the photography space." *Larry Ossei-Mensah, independent curator; cofounder, ARTNOIR, New York, NY*

————— "In 2003, my wife, artist Rossana Martinez, and I built a website that was a platform for artists like us, our community of practice, our tribe. At the beginning, we simply asked the artists we'd been showing with to join us. I'm going to stress here that we had no intention of ever opening and running a gallery. The gallery just came about organically from our online activities. We lopped off half our studio, turned it over to another artist that was part of our project, and said, 'Do something you've never done before, that you've never been given the permission or opportunity to do.' Shows would sometimes last a day, if it was a performance, or a weekend, or maybe a couple of weeks. And it grew from there." *Matthew Deleget, artist, curator, educator, founder, Minus Space, Brooklyn, NY*

You can launch your own DIY gallery on any site or service that allows users to upload content: blogging platforms, social media services, video- and photo-sharing apps, e-commerce marketplaces, etc. These venues offer an inexpensive way to create community, align yourself with artists you respect, and share your images with a broader, more geographically diverse audience.

Keep in mind that while curating a show online seems easier than putting one together for a physical space, in fact, the opposite is often true. The labor and logistics behind a physical show are daunting, to be sure, let alone the risks associated with safekeeping other artists' original works. But there are equally important issues to address with an online show, such as scope of copyright, sales parameters, attribution, exhibition time frames, press inquiries, promotion tactics, and more. So if you're going to curate a show online, reread this book from a gallerist's point of view and think through all of these issues ahead of time. As long as you maintain a professional manner, treat your vendors and artists with respect, and clarify everyone's expectations, you'll be in great shape.

MY PAINTING IS OBVIOUSLY THE BEST ONE.

Finally, a word about community. Cultivating an online community can help you develop as an artist for all the same reasons an off-line community can: it's a network for soliciting professional feedback, receiving personal support and inspiration, and nurturing other artists and art-minded people. And it's a community that may enhance your off-line network as well. Curators will sometimes host real-world receptions to compliment their online exhibitions; online galleries will occasionally develop into physical spaces.

COLLABORATIVES AND ARTIST-RUN SPACES

Another way to get your work out there is to start your own space or form a collaborative (or a "cooperative") and curate shows with others. Some collaboratives only produce and exhibit group work, while in others, members make their own work but curate their shows together. Or maybe you want to take turns exhibiting the work of outside artists. The mission of the group is entirely up to you. Whatever the arrangement, pooled resources and creativity make it easier to rent space and get the word out.

With those advantages come the complications of group decisions and creative differences, so it's good to think through a few issues before opening a collaborative space:

—Who will the members be?
—Will you accept new members over time?
—How will you divvy up responsibilities?
—Will the group need to make decisions unanimously, or by a majority?
—Will this be a one-time thing or a long-term project?
—Will every member get a show? If so, how often?
—How do you decide what to show, whether to sell, and at what price?
—What will the collaborative do with money from sales or donations?
—What happens if a member wants to leave?

An example of virtual/physical overlap
BYOB (Bring Your Own Beamer) was developed by the artist Rafaël Rozendaal as a series of open-source, one-night exhibitions hosting artists and their projectors. They've occurred in spaces all over the world based on the guidance provided by his online FAQ. After the physical events, documentation returns to online space.

———— *"I came up with the idea for BYOB (Bring Your Own Beamer) and then I put the manual online so that anyone can do it around the world. It's an open-source exhibition format. . . . Everything's fine as long as money's not made—it's such a community thing. It's about young people and a platform."* **Rafaël Rozendaal, artist, New York, NY**

———————— *"The current feeling in the art environment is if you don't feel like there's a space that you enjoy going to/are inspired by, you should just start one yourself, and many folks are doing just that. I saw it many times in the Bay Area, and I see that here in Chicago, too. People create exhibitions in their homes, their studio spaces, garages, hallways, kitchens, back/front yards. While it may not reach a huge, broad audience, it's wonderful for building a sense of local community."* **Hillary Wiedemann, artist, Chicago, IL; former codirector, Royal NoneSuch gallery, Oakland, CA**

———————— *"Collaboration allows people to refine ideas in debate and in encounters with difference— difference of experience, of perspective, of values. A diversity of opinions strengthens projects because collaborators are challenged to confront their individual assumptions and either come to agreement as a group or make space to consent to individual expression or dissensus. Collaboration often means balancing interpersonal growth and project output, allowing collaborators to speak up and transform one another as well as the project. But most people have no experience of democracy at school, at home, or at work, so shared decision-making is difficult."* **Caroline Woolard, artist, Brooklyn, NY**

———————— *"The reality is: running a gallery from a fixed-cost perspective is expensive. Paying a staff is expensive. There is a trend of people going back to a salon model, where they're either working in partnership with a developer and taking over a loft space or a street-level space or, if they were lucky enough to do well, doing things in their home. How we engage with art will continue to shift and expand, but it also creates a unique opportunity to rethink how art is intended to be experienced."* **Larry Ossei-Mensah, independent curator; cofounder, ARTNOIR, New York, NY**

———————— *"It is a bad idea for artists to sit around waiting for a gallery to come to them or a museum to discover them. They should take matters into their own hands. Artist-run spaces continually provide the new fuel for new art scenes. It is artists getting together and doing their thing. People like me like it because there is an edge and pure intention. I can't say enough for those initiatives."* **Michael Darling, chief curator, Museum of Contemporary Art, Chicago, IL**

———————— *"The downside of running an art gallery is having to turn away people when you really like their work. At best, you can only show ten artists a year and that's not many. So we do projects some of which are traditional and some less traditional—like a gallery without walls. We wanted to create art with these people so we started a performance radio in the gallery. We wanted to break out a little. Now we're on public radio."* **David Salmela, artist, cofounder, Creative Electric Studios, Minneapolis, MN**

———————— *"I'm seeing the emergence of much more robust artist-run culture, which I think is a very good thing. This culture is largely defined by projects that are temporary by nature. In the short time that they exist, there's a lot of energy surrounding the initiative. I have friends who now say that they could see themselves participating on that circuit for their entire career, without ever having gallery representation. This fills an important need—many artists teach and need an exhibition record—without forcing an artist to adapt their practice to the commercial circuit. It can also facilitate the growth of an artist's practice before they hit the commercial circuit, where change can be more challenging. So it can give an artist the opportunity to cross over, but doesn't necessarily ensure it."* **Paddy Johnson, founder, Artfcity.com**

These questions can suck the fun out of the room in no time, but they're much more difficult to figure out later on, when you discover that your partners had very different expectations than you did.

Some artists start their own galleries in their studios, apartments, or rented or donated spaces. Opening a more traditional gallery space raises fewer "group" issues than starting a collaborative, but it is no cakewalk. As the saying goes, with great creative control comes great administrative responsibility.

Even if you're not up for starting your own space, you should research artist-run spaces in your area to see whether they make sense as places to show your work or propose a project. While you need to approach them in the same professional way you would any other gallery, they're typically more approachable and understanding, since they know exactly what you're going through.

Larger cities, and the areas surrounding art schools, typically boast the highest number of artist-run spaces. These spaces often show the most interesting work in the region, because the artists/founders running them tend to be far more nimble, and feel far less commercial pressure, than traditional gallerists. These venues are mined by press, curators, and gallerists for "undiscovered" talent and new ideas. Unfortunately (or maybe it's fine!), "less commercial pressure" typically translates to commercial failure; these ventures are often exciting and worthwhile, but short-lived.

NONPROFITS

Because nonprofits, by definition, do not have a commercial focus, they provide a crucial space for more experimental, cutting-edge work, often by lesser-known artists. This is how many installation, performance, social practice, and new media artists get their start.

Nonprofits do not work with the same stable of artists over many years, the way commercial galleries do. Every show will

You're So Alternative

People throw around the term *alternative space* to mean just about anything that isn't a commercial gallery. (Although you can probably find commercial galleries that consider themselves "alternative," too.)

We focus in this chapter on the most common alternative spaces in the art world, but if you're enterprising you can create an alternative space just about anywhere. Artists find ways to show their work in libraries, botanical gardens, science centers, natural history museums, and hospitals. If you think the context fits, by all means put your work there.

The "space" doesn't have to be three-dimensional, either. Books, catalogs, 'zines, podcasts, and project-specific websites are all "alternative" spaces for interesting shows and the sharing of ideas.

Nonprofit Auctions

Many nonprofits hold auctions of donated work to raise money for their programs. This is a fantastic way to get your work and your name out there.

Three things to keep in mind:

1. Donating work is like donating money. Give to organizations you feel strongly about. Once you do it, every place in town will start asking you for more. Pace yourself. Learn to say no.
2. Don't donate crappy work. If you wouldn't put it in a show, don't give it to a benefit.
3. Historically, when collectors donate your work, they've been able to deduct its market price from their taxes. When you donate your work, you can only deduct the cost of materials.

———— *"So many good things have come from giving work to nonprofit auctions. You believe in them and your work goes out into the world to a new group of people. Those people sometimes come back to you or their friends do."* **Jane Hammond, artist, New York, NY**

include new artists, meaning your chances of fitting into a show at a nonprofit are much higher than at a commercial gallery. In fact, nonprofits often solicit proposals for exhibitions and events, so you're actually *expected* to approach them with ideas about showing your work. And while they don't usually sell work, their shows can lead to direct sales or come with stipends.

It's easy to research nonprofits because they have clear mission statements posted on their websites. Use these statements to narrow your list the way you did in chapter 6 with foundations.

Academic Nonprofits

Academic nonprofits, such as university galleries and university museums, are also potential venues for your work. Given their educational mission, they are particularly well suited to art that is theory-based, art-historical, conceptual, experimental, or that demonstrates an advanced technique. Showing at a school has a few perks: you're allowed to draft a team of student "volunteers" or paid assistants to help make and install your work; there's usually a budget for some sort of brochure or catalog, which makes for an impressive addition to your submission materials; and, most important, your work will be recognized as withstanding academic scrutiny. In return for the exhibition, the university may ask you to teach a class, give a lecture, or do studio visits with the students. If you get a stipend, it won't turn on sales.

Some school galleries are the hottest venues in town, while others cater to the campus population. Don't undervalue an academic venue just because the student population is small, as it may still be an opportunity to work across disciplines and influence the next generation of artists and thinkers.

Museums

You usually have to gain considerable attention before a museum will look at you. But that doesn't mean you can't participate in museum programs and get to know the curators. The museums in your area might offer programs for local artists. They may

have education departments and installation crews that hire artists and residency programs within the space. Some museums even take submissions and curate project spaces dedicated to local talent. It doesn't hurt to get involved in one way or another. Even if it doesn't lead to a show, you'll expand your circle of artists and curators. Younger curators outside of major art centers are especially open to community artists and they will often go to open studios and other events.

ART FAIRS

In the early 2000s, when art fairs (essentially trade fairs for commercial galleries) gained in popularity as a showcase for contemporary art, it was nearly impossible for an unrepresented artist to participate as anything other than a viewer. Slowly, fairs for artists only (featuring artist-run booths as opposed to gallery-run booths) began to pop up with varying degrees of prestige. Almost twenty years later, art fairs are an integral part of the contemporary art market and many nonprofits, publications, and artist-run galleries are known to participate in even the most selective fairs.

With this expansion of the sector, it is possible to participate in an art fair even if you are unrepresented. Commercial galleries may test your work in front of a broad audience, or nonprofits may exhibit your work as an example of the type of work they support. Some fairs even have open calls for their video program or solicit artists for work in their lounges or other public spaces. In this section, we'll talk about artist-only fairs and, later in the chapter, explain how art fairs play a key role in your research.

If you want to participate in an artist-only fair, you apply to them as you would anything else and, if you're accepted, you get—that is, you pay for—a booth or a hotel room and typically three or four days to sell your work.

Participating in an artist-only fair will make you sympathize with galleries in a way you never thought possible. You will stand for hours on end. You will have to talk to lots of people, and then

———— "Does a bigger institution equal greater impact and reach? Maybe? I think it means reaching a more general audience and the level of press is higher and more frequent when you have a PR company on retainer. But big and more isn't always better. Institutions feel faceless—people will drop by, but they don't necessarily have the same attachment to the program, and thus desire to support it and talk about it, the way they do with smaller organizations that can feel like family." **Shannon Stratton, William and Mildred Lasdon chief curator, Museum of Arts and Design, New York, NY; founder, former director, Threewalls, Chicago, IL**

———— "We are looking everywhere for artists. We look at the submissions when they come in, for sure, though it sometimes takes us some time to get through them. These are artists who are taking the time to introduce us to their work and, in most cases, have made a thoughtful effort to give it to us in the best light." **Peter Eleey, curator, PS1 Contemporary Art Center, Queens, NY; former curator, Walker Art Center, Minneapolis, MN**

———— "For the most part, artists have already worked through the early stages of their art careers by the time they get to SFMoMA. However, when I was an assistant curator there, my job, and the jobs of the other assistant curators was to have a relationship with the local art community. We did the SECA [Society for the Encouragement of Contemporary Art] art awards every other year. We solicited nominations from two hundred to four hundred people in the art world in San Francisco. Then we invited nominated artists to submit." **Alison Gass, director, Smart Museum of Art, Chicago, IL; former curator SFMoMA, San Francisco, CA**

———————— "When I did Geisai, it was amazing. I met more people in one weekend than I would have in a year. I didn't know what anyone looked like, so other artists pointed out collectors and curators coming through. I got to know who they were and when they came in, I was thrilled. I developed a great respect for the gallerists doing the fairs—it was absolutely exhausting." *Blane De St. Croix, artist, Brooklyn, NY*

———————— "I participated in the POOL fair to get feedback on my work. I think others thought they were going to get their big break. I got lots of great feedback and had conversations about my work, which made it worthwhile." *Leah Oates, artist, curator, writer, Brooklyn, NY*

you will have to talk to more people, and then more people. It will start to hurt when you smile. You'll explain your work over and over and over. You'll answer the same questions over and over and over. And then you'll do it all again the next day, and the day after that.

But that's what experience is, and there's no better way to practice all the skills we talked about in chapter 5 than running your own booth at an art fair. You'll need to know your prices, prepare your invoices, and be ready to pack and ship your work anywhere in the world (see chapter 9). And all that explaining will help you learn how to talk about your work clearly and effectively.

It's also a chance to meet curators and galleries interested in unrepresented artists, as well as expand your circle of artist friends.

A few issues to think about:

1. Before you sign, read all the fine print and ask the fair organizers what they provide. Advertising? Shuttle buses from larger fairs? Email blasts and press outreach? What do they expect of you? How will they spend your money?

DID YOU BRING A COMPASS?

ART FAIR

2. Don't expect to make back everything you spend on the booth, travel, and shipping. Success is often breaking even, and not everyone "succeeds." Decide whether the exposure, and whatever the fair provides you, justifies the expense. Many galleries consider part of the fair cost as advertising or marketing. (Hotel fairs end up costing less, by the way, because you can sleep in the room.)

3. Find out what the walls are made of and whether you are allowed to drill into them. See chapters 5 and 9 for more on installation issues.

4. Most fairs provide the same, neutral sign for every booth and won't let you use your own. Ask before you spend a long time making a pretty sign.

5. Fairs do not provide wall labels so you'll have to make your own labels. A price list is also a good idea.

6. Ask whether the fair provides storage for packing materials. If it doesn't, disguise them as tables or pedestals.

7. Find out what the floors are made of. Carpet is a godsend. Concrete is not. Dress accordingly.

8. Don't forget your business cards and a sign-in book to capture contact information and notes on your visitors.

9. Bring a laptop or tablet to display your other work.

———— "Advice for artists participating in the fair: Present your hotel room like your solo exhibition space for the duration of the fair. Hang it thoughtfully; don't try to cram in all the work from your studio. Less is more. Invest in lighting your show properly, as hotel room lighting is rarely sufficient. Have plenty of collateral available: business cards, CVs, price lists, and by all means please have some way to capture emails and contact information from visitors to your room. Sales often do not happen during the weekend of an art fair, but they do happen down the road, if you are diligent about keeping in touch with your new contacts made at the fair and following up. Finally, if you are uncomfortable with being alone, and/or speaking with the public for three straight days, hire or ask a friend to help you. Assistance during the marathon of an art fair is invaluable and provides a more professional approach to your exhibition." *Steve Zavattero, cofounder/director, stARTup Art Fair; former gallery owner, San Francisco, CA*

VENUES OUTSIDE THE ART WORLD—CAFÉS, POP-UPS, PARKS, AND MORE

Go back and review your goals from chapter 2. Think about the content of your work and your target audience. Who are your ideal viewers? Maybe they're not at gallery openings. Maybe they're at a botanical garden, or they work at a hospital or local

————————— "I would not say a restaurant, out of hand, is a good or bad place to exhibit. It depends on many things, especially what the respect level will be for the work. One could say that no exhibition is a bad exhibition, especially at a more emerging period of your career. However, if there's a lack of respect for your work on the part of the hosting venue, something could go wrong, and in a restaurant that is possibly more likely. Your work could get damaged or stolen. Is it worth it to exhibit somewhere at any cost?" **Catharine Clark, Catharine Clark Gallery, San Francisco, CA**

————————— "I think that in the beginning, the artist should try to show anywhere they can only because it shows them what goes into doing an exhibition. For better or for worse, whether it be at a café or not. They know how to mount a show—what goes into it—and they learn how to work with people. One should not keep it on their résumé when they approach a higher caliber of gallery, but we wouldn't discourage them from taking those shows early on." **Heather Marx and Steve Zavattero, Marx & Zavattero, San Francisco, CA**

————————— "A simple demographic fact: You have tens of thousands more artists than the art world can absorb." **Joachim Pissarro, curator, professor, art historian, director of Hunter College Art Galleries; former MoMA curator, New York, NY**

————————— "Wave Hill's galleries are unique spaces that are different than the white box galleries in which contemporary art is typically shown. Artists make work that responds to the architecture of the space, the views, the history of our site (a former private estate), our plant collection, and the natural light. All of these elements offer a unique set of parameters for artists to work with." **Gabriel de Guzman, curator, Visual Art, Wave Hill, Bronx, NY**

————————— "It's not like twenty years ago. Now the world is so broad, with everything happening at the same time. There are all these crossovers with fashion and popular culture and so the lines are very blurry.

"I just make whatever's interesting to me—everything else is secondary after that. So you just, ah, it sounds cheesy, but you just follow your heart." **Rafaël Rozendaal, artist, New York, NY**

————————— "Recently, I've become less interested in an 'art smart' audience and more interested in what a lot of museums are doing, which are interactive activities. I'm really into diversifying my audience and there are different ways that I personally have gone about that. One is looking for more opportunities to do events. For instance, the program I did with Big Car Collaborative and the IMA in Indianapolis was a weekend. I did that on the street and then I translated that into a Twitch TV performance where I recontextualized it for people who understood gaming." **Krista Hoefle, artist, South Bend, IN**

————————— "I became interested in working in the public realm for a variety of reasons, both personal and practical. As a new parent, I was increasingly interested in making work that could be experienced outside the rarified setting of the gallery, and by audiences of different ages and backgrounds. I was excited to move my paintings in three dimensions and to reach new audiences in the process. As I started to explore opportunities for larger-scale, site-specific work, I also realized that there were significantly more opportunities to make publicly funded art than, say, gallery exhibitions or representation. I now feel I can move freely between the two realms, depending on what opportunities come up. It is freeing to know that you can work back and forth between different media, processes, and scales." **Ann Tarantino, artist, State College, PA**

——————— "I returned to Minneapolis from graduate school and shopped my work around. Unfortunately, there were no venues for the conceptual type of work that I was making at the time. Even though I had never worked at a gallery, I decided to start one that would provide a platform for this type of work. Midway was an artist-run space from the beginning. We established it as a nonprofit in part because of what we perceived as a lack of a collector base here in Minneapolis, but also because of the non-commercial type of work we wanted to show. And we wanted to work with different artists every single year as opposed to working with a stable of artists like a commercial gallery." **John Rasmussen, director, Midway Contemporary Art Center, Minneapolis, MN**

——————— "I lived with my friend, Tim Brower, in an old sporting goods storefront called Bodybuilder and Sportsman Inc. Part of the space was a makeshift motorcycle repair shop where Tim and another roommate fixed Nortons and BSAs. We lived in the back of the space and decided to turn the front fifteen feet facing the street into a gallery. Our intent was to give exposure to our friends who weren't getting much attention in town. At first we were open only on Saturdays. We split the time in the gallery and divided the cost of the announcement cards with the artists. At the time, you could get five hundred cards from Modern Postcard for $99. We served Old Style beer for a donation of $1 per can." **Tony Wight, manager, Spencer Fine Art Services; former director, Tony Wight Gallery, Chicago, IL**

——————— "Nonprofits played an important role for me. In a way, it was an extension of graduate school because there was such a youthful atmosphere. Many of the curators that ran those spaces were about the same age and I was showing in a very mixed group. Sometimes with old friends and often making new ones. It was a wonderful, mutual support system and very exciting." **Charles Long, artist, Mount Baldy, CA**

——————— "Any smart person can figure out how to lay out a show to varying degrees of quality and success. It's not so hard. The challenge comes when it's time to invite people. All that work doesn't matter if you don't get writers, collectors, and curators through the door. If they don't come, it's just a party for your friends, which you could have just done at home. It's about being honest about the limitations of your network before you even find a space. To say, 'Okay, what's the purpose of this "do it yourself show"? Is it simply that we're bored and we want to see our work on the walls?' Fine if that's what you want. Is it about finding a gallery to represent us? That's a very specific goal, which means that you need to answer the question: How are we going to get potential galleries through the door?" **Dexter Wimberly, executive director, Aljira, Newark, NJ**

——————— "What Artists Space has always provided, ever since it was founded, is a platform for experimentation. And a place where artists can come and safely experiment to carry out projects. As much as the market has become a very important part of what the art world is about, I think it's really important that there are pockets where the pressure of the market is not as strong. Artists Space's goal, as much as possible, is to support those artists in making things happen in a professional context so they can carry out ambitious projects without pressure to sell." **Benjamin Weil, artistic director, Botín Centre, Santander, Spain; former director, Artists Space, New York, NY**

——————— "The people the Soap Factory prioritize are emerging artists and we give them an expansive space that they wouldn't normally be given at that level. Because it is a place of experimentation, if shows don't turn out the way that was expected, that's seen as part of the learning and figuring out what you are doing as an artist." **Ben Heywood, independent consultant, Seattle, WA; former director, Soap Factory, Minneapolis, MN**

politician's office, or attend school. Are you going for mass viewership? An exhibition at an airport or a spread in a newspaper might make sense. Always keep your eyes open for interesting exhibitions in unexpected places. Look for spaces that could benefit from your exhibition.

Museums and nonprofits outside the art world may still present artwork to their audiences. The Museum of Mathematics in New York City, for example, often utilizes artwork to visualize complex mathematical principles. The Exploratorium in San Francisco highlights the intersection between science, art, and human perception. Many banks, law firms, and insurance companies own impressive collections and exhibit work on a regular basis. Government buildings and libraries often put on rotating exhibitions.

Pop-up art exhibitions can get a lot of attention and buzz, since they're temporary events, often in high-trafficked locations. Developers and landlords will let artists activate empty retail spaces when they're in between tenants, since art events and the crowds they attract make the space more desirable (and basically serve as free advertising for the building). Whether you're considering participating in someone else's pop-up or you think you want to throw your own, walk into the situation eyes wide open. Make sure the benefit you expect to get out of the experience justifies the money and time you would need to put into the exhibition. (For example, don't sign up to do an inordinate amount of cleanup for a one-night show.) To get an idea of how professionals do it, take a look at No Longer Empty and other nonprofits that take over derelict buildings to show art and galvanize communities.

One thing to keep in mind when dealing with busy retail venues such as cafés and restaurants: the risk of damage can be high while the benefits can be low. People go to these places to eat, drink, or buy clothes. Sure, it's nice to see some art on the walls, but they're not likely to appreciate your work in the way you'd like them to. A lot of them won't even notice it.

As always, there are exceptions to this rule. Some stores set aside separate rooms for rotating exhibits. Some restaurants are known for the quality of their art program. Since these spaces look and act more like traditional galleries, visitors naturally

treat the work more like art and less like décor. In any event, be extra careful with installation and any special instructions. Make sure the work is labeled and you are properly credited. And always confirm that the place has insurance.

Finally, consider the space outside. Public projects come with a particular set of constraints, considerations, and permissions (read more in chapter 11 where we talk briefly about public commissions), but that doesn't mean they're impossible to achieve. While well-established mural projects and public art commissions exist in cities and towns across the country, nonart agencies, community boards, private land owners, and groups of motivated citizens initiate and control much of the work outdoors. Social-practice artists and artists looking for public interaction often thrive in these situations. Does the parking lot of a local grocery store serve your needs better than the nearby gallery space? If your town doesn't have an established outdoor art program, maybe you should approach local businesses, community groups, or the town council about starting one.

———— "The public realm is currently on fire as a place for creative engagement, opportunities, and funding. Artists interested in making the leap should take baby steps first. Look for calls or opportunities for temporary projects that will be on a short timeline and a small investment for your time and talents. Those projects will give you a sample of what the process may be like and help you determine if you want to continue working in the public realm. Once you can show you have successfully navigated a project in public space, it opens the door for future commissions. The commissioning group almost always contacts your references and many of the questions will relate to your professionalism and ability to work within the framework of the process. In my experience, there are as many questions about you as the quality of the piece." *Kim Ward, principal consultant, RabenArt, Huntsville, AL; former director, Washington Project for the Arts, Washington, D.C.*

——————— "When good things happen, you have to understand this isn't something you can put in the deep freeze and pull it out and reheat it any time you want. This person is interested in you right now; in six months they might be dead or have moved to Europe. You can't save all these things. Almost everything is conditioned by its moment. You have to rise or not rise in the moment." *Jane Hammond, artist, New York, NY*

——————— "In the beginning I said yes to everything. And I did a whole bunch of exhibitions and projects whenever there was an opportunity to experiment with a space. Even if it was a very narrow space in a small, far-away city with no audience. It didn't matter because I got to experiment. With shows that are more marginal, you take more risks because you're not worried about all the famous critics seeing it. When you're not worried, you actually do better work.

"But at some point, you should only say yes if it's super exciting. Let's say you have three solo shows and a bunch of group shows, so you're actually quite busy. If somebody comes up and it's not super exciting, don't do it. I usually just explain that I want to do things with maximum focus, so I don't commit to too many things." *Rafaël Rozendaal, artist, New York, NY*

Should You Ever Say No?

——————— "Early in my career, I never said no. I eventually came to the idea that it was better to wait for the right situation—something I was comfortable with and I could grow with. My modus operandi of just saying yes to every person probably wasn't the best. I could have hung out, making work, waiting for something more solid. At the time, I did the best I could with the information I had. But then I learned the hard way that it was better to just be patient and not go all out in a context where people won't see it. It comes and goes and nobody knows." *Fred Tomaselli, artist, Brooklyn, NY*

——————— "I don't think you should say no. I just don't. You never know what an opportunity is going to be." *Eleanor Williams, art dealer, independent curator, Houston, TX*

——————— "There's a power to knowing you don't want to do something and then being able to express to the person why. But in all fairness, you have to earn that. In the beginning, you can't be too fussy. Nobody ever rings a bell when you're allowed to say no, so you have to figure it out. One way you figure it out is you say yes to things when you should have said no. And then you go through the experience and feel degraded and pissed off and you reassess." *Jane Hammond, artist, New York, NY*

——————— "I feel strongly that artists need to realize their art can survive all the different curatorial contexts it is put into. To control it and limit it denies the work that robust quality of being able to mean something to this person or that person. It needs to transcend the curatorial concept. If it can only fit into one box, it's not going to last that long. One artist I know did not want to be in a group show because she only wanted her art to be seen on her own terms. Another artist was intent on writing the catalog on her own show because she wanted to control the interpretation. It revealed a lack of confidence in the work and its ability to speak on its own in the world.

"However, there is something an artist once told me—if you lay down with dogs, you're going to get fleas. Artists need to be hyperaware of the galleries they choose to show in and, if they find out a group show they are going to be in is filled with artists who are not very good, or the place has a bad reputation, they should stay away from it. It is better to develop a cult following as an unknown than slumming it with not-so-rigorous artists." *Michael Darling, chief curator, Museum of Contemporary Art, Chicago, IL*

————— *"Saying no is great! If you've already had some exposure, say no to the things that aren't quite right—even if it's pretty right, but it's not quite right. Saying no in those cases leaves you time to prepare yourself for when the right thing comes along. I've had some nice opportunities that could have been great, but they were not what I really wanted. There's only so much time you can put into making great work. What artist isn't scraping for that time?*

"A friend of mine has an interesting formula. She asks herself three questions. If the answer is yes to at least two, she will say yes to the opportunity:

1. Is the money good?

2. Is it an opportunity that brings something to my career or body of work?

3. Is it personally fulfilling?"

Charles Long, artist, Mount Baldy, CA

————— *"If something is offered to me, I will research the space and scratch around a bit. Often things are gained by taking a chance on an offer that looks dicey or risky. You learn about your own work and how to deal with people. Sometimes it's a huge drag and a disappointment, but other times it's wow. Remarkable."* **Michelle Grabner, artist, educator, critic, curator, Milwaukee, WI**

————— *"Part of me wants to say 'Who cares?!' We have become so structured in our approach to viewing contemporary art that there is not enough happening where you can just throw art up on the wall and let the cards fall as they may. And for many artists, there is a moment early in their careers when they feel enormous pressure to exhibit and get feedback, so any opportunity could look good. But, ultimately, when your work is up in a restaurant, it may not be the venue where you will get the feedback and attention you are seeking. I would err on the side of being pickier.*

"When artists ask my opinion about participating in a group show when they don't know the curator or any of the other artists included, I am always skeptical. It could be great and you don't want to come across as a prima donna, but you need more information. If you are asking advice, you have misgivings. If it doesn't feel right, you shouldn't do it. It's not like there won't be another opportunity. In fact, the opportunities that come from participating in a show you don't feel good about may not be the right opportunities. I think people should be discerning. I am not going to work with an artist I don't feel strongly about. Why would an artist exhibit with a curator or in a context they don't feel strongly about? If your work is much stronger than everyone else's, it's not necessarily going to read that way. That is not a discrepancy that is fruitful." **Anne Ellegood, senior curator, Hammer Museum, Los Angeles, CA**

————— *"I really think it's important to work with people you like and if you have a weird vibe about someone, then don't work with them."* **Rafaël Rozendaal, artist, New York, NY**

————— *"Don't feel like you have to say yes to everything, because there will be another opportunity. Don't move with fear. Be judicious and be selective. Don't be difficult, but make sure you stand up for yourself and if you have to say no to something, just do it. And don't feel bad about it."* **Jamillah James, curator, ICA LA, Los Angeles, CA**

Top Ten Ways Curators and Gallerists Find Artists

1. Artist recommendation
2. Curator recommendation
3. Social media or other online presence
4. Seeing a solo or group show in person
5. Art fair
6. Submission or open call
7. Social event
8. Jurying a show
9. Open studios
10. Registry or flat file

——————— *"I am interested in working with artists to realize projects that might be absurd or difficult. I am also interested in showing art in places that are not necessarily devoted to it and therefore create new, unexpected connections between an artwork and its surroundings, providing new possible readings. I am interested in providing tools, knowledge, assistance, and resources for an artist to produce artworks that make a difference in his or her understanding of his or her work, and I am interested in providing tools, knowledge, resources, and assistance in producing works that will make a difference in the way the public perceives a certain artwork and even—to be very ambitious—the very definition of art. I am interested in doing what is not there, what has not been done. I am interested in witnessing the moment in which a new artwork comes to exist and creates that strange space around itself that demands our attention."* **Massimiliano Gioni, artistic director, New Museum, New York, NY**

——————— *"I'm looking for someone who is dead serious about being an artist. There's no plan B that they are simmering on the back burner."* **Dexter Wimberly, executive director, Aljira, Newark, NJ**

——————— *"Word of mouth is how we built and grew Minus Space. For the first few years, it was exclusively by word of mouth, mainly artist to artist, and this definitely continues today. I learn about new artists in a lot of different ways, including solo and group exhibitions, online publications, as a juror on award panels, through emails and social media, and, of course, through referrals from the artists I work with, as well as curators, writers, and collectors who know my particular interests."* **Matthew Deleget, artist, curator, educator, founder, Minus Space, Brooklyn, NY**

——————— *"I have to admit that I've come to rely more on word of mouth than I used to—I think I used to be reluctant to do that because I felt like I had to do my own leg work. Somehow asking for recommendations seemed like cheating or taking a shortcut! I've definitely come around on that. Artists in fact can be the best sources for recommendations of other artists."* **Lauren Ross, curator, Richmond, VA**

——————— *"I trust artists' judgment because they're artists. They produce work, so they know how challenging it is. They're going to be as rigorous in their assessment as any curator or critic would be."* **Larry Ossei-Mensah, independent curator; co-founder of ARTNOIR, New York, NY**

——————— *"As much as curators want to meet every artist in the universe who's working and to be aware of what everyone is doing, it's not possible. So the thing that I say to artists who are interested in meeting a curator, is that other artists are their biggest advocates. They have to make sure that they are keeping the lines of communication open with artists that are in their immediate circle."* **Jamillah James, curator, ICA LA, Los Angeles, CA**

———————— "I've had a weird career that some have called slow and steady. I never made a big splash. I was showing in more low-key galleries and grew into my life as an artist in dribs and drabs. It wasn't like one day no one knew my work and then, the next day everyone was talking about it. Maybe it's a little more solid for me because of that." **Fred Tomaselli, artist, Brooklyn, NY**

———————— "Usually cities have artist cooperatives. I think sometimes those artist-run spaces do really innovative programming and the artists that they choose to show are artists who are really committed to their craft. So I tend to look at those spaces to see new, upcoming artists. I think once you get out of school, being involved in some sort of organization like that is crucial. It gets your work out there and starts that network going, and that is such a big thing." **James Harris, James Harris Gallery, Seattle, WA**

———————— "How can you get your work shown? Be part of the artist community. When I'm coming to Detroit and I'm asking the local scene in Detroit about their artists and no one names you, then I don't know you exist. I'm not going to find you." **Deana Haggag, president and CEO, United States Artists; former executive director, The Contemporary, Baltimore, MD**

———————— "I go see a lot of things; I go to galleries, museums, and I do lots of crits at schools. I keep tabs on artists who I think are interesting, that I've seen when they were getting their MFAs. But hands down the best source for artists is other artists, word of mouth. If you want to contact a curator, tell an artist you know to tell them to look at you and they will. Almost always, if an artist tells me, 'You should look at this,' I do it." **Denise Markonish, curator, MASS MoCA, North Adams, MA**

————— "Study the scene. Get to know the bigger picture and the smaller picture. Come up with a list of galleries you feel an affinity for. What artists do they show? Who is working there? Make yourself a familiar face. Be an engaged member of the audience. Ask interesting, interested questions. Think long-term. Think a forty- to fifty-year career. Invest yourself in the culture." **George Adams, George Adams Gallery, New York, NY**

————— "Any artist who is blindly taking work around is not a good artist. The only artist who is good enough to show somewhere is an artist who feels their work is at the right point and knows in a really intuitive and knowledge-based way that that is the place for their work. They know it will happen. It's not magic. It's very clear. Whether they are looking at a gallery that opened a week ago or a gallery that opened twenty years ago, they know where they are with their work and how confident they feel about it. They know what that gallery is showing and they feel that that is their context. It is based on confidence in their work. It can't be artificial." **Andrea Rosen, Andrea Rosen Gallery, New York, NY**

————— "To be honest, I don't know many curators who end up working with folks from blind submissions—it nearly always comes from seeing the work out in the world and following whatever piques my interest, or from conversations with colleagues and artists I respect. It's my responsibility to see as much as I possibly can, of course, but curators build up a set of critical ideas and interests that hopefully become a part of how their curatorial vision is perceived, so recommendations from folks who understand their thinking can be invaluable as well." **Shamim Momin, director/curator, LAND, Los Angeles; former curator, Whitney Museum of American Art, New York, NY**

VANITY GALLERIES (OR, "ARTIST BEWARE!")

Vanity galleries are spaces that charge artists a fee in exchange for a show. We don't mean an artist-run co-op where everyone chips in to cover costs. We're talking about a business that decides who will be shown based on the price they're willing to pay. And we're not fans.

Most vanity galleries do not close sales and do not receive press. Collectors would rather buy from galleries with more rigorous curation; art critics generally are not interested in who they're showing. If a gallery approaches you promising you sales and exposure in exchange for some "nominal" up-front or monthly fee, think long and hard before saying yes.

If you have the money, you're better off putting it toward your work, or a pop-up space with other artists where you can control the context, send releases to press who are more apt to listen, and invite your audience proudly.

COMMERCIAL GALLERIES

Even after considering the broad range of exhibition options out there, many artists want to get into a commercial gallery. Having a gallery represent you and show your work validates what you're doing and can give you the psychological (and economic) boost to keep going. But it's not easy to get a gallery to notice you, let alone consider showing your work. And the cold, hard truth is that the vast majority of artists out there never land gallery representation. This does *not* mean you should give up on the idea of getting a gallery or, worse, give up on your art altogether. It means you should approach the gallery system realistically; try not to take rejection personally; and recognize that there are many ways to pursue a fulfilling art career without a commercial gallery.

Approaching Galleries

The worst thing you can do for your prospects is mass-mail a bunch of galleries with a form letter saying "I'd be great for your program." Just as bad—though much more demoralizing—is to trek in person from gallery to gallery with your portfolio asking each one to look at your work. Do not do this!

Seriously, don't do it.

It is more than a waste of your time (and everyone else's). What if you "luck out" and a random gallery tells you it wants to show your work? Do you really want to trust your first show to a place when you don't know its program or reputation? A gallery that wants to use your installation work to diversify its all-photography program may not be the right first step for you.

So what *can* you do?

Take Your Time

Young artists have felt increasing pressure to produce show-worthy work right out of school and get a gallery as soon as possible. This might seem like a good thing from the outside, especially when the latest MFA hotshot is picked up by a blue-chip gallery, sells out a major solo show, gets a fantastic review, and sees his or her prices skyrocket. Success, right? Maybe in the short term, but how do you sustain it? You have to be extremely strong to withstand that kind of jump at any point in your career, let alone the first few years. And there's no tolerance in the art world for declining prices, so you immediately face the wrenching choice between continuing with work you know will sell and taking the (now higher-stakes) risk of developing in a different direction.

Truly successful art careers last a long time. It is not "now or never," and you only do yourself a disservice by rushing your career. Having a lot of energy is great, but so is having a lot of patience. It can take years for your work to develop to a point where it's ready for a program you want to be in. That's why one of the first things we said in this book was to make your work constantly. Countless artists didn't "make it" until they'd been making art for decades. So, take your time.

"Name Five Artists in My Program"

That's Mary Leigh Cherry, a Los Angeles gallery owner, expressing a very common sentiment among dealers. "We were joking that if an artist came in our art fair booth to give us a submission, we would say 'Name five artists in our program.' If they couldn't, they are done. Then we thought about it. Could we name five artists in the programs of galleries we approach for work? Yes! Because we've done the research on their program."

Asking a gallery to look at your work is akin to announcing your belief that you fit into its program. So you'd better be ready to explain why you fit in—something you can't do, of course, unless you are familiar with the other artists. This is a good thing. The more you know about a gallery's artists, the better equipped you'll be in deciding for yourself whether it really is the right place for you.

—————— *"The most important thing you can do is become familiar with the gallery program. If you're interested in having anybody see your work, you should go to their openings; you should look at their website; you should watch their program and go see all their shows, for a year—at least—so that you can make a really good case for your artwork being part of a certain program."* **Melissa Levin, vice president, Artists Estates and Foundations, Art Agency, Partners, New York, NY; former vice president cultural programs, LMCC**

—————— *"A lot of artists complain that they don't want to be at every opening, and I get it, but I think they should be strategic. If you know artist X is going to be showing and the people that you're interested in talking with are mostly going to be at the opening, that's a place you should be, where you can at least introduce yourself."* **Larry Ossei-Mensah, independent curator; cofounder, ARTNOIR, New York, NY**

The "One Year" Rule

You should follow a gallery's program for about a year before you even *think* about asking the gallery to look at your work. That means going to see the shows; looking at everything on the website; understanding the program and what the owner is trying to do. (And taking advantage of other exhibition opportunities in the meantime.)

Study Artist Résumés

Just as important as understanding a gallery's program is becoming familiar with the résumés of all of its artists. Those résumés tell you where the artists were in their careers when they started showing at the gallery, and in that sense they reveal the kinds of things that you need to do before that gallery would probably consider you. Doing the same residency as one of the gallery's artists won't guarantee a thing, obviously. But getting a sense of how many residencies or shows the artists have had; whether they've had several solo shows already; how many years into their careers they are—these are all ways of gauging realistically whether you're ready for a particular gallery.

Talk to Other Artists

The best way to hear about how a gallery operates is from artists who have shown there. They can tell you how they were treated, how the place is organized, and whom to approach about submissions. They can give you a sense of the gallery culture so you can decide whether it's a good match.

Go to Openings

If you've got your eye on a few galleries, you should go to as many of their shows as you can. You should make it a point to see what their openings are like. It's a great way to get to know their artists and to see who works there. Just remember that an opening is a social event; it is not the best time to see the art. It's

probably the worst time. You're there to see what the place is like and how it's run. You can always go back on a normal day to get a better look at the show itself.

Speaking of going back: there's a fine line between becoming a familiar face and becoming a nuisance. Use your judgment. You don't need to go to *every* opening. You don't need to strike up a conversation with the staff *every* time you walk in the door. They know what's going on; they'll understand why you keep checking out their shows.

If you don't live in the same city, keep track of the shows online and then make a trip at some point to visit the gallery in person. Coming from out of town is a good excuse to interrupt the staff for a quick hello. Tell them how much you like the program and ask what their submission policy is (if it's not already posted online). Asking a question that shows you are genuinely interested in their program is a great idea, too.

Go to Art Fairs (Unless You Don't Want To)

They may not be the best way to see art, but art fairs are the only way to see galleries from all over the world in one place at one time.

An art fair is essentially a trade show. A bunch of galleries—anywhere from fifteen to five hundred—set up booths in a convention center, hotel, or outdoor space, and spend several days selling as much as they can. The biggest and most respected contemporary art fair is Art Basel in Switzerland every June, Miami every December, and Hong Kong every March. There's Frieze in London and New York, FIAC in Paris, and ZONA MACO in Mexico City; Art Dubai, EXPO CHICAGO, and ARCOmadrid; and the fifty-some satellite fairs, such as PULSE, NADA, VOLTA, Spring Break, and SCOPE.

It is *really* expensive for a gallery to participate in an art fair. Booths run from $6,000 for smaller fairs to over $40,000 at the biggest ones. And that's just for the empty space. Add shipping, insurance, airfare, and lodging and a five-day fair can easily run $100,000. Edward Winkleman estimated this budget to attend a London art fair back in 2007:

——————— "These days, unfortunately, there is an expectation of artists that they will show themselves around a little bit. There are of course many who don't, some of whom are successful nonetheless, but they seem today to be in a minority. Clearly many feel that there is a need, certainly when there's no gallery to do it, for them to play the game and get out there. They can do it in a smart manner, seeking out and engaging the right people in dialog. But if the strategy is limited to turning up at every opening only to spend the evening with a beer in your hand, it can become tiresome." **Jasper Sharp, curator, Kunsthistorisches Museum, Vienna, Austria**

——————— "I often receive emails from artists I've never met before in person, who've never visited the gallery, who have absolutely no idea what I show, asking me for a solo exhibition. This is the worst possible first impression and totally avoidable." **Matthew Deleget, artist, curator, educator, founder, Minus Space, Brooklyn, NY**

—————— "Art fairs have dominated the markets, spreading tendrils into museums, pop-ups, real estate investment schemes, and virtual economies. The impact on the brick-and-mortar galleries is threatening their actual survival." **Jonathan Schwartz, CEO, Atelier 4, Long Island City, NY**

—————— "When you approach a dealer at an art fair, that blank look on their face is them trying to calculate whether they can fit your corpse into their crate and ship it back." **Edward Winkleman, cofounder, Moving Image Art Fair; author, former director, Winkleman Gallery, New York, NY**

—————— "I know several artists whose production schedules focus for months on end on one fair after the other. The demands made on them have completely changed the way in which they work. When an artist has two or three galleries, and each of those galleries is doing four or more fairs a year, they are expected more often than not to produce work for those fairs. Two years of work, which traditionally would have become a show, is now only briefly shown in the context of an art fair." **Jasper Sharp, curator, Kunsthistorisches Museum, Vienna, Austria**

—————— "I understand a lot of people will only see work at art fairs, so occasionally I give a piece to a dealer for a fair with the proviso that they have to get it back for my show. It takes me so long to make a piece, if a collector really wants it that badly, they have to loan it back for the show. Otherwise, I wouldn't have enough work for my exhibition. I've only been to one art fair. It made me feel like the screaming Edvard Munch head." **Fred Tomaselli, artist, Brooklyn, NY**

—Booth: $31,000
—Booth extras (electrical outlet, extra wall, etc.): $2,300
—Crating: $5,000
—Shipping both ways: $25,000
—Empty crate storage: $1,000
—Art handlers to install and deinstall booth: $3,000
—Air travel for gallery staff of four: $2,000
—Hotel for staff: $5,600
—Lunch for staff: $720
—Dinners with clients: $2,500
—Cell phone roaming charges: $1,500
—Car service: $400
—Party for clients: $20,000
Total: $100,020

The biggest "blue chip" galleries spend even more. The costs are apparently worth it, though, since a gallery can make more than half its *annual* revenues at an art fair.

Should You Go?

While there are a few fairs that try to import noncommercial values into the selection and presentation of work, by "curating" the fair, requiring solo exhibitions, or including noncommercial entities, most art fairs treat art like a pure commodity. Galleries are condensed and lined up in rows and rows of claustrophobic booths, where they typically show as much of their program as possible to the hordes of collectors, curators, and spectators marching by.

This commercialized context can be a difficult thing to be exposed to, which is why some artists never go to art fairs and a few even refuse to let their work be sold at them. Plenty of artists do attend, though, either out of grudging curiosity or because they know it's the best way to get a snapshot of what's out there and to keep up with people in the art world.

Bottom line: don't feel obligated to go, but know that there's a lot to get out of it if you do go.

Art Fair Survival Guide

Here are few ways to take the edge off your art fair experience:

—*Do your research.* There can be dozens of fairs going on the same weekend. It's overwhelming to try and see everything. Find the type of fair you want to see first—some emphasize emerging art, some look like they came straight from a museum—and then focus on which galleries you need to visit.

—*Check the schedules.* You don't have to do it all in one day. Look up performances, panels, and other events and time your visits accordingly.

—*Eat before you go.* The food at these fairs is almost as expensive as the art.

—*Wear walking shoes.* You'll be on your feet for hours.

—*Don't go alone.* It's much easier to take everything in when you're with a friend. And more fun.

—*The maps are free—take one.* "Browsing" will only give you a headache. Get a map or download their app at the entrance and visit the galleries you want to see first. Then wander around until your vision blurs.

—*Take notes.* Bring a pen and paper to jot down the names of galleries and artists you like. Use your phone to take photos. Note the shows with work that relates to yours.

—*Look for prices.* This is the time to get a sense of the price ranges for different kinds of work. They won't always be on the wall; you may need to ask or look in the paperwork that galleries usually set out on a table in the middle of their booth.

—*Leave the staff alone unless you're going to buy something.* This is absolutely the worst time to introduce yourself to a gallerist. Obviously you can say hi to anyone you already know, but even then you should make a point of making it short.

Then What?

So you've gotten to a point where you *know* you fit into a gallery's program, you know who the other artists are, you know who works there. Find out from the artists (or the gallery staff) whom you should approach about looking at your work (maybe it's the director, not the owner) and how (it might be in person, it might be email). And don't be shy about asking artists you know to put

——————— "There is no better way for an artist who may be doing well in a local or regional market to become humble than by going to an art fair. It can also be affirmative seeing exactly how many artists are doing the same thing they are. Artists either crumble or come back stronger. When you start to really look, there are some incredible visions out there. If you can't travel to London or New York or L.A. trimonthly, then going to an art fair is a good way to see everything." **Leigh Conner, CONNERSMITH, Washington, D.C.**

——————— "The main tip is to go, to be there. It's being social in the art world—just like openings. You're present, you're there, and you meet people. If I have an ongoing relationship with a gallery, it's a good way to see them, check in and be present, have them know I'm around.

"It's something that I struggle with because it gets overwhelming at times. But every time I go I'll see something I love, or make a great connection, and ultimately it's always a really good thing. That said, usually I'll leave freaking out a little bit. Overwhelmed, exhausted." **Stephanie Diamond, artist, New York, NY**

——————— "Art fairs are strange because they are such an overwhelming experience. A few years ago I would have said that going to an art fair was a fruitful way to find new artists. But I think art fairs generally have shifted to presenting more of a known quantity and there is less experimentation going on there." **Anne Ellegood, senior curator, Hammer Museum, Los Angeles, CA**

———————— "I really want to emphasize that an artist should do their homework. You should never want to show in a gallery just because it's a gallery. You want to show in a gallery that is the right gallery for you." **Edward Winkleman, cofounder, Moving Image Art Fair; author, former director, Winkleman Gallery, New York, NY**

———————— "Most of the best dealers running good galleries are the ones who are constantly listening to their artists. Because the artist is the most important client of the gallery—and somebody you can trust in terms of their eye." **Tim Blum, Blum & Poe, Los Angeles, CA**

———————— "I've found most of my artists through other artists. I don't think it's a big secret that curators and galleries trust the opinions of the artists whose work they respect more than anyone else. More than other gallerists and other curators. Artists are the most discriminating because they want to impress you as much as you want to impress them." **Amy Smith-Stewart, curator, Aldrich Museum of Contemporary Art, Ridgefield, CT**

———————— "The best example I have of someone doing their research was an artist who came to almost every show for a year. Subtle introductions. I started to recognize him and knew his name. One day he came in and asked if I would come to his studio. I said definitely. He had put in the work. Over the years he has kept in touch via email. I haven't done anything with his work yet, but I am following his career. He did it the right way and it was clearly obvious that he got to know the program." **Mary Leigh Cherry, Cherry and Martin, Los Angeles, CA**

———————— "Sometimes I know I want to represent an artist. Sometimes I just want to watch. There is an artist I saw in London recently whom I've known for twelve years. Just now I offered him a show." **Shoshana Blank, Shoshana Wayne Gallery, Santa Monica, CA**

———————— "As an emerging artist, you have to be realistic when you look at galleries. You can't all be represented by Sikkema Jenkins—look at the size of the space. We all love Sikkema Jenkins, but you have to be a good, solid midcareer artist before you can fill that room with good work, which is why we have two spaces. We recognized that we moved into a realm where some of our artists can't fill the big room. I don't mean they can't literally fill it—they're not ready for it." **Kerry Inman, Inman Gallery, Houston, TX**

———————— "I do feel like with young artists, you want to see them doing things outside of the system for a while, rather than in an annual exhibit with a gallery. If you are out there, creating opportunities for yourself, there are people who are going to respond to that and you may widen the audience for your work, including the kinds of galleries that might take interest in your career. There is ultimately a career path for everyone." **Catharine Clark, Catharine Clark Gallery, San Francisco, CA**

————————"If an art community doesn't exist in your area (not likely) or you don't identify with the one that does, change it or make your own. Develop a co-op space with some friends, start a blog, or curate shows in your apartment. Art is made to be looked at, talked about, and argued over. What better place to start than your own backyard?"

Jason Lahr, artist, professor, University of Notre Dame; former curator of exhibitions, South Bend Museum of Art, South Bend, IN

——————— "We do an enormous amount of our annual business at art fairs. I think everybody does. It is such an intense week for us and we are trying to stay focused, and I just want artists trying to introduce themselves or show us their work to stay out of our booth. Please! It's the busiest week ever!" **Sabrina Buell, partner, Zlot Buell + Associates, San Francisco, CA; former director, Matthew Marks Gallery, New York, NY**

——————— "I had one artist who I threw out of the gallery and told him never to come back again because he was hanging out while I was working with a client, trying to sell something, and it was just not good business behavior. There's a difference between a familiar face and someone who's annoying. Know that boundary. When you see things happening, you should really step aside or come back at another time." **James Harris, James Harris Gallery, Seattle, WA**

——————— "If you contact me three times and I don't respond, I'm not interested. Three times is the cutoff. I wouldn't ask a guy out more than three times." **Anonymous**

in a good word with their gallery. It's the number one way gallerists and curators find the artists they work with.

Chances are you'll be asked to send an email with a link to your website. Keep it short and simple. Mention any personal connection you have to the gallery (assuming it's okay with that person), convey your interest in the program, and ask whether the gallery would like to see your work in person. Make the link to your website easy to see. Don't include an image in the body of the email (unless you were specifically asked to). Let the gallerist go to your site and see all of your work in context.

What Not to Do

So those are all the things to do in your quest for a gallery. Here are some ways to shoot yourself in the foot. They're not hypothetical. Artists make these mistakes all the time.

1. Don't send blind submissions. It's okay if you eventually contact a gallery that is "blind" about you, assuming you've taken the time to learn about its program, you really believe you belong there, and you can explain why when they ask you. But it's never a good idea to submit your work to a gallery that *you're* blind about. Do your research first.

2. Don't walk into a gallery with your portfolio asking for "just five minutes."

3. Don't bring your portfolio to someone else's opening.

4. Don't "CC" a group of galleries on the same email blast. If you don't take the time to contact them individually, they're not going to take the time to read your email, let alone look at your images.

5. Don't start emails with "To whom it may concern" or "Dear Sir/Madam." You should know the gallery well enough to have a name.

6. Don't ever, ever approach a gallerist you don't know at an art fair and ask about submissions.

7. Don't interrupt a gallerist when he or she is talking to people you don't know. You could be interfering with a sale or simply interrupting a story. It's not the way to make yourself known. Wait till they're in between conversations to say your hello.

8. Don't harass people. It's not easy to read every signal and everyone does things a little differently, but "no" usually means "no." Silence is a little trickier, but if someone doesn't get back to you after a few messages, it's a no.

You May Not Need a Gallery (Really)

This deserves repeating: some work doesn't fit in a commercial context. Maybe your work is "too" experimental, or conceptual, or ephemeral. Maybe you work on such a large scale that a gallery couldn't show you. If that's the kind of work you do, you might be happiest working with alternative spaces.

——————— *"An artist doesn't necessarily need a gallery. It depends on what part of the art world you want to be in or what kind of artist you want to be. We tend to think of the art world as one singular thing and it's not. The magazines, the fairs, NYC, LA— that's just one version. More importantly, what are your goals and aspirations? How do you define success?"* **Howard Fonda, artist, Portland, OR**

CHAPTER 8

—————Rejection: It's Not You, It's Them

———————— "We narrow the pool from three hundred to twenty-five. Then we take the twenty-five and pick four. Probably any of those twenty-five people, if they got into the program, would be okay. Some of the people who are our star alums were wait-listed. And, there have been very well-known artists who have not gotten into our program and probably would have been great in our program. After the twenty-five, it's a little bit of a crapshoot." **Joseph Havel, artist, director, Core Program, Houston, TX**

———————— "Sending in an application or work samples in response to an open call for a show, residency, or other program is a great way to get your work seen by arts professionals. Programs will often have rotating juries selecting work, so it's important to apply more than once and not be discouraged if you're not awarded the first time you apply for something. But if you do reapply, it's important to show progress because there might be someone on the panel who's seen your work before." **Melissa Levin, vice president, Artists Estates and Foundations, Art Agency, Partners, New York, NY; former vice president, cultural programs, LMCC**

———————— "While artists may suspect dealers get a secret, vile pleasure out of saying no, the real pleasure comes from saying yes. To give artists their first show is hugely interesting and fun. Talking artists through their anxieties and working collaboratively is hugely gratifying." **George Adams, George Adams Gallery, New York, NY**

———————— "There have been times when people told me, 'Oh, you should apply for this residency. It's a done deal; it's just a formality.' And then I didn't get it. It's a bit of a bummer, but it's also important not to attach any emotions to the outcome because it's a lottery with higher chances than the real lottery, but it's still a lottery. It doesn't say anything about the quality of your work." **Rafaël Rozendaal, artist, New York, NY**

To become a professional artist is to court rejection. We don't know a single artist who hasn't been rejected from *something*. The odds pretty much guarantee it.

There are roughly two hundred thousand fine artists working in the United States. Some three hundred art programs across the country produce around ten thousand BFA and MFA graduates a year. Many of them want to land New York representation. So how many galleries are there in New York? About one thousand—of which maybe two hundred look at newly minted graduates.

Residency programs with national reputations are just as competitive. The Lower Manhattan Cultural Council, for example, receives about 1,200 applications every year for 15 residency spots. Omaha's Bemis Center for Contemporary Art takes around 40 artists a year out of more than 1,200 applications and Skowhegan chooses 65 people from more than 2,000 applicants.

The only way to face these odds is with grit and persistence. You have to develop some pretty thick skin and take rejection in stride. You simply *cannot* afford to take it personally. Easy to say

THIS SUIT IS SPECIALLY DESIGNED TO SHIELD ME FROM THE STING OF REJECTION.

———————— "There's a difference between failure and rejection and I think it's very important that people understand the difference. Failure is something that you decide. No one can make you a failure. Rejection is purely subjective. Expect it, revel in it, know it will come."

Dexter Wimberly, executive director, Aljira, Newark, NJ

Causes of Rejection That You Can't Control

—gallerist/curator/juror/panelist taste
—your work is too similar to other applicants'
—your work is too different from other applicants'
—your work doesn't balance well with other applicants'
—the program shifts focus to other mediums or styles
—the program budget
—luck

Causes of Rejection That You *Can* Control

—failing to follow directions
—poor-quality images
—sloppy written materials
—not tailoring your submission to the program
—your proposal has unrealistic goals
—not sufficiently describing your experience and background
—failing to make your need apparent

Causes of Rejection That You Can Minimize by Doing Your Homework

—institutional taste: the program never shows that style or medium
—your work isn't ambitious enough
—your work is too ambitious given the program's facilities
—your work does not address the program's mission
—your background and experience don't fit the program
—you don't actually need the program or support

and hard as hell to do. Risking rejection and learning how to handle it are two important parts of your job.

And just so we're clear: you don't have to pretend you're happy to get rejected from a good program or passed over by your dream gallery. Of course that's disappointing and there's no point faking how you feel when it happens. But a rejection doesn't automatically mean there's something wrong with you or your work.

Take residencies: By the time a committee makes its final selections, the decisions aren't just about quality, as there are obviously many more talented applicants than there are spaces. You might get rejected because your work is too similar to that of someone else already admitted that year. You might get rejected because your work is too different from what the program is emphasizing—a criterion that can change from year to year, meaning that you could fit the program perfectly one year but not another.

You also don't know how "close" you were to getting in. For all you know, four out of nine committee members were ecstatic about your work. Don't assume that a rejection was unanimous or that the committee is telling you to quit. That's why we said in chapter 6 that you should expect to apply to a residency several times before getting in or giving up.

Panelists and jurors go on to judge other competitions, curate shows, and work with collectors. The more often jurors see your name, the more likely they are to remember you, and maybe think of you for a personal project or a client—or indeed champion your latest application to a particular program.

As for galleries, very few take on new artists each year. When they do, the quality of the work is the most important consideration—but it's not the only one. A gallerist might love your work but not have the collector base to support it. Or you might work on a scale that is too big for that particular space. Or the gallery may already have a couple of artists who do similar work. Or the gallerist may think you wouldn't actually be happy there (believe it or not, gallerists do think about how their artists feel). Or the gallerist might believe that your personality wouldn't mesh well with the gallery's culture.

Like panelists and jurors, gallery staff frequently change jobs. Someone who loved your art but couldn't show it where she used to work may think it fits her new program. (Nearly all the people

There's always *this* way to deal with rejection. It didn't get the artist a show at the gallery, but the gallerist will never forget him:

<div align="right">12/26/91</div>

Dear gallery director:

 I am sorry to inform you that I cannot consider your gallery an appropriate space for the exhibition of my work at this time, due to any number of the following reasons:

- Bad location

- Poor lighting

- Style of work exhibited incongruous with style of my work

- Lack of reviewed exhibits in art journals

- Lack of advertising in art journals

- Poor quality of work exhibited

- Reputation as 2nd or 3rd rate gallery

- Incompetent or rude staff

- I didn't like the sound of the gallery name

- I was in a bad mood when I visited your space

- I hadn't heard of your gallery before, so I didn't bother to visit

- I hadn't heard of any of the artists represented by your gallery, so I didn't bother to visit.

 Perhaps there are other artists who might be interested in working with your gallery. Best of luck.

interviewed for this book changed jobs between the first and second editions.)

And curators? They may love your work but not be working on a show that relates to what you do. They may initially want to include you in a show but the theme or concept evolves in a different direction—a natural consequence of the fact that shows can take years to develop. Sometimes they don't have final say on who ends up in the show because they have to collaborate with a gallery owner, work within funding restraints, or get approval from an institution's senior curators or directors.

These reasons for rejection are all common—and very few of

them have to do with your artistic ability. So really, *don't take it personally.*

Why can't a gallery just tell me "yes" or "no" right away? How hard is it to write "yes" or "no" in an email?!

Well, it's not hard to write *one* email, but it eats up a lot of time to write hundreds. And galleries receive anywhere from one to fifty unsolicited submissions a day. They just don't have the time to respond to every one. Many times the answer is not as clear as yes or no—it's more like "maybe later, hopefully." It can take years before a gallery is ready to introduce a new artist to its program, or curate a group show where your work fits.

You're Not the Only One Getting Rejected. Galleries Feel It, Too.

———————— *"It is hard to reject galleries. Saying 'no' is one of the most difficult things to say. Who would want to call a friend and tell them that their gallery, whose program you like and have supported for years, has not been accepted into the fair? One of my roles as director is to carry out decisions of the selection committee; this, as one can imagine, is one of the most unsettling parts of the job.*

"The reality is that I personally have no say in who is accepted into the fair, but, of course, no one really believes that. I had a gallery FedEx me a single sheet of paper from the nether regions of Europe after they were rejected from PULSE. They spent $100 just to tell me how angry they were and what poor taste they thought I had (although I don't sit on the selection committee)." **Helen Allen, cofounder and principal, Allen/Cooper Enterprises, NYC**

WHEN DOES "NO" MEAN NO?

It's not always easy to translate what you're told. Most applications are straightforward: you're either in or you're out. But with galleries, nonprofit spaces, and other venues, there's a lot more gray than black and white. Let's say you meet a gallerist or curator who asks you to send them your work. (If you're not sure what that means, check out chapter 3.) You send them everything and you wait to hear back.

We'll go in order from Definitely No to Yes.

—*"We've decided to go in a different direction."*
—*"Your work is developing in a different direction than our own."*
—*"Your work is not a good fit for the program."*
These all amount to a diplomatic no. Getting a letter or email saying something along those lines—and nothing else—means don't hold your breath. You can think about resubmitting later if your work changes and you believe you fit the program better. Asking for more explanation will only exasperate the person who sent you the letter in the first place. If he or she had the time to give you more personalized feedback, you would have gotten it. The reason you didn't is that the person had to send similar letters to a dozen other artists at the same time.

—*Radio silence.*
This is not a no! It's not a yes, either, but it means there's still a chance. Since most shows are scheduled at least a year in advance, no one's going to feel any particular urgency to get back to you right away. It's entirely possible that the person you sent your work to really liked it but has been wrapped up in other things. Gallerists are busy people. They have to tend to their artists, cultivate their collectors, and juggle multiple art fairs every year. Curators are just as busy working on multiple shows.

So what do you do? You don't want the person to forget about you, but you don't want to be annoying. If there is a submission policy, read it again. It may state, for example, that submissions are reviewed every three months, in which case you won't endear yourself to anyone by calling every week. Second, continue going to the openings and following its program. Third, the next time you have a show or event that makes sense to invite the person to, it's probably all right to include him or her on your list. Fourth, send a note about new work, big projects on the horizon, or other exciting news, when appropriate. This is a better way to keep in touch than asking for an "answer" to your submission. We're talking about one or two invites over the following year. Enough to remind the person that you're around and still doing interesting work but *not* so much that he or she feels spammed.

That said, if a clearly stated deadline for someone to respond to you has passed (don't forget to check their website for any timing updates), then *and only then* should you reach out to ask if they've made their decision.

—*"Send us cards/invites to your shows."*
This is not a yes, but it's encouraging. The person likely doesn't think he or she can show you, but is curious about what you'll do and wants to be kept in the loop. Add them to your contact list. Always include a personal note, even if it's a simple "Hope to see you there." Don't expect a response or take offense if they don't come. The goal is to stay on their radar.

—*"Keep us informed."*
—*"Show us your next body of work."*
Again not a yes, but a sign of real interest. You should be happy if you get this kind of response. It means you have real potential at that venue *and* you could end up being a good fit for the program or a group show in the future. The key here is to follow up. "Keep us informed" means just that: you can add the person to your contact list and let them know when you have work up anywhere else. "Show us your next body of work" is a request to send them another submission or link to an updated website when you finish your next body of work. Do it and remind them of their request when you do.

———— *"Artists are courageous and vulnerable. They are putting themselves out there and you don't want to make them feel defeated. Their work may not be right for us, and usually it isn't, quite honestly, but you still want to encourage them to continue their quest."* **Steve Henry, director, Paula Cooper Gallery, New York, NY**

———— *"I honestly wish I had the capacity to take more artists on. I wish we had more time slots and spaces to present their work, to give it a platform, a voice, to advocate for it, and sell it. At this point though, it's just not a reality. Even though the gallery I run may specialize in what you do and I may be absolutely enamored with what you make, adore you as a person, see the world the same way you do, and our values align, I still might not be able to do anything for you. It all comes down to capacity."* **Matthew Deleget, artist, curator, educator, founder, Minus Space, Brooklyn, NY**

———— *"Each artist's work needs to support the others. Conceptually, they have to meld. One person's work informs another. It's a big circle. Each artist supports the one next to him or her, but the two on either side may not relate as much. It's like a complementary color wheel."* **Sara Jo Romero, Schroeder Romero Editions, New York, NY**

———— *"It's very unusual for someone to get the award the first time they apply. The vast majority have applied twice. We've had people apply five times and get it on the fifth try. And these are people who are fantastic artists. I tell artists to keep applying because it is a skill, your work changes, and you evolve as a person."* **Lisa Dent, director, resources and awards, Creative Capital, New York, NY**

—————— *"You may get rejected not because the work stinks, but because the gallery's agenda was not being met."* **Andrea Pollan, owner, Curator's Office, Washington, D.C.**

—————— *"A curator's job is to create a balanced program throughout an entire year or multiple years. There are tons of artists who would be great to work with, and there are artists who may have a lot of support at a given museum but, for a wide array of reasons, may not actually find their way into the program at a particular moment. Those are realities that can't be very well articulated beyond the framework of an institution."* **Peter Eleey, curator, PS1 Contemporary Art Center, Queens, NY; former curator, Walker Art Center, Minneapolis, MN**

—————— *"You need to apply when you have the right project and it just feels right. I really want to encourage artists to think about that. Who am I right now? What are they asking for? Is it the right fit? Don't just do the applications so you can check off you've applied to something else. Then you just end up getting rejections, rejections, rejections, and it's frustrating."* **Christa Blatchford, artist, CEO, Joan Mitchell Foundation, New York, NY**

—————— *"I don't think there's a time to stop applying. There's a different panel every time and decision-making is subjective. The only time you may want to reconsider is when your submission is completely redundant every year and you're not getting in. There should be growth from year to year."* **Suzanne Kim, independent curator, consultant, Providence, RI**

—*"We'll keep you in mind for future programming."*
—*"We're keeping your materials on file."*
This is the best thing short of an all-out yes. Galleries and other institutions that keep artists "on file" will go to the file to spark group show ideas, add artists to a group show list, or schedule studio visits. Rarely will someone store hundreds of submissions on file, so this response means you are now in a small, select group of artists. Definitely add the person to your contact list and make sure you update/resubmit whenever you finish a new body of work. Don't send in something every month—let them know when you have important news or a truly new body of work.

—*"Yes."*
You won't get a "yes" letter. It will likely be more informal, like a phone call, and will trigger a protracted courtship. The next step is usually a studio visit.

HOW CAN YOU POSSIBLY REJECT ME?.... I OWN EVERY VELVET UNDERGROUND RECORD!!

THERE'S A PLACE FOR EVERYONE

It's good to push yourself. If you're getting accepted to everything you apply for, you should try applying to more selective programs.

Likewise, if you're getting *rejected* from everything, you're probably aiming for the wrong places—either because they're too competitive or because they're geared toward a different kind of artist. It's time for you to re-evaluate your research. Yes, persistence is important and it's almost a given that you'll need to reapply a few times before getting into a program that's right for you. But after a certain number of years (we'll let everyone else argue over how many, exactly) it becomes clear that the program just isn't a good match.

You can minimize your rejections by targeting your applications more carefully. Go back and reread chapter 6 on searching for the right residency or grant. Or chapter 7 on the different types of venues out there. These chapters should give you an idea of how you can learn where you fit into the art world.

You might also try setting a rejection goal each year. Applying for opportunities can be a numbers game, so decide ahead of time that you'll receive X rejections by a certain date. This won't make it fun to get rejected, but it *can* reduce the anxiety and push you if you're becoming too risk averse. It should also keep you working toward your longer-term goals as you pick yourself up and move on to each new opportunity.

———— *"I apply every year to certain programs I really want. I always expect rejection. If it's the same jury every year and they see progress, then it makes sense to do that."* **Alessandra Exposito, artist, Queens, NY**

———— *"Rejection can be devastating for a day or weeks or months. It can make you backtrack and try to find faults in your artwork or process. I've gotten rejected for grants and exhibitions, been asked to be in something, and then, at the last minute, been pulled out. I've had sales fall through. But I always try to keep work going, because that's the one thing that excites me—as loose as that sounds and as airy and perhaps not practical as advice. The thing that I keep going is the thing that got me going in the first place—dialogue with other people and other artists.*

"After a rejection, the last thing you want to do is get back in the studio, but it's the first thing you should do. Or just go out somewhere and get more inspiration. Look around. I keep a number of projects going (whether they're actually going someplace or not) and when there's something that misfires, there's always someplace to turn energy.

"Rejection can be fuel and it's something that you've got to realize you're not alone in. It's part of the pulse and the pattern and it should be seen as part of the whole picture. If you don't have rejection, there is something wrong with the picture." **Michael Joo, artist, Brooklyn, NY**

———— *"Ultimately, there is a place for you. That's the key thing. I had lots of dealers and curators whom I had hoped to work with come to my studio after graduate school and I just wasn't the right person for them. It's all for the best because the fit has to be right for both parties. You don't want to find yourself in a high-profile gallery that loses interest if the response to your work disappoints them."* **Charles Long, artist, Mount Baldy, CA**

CHAPTER 9

—————— Getting Your Work to the Show

PACKING

When you need to ship your work somewhere, packing it well is crucial. In this chapter we tell you how to do it right.

That said, there's more than one way to do it "right." What we recommend below are safe ways to pack the most common art objects. So take our detailed instructions for the recommendations that they are. Different shapes and materials call for different techniques; your budget may require cutting corners (so to speak). We can't cover every possibility here, so take the principles we outline in this chapter and apply them intelligently to whatever it is you're packing.

Some museums with exceptional budgets have machines that can scan an art object and create foam pieces to fit perfectly around the work, preventing it from shifting once it's placed in a crate. This is called "cavity packing" (yup) because the foam fills the space between the object and the sides of the crate. No matter what you're packing, no matter how small your budget, no matter where your destination, you want to follow the same basic principles as best you can: your work should sit in the center of the crate or box, it shouldn't shift around, and its weight should be as evenly distributed as possible.

A few more guidelines before we get into it:

—Clean your work area. Clear out more space than you think you'll need.

—Wear gloves whenever you touch finished artwork; they protect the surface from the oil and dirt on your hands. Generally, a pair of white cotton gloves is the cheapest and most comfortable option, especially for works on paper. But disposable nitrile gloves (powder free) offer the best all-around protection for your work. For heavy, slippery, or less fragile work, use gloves with "grip" that won't mark the surface.

—When packing work, any materials that touch the surface of an artwork should be "archival" (meaning permanent, pH-neutral, durable, and used for preservation). You can find archival materials at stationery, hardware, craft, and art supply stores.

—Your work should have the same orientation when it is packed that it has when it isn't.

—Fill space around artwork with bubble wrap, foam, or other soft material. If money is tight, use newspaper. Don't use foam packing peanuts: they are a big pain for the recipient, especially if the work is to be repacked after the exhibition.

—Never let tape touch a piece of art. After sunlight and gravity, tape is the most common cause of damage to art.

—To seal any material that you wrap around the work, use archival tape or the "blue tape" or "painter's tape" that removes cleanly from most surfaces. Once you've protected the work in at least one layer, you can use a stronger plastic tape to tape up the bubble wrap and the box.

—As for that stronger plastic tape, buy brown, printed, or colored tape that you can see. Many artists use clear plastic tape because it looks so good. But it looks good because it disappears, making it a nightmare to remove. And bits of tape that you don't remove can end up harming the work.

Myth buster

People think blue tape (often called "artist's tape" or "painter's tape") comes off paper and walls easily, without leaving damage or residue. This is not always true! It works fine in the short term, but if you leave it on for more than two weeks, it's just as bad as all the other tapes we warn against. If you're going to use it, do so to fasten material around a work; never let it touch the work itself or anything else for an extended time.

Here Comes the Sun

Frame your flat work with UV-treated Plexiglas, not regular glass. Plexiglas is not as fragile and a whole lot lighter, so it's much easier to ship. It's also the best thing for the work. Sunlight is the greatest enemy of art and UV-Plexiglas is the easiest way to protect works on paper (including photographs) from harmful UV rays.

Even with the UV-Plexiglas, works should never be hung in direct sunlight. In fact, some serious collectors go as far as getting a UV-treatment on the windows in their homes.

For work that is dark, reflective, or simply hard to see if there is a glare on the Plexiglas, consider anti-reflection Optium Museum Acrylic or Museum Glass. Both filter out UV rays, with minimal reflection. It's the closest you'll come to feeling like there is nothing between you and the work (although you'll still get some reflection if you place the work directly in front of lights, sometimes with a purple-ish glow). Unfortunately, these alternatives are much more expensive than regular UV-Plexiglas. And Museum Glass, being glass, will require professional wrapping and shipping, which can amount to a small fortune over the years. There are less expensive "anti-glare" products out there, but we don't recommend them because they often reduce contrast and clarity, which isn't a good trade-off.

—Pay special attention to edges and corners. They're always sticking out and getting hurt. Reinforce and protect them accordingly.

—You'll make your life easier by reusing packing materials (except glassine and tape). As you pack, label each layer of wrapping with the name of the piece so you'll know what goes with what when you repack.

—If you're shipping your work to someone who bought it, consider charging a "shipping *and handling* fee" to cover the extra expense of quality packing materials. Many galleries do this because collectors understand that it's worth paying a little more to have their work packed properly.

—When you're sending an unsold piece to a show, it doesn't hurt to ask the venue whether there is a budget for crating (and shipping). Never be afraid to ask the gallerist or curator for advice on how to get your work to the show in the safest, least expensive way possible.

Flat Work—Framed

Repairing a frame can cost nearly as much as buying a new one. So protect the frame as carefully as you would the work itself.

1. Wrap the framed piece in butcher paper and jot down "front," "back," and "up" with an arrow.
2. Make a tight-fitting box around the wrapped frame, or place Styrofoam or cardboard corners around each of the frame's corners. You can buy corners or make them yourself.

3. Wrap with bubble wrap, bubbles facing *in* for extra support. Use one-inch, big bubbles for large works and little bubbles for small works. If you skipped Step 1, for whatever reason, make sure the bubbles face *out*. Otherwise, if they're in direct contact with the frame, they could mark up the Plexiglas and even stick to it.
4. Tape up the bubble wrap.
5. Wrap with another layer of bubble wrap, bubbles facing *in*. Tape up.
6. Place the wrapped work into a cardboard box and stuff the space between the wrapped work and the sides of the box with more bubble wrap or similar material.
7. At this point, the piece should be suspended in the center of the box with packing material surrounding it on all sides, packed tightly enough to prevent it from moving inside the box. Keep at least an inch of space/padding between the outside of the box and the outside of the frame.

MAKING A BOX!

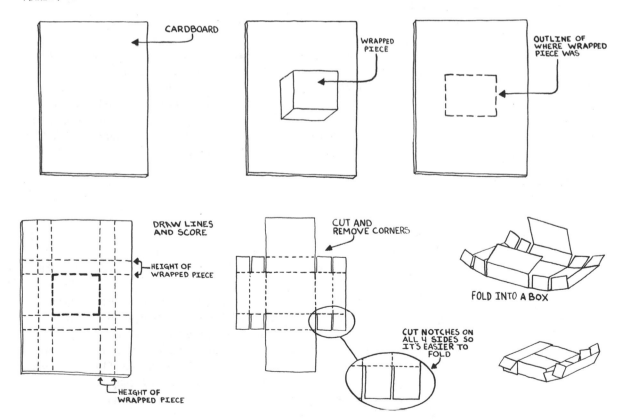

8. Pieces larger than around 16 x 20 inches need more stabilization. There are three ways to do this:

 a. Compete Steps 1 and 2 above. Then, on either side of the butcher paper–wrapped work, place sheets of Masonite, plywood, double-wall cardboard, or a rigid foam material. The budget buys are pink or blue insulation foam; the professionals use Ethafoam or PolyPlank, which come in various grades of rigidity. Bubble-wrap and box.

 b. OR complete Steps 1 through 5 above. Then place foam on each side of the bubble-wrapped work and box it up.

 c. OR complete Steps 1 through 6 above. Then place the box into the center of a second, slightly larger box and pack up as if the first box were the artwork.

 If none of these techniques gives you enough stability and there's still a chance that the work will twist, you'll have to make a crate. (See "Large Paintings" below.)

Flat Work—Unframed

There are two ways to ship unframed work: rolled up in a tube or flat. Don't use a tube unless you're shipping a photograph or other "simple," smooth work on paper. (Painted and textured works can crack and flake when you roll them up.) You basically roll the work around a small tube and place that inside a larger one. Needless to say, the outer tube has to be very strong. One little dent will damage your piece.

To ship flat work in a tube, follow these steps:

1. Wrap the drawing in Tyvek, glassine, or archival paper.
2. Roll the wrapped work around a tube that is longer than the work. Tape it down to prevent shifting.
3. Bubble-wrap the tube, bubbles out. Then, once again, bubbles facing in.
4. Slide the bubbled roll snugly into a second tube. You can use quarter-inch-thick cardboard or plastic tubes. Sonotube makes inexpensive, widely available tubes.
5. Fill extra space at the ends of the tube to ensure the artwork cannot move during transit. Seal each end of the outer tube securely with thick cardboard and strapping tape.
6. Write your address and the shipping address on the tube.

Toss That Tape!

While you should keep your packing materials after unpacking your work so you can use them to repack after the show, toss *all* the tape. Random bits of tape tend to find their way onto artwork and are a real pain to remove. Better to use new tape each time.

——————— "Wrap work like you're wrapping a present. It should only take three pieces of tape. Sometimes I'll be with a client and they have to wait while it takes fifteen minutes to unwrap a piece!"
Heather Marx, Heather Marx Art Advisory, San Francisco, CA

7. Wrap the entire tube in plastic to protect from moisture.
8. Write the addresses again on the plastic.

To ship unframed work flat, follow these steps:

1. Make a "sleeve" or envelope out of glassine, pH-neutral tissue paper, or soft-spun Tyvek.
2. Slide the work into the envelope and seal it with just enough archival tape to ensure it won't move around in the envelope.
3. Attach the envelope to a piece of cardboard (or foam board or rigid foamcore) the same way you'd attach photographs to a scrapbook. To do that, make "corners" by folding pieces of paper into triangles with open ends, like triangular pita bread. Tape the corners to the board, which we'll name "Martha." (Just go with us here.) Slide the envelope into the corners and tape the edges of the envelope to Martha, using archival tape.

Tyvek vs. Glassine

A lot of artists and galleries prefer glassine because it's cheaper than Tyvek. While you *can* use glassine, you should understand its limitations: when exposed to humidity it can become rough; if it gets folded anywhere, the crease will be sharp and could damage your work; and glassine won't protect your work from vapor the way Tyvek does.

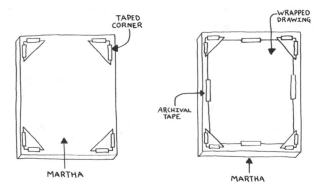

4. Cut a second board the same size as Martha. We'll name this one "Henry." Take four pieces of tape and wrap them over the middle of all four of Henry's edges. (The tape provides a better surface for sealing the boards together.)

5. Sandwich the envelope between Martha and Henry.

6. Take four more pieces of tape and fold over one end of each of them to create a tab. Use these tabbed pieces to tape Martha to Henry. Each tabbed piece of tape should line up with the tape on Henry's edges (tabbed end on Henry, untabbed end on Martha). This makes it very easy to untape and retape the sandwich.

7. Secure the entire package between two pieces of dense foam, hardboard, or Masonite (making a second sandwich).
8. Bubble-wrap and box as described above in "Flat Work—Framed."

——————— "I'm not in this business to talk about pet peeves. I do what I do because I learn something different from every single person every time I have an interaction with them. I find that my world is illuminated. But if I had to choose a pet peeve, mine would be—learn how to wrap your own work!"

Eleanor Williams, art dealer, independent curator, Houston, TX

Small Dry Paintings

Follow these instructions for dry paintings up to 30 x 40 inches. If your painting is covered in impasto or has a delicate surface, such as enamel or encaustic, follow the instructions below for "Small Wet Paintings."

1. Cover the front of the painting with a sheet of soft-spun Tyvek or glassine. Tape the sheet to the back of the painting, to itself, or to the stretcher bars. It's really not a good idea to use plastic at this step, because over time it can bind to the surface of the work. This is bad.
2. If you're using Tyvek, skip to Step 3. If you're using glassine, wrap the painting a second time with plastic. (Glassine doesn't protect the work from vapor the way Tyvek does, which is why you need the outer layer of plastic.)
3. Completely cover the front of the painting with a piece of cardboard slightly larger than the painting.
4. Attach corners, bubble-wrap and box as described above in "Flat Work—Framed."

Cutting Down on Your Art Shipper's Bill

Art shippers will pack everything for you, but they charge by the hour so the packing alone can be very expensive. To save money, pack your work before they arrive (ask them how they want it packed).

You can also save money by "soft-packing" your work, which means protecting your work so someone can carefully pick it up and place it in a van without damaging it. It's the way you'd pack your work if you were moving it yourself: maybe a layer or two of bubble wrap or a box. In other words, less than what you'd do to ship with a common carrier.

You shouldn't soft-pack large or delicate paintings, though. Better to build a travel frame: a crate without a front, covered in Tyvek or plastic. It's basically a deluxe collar.

Make sure you tell your art shippers how you are packing the work, because they may use different trucks for crated and soft-packed items.

She did WHAT?

A few years ago, an artist we know needed to transport her painting home from a show herself. It was a large, heavy painting—6 x 6 feet—so she put it in the back of a pickup truck and hit the highway. No rope, no cover, no nothing.

Somewhere around sixty miles per hour, the painting lifted up like an airplane wing and flew out into the traffic behind her. She was lucky it didn't kill anyone.

And that painting, which proceeded to get run over by dozens of cars, happened to be the one that art critic Jerry Saltz said was the best she'd ever done.

Estimated Shipping Costs (2017) for a 36 x 48 x 4 inch package weighing 20 lbs (before insurance and other add-ons)			
FROM CHICAGO TO LOS ANGELES			
	GROUND	2ND DAY	NEXT DAY
UPS	$85	$250	$310
FEDEX	$90	$288	$340
ART SHIPPER	$500–$1,200		
ROUND-TRIP RENTAL CAR	At least $300 plus gas/tolls/hotels and a week of your life!		
FROM MANHATTAN TO BROOKLYN			
UPS	$40	N/A	$100
FEDEX	$40	$85	$110
ART SHIPPER	$100–$400		
TAXI	$20–$40		

"There are more fine art handling companies than ever before, which at first is a boon to the buyers of these services, but with the scramble for market share, it is important to know which company is right for which project. This usually comes down to price, comfort, and, finally, capabilities. You would not hire the man with a van to handle the international movement of an object on the CITES list, that requires engineering or a variety of bespoke issues common in the handling of art works, especially contemporary works utilizing unconventional media." **Jonathan Schwartz, CEO, Atelier 4, Long Island City, NY**

"I've never insured anything I shipped. I just sent it, usually via UPS. I figure I made it, so I can make another one. It would be sad to have a piece lost or damaged, but I can make another one, and insurance money won't fix it. I lost a painting for a year once, but it eventually turned up unharmed, just when we thought it was gone forever." **Bill Davenport, artist, critic, Houston, TX**

The more you plan ahead, the cheaper your shipping will be. It is much more expensive to ship wet paintings.

——————— "The ramifications of a wet painting are huge. This is what happens: you give an estimate for a painting that is two inches deep. You add an inch for packing. We're talking domestic shipping here where volume is an issue (local shipping is usually charged hourly). It's volume times distance equals cost. So the farther it goes and the larger it is, the more expensive it is. All of a sudden, instead of two inches, it's going to be six or seven inches thick. It's 3-D. Every time you add to the depth, the volume double, triples, and quadruples. You have to think about this." **Jonathan Schwartz, CEO, Atelier 4, Long Island City, NY**

Small Wet Paintings

Build a "collar" for the painting out of foamcore or cardboard. A collar is just what it sounds like: it wraps around the edge of the painting just as a collar wraps around your neck. A cross-section of a painting collar should look like an L, with the short end of the L flush against the back of the painting, and the long end parallel with the sides (but not touching the wet edges) of the painting, extending several inches beyond the painting's surface.

1. Staple or screw the short end of the L to the stretcher bars behind the painting. Be careful not to poke any holes in the canvas. If you have D-rings or other hanging hardware on the back of the painting, poke them through the cardboard collar and tape them down to reduce the number of screws you need to use.

2. Stretch Tyvek or plastic over the collar, covering the painting without actually touching its surface. You can use plastic here because it won't touch the piece. Tape in back. Or you can build a lid, like a shoebox.
3. For paintings up to 11 x 14 inches, bubble-wrap and box as described above in "Flat Work—Framed." For larger wet paintings that you're shipping with a common carrier, build a crate as described below in "Large Paintings."

Large Paintings

For dry paintings larger than 40 x 40 inches and wet paintings larger than 11 x 14 inches, you really should either hand-deliver

them yourself or hire an art shipper. If you have to use a common carrier, or you want to cut down on your art shipper's bill, build your own crate.

It's safest to build a custom-sized crate each time you ship, though sometimes you can get away with repurposing a sturdy wooden box you already have. Here's how to build a custom crate:

1. The thing you're building has three components that sit one inside the other like Russian nesting dolls: the painting, which fits into a wooden travel frame, which is packed inside of a larger wooden crate.

2. If the painting is wet or very textured, skip to the next step. If not, wrap the painting in Tyvek or glassine and plastic, as described above in the "Small Dry Paintings" section.

3. Construct the travel frame: essentially a wooden box with the top missing. The frame should be large enough to leave at least a one-inch gap around the painting's edge and a one-inch space from the painting's surface to the top of the box.

 a. Secure the painting to the travel frame by *carefully* drilling screws from the back of the travel frame upward, into the painting's stretcher. Draw circles around the heads of the screws you just drilled so that people on the receiving end know how to take the painting out without taking apart your travel frame. Number the circles in the order you want them unscrewed, if that matters.

 b. If your painting is wet or delicate, use mending plates to secure the painting to the travel frame. You screw one end of these guys into the back of the stretcher and the other end into the frame (see diagram).

 c. Attach a lid made of plywood or foamcore to the top of the travel frame.

 d. Wrap the entire travel frame in a plastic sheet.

———— *"If you're an artist who makes delicate paintings where nothing can touch the surface, then learn how to build a travel frame! Your gallery is not a storage facility; it is an active exhibition space. If you want your pieces be shown in between your exhibitions, you need to build a travel frame so they can be pulled out of the rack, shown, and shipped safely."* **Steve Zavattero, co-founder/director, stARTup Art Fair; former gallery owner, San Francisco**

———— *"We are a gallery, not a museum, so we use common carriers sometimes. One time, we had a painting that had heavy impasto so I used an art shipper. I paid extra for them to collar the painting so nothing would touch the surface. The painting arrived, wrapped in plastic. I had to call a conservator! The artist was present in the studio when it was wrapped. She, another dealer, and I had all agreed the painting needed to be collared and the guys bullied her. They told her it didn't have to be packed that way and they were in a hurry. She is a sweet, nice girl and she didn't stick up for herself. I would tell artists not to let anyone bully you. Make sure your work is handled the way you need it to be handled because it is your work and no one is going to take care of it better than you. Even if the dealer tried to make sure everything is right, there is always an in-between person involeved."* **Eleanor Williams, art dealer, independent curator, Huston, TX**

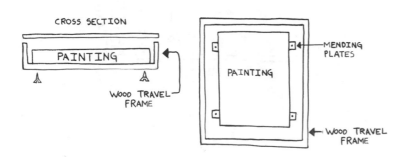

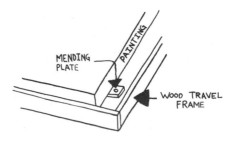

4. Construct the crate: a plywood box several inches larger than the travel frame on all sides. The actual dimensions will depend on the type and thickness of the foam padding you use to stabilize the travel frame within the crate.

 a. Use plywood at least ¾-inch thick. (For international shipping, use heat-treated wood to comply with regulations.)

 b. Fasten the pieces together (minus the lid) with screws or nails and wood glue along all the seams. For larger crates, add "skids": strips of wood along the bottom to raise the box off the ground.

 c. You might also add strips of pine over all the seams and metal or wood handles to make it easier and safer for shippers to maneuver the box.

 d. Hot-glue foam blocks to the interior of the crate or cut sheets of foam to line each side of the crate (check to see how the foam reacts to the hot glue before using it). The foam protects the travel frame and ensures that the frame fits snugly inside the crate without touching the crate's sides. Examples of foam include insulation foam and Ethafoam.

5. Put the travel frame in the foam-lined crate.

6. If needed, add more strips of foam so that the travel frame doesn't move around. It is critical that the travel frame never shift in transit.

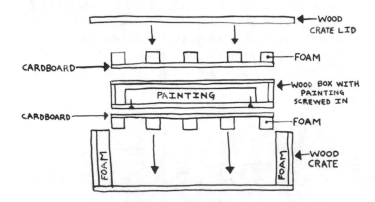

How can I get specific advice on packing my work if there aren't any galleries where I live?

For advice on packing and shipping, look up any institution or store in your town that handles fragile goods. You might try a local museum (of art, natural history, or science) or an antique shop.

7. Drill the front of the crate in place. Circle the heads of these screws as well.
8. Write your address and FRONT, BACK, and TOP on the crate. Draw arrows to show which way is up.

3-D Work

The right way to pack three-dimensional work depends on the material. Whatever you decide to do, plan it all out before you start to pack. You'll often need to separate the work into parts, wrap the parts separately, and then pack them into a few boxes. As with paintings, you need to build a crate for large pieces. Be especially careful with fragile edges and delicate extremities. Protect them with foam covers the way you would the corners of a frame.

You can hang a lightweight sculpture inside a box (or crate) with fishing wire and secure it, suspended in the center of the box, by tying more fishing wire to its sides and bottom.

If any of your sculpture's components were delivered in specialized packing material, save them to reuse when you ship your work.

Include instructions for unpacking and reassembling *and disassembling and repacking* the work. Note every single component: how it should look after unwrapping it, how it fits with the others to make the piece, and how to take them apart and pack them after the show. Make your instructions idiot-proof with photographs and diagrams. It's the only way to ensure that the people receiving your work handle it properly.

Do this even if you plan on unpacking the work yourself at the gallery, art fair, collector's home, or wherever it's going. Things come up, flights get canceled, cars break down . . .you might not be there when the work arrives and someone else may have to unpack it after all. Do it even if your collector says she'd never dream of reselling the work. Tastes change, memories fade. You can't prevent your piece from being resold, but you can protect it from being damaged.

——————— "Sculptors should definitely consider how their pieces will move. In some ways that is a buzzkill for the artistic process, but you'll be really popular with gallerists and collectors if you consider these things." **Jonathan Schwartz, CEO, Atelier 4, Long Island City, NY**

——————— "One artist I worked with brought 'instructions' to the install that were just tons of photos of the process. It was a lot of interesting information, but it didn't help us install the work. Install instructions need to be clear and simple." **Suzanne Kim, independent curator, consultant, Providence, RI**

——————— "I am working with a technology consultant to construct a complex projection/wall drawing for a museum collection. My goal is for the museum to be able to exhibit the work long after I am gone. To that end, we are working to make certain that: the work can be installed easily by someone other than myself; the work can accommodate future hardware/software; and the files are saved/stored in multiple ways. Understanding that in the twenty years the technology landscape will be unrecognizable, our specs focus not only on specific hardware, but on quantifiable measures such as resolution, contrast ratios, lumen counts, etc." **Stas Orlovski, artist, Los Angeles, CA**

SHIPPING

When you're represented by a gallery, the space hosting the exhibition should pay for shipping. Otherwise, don't count on it. Sometimes the space will cover one-way shipping; sometimes it won't cover either way.

When you're stuck dealing with the shipping and the show is local, deliver your work yourself. You won't need to build a crate but make sure you pack the work carefully. And if your painting will need a collar or travel frame while stored at the venue, build one regardless of whether you need it for transport.

If you can't deliver the work yourself, the safest way to ship it is with reputable art shippers. They can pack your work for you, have specially equipped, temperature-controlled storage and vehicles, and can take care of any insurance and customs paperwork.

Just be sure to plan ahead when you go with an art shipper. These guys tend to be smaller operations with less flexible schedules than the common carriers you may be used to using. They may have shuttle routes that consolidate shipments on a predetermined day of the month, making the service less expensive but the lead time much greater. Be clear about what you're shipping, how it's wrapped, and whether it needs special care. Paper sculptures, for example, need to travel in climate-controlled trucks because they're so sensitive to heat and humidity.

While most art shippers take their jobs seriously, sometimes they're sloppy. It's a good idea to hang around while they pack your work to make sure they're doing it right.

Given how expensive art shippers are—they are really expensive—the vast majority of artists and galleries go with FedEx, UPS, or other big commercial shippers whenever possible. Keep a few things in mind when shipping with these guys:

—To be absolutely safe, you need to crate larger works.

—Make sure the package is safe to drop and can withstand a one-inch gouge without damaging the work.

—Some of these companies offer very low insurance caps (like five hundred dollars) or say they won't ship fine art. Check with your insurance provider about what your policy covers. If your consignment form, invoice, or other paperwork isn't clear as to who covers shipping and insurance, figure it out and confirm it with your shipper before the work leaves the studio.

—Common carriers can charge less because they make it up in volume. They will stack, rotate, and jostle your work.

—Cover your crate or box with FRAGILE stickers. It can't hurt.

—Write the waybill number, your address, and the delivery address clearly on the box or crate. Don't rely on the waybill alone. Make your box distinctive so it's easy to locate. For example, you can seal it with fluorescent pink tape.

—Never ship on a Thursday or Friday. When you do, there's a much higher risk of damage because your work will likely sit in storage over the weekend. That means more moving around, more handling, more stacking and unstacking—all by personnel who aren't trained to handle art. And the warehouses aren't climate-controlled.

International shipping is slower, riskier, and more expensive. Go with an art shipper if you can afford it; otherwise, use a common carrier and pack your work extremely well.

——————— "If it is an emerging artist, I usually like them to pay one-way here and I'll pay for it back. As an artist gets more established or is represented by another gallery, I'll pay for all of it." **James Harris, James Harris Gallery, Seattle, WA**

——————— "They should always ask, but they shouldn't always expect it. At the beginning, I couldn't afford it, so I counted on them to get things here. Now, they can expect it from me." **Monique Meloche, moniquemeloche gallery, Chicago, IL**

——————— "If an artist is going to ship internationally and the work has enough sentimental value or monetary value, or the collector just really wants it in one piece, they should hire a professional. If artists want to do it themselves, they should learn some carpentry skills to build a crate and hire UPS or FedEx and hope for the best. That's what those courier systems are for—people who know next to nothing about shipping." **Jonathan Schwartz, CEO, Atelier 4, Long Island City, NY**

INSTALLING YOUR SHOW

For basic installing tips, see chapter 5 on open studios. Here are a few more tips for installing a show or art fair:

—*Ask ahead of time whether there are any general restrictions.* Can you paint on the walls? Drill into the floor? Does the venue require you to use union labor or can you install everything yourself? How big are the doors and elevators? Your piece may

—————— "Sound is my most common problem with showing video. Even headphones are more complicated than they seem, as they often need to be amplified.

"Unless it is part of an initial agreement that the gallery will provide all the equipment, you probably have to supply the hardware. This may be to your advantage as you can control the image quality. (Never expect a gallery's staff to be more tech-savvy than you are.)

"I have to choose my battles. There's no point in making the gallery angry, but when I come in and the sound has been turned down on my video, it's as if the lights were out on my photo." **Rob Carter, artist, Richmond, VA**

—————— "I would encourage artists to be very, very clear about what the ideal viewing experience is for their work, but that means to give it a good deal of thought. Just because it might take up more space doesn't mean every moving-image work should/must be projected really large. We've seen artists very strongly insist their work must be projected really large, to then be told that's not possible and so their work can't be part of an exhibition, only to have them say, well, in that case, it can be on a monitor. Generally, it's hard to take them seriously at this point. In fact, this is the wrong order of things in our opinion. State what the ideal presentation is (and be clear on why), but also say how you're willing to be flexible for certain contexts, like group exhibitions." **Edward Winkleman, cofounder, Moving Image Art Fair; author; former director, Winkleman Gallery, New York, NY**

fit inside the room, but that doesn't matter if you can't get it *into* the room. Depending on these kinds of restrictions, you might have to show different work.

—**Ask what the walls are made of.** Plywood—which is what most art fair booths are made from—can take regular screws. Drywall, plaster, and other thin walls require specialized hardware. Galleries and museums have no real standard when it comes to wall material. You don't want to wait until you're installing to discover that behind the clean white wall is a layer of brick.

—**Ask whether you'll get assistance from staff.** For artist-run shows and nonprofit venues, or if your work is site-specific, expect to install and deinstall everything yourself. Galleries and museums will usually have staff to hang and take down your work.

—**Ask how much time you'll be given to install your work.** Don't assume you'll be able to stay late unless they say so.

—**Be realistic about how much time you need to install.** You know how airlines always say a flight takes longer than it really will, so that even if there's a delay they can pretend they arrived on time? Same principle for estimating your installation time—especially if people are going to be assisting you. They have other artists to help, other tasks to finish, and are under as much stress as you are. No one cares if a "three-hour job" ends early. But a "one-hour job" that actually takes three hours will make everyone angry (and ripple out and disturb a lot of other people's schedules).

—**Ask what equipment they have and what you need to bring.** A lot of artists bring their own drill, level, and measuring tape—even if the venue has its own equipment—because it's frustrating to have to wait your turn for the drill. Make sure they have a ladder if you need one. If you're an unrepresented video artist or digital artist, for example, you will likely have to provide your own hardware. Don't forget to bring backup disks, a thumb drive, and have several ways to access the files

———————— "It may sound obvious, but wherever possible, transparent communication and clear expectations can result in the best working relationship between an artist and an institution (or organizing body). Ideally, the artist feels comfortable reaching out to the curator with ideas and concerns, and she should expect the same from her curator."

Laura Fried, curator, Los Angeles, CA

——————— "Artists who work at LA><ART have a great deal of autonomy throughout the process. But the entire process from inception to production to installation is truly collaborative." **Lauri Firstenberg, founder and former director, LA><ART, Los Angeles, CA**

——————— "Be a professional about the installation. Be a professional about every part of it. It's not grad school and a bunch of artists getting together and having a fun time. There is a lot of money at stake here. Even though you and your gallery might get along great, it's still a business venture." **Murat Orozobekov, president and cofounder, Moving Image Art Fair; former director, Winkleman Gallery, New York, NY**

——————— "Whether it's at a gallery or a museum, you have to call your own shots in terms of the artwork itself. I've learned that more from positive experiences than negative ones. Galleries and museums benefit from your saying what you know is right for the work. They have their areas of expertise and you have yours. My personality is often too eager to accommodate, but I've learned that it doesn't do anything for the work if I lose track of the boundaries." **Charles Long, artist, Mount Baldy, CA**

online. And train the staff how to maintain the work throughout the show: how to turn it on and off; what the volume should be; how to keep it clean. Leaving them with an instruction sheet is a nice touch.

—**Be kind to the staff.** They are there to help you—really. Don't take them for granted, don't act like a prima donna, and don't tell them to be there at 9 a.m. if you're going to waltz in at noon.

—**Understand how much control you have (or don't).** Some venues don't let their artists anywhere near the installation process, period. If you don't like that, don't show with them. For the rest of the venues that do collaborate with their artists on installation decisions, you have more say when you're installing a solo show than when you have one piece in a group show. (If this seems obvious and fair to you, wonderful. You'll

be easy to work with and people will want to continue showing you.) Installation artists get more say in how their work is installed—even for a group show—because the installation itself is integral to the work. For the same reason, no matter what kind of art you make, if the work's meaning requires a particular placement or lighting, make sure you tell the curator.

—*Be professional.* Don't bring friends or family to the installation. The curator or gallerist is collaborating with *you,* not your crew.

—*Leave the place as you found it.* If you changed the architecture or painted the floor, the venue may expect you to help put the place back together when the show ends.

——————— *"I have watched relationships between collectors and artists end because the artist did not thank that person in a way that felt genuine or real. I've watched curators encourage people not to work with artists because—the direct quote is, 'They were not gracious.' It can be as simple as getting up to talk about the project and saying, 'Thank you to curator so-and-so, or so-and-so who put their blood sweat and tears into that thing.'"* **Deana Haggag, president and CEO, United States Artists; executive director, The Contemporary, Baltimore, MD**

Group Show Etiquette

The kindergarten basics apply here: think about the other artists, think about the other work, and think about how you all fit together.

—Don't take up more space than you're allotted, because that will encroach on someone else's space. That said, don't let someone else take over your space. Ask the gallerist or curator for help if you're uncomfortable.

—If you're going to do anything that creates a lot of dust (like drilling) or emits toxic fumes (like gluing), find out ahead of time when you should install so as to minimize the nuisance.

—Mind the work on the other side of the wall.

—Use headphones for sound work, or keep the volume low, or work out intermittent plays, or ask everyone if they're okay with full blast—including the gallerists.

—Talk to the venue ahead of time about what to do with your packing materials during a show. Most of the time, the venue should be able to store them, but that may not be possible for large group shows.

CHAPTER 10

Consignments

——————— "Number one: work with people you know and trust, who also know how to do business. If you don't trust your best friends in business, then don't do business with them." **Adam Holofcener, artist; executive director, Maryland Volunteer Lawyers for the Arts, Baltimore, MD**

——————— "The majority of claims involve copyright and contractual issues. With individual artists, the contractual issues primarily concern consignment of artworks and nonpayment." **Sergio Muñoz Sarmiento, attorney, artist, educator, Brooklyn, NY**

——————— "The reality of making an exhibition is a lot of administration and a lot of paperwork and I think artists tend to forget about those things, until something goes wrong. It is a protective measure for them to have contracts in place, but to also really understand the nuts and bolts of making an exhibition. I can't just snap my fingers and the work gets made and the show's up." **Jamillah James, curator, ICA LA, Los Angeles, CA**

We recommend that you use a written consignment agreement whenever you let _anyone_ sell your work for you. A one-day art fair, a nonprofit group show, an online sales platform, a solo show at a reputable gallery—it doesn't matter. If the venue doesn't have its own consignment agreement, you need to make your own. It's easier than you might think and in this chapter we'll show you how.

WHAT IT MEANS TO CONSIGN WORK

Almost all contemporary galleries sell art by consignment: you let a gallery take your work and sell it for you, and the gallery keeps a percentage of the sale. Because it doesn't buy the work from you, the gallery _possesses_ it but never _owns_ it. You still own the work while it's in a show or at a fair; as soon as a collector buys it, ownership passes directly from you to the collector. And you don't get paid until the collector pays the gallery.

Consignment arrangements apply to any kind of relationship—exhibition or no exhibition—where the works are for sale. For example, a commercial gallery, a nonprofit's website, a café space, and an art consultant are all potential consignees, regardless of whether anyone expects the art to sell. So it is almost a given that whenever you entrust your work to others, you'll be offering it under consignment.

By this point in the book, you can probably anticipate what we're about to say: _sometimes things go wrong._ A gallery doesn't give back your unsold work when you need it for a new show; a nonprofit space loses its lease and the landlord confiscates everything inside, including your work; an online gallery sells your work at half the price, thanks to its buggy app.

You cannot afford to be naïve about these things. It's not that everyone's trying to take advantage of you—they're not. It's that you can easily minimize the fallout from the kinds of accidents and misunderstandings that happen all the time in the art world. A written consignment agreement will protect you from the unhappy consequences of consignment mishaps.

How? Thirty-three states, including New York and California, have laws specifically protecting artists who consign their work. While they vary from state to state, most of them prohibit your artwork from being seized if the venue goes bankrupt; require that money from the sale of your work goes to you *first* (rather than, say, the electric bill); and, in some states, even dictate thirty-day payment deadlines. Some of them protect you whether you have anything in writing or not, but it is much harder to prove that you consigned something if you don't have it in writing. A consignment agreement is like a receipt that proves you consigned the work.

It's also very helpful to have a record of what you've given whom. And writing up a consignment agreement encourages you and the venue to think about the basic arrangement ahead of time, so you don't discover after the fact that you had very different expectations.

It's easy to make one—you won't need more than one or two pieces of paper. Consignment agreements have two basic parts: an inventory list and terms. The inventory list identifies the specific works you're consigning and states the basic price information. The terms are all the details of the arrangement, such as the length of time, the maximum discount, etc. (We'll walk you through all of them in a moment.) Any inventory list that includes more than just the description of the work is technically a consignment agreement, although it may not be a "complete" agreement, in that it leaves out a lot of details.

Before you spend time making your own consignment agreement, ask the venue whether it plans to give you one. Most venues will prefer to fill out their own form, rather than use yours. *Who* drafts the agreement isn't as important as what it says. Some places just give their artists inventory lists, so there's a record of which work the place has under consignment but no details about the arrangement. Some add a few basic terms. Some don't write anything down at all.

If the venue does have a form—whether a comprehensive consignment agreement or bare-bones inventory list—read through it and make sure it covers all the issues that are important to you. You may need to add language specific to the type of art you make. Just discuss any changes with the venue

Call your local bar association to find out whether your state has an art consignment law. For a detailed comparison of all art consignment laws in the country, see the book *The Artist-Gallery Partnership* by Tad Crawford and Susan Mellon.

——————— *"There's still very little paperwork between galleries and artists. Very little if any, incredibly enough. It's still the Wild West. Although that is changing and artists are changing. If one of my artists asked for paperwork, I would do it. Absolutely. Happy to."* **Tim Blum, Blum & Poe, Los Angeles, CA**

——————— *"If the gallery refuses to sign something like an inventory list, you might really wonder whether you want to work with that gallery. I mean, would you just leave personal property with anybody without getting some sort of written statement? But in that case, you could always then send a letter to the gallery saying, 'On such and such a date, I left the following art with you.'"* **Tad Crawford, arts lawyer, author, publisher, New York, NY**

——————— *"Many of the terms of an oral contract will be unclear, or subject to dispute, without putting them in writing. People simply don't know what they've agreed to on issues they never discussed, or issues that they heard differently from what the other party thought he or she was saying. It creates a much higher likelihood of disagreement, and ultimately a bad relationship, than if you have a clear, written agreement."* **Tad Crawford, arts lawyer, author, publisher, New York, NY**

first, so you're on the same page. You can have the conversation over email, but you should still take whatever additional issues you've agreed on and add them to the consignment agreement so that they're in one place.

If the venue doesn't write anything down, offer your own consignment agreement. This is another situation to approach delicately, because people can overreact or misinterpret your intentions when you hand them an "agreement," especially people who aren't in the habit of writing things down. (For more on written agreements in general, see chapter 14.)

One way to handle the situation is to just ask for an inventory list, since even venues who don't usually give their artists inventory lists should be willing to make one for you. If they're not, offer to make one for them. At that point, you'll need to

decide whether you're comfortable saying you want to add a few more details to the form so that it covers your consignment arrangement, or whether you'd rather just take your chances.

WRITING A CONSIGNMENT AGREEMENT

Now we'll show you how to write a simple consignment agreement. You'll notice that the language we suggest using is more colloquial than you're likely to find in a lot of the consignment agreements out there. That's because our goal is to set you up with the most practical, user-friendly agreement we can, avoiding formal language and legalese wherever possible.

We'll say "venue" throughout the agreement, which can refer to any person or place, with or without walls, you entrust to sell your work. While going over the core components of a consignment, we'll suggest additional issues and complicating factors you may want to discuss with the venue, whether you include them in the written agreement or not. This requires you to think actively about each of the terms in relation to your work.

Note also that we're only talking about a consignment from you directly to a venue that will show or sell your work, not a consignment from your gallery to a second gallery or a loan to a museum (loans are discussed in chapter 11).

Your consignment agreement should begin with the basics:

—your name and contact information (address, email, phone)
—the name and contact information of the venue to which you're consigning your work
—an inventory list: the name and description of each work you're consigning (title, year, medium, dimensions or duration, edition)
—the retail price of each work
—production and framing costs (on a separate line)

Remember that retail price is what the collector pays, so it includes any production and framing costs. You break those out on a separate line to be clear about any amounts you or the

venue (depending on the arrangement) will be reimbursed *before* applying any discounts or calculating the venue's commission. Venues differ on how they treat production and framing costs, so ask them what their policy is. (See chapter 13 for more on production and framing.)

When setting the retail price for a consignment, think about whether your labor, presence, or other involvement are necessary for installing the work after it sells (this is often a concern for installation artists and those who do site-specific or performative work). If a collector from another state (or country) buys your work, who covers your travel and time, or hiring an assistant? Whether you build these costs into the retail price, or break them out separately, have a conversation with the venue and decide together the best way to handle.

The rest of the consignment agreement contains the terms. At a minimum, a consignment agreement should include these terms:

1. Consignment language
2. Time frame
3. Commission
4. Discounts
5. Payment
6. Shipping
7. Safekeeping and insurance

We'll go through each of these in turn, and then raise some other common issues you may want to add.

Consignment Language

You'd think that putting "Consignment Agreement" at the top of the page would be clear enough, but you actually need to state that you're consigning your work (as opposed to selling it to the venue). If you ever need to prove that the venue doesn't own your work, this is the sentence you point to:

I consign to the venue the work identified in the inventory list above.

A Matter of Style

A lot of galleries use terms like "the Artist" and "the Gallery" in their consignment agreements because there's less to fill out every time they write up a new one:

The Artist consigns to the Gallery the work identified in the inventory list above.

Since it's obvious that you're the one doing the consigning, we say "I" or "me" instead of "the Artist" because it's less formal and a little friendlier. We stick with "the Venue" because it's a catchall for the spaces and people you may work with and it'll save you a lot of time, but go ahead and substitute the actual name of the venue everywhere you see "the Venue" if you like how that sounds better.

———————— "As an advocate for artists, I would be in favor of anything written rather than just a handshake. If only to train people: get your dealer used to the fact that, each time you're consigning some work, they have to sign something."

Donn Zaretsky, partner, John Silberman Associates; writer, Art Law Blog, New York, NY

——————— *"Several years ago, one of our artists consigned us three pieces for Miami and two pieces for the Los Angeles art fair. It took sixteen emails and six phone conversations to get these works consigned with the correct titles, dates, sizes, media, and prices. He said things like 'Can you check the size on this?' and 'This says 2007, but I actually made it in 2006.' It was amazing how complicated it could be. So now we make emailed consignment forms and ask our artists to fill in the inventory before they give us the work."* **Greg Kucera, Greg Kucera Gallery, Seattle, WA**

——————— *"Issues can certainly arise around keeping track of work and getting work back. Sometimes it is just awkward and sometimes it requires investigation or confrontation. It's important for an artist working with a gallery they don't know or a gallery that's a little fishy, to have a time limit on consignments. Time limits and spelling out how discounts work. Because there's always a discount and it shouldn't be a surprise."* **Charles Long, artist, Mount Baldy, CA**

If you are represented by a gallery, or have a long-term relationship with another party, and expect to consign work to it regularly, you can write a general consignment agreement to cover all your future consignments so that, from then on, all you need is a new inventory sheet each time you deliver work. Just add this sentence to the end of the agreement.

This consignment agreement will apply to all works I consign to the venue in the future, unless a new inventory list modifies some aspect of this agreement or the venue and I write a new agreement.

The reason for the second part of the sentence is that many venues do more for their artists the longer their artists are with them. Maybe you have to cover shipping for your first show, but by your third, the venue will pick up the tab. As these things evolve, so should your consignment agreement. Update it to say "the venue pays for shipping" where it used to say "I pay for shipping" and give it to the venue. (Or add it to your next inventory list.)

Note that we don't include this sentence about future consignments in our sample agreements because most consignments are one-offs and you don't want to come across as too presumptuous. You should add the sentence once you have an ongoing relationship.

Time Frame

Specify how long the consignment will last. Either tack the dates onto the first sentence of the agreement or start a new sentence:

The consignment will last from [start date] through [end date].

Consignments can range from a few days to many months. If the impetus is a show, the consignment typically lasts from the week before the show opens through the week after it closes, though venues often want to hold work longer than that to follow up with interested collectors. When you're consigning your work

to a venue that doesn't represent you or an entity that's trying to sell the work without showing it, the consignment shouldn't need to last more than six months. A venue that does represent you might want an indefinite consignment, which is fine given that your relationship will continue well beyond the current show. (More on that in chapter 13).

It's also a good idea to state:

The venue will return any unsold work to me within [15] days of the end of the consignment period.

You and the venue can always decide to extend the consignment period. Just do so in writing, either by marking up your original consignment agreement or sending the venue an email with the new date. It doesn't have to be formal:

Hi [gallerist],

It's not a problem at all if you want to hold on to [title of work] until [new date], instead of what we said in the consignment agreement. Let me know before [new date] if you end up needing more time than that.

Hope all is well.

The point is to avoid an ambiguous, open-ended arrangement where you don't know when you'll get your work returned. Otherwise you'll be stuck in the awkward position of trying to guess when it's appropriate to ask for it back. Too soon and you give the impression that you don't like the venue; too late and your work just stays hidden. This also complicates planning for upcoming shows, since you don't know whether you'll be able to include the work. Much better to set expectations in advance.

Some consignment agreements state that, regardless of the time frame, either the venue or you can end the consignment at any time, usually with some kind of written notice:

Either the venue or I may cancel this consignment agreement with [14 days] notice by writing to the other, in which case the venue will return any unsold work to me within [30] days.

Why You Need a Consignment Agreement, Part Two
As we were writing this chapter, a New York gallery closed down without paying the fees for storing its artists' work in an off-site facility. None of the artists could get their work back from the storage facility without proof that they had consigned the work to the gallery.

—————— "My only advice to an independent artist working with a consultant is to be sure the consultant is professional, has experience in the field, and that you settle on pricing and commission structure in writing in advance of any sale." **Heather Marx, Heather Marx Art Advisory, San Francisco, CA**

—————— "Artists are not nonprofit, we are for profit. We need to be paid." **Stephanie Diamond, artist, New York, NY**

—————— "It seems like artists don't know they can ask to be paid. Don't go up there guns blazing to an institution that is offering you an opportunity, but it's okay to sit down, person to person, and tell them, 'This is what I need to make this work. What can you do on your end? And how can we work together?' I've been thinking a lot about building community in that way, which is just providing transparency around money and power." **Deana Haggag, president and CEO, United States Artists; former executive director, The Contemporary, Baltimore, MD**

Commission

State the commission structure for any sales and whether one of you will be reimbursed for production costs off the top. (For an explanation of production costs, see chapter 13.)

Nearly every contemporary brick-and-mortar gallery in the United States takes a 50% commission on sales, unless there is a special circumstance or you are a rock star who can demand more. Art consultants take from 20 to 50% (although most skew closer to 20%). Online galleries and other digital venues also take anywhere from 20 to 50%. You should agree to a percentage that reflects the amount of work they're doing for you. Although they may not have the overhead of a physical space, they could warrant the high commission through extraordinary support. If the benefits of the sale aren't all that, 50% may be too high.

When a venue works with an outside curator to put together a group show, the curator may also take a commission—usually around 10%—but that commission should come out of the venue's half, not yours. So it's easier to state the percentage *you'll* get, regardless of any arrangement between the venue and a curator (or art consultant or anyone else).

The venue will offer the work for the prices listed above. For any sales, I will receive [50%] of the retail price, after subtracting production costs. [The venue or I] will receive 100% of production costs for any work sold.

If the venue does not agree to reimburse you for your production cost, then you can omit everything after "retail price" in the paragraph above. If the general split will be different for a specific work, just add that fact:

For any sales, I will receive [50%] of the retail price, except that for [title of work], I will receive [_%] of the retail price.

Nonprofit venues usually take a smaller commission—from 10 to 40%—if they take one at all. When a nonprofit doesn't take

a commission, your consignment agreement should say that you will receive 100% of the retail price. In that case, it is considered good form to make a donation when you end up selling work because of the show. You can donate 10% of the sale price or whatever dollar amount you think is fair (that is, give more to a nonprofit that spent a lot of money to make your show happen). It's a tax write-off and good for karma. If the venue won't actually offer the work for sale, you should use a loan form (see chapter 11).

Speaking of karma, when you donate a work to be auctioned at a benefit, you still use a consignment agreement (since the work is still yours until someone buys it, and if no one buys it you get it back). Just say in the agreement that the venue's commission is 100% of the sale price.

Discounts

State the maximum discount you will split with the venue:

I will split up to a [10%] discount, unless we agree to split a larger discount before a particular sale.

As you know from chapter 5, discounts are so common that many collectors expect them. The average discount for an ordinary sale is 10%. "Splitting" that means 5% comes off your half and 5% comes off the venue's half (so you end up with 45% of the original price). Museums regularly get 20% discounts—sometimes even more—and the venue will expect you to share that discount as well.

While we don't recommend agreeing to more than a 10% discount on a regular sale, the venue may want more leeway—say, up to 15%—for an especially important collector. Or you may feel that you're at the mercy of the venue anyway, so you'll live with the discount whatever it is. You should still put it in your consignment form to prevent unpleasant surprises.

————— *"I want consignment forms only because they help me to keep track of everything and because they help artists—especially younger artists—outline everything, including whether they agree to split a discount. That way I don't have to make that phone call every time I want to give a discount. It's already in writing and understood."* **Eleanor Williams, art dealer, independent curator, Houston, TX**

———————— *"Everything went smoothly with a show I curated except one of the artists and the gallery director had bad chemistry. There were no consignment forms and I was not in town so I couldn't help smooth things out. One piece sold but months later the artist was still not paid. The gallery and the artist were both calling me because I was the in-between person. There was nothing I could do really.*

"I suggest, from this experience, that artists always use a consignment form and not worry about being too pushy. Consignment forms are a good business practice and the gallery may respect you more when you ask for a consignment form." **Leah Oates, artist, curator, writer, Brooklyn, NY**

———————— *"I pay right away if the artist needs it. Sometimes, if I need it, the artist gives me permission to pay it out in chunks. Typically, I pay within thirty to sixty days. Sometimes I give advances if the artist is under financial pressure and it's really distracting them."* **George Adams, George Adams Gallery, New York, NY**

———————— *"I try to pay within forty-five days. I do all my own bookkeeping, so sometimes it takes sixty days from the time of a sale. Other times I can do it in ten days. Sometimes it can be the day I get paid if I know the person's counting on the money."* **James Harris, James Harris Gallery, Seattle, WA**

———————— *"In some cases, you are lucky to know if something has sold at all. In the past, I have personally had the experience and I know at least two or three other people who had similar problems. It is not uncommon for dealers to take your work and, two years later, when you ask for its return, tell you it sold and (hopefully) pay you. It's a way of not paying until the very last minute."* **Bill Davenport, artist, critic, Houston, TX**

Payment

Note when you'll be told of any sales, and when you'll be paid:

The venue will let me know of any sale within [one week] of making it. The venue will pay me my share of any sale within [30] days of receiving payment from the buyer.

Some people are very good at telling artists right away when their work sells (who doesn't like giving good news?!), but others are notoriously lax. There's just no good reason you should have to wait a long time to know your work sold.

Even more important, of course, is when you get paid. Once again, venues differ greatly on this point. Some pay the same week, some pay at the end of the month, a few are known to drag their feet for a year. We think every venue *should* commit to paying within thirty days from when a collector pays them, but don't be surprised if you find yourself consigning work to a place with a two- or three-month turnaround. In any case, don't agree to more than ninety days. That's not fair to you.

Shipping

If work is moving around, say who will cover the costs of packing, shipping, and insuring the work. Expect to pack the work in your studio before it goes to the venue. Usually the venue will pack the work before it's shipped back to you, though some places will expect you to pack it on both ends. Many insurance plans do cover work in transit, as long as there is a signed consignment or loan agreement.

[The venue is or I am] responsible for shipping the work to and from the venue, including insuring the work for risk of loss or damage during shipment. I will pack the work before shipping it to the venue and the venue will pack the work before shipping it back to me (or to the buyer if the work sells).

What you can get here depends on your clout and your relationship with the venue (more on that in chapter 13). Expect

—————— "I have consignment forms with my artists. You have to be straightforward with every agreement you do with an artist. You can't surprise them—it's not fair. Most artists, when you show them at the beginning of their careers, really don't know how the art market works. You need to carefully explain it to them and be up-front and clear. When everything is clear, it works well. When things are muddy, you're opening yourself to problems."

Shoshana Blank, Shoshana Wayne Gallery, Santa Monica, CA

very little from a first-time group show—though it never hurts to ask. Some places will only pay for shipping when an artist raises the issue. A nonprofit might give you a shipping stipend. An art consultant may pay outright. Smaller venues often ask artists to cover shipping *to* a show but not from it (they hope to sell the work and not have to pay shipping at all), in which case you could say:

I am responsible for shipping the work to the venue. The venue is responsible for shipping the work back to my studio, including insuring the work (to its retail price) for risk of loss or damage.

What if you're making a site-specific piece in the exhibition venue? Or your piece changes form over the course of the show? Do you expect the space to ship it back to you when the show is over? Be specific about your expectations.

Safekeeping and Insurance

Your consignment agreement should include a line about the condition of the work and its safekeeping:

The work will be assumed to have arrived in good condition unless the venue notifies me in writing, within 24 hours of delivery, that it arrived damaged. The venue is responsible for safekeeping the work while it is in the venue's possession.

If the venue pays for shipping both ways, it should insure your work from the moment it leaves your studio to the moment it comes back (sometimes called "on a nail-to-nail" or "shelf-to-shelf" basis). If you're paying for shipping the work one or both ways, the venue should insure the work the rest of the time. Don't compromise here: the venue *must* have insurance for its premises (even small nonprofits do), or be willing to accept financial responsibility if the work is damaged while in its possession.

Keeping work "safe" can mean different things for different works: it might just mean keeping it free of damage; or it could involve watering, brushing, feeding, rotating, guarding, keeping

the humidity low, etc. Be specific if your piece warrants that level of detail.

The venue will insure the work (to its retail price) for any loss or damage while the work is in the venue's possession.

Jump to the end of the chapter to see what your consignment agreement will look like if you only include what we've discussed so far.

EXTRAS

There are a few more issues you or the venue might want to address in your consignment agreement. We'll include all of them in another sample consignment agreement but you can decide to use any combination of them (or none at all). It depends on how detailed you and the venue want to get in the agreement.

8. Installation
9. Removal
10. Reproduction
11. Alteration
12. Collector information

Installation

You or the venue may want to specify:

[The venue is or I am] responsible for installing and deinstalling the work.

Think carefully about the installation. Is the work so complex that you need to include specific instructions for the venue to follow? (Make sure they are clear!) Do you need to be there in person to install, and, if so, will the venue pay for your travel and/ or time? Have the conversation with the venue ahead of time, and add those items to your form as needed. You can attach the

—————— "At the Contemporary, we worked with a company outside the art world that handed us a sheet of paper, basically stating their 'rules of engagement.'" Here's what's going to make things better for everyone; here's what's going to complicate some things; here are things that, no matter how well or how organized all of us are, are going to get clumsy at a certain point. We tried to draft something similar, thinking about our projects with artists. There were still a lot of questions, so we're always working on how can we clarify our process." **Deana Haggag, president and CEO, United States Artists; former executive director, The Contemporary, Baltimore, MD**

—————— "When I teach, I show artists a sample consignment agreement with various clauses and I tell them they'll never be able to ask for all of these things the first time around. But it's remarkable how many artists do not even know about some of the issues that are addressed in those clauses. Education alone is a point of enlightenment." **Sergio Muñoz Sarmiento, attorney, artist, educator, Brooklyn, NY**

installation instructions to the form, or note that they will be provided:

[The venue is or I am] responsible for installing and deinstalling the work [per the attached instructions/per the instructions I will provide the venue in advance].

Removal

A venue might want to take your work to an art fair, bring it "on approval" to a corporation, or consign it to another venue, all in the hope of making a sale. If you're consigning your work to someone for the first time, you may want to include a line reminding them to ask you for permission:

The venue may not remove the work from its premises during the consignment period without first getting my permission.

Ask the venue whether it has removed other works before, and under what circumstances. Does it plan on doing the same with your work? Some venues may loan works for short periods to model apartments or hotel lobbies, for example. If they want to do that with your work, you'll need to decide whether that sort of exposure is valuable on its own, or only worth agreeing to if you're given some share of what the venue will be paid for the loan.

Reproduction

Almost every venue will want to use images of your work for *something:* the website, a press release, a show card. Typically, you'll give them documentation of individual pieces that you've taken, and they'll give you installation shots that they've taken. It's a good idea to clarify who is responsible for taking which images, to have the venue keep you posted on how it uses your images, and to make sure you get proper credit:

[The venue is or I am] responsible for taking images of the individual works (or documenting them in the appropriate manner). [The venue is or I am] responsible for taking installation shots of the exhibition. Although I retain all reproduction rights to my work, the venue may use these images to promote the show or my work, crediting me as the artist. Images reproduced in the press should include the line "Courtesy of [my name and the venue]."

Alteration

Once you consign your work to a venue, it will not appreciate you coming in to "improve" the work in the middle of a show (unless the work is supposed to change, of course). Some venues have had problems with artists doing this and therefore say something in their consignment agreements such as "The Artist may not alter the work during the consignment period." We don't include this sentence in our sample agreements, but if a venue raises the issue, you can always add it.

But wait—what if your work is *supposed* to change over the course of the show, or sometime after it's purchased, such as an installation of living plants? Set these expectations now so the venue understands what it is offering, and any would-be collectors know what they'd be buying. Maintenance and longevity can be complex issues. There are no right or wrong answers, only realistic and unrealistic expectations.

Collector Information

We think you are entitled to know who buys your work. Not all venues agree with us, though, so, as we explain more thoroughly in chapter 13, you have to tread carefully here. Assuming the venue agrees to do so, you can add this phrase to the sentence on payment turnaround:

Within [30] days of receiving payment from the buyer, the venue will pay me my share of any sale and give me the buyer's name and contact information.

Additional Protections

You may not have direct contact with a venue's collectors when you consign your work, but you still have a stake in any sales agreement between the venue and a collector. So go back to chapter 2 and review the terms we recommend for invoices—do you want the venue to include any of them in its own sales agreements? Again, raise the topic now so everyone's on the same page.

LEGAL ISSUES

There are a number of legal terms that any lawyer would tell you to definitely include in a consignment agreement. At the same time, we understand that you have to balance the need to protect yourself with the need to show your work. Try to add too much legalese to an agreement and you might scare people away.

If you live in a state with art consignment laws, many of these legal protections exist even if you don't write them into your consignment agreement.

13. Agency
14. Warranty
15. Title
16. Creditors
17. Trust
18. Gallery disclaimer
19. Automatic termination
20. Entire agreement
21. Modification
22. Assignment
23. Enforceability
24. Waiver
25. Interpretation
26. Legal fees
27. Choice of law

We'll go through these terms one at a time, but you can pack them all into one paragraph at the end of your agreement to make them look less offensive.

Agency

The venue you consign your work to becomes your agent for whatever you're consigning. This is important from a legal perspective because an agent automatically has a number of responsibilities to its principal (that's you).

When you consign your work on an exclusive basis, you're telling the venue that no one else is allowed to sell the same work during the consignment period. Most venues assume that this is the arrangement, as opposed to a "nonexclusive" one in which you could theoretically have another venue try to sell the same work. (Legal issues aside, trying to consign the same work to more than one gallery is a very bad idea.)

This concept of exclusivity applies equally to digital platforms, so find out what the venue's expectations are around posting your images on various sites and apps, especially ones that sell art. You don't want to be in a position where the same work could be sold simultaneously by two different entities, unless your work is in multiples or large editions. Even in that case, you need to be

extremely organized, and ensure that both entities are prepared for the possibility ahead of time.

I appoint the venue as my exclusive agent for the work identified in the inventory list above.

Note that the "exclusivity" relates only to the work you consign. If the venue doesn't fully represent you, then there's nothing wrong with consigning *other* work to a different venue— as long as you're aboveboard with everyone and not trying to go behind anyone's back. See chapter 12 for more on courting commercial galleries.

Warranty

A warranty is essentially a promise that something really is what you say it is, or really does what you say it will do. When you buy a new TV, for example, the manufacturer gives you a warranty that the thing works (at least for a while). A venue selling your work on consignment wants to be sure that the work you consign really is yours, and that you haven't, for example, sold the copyright to someone else.

I warrant that I own the work and all proprietary rights to it and that I have the right to appoint the venue as my agent to sell it.

Title

You already know about title from chapter 2, where you added it to your sales invoices. Here, you want to make it clear:

I retain title in each work I consign to the venue until I am fully paid for any sale, at which time title will pass directly to whoever bought the work.

Creditors

You also want to make sure you won't be on the hook for any of the venue's debts:

I shall not be subject to claims by any creditors of the venue.

Now, there's this thing called the Uniform Commercial Code (UCC). If you're ever suffering from insomnia, the UCC will cure you in about five minutes. It's basically a bunch of rules for buying and selling things.

If the venue goes bankrupt (or becomes "insolvent"), you want to be what the UCC calls a "secured party," because you have a better chance of getting your stuff back than if you're an "unsecured party":

If the venue becomes insolvent, I shall have the rights of a secured party under the Uniform Commercial Code.

Technically, if you don't live in a state with an art consignment law, you or the venue has to fill out a specific UCC form and file it for each consignment. Whether it's worth going through all of that hassle is something you should discuss with the venue.

Trust

One technical aspect of a consignment relationship is that the person to whom you consign your work can't use your share of sales for anything other than paying you. This is called holding your money "in trust." Many states have art consignment laws that require sale proceeds to be held in trust, but it doesn't hurt to address the issue in your agreement. And if you're in a state that doesn't have an art consignment law, you definitely need it:

The venue will hold in trust my share of the proceeds from any sales.

———— *"There was a gallery facing bankruptcy and the creditors wanted their money. An artist called me and said 'I need to get my work out of there.' Unfortunately, the artists were not allowed to go back into the gallery to get their work unless they had a piece of paper proving they had loaned the work to the gallery."* **Sara Jo Romero, Schroeder Romero Editions, New York, NY**

———— *"I do not own the art, the artist owns it. It's $20,000. When it sells, I get paid $10,000 to sell it. It's not our money and we are holding it in trust for the artist. A lot of gallerists don't think about it, but I think it's a critical base for the rest of the relationship."* **Kerry Inman, Inman Gallery, Houston, TX**

Sales Disclaimer

There's no guarantee that a venue will sell your work. It will hope to sell your work, and if it's doing its job it will *try* to sell your work, but no venue is going to promise that it *will* sell your work. That's pretty much built into the concept of consignment, but some venues may want to be explicit about it:

I understand that the venue does not promise any particular outcome from its sales efforts on my behalf.

Automatic Termination

Here's a downer! What happens if you die? The law doesn't necessarily cancel your consignment agreement, so you might want to include this sentence:

This agreement will automatically terminate if I die or the venue becomes insolvent.

Entire Agreement

It's standard for written agreements to state that they "express the complete understanding of the parties" or something like that, so you don't end up arguing later over whether there were other promises made (orally or in writing) on top of what's in the agreement.

This agreement states our complete understanding and replaces any earlier understandings between us.

But *watch out* with this one. Don't include it unless it's really true! If you use a bare-bones consignment agreement because the venue hates paperwork and doesn't want to see anything longer than one page, then whatever you've written probably *isn't* the "entire understanding."

Modification

It's standard to spell out how you can change an agreement if you want to, so you don't end up arguing later over whether the agreement was actually changed.

We may only modify this agreement in writing, signed by both of us.

Assignment

Normally, you can let anyone else take your place in an agreement. This is called "assigning" the agreement, and it means the new person takes over your obligations and becomes entitled to whatever benefits you were getting. It makes sense for certain agreements in other markets. It makes no sense at all for consignment agreements, given that relationships in the art world are so personal. You may like the gallery owner's son just fine, but that doesn't mean you want him selling your work for you when the gallery owner retires and assigns your consignment agreement to him.

To make sure you have a say in the matter, add this sentence:

The venue may not assign its rights or obligations under this agreement without my written permission.

Enforceability

Sometimes a judge will decide that a specific part of an agreement isn't enforceable for some reason or another. Maybe it's too vague, or requires something illegal (you can't enforce an agreement to consign crystal meth, for example, because selling crystal meth is illegal). When that happens, the judge could throw out the entire agreement unless it says something like this:

If a court holds any part of this agreement illegal, void, or unenforceable, the rest of the agreement will remain enforceable.

Do you need this when you consign a $600 drawing? Probably not. Will it make you look like someone planning on suing if things go wrong? Maybe. So don't include this language unless you're including all the other legal terms we recommend.

Waiver

This is another get-ready-for-court clause. Say the venue doesn't live up to one of its obligations (it "breaches" the agreement): you find out through the grapevine two months later that the venue sold your work and didn't tell you within a week, as it was supposed to. If you don't sue the venue right away (which you're probably not going to do), then you might "waive" your right to sue the venue later. Now say the venue never pays you for the work. If you sue the venue to get paid, a judge might tell you that by waiving the right to sue over the first problem, you waived your right to sue over *anything*. To prevent this, you need to include:

The waiver of one right is not a waiver of any other right.

Interpretation

If any part of an agreement is ambiguous and you end up in court arguing over what it means, a judge will have to interpret the ambiguous language. Normally, the judge will accept the interpretation of the person who *didn't* draft the particular sentence that's ambiguous—unless you add this sentence:

This agreement shall not be interpreted for or against me (or for or against the venue) because one of us (or our respective counsel) drafted a contested provision.

This is important because by starting with your own agreement, you are considered to be the one who drafted it. And you don't want a court favoring the venue's interpretation of the agreement over yours just because you used your agreement.

Legal Fees

Hiring a lawyer can easily end up costing more than the amount of money someone is refusing to pay you. So it's often not worth it, from an economic perspective, to sue the venue (never mind all the other reasons it's not a great idea, which we'll talk about in chapter 14). One way to at least leave the option open to you, regardless of your pocketbook, is to add that:

In any proceeding to enforce this agreement, the losing party will pay the winning party's reasonable attorneys' fees.

In other words, assuming the venue really does owe you the money, when you win, the venue will not only have to pay you what it owes you, it will have to pay for your legal bills, too. The prospect of this will encourage the venue to try and settle quickly, since delay only drives up your legal costs, which the venue is now on the hook for.

Don't go filing any frivolous claims, though, because if you lose, you'll have to pay the venue's fees.

Choice of Law

Say you live in Texas and have a gallery in California—does Texas law or California law govern your consignment agreement? If you're a normal person, the answer is "Who cares?" But lawyers *love* these kinds of problems, because they're very expensive to solve.

The last thing you want to do, if you end up in court, is spend time and money arguing over which state's law applies to your consignment agreement. So decide ahead of time:

[State] law shall govern this agreement, regardless of conflict-of-law principles.

To decide which state is "best" for you, talk to a lawyer. People *usually* choose the law of the state they're in: if you and the venue are both in California, you will almost certainly end up

———— *"The problem with the art consignment statute is that it's not self-enforcing. One of the things it says is that the gallery can't hold the work for ransom. But galleries do it anyway, and they know it's expensive for the artist to try to do something about it. So you end up settling for something less than 100 cents on the dollar in order to get the work back."* **Donn Zaretsky, partner, John Silberman Associates; writer, Art Law Blog, New York, NY**

choosing California law; you will probably not choose the laws of North Dakota. But sometimes people do choose to have another state's laws govern a contract (which may sound weird but is perfectly legal and, in other industries, happens all the time). As you can imagine, there are serious implications to choosing one state's law over another's, so get advice from a volunteer arts lawyer.

AND NOW FOR THE MOST IMPORTANT PART

Both of you should sign and date the consignment agreement.

SAMPLES

Here are a few different samples. First, a basic inventory list (without any terms). Then three consignment agreements, corresponding to the three sections in this chapter: a bare-bones version, a version with some "extras," and a full-blown version with all of the legal terms, too. We obviously recommend using the full-blown version, but if you're not comfortable with it, using the simpler ones is still better than nothing. And if you really won't follow our advice on consignment agreements, at the very least use the basic inventory list!

Remember that you should edit these sample agreements. We present them as starting points, not finished products. Add items, delete terms, and edit phrases to make them more specific to the venue and your work. The venue may want to do the same. And the arts lawyer you ask to review the final draft may also need to add language specific to the state you're in.

Inventory List

Work by _____

(Artist name and full contact info)

TITLE, YEAR MEDIUM, EDITION DIMENSIONS/DURATION	RETAIL PRICE
	FRAMING/PRODUCTION COST
1.	
2.	
3.	
4.	
5.	
6.	
7.	
8.	

_____ has received on consignment the works described above.

(Venue name and full contact info)

The consignment will last from today until _____

_____ _____

Venue signature Date

(print name)

Consignment Agreement

From:

_____ ("I/me")
Artist

Address

Email

Phone number

To:

_____ ("venue")
Venue

Address

Email

Phone number

Inventory List

TITLE, YEAR *MEDIUM, EDITION* *DIMENSIONS/DURATION*	*RETAIL PRICE* *FRAMING/PRODUCTION COST*
1.	
2.	
3.	
4.	
5.	
6.	
7.	
8.	

1. I consign to the venue the work identified in the inventory list above, from_____through_____.

2. The venue will offer the work for the prices listed above. For any sales:

 a. I will receive _____% of the retail price, after subtracting production costs.

 b. I will split up to a _____% discount, after subtracting production costs, unless we agree to split a larger discount before a particular sale.

 c. _____ [The venue or I] will receive 100% of production costs for work sold.

3. The venue will let me know of any sale within one week of making it. The venue will pay me my share of any sale within_____ days of receiving payment from the buyer.

4. _____ [The venue is or I am] responsible for shipping the work to and from the venue, including insuring the work for risk of loss or damage during shipment. I will pack the work before shipping it to the venue and the venue will pack the work before shipping it back to me (or to the buyer if the work sells).

5. The work will be assumed to have arrived in good condition unless the venue notifies me in writing, within 24 hours of delivery, that it arrived damaged. The venue is responsible for safekeeping the work while it is in the venue's possession. The venue will insure the work (to its retail price) for any loss or damage while the work is in the venue's possession.

6. The venue will return any unsold work to me within_____ days of the end of the consignment period.

7. Either the venue or I may cancel this consignment agreement by writing to the other, in which case the venue will return any unsold work to me within_____ days.

Dated: _____

Artist signature

Venue signature

(print name)

Consignment Agreement

From: To:

_____ ("I/me") _____ ("venue")
Artist Venue

_____ _____
Address Address

_____ _____
Email Email

_____ _____
Phone number Phone number

Inventory List

TITLE, YEAR MEDIUM, EDITION DIMENSIONS/DURATION	RETAIL PRICE
	FRAMING/PRODUCTION COST
1.	
2.	
3.	
4.	
5.	
6.	
7.	
8.	

1. I consign to the venue the work identified in the inventory list above, from_____ through_____.

2. The venue will offer the work for the prices listed above. For any sales:

 a. I will receive _____% of the retail price, after subtracting production costs.

 b. I will split up to a _____% discount, after subtracting production costs, unless we agree to split a larger discount before a particular sale.

 c. _____ [The venue or I] will receive 100% of production costs for work sold.

3. The venue will let me know of any sale within one week of making it. Within_____ days of receiving payment from the buyer, the venue will pay me my share of any sale and give me the name and address of the buyer.

4. _____ [The venue is or I am] responsible for shipping the work to and from the venue, including insuring the work for risk of loss or damage during shipment. I will pack the work before shipping it to the venue and the venue will pack the work before shipping it back to me (or to the buyer if the work sells).

5. The work will be assumed to have arrived in good condition unless the venue notifies me in writing, within 24 hours of delivery, that it arrived damaged. The venue is responsible for safekeeping the work while it is in the venue's possession. The venue will insure the work (to its retail price) for any loss or damage while the work is in the venue's possession.

6. The venue will return any unsold work to me within_____ days of the end of the consignment period.

7. _____ [The venue is or I am] responsible for installing and deinstalling the work. The venue may not remove the work from its premises during the consignment period without first getting my permission.

8. [The venue is or I am] responsible for taking images of the individual works (or documenting them in the appropriate manner). [The venue is or I am] responsible for taking installation shots of the exhibition. Although I retain all reproduction rights to my work, the venue may use these images to promote the show or my work, crediting me as the artist. Images reproduced in the press should include the line "Courtesy of [my name and the venue name]."

9. Either the gallery or I may cancel this consignment agreement by writing to the other, in which case the venue will return any unsold work to me within_____ days.

Dated: _____

_____ _____
Artist signature Venue signature

 (print name)

Consignment Agreement

From: To:

_____ ("I/me") _____ ("venue")
Artist Venue

_____ _____
Address Address

_____ _____
Email Email

_____ _____
Phone number Phone number

Inventory List

TITLE, YEAR *MEDIUM, EDITION* *DIMENSIONS/DURATION*	*RETAIL PRICE* *FRAMING/PRODUCTION COST*
1.	
2.	
3.	
4.	
5.	
6.	
7.	
8.	

1. I consign to the venue the work identified in the inventory list above, from _____ through _____.

2. The venue will offer the work for the prices listed above. For any sales:

 a. I will receive _____% of the retail price, after subtracting production costs.

 b. I will split up to a _____% discount, after subtracting production costs, unless we agree to split a larger discount before a particular sale.

 c. _____ [The venue or I] will receive 100% of production costs for work sold.

3. The venue will let me know of any sale within one week of making it. Within_____ days of receiving payment from the buyer, the venue will pay me my share of any sale and give me the name and address of the buyer.

4. _____ [The venue is or I am] responsible for shipping the work to and from the venue, including insuring the work for risk of loss or damage during shipment. I will pack the work before shipping it to the venue and the venue will pack the work before shipping it back to me (or to the buyer if the work sells).

5. The work will be assumed to have arrived in good condition unless the venue notifies me in writing, within 24 hours of delivery, that it arrived damaged. The venue is responsible for safekeeping the work while it is in the venue's possession. The venue will insure the work (to its retail price) for any loss or damage while the work is in the venue's possession.

6. _____ [The venue is or I am] responsible for installing and deinstalling the work. The venue may not remove the work from its premises during the consignment period without first getting my permission.

8. [The venue is or I am] responsible for taking images of the individual works (or documenting them in the appropriate manner). [The venue is or I am] responsible for taking installation shots of the exhibition. Although I retain all reproduction rights to my work, the venue may use these images to promote the show or my work, crediting me as the artist. Images reproduced in the press should include the line "Courtesy of [my name and the venue name]."

8. The venue will return any unsold work to me within_____ days of the end of the consignment period.

9. Either the venue or I may cancel this consignment agreement by writing to the other, in which case the venue will return any unsold work to me within_____ days.

10. I appoint the venue as my exclusive agent for the work identified in the inventory list above. I warrant that I own the work and all proprietary rights to it and that I have the right to appoint the venue as my agent to sell it. I retain title in each work I consign to the venue until I am fully paid for any sale, at which time title will pass directly to whoever bought the work. I shall not be subject to claims by any creditors of the venue. If the venue becomes insolvent, I shall have the rights of a secured party under the Uniform Commercial Code. The venue will hold my share of the proceeds from sales in trust. I understand that the venue does not promise any particular outcome from its sales efforts on my behalf. This agreement will automatically terminate if I die or the venue becomes insolvent. This agreement states our complete understanding and replaces any earlier understandings between us. We may only modify this agreement in writing, signed by both of us. The venue may not assign its rights or obligations under this agreement without my written permission. If a court holds any part of this agreement illegal, void, or unenforceable, the rest of the agreement will remain enforceable. The waiver of one right is not a waiver of any other right. This agreement shall not be interpreted for or against me (or for or against the venue) because one of us (or our respective counsel) drafted a contested provision. In any proceeding to enforce this agreement, the losing party will pay the winning party's reasonable attorneys' fees.

_____ [State] law governs this agreement, regardless of conflict-of-law principles.

Dated: _____

Artist signature

Venue signature

(print name)

CHAPTER 11
Loans and Commissions

—————— "We learned the difference in tone between emailing an artist a contract and asking them to send it back to us versus sitting down face-to-face to read through every section of the contract together. You're going to ask all the questions you have; we're going to give you all the answers we have. We all sit down, take notes, learn what about the contract is still too confusing, what people really need. It clarifies. Then when we're having conversations when the project's in full force, and everyone's stressed and there's never enough money or time, the artist remembers that conversation we had, not an email they may or may not have read. It's very transparent. It completely shifts the conversation." **Deana Haggag, president and CEO, United States Artists; former executive director, The Contemporary, Baltimore, MD**

—————— "In most cases a contract is the right thing to do and it protects the artist. We always write an initial draft and give it to the artist to review. If there is anything the artist is uncomfortable with, it will be addressed, and we often go through a few drafts before we get to a final version. It is a negotiation. Many times copyright and other things get factored into those contracts, and I always tell artists to look really carefully at those details.

"For me, a contract really lays out the production schedule, and it's nice to have that in writing. You'll probably have to change it, but it's good to all work off the same schedule for deadlines so expectations are shared. If the artist needs more time, the curator will advocate for the artist to their institution, within reason, and reach some kind of compromise. Contracts are not written in stone, but you have to have a common goal." **Anne Ellegood, senior curator, Hammer Museum, Los Angeles, CA**

There are a couple other arrangements you might run into: a loan, which is basically a consignment without the sales part, and a commission, which is when someone (or some organization or company) commits to buying specific work from you before you've made it.

LOANS

Museums and nonprofits almost always have their own loan agreements (or "loan contracts"), so you shouldn't need your own. Just make sure you read what you're given and find a volunteer lawyer to help you understand everything. And don't be afraid to edit the language if you disagree with something, or to add items that are important to you but not addressed in the agreement.

There's no industry standard, by the way, when it comes to loan agreements. You might get a long document full of legalese, you might get a short list of touchy-feely requirements ("Be nice to interns").

Since loans are very similar to consignments, pay attention to all the issues we talked about in the last chapter (except the ones related to payment). And while you still need to have a lawyer look through the agreement to make sure you're okay, there are three big issues to look out for.

First, don't give away your copyright or grant the venue an "irrevocable, perpetual, exclusive right to reproduce images of your work for any purpose." Agreeing to that means giving the venue permission to do literally anything it wants with images of your work. If you see a sentence along those lines, either take it out or limit the grant to one "for any _noncommercial_ purpose." If the venue wants to use your images for commercial purposes (such as selling shirts in the gift shop) it should have to get your written permission on a case-by-case basis.

Second, try to get an "indemnity." That means the venue—and _not_ you—will have to pay for any accidents or injuries that happen while the venue has your work. If someone trips over part of it, breaks a leg, and sues you for "injuring" them, the venue

will pay the legal fees to defend the case, pay any settlement amounts, etc. Look at paragraph 11 of our sample site-specific commission agreement to see what indemnification language looks like (later in this chapter).

Third, pay attention to insurance value. Even though your work won't be for sale, the institution will need to insure it, which means it will need to value it. Some places try to cut corners by having you value the work at 50% of its retail price, on the theory that, if you were selling the work through a gallery, you'd only get half the sales price. Bad idea. List the *full* retail price. That's the price that reflects the market value of the piece, and, therefore, affects the value of your other work. That's the price you deserve if the work is damaged beyond repair.

If you find yourself loaning work to a space that does not have a loan form, you can tailor a consignment agreement to the situation, deleting any language related to sales and then adding:

The venue will provide me with the contact information of anyone who expresses interest in the loaned work or my work in general (and who is willing to provide their contact information).

——————— *"Artist Space has loan agreements as contracts. There needs to be room for experimentation, but there are some set things and having a contract protects both parties.*

*"Artists come in not knowing how things work and funding is constantly changing. Sometimes the institution can pay for shipping and sometimes it can't. Sometimes it can install work and sometimes it asks the artist to install it. It depends on multiple factors, so it's good to make those things clear from the beginning." **Hillary Wiedemann, artist, Chicago; former codirector, Royal NoneSuch gallery, Oakland, CA***

PRIVATE COLLECTOR COMMISSIONS

Being asked to do a commission can be very flattering. It means someone likes your work enough to want to buy something from you before they've even seen it. The thing to keep in mind, though, is that collectors often have very specific ideas about what they want when they commission something, which necessarily limits your creative freedom. If they were just going to let you make whatever you wanted, they wouldn't need to commission it; they could just wait and see what you make and then decide whether to buy it.

This aspect of working on a commission can be rewarding, in that the collector's priorities challenge you to experiment in new directions. But it can also be frustrating if, for example, the

———— "As long as it's interesting, offers a decent and fair payment, I like the people I'm working with, and find inspiration in the space itself, I'm up for commission-based work. It's a case-by-case situation; you usually know in your gut if you're excited to do it or not." **Naomi Reis, artist, New York, NY, and Tokyo, Japan**

———— "You can say no! The artist is still in the power seat. This person or institution is approaching you to make a thing in your vision. They could approach anyone in the world and they're coming to you. If you only make work in black and I sit you down and pressure you to use color, you can say no. Or you can vocalize why this makes you uncomfortable." **Deana Haggag, president and CEO, United States Artists; former executive director, The Contemporary, Baltimore, MD**

———— "Sometimes the things I have done for commissions are things I would not have thought of doing in exactly the same way, but they're actually extensions of the ideas in my work. There have been situations when I have done commissions for a little less because I already got something from it. There's intellectual currency." **Joseph Havel, artist, director, Core Program, Houston, TX**

collector starts telling you to "add more blue" or "make me look younger and thinner."

That's why you need to set the ground rules ahead of time. Decide how much creative control the collector has—and what *kind* of creative control. Will you need to agree on the subject matter together? On the materials? Who will have final say at each step? What is the budget? Which costs will the collector cover? When will you get paid?

You *have* to talk about these issues before you get started. You don't avoid them by delaying the conversation, you just make them more complicated. We know too many artists who weren't paid for a commission, or ended up ruining a relationship with a collector, because they didn't clarify expectations at the start.

To help you think through those expectations, we've made two sample commission agreements that you can use when you're working directly with a collector: a basic commission, for work that can be hung or installed anywhere, and a site-specific commission, for work that can only be installed at a particular location. (When a gallery represents you, it should use its own agreement, although you can still compare that with ours to make sure it covers all the issues you want it to.)

We set up the sample agreements so that you're paid a fee up front to compensate you for the initial creative work and planning you'll have to do. The amount is for you and the collector to agree on; it should correlate with how much time and effort you have to put into the planning stage. If all you have to do is a simple mock-up or description that won't take a lot of time, ask for a small fee. If it will take a lot of effort to put together the proposal, your fee should be significant.

During the proposal stage, you may want to limit the number of changes the collector can suggest, to avoid endless back-and-forth. If you go down that road, the collector may want to limit the number of changes *you* can make, so be clear about who can require what, and how often, when it comes to modifying the original proposal.

When you finish that stage, you propose your final ideas to the collector for approval. If the collector doesn't approve your proposal, you can walk away or start over (for another up-front payment). If the collector *does* approve your proposal, then you know you're on the right track and the collector, by approving the

proposal, is agreeing to pay you for the finished work. This arrangement does several things: it gives the collector some creative input, ensures you're paid for the effort you've put in until that point, and protects you from taking a direction the collector won't pay for in the end.

Of course, once the collector has approved your proposal, you have to stick with it. You can't just change major elements and expect the collector to go along—unless, that is, you stated in your proposal that those elements might change. So give yourself enough leeway in your proposal to make the kinds of adjustments you may need to make as you create the work. Same goes for the collector, who has to stick with the plan you both agreed to, and can't rescind his or her approval once you're onto the next stage. The whole point of the approval is to lock in your plan; the collector changing requirements later on would be akin to you turning in finished work that was completely different from what you'd proposed.

We recommend building in an additional fee if a collector wants to make more changes than you both agreed to up front; wants to make new changes after approving the proposal; or wants to make particular complicated changes.

Like our consignment agreements from chapter 10, our commission agreements are made to be edited. You can add details and change or delete any sentences that don't apply to your situation, and the collector may mark it up as well.

One thing you should *not* let the collector add, though, is a sentence saying you agree "not to make any work in the future that is *substantially similar* to the commissioned work." Collectors sometimes put this in a commission agreement because they want to ensure that the work they commission is unique and that you won't make a bunch of copies in the future. Their concern is understandable but the language is a problem. Isn't a lot of your work "substantially similar"? Certainly all the pieces in a body of work are "substantially similar"—that's what justifies them being in the same body of work! It's fine to agree not to make "identical" work, but get that "substantially similar" phrase outta there.

There are a few legal terms at the end of the agreement. Go back to chapter 10 if you need to jog your memory about what they mean. And bring the agreement to a local volunteer lawyer for the arts before you sign it, to make sure it works for the state you live in.

Pricing Your Commission

Your commissions should cost anywhere from 20 to 100% *more* than comparable "uncommissioned" work. The premium is based on the fact that you're giving up some creative control and that the commission takes you away from your regular studio practice. The more creative control you have to give up, and the further away you have to move from your practice, the more your commission should cost.

——————— *"The problem with commissions is doing way too much. Too much for too little. Artists tend to give a little bit more and they don't realize they are giving so much away for not enough. They tend to undervalue their commissioned artwork." **Steve Henry, director, Paula Cooper Gallery, New York, NY***

Commission Agreement

between

_____ ("I/me") _____

Artist Address

_____ _____

Email Phone number

and

_____ ("buyer") _____

Collector Address

_____ _____

Email Phone number

1. Buyer has asked me to conceive of and create an original _____ ("work").

2. The price of the work is $ _____. The price does not include the costs described below.

3. Buyer will pay me a non-refundable fee of $ _____ on signing this agreement (which will count toward the price of the work).

 a. Within _____ days of signing this agreement, I will propose the work to buyer.

 i. Buyer may suggest up to ___ changes to my proposal, after which any additional changes (up to the same number) will require another up-front, non-refundable fee, in the same amount. Buyer will make any such suggestions within ___ days of receiving my most recent proposal. Any additional fees are incremental and will not count toward the price of the work.

 ii. Once we agree on any changes to be made, I will present a new proposal within ___ days.

 b. If buyer does not accept my most recent proposal within 30 days of its presentation, I will not have any more obligations to buyer.

 c. If buyer accepts my proposal, buyer will pay me 50% of the work's price (minus the initial, non-refundable fee) within 30 days of accepting the proposal, and I will make reasonable efforts to finish the work within _____ days of receiving this payment. Buyer will pay me the remaining 50% within _____ days after I finish the work.

4. Buyer will promptly provide me (at buyer's expense) any photos, documents, and other information that I need to create the work.

5. Buyer will cover the costs of insurance, shipping, and any storage of the work.

6. Buyer may not allow any modification to the work during my lifetime without my written permission. If anyone modifies the work during my lifetime without my written permission, the work will no longer be attributable to me.

7. I do not waive my rights under the Visual Artists Rights Act. Buyer may not allow any damage to the work. If the work is damaged during my lifetime, buyer must pay for restoration by a restorer whom I approve; otherwise, it will no longer be attributable to me.

8. I retain the copyright to the work. I grant buyer a limited, nonexclusive right to reproduce images of the work for non-commercial purposes, as long as they are credited as "Courtesy of [me], [my city]."

9. I continue to own any drawings, models, molds, digital renderings and similar materials created for making and installing the work.

10. If I die before finishing the work, neither I nor my estate will have any more obligations to buyer and the unfinished work may not be attributed to me.

11. This agreement states our complete understanding and replaces any earlier understandings between us. We may only modify this agreement in writing, signed by both of us. Buyer agrees that I will be entitled to specific performance and injunctive and other equitable relief to prevent or remedy any breach of this agreement. If a court holds any part of this agreement illegal, void, or unenforceable, the rest of the agreement will remain enforceable. The waiver of one right is not a waiver of any other right. This agreement shall not be interpreted for or against me (or for or against the buyer) because one of us (or our respective counsel) drafted a contested provision. In any proceeding to enforce this agreement, the losing party will pay the winning party's reasonable attorneys' fees.

_____ [State] law shall govern this agreement, regardless of conflict-of-law principles.

Dated: _____

_____ _____
Artist signature Buyer signature

Site-Specific Commission Agreement

between

_____ ("I/me") _____
Artist Address

_____ _____
Email Phone number

and

_____ ("buyer") _____
Collector Address

_____ _____
Email Phone number

1. Buyer has asked me to conceive of and create an original _____ ("work"), to be installed at this site:

_____.

2. The price of the work is $ _____. The price does not include the costs described below.

3. Buyer will pay me a non-refundable fee of $ _____ on signing this agreement (which will count toward the price of the work).

 a. Within _____ days of my initial site visit, I will propose the work to buyer.

 i. Buyer may suggest up to ___ changes to my proposal, after which any additional changes (up to the same number) will require another up-front, non-refundable fee, in the same amount. Buyer will make any such suggestions within ___ days of receiving my most recent proposal. Any additional fees are incremental and will not count toward the price of the work.

 ii. Once we agree on any changes to be made, I will present a new proposal within ___ days.

 b. If buyer does not accept my proposal within 30 days, I will not have any more obligations to buyer.

 c. If buyer accepts my proposal, buyer will pay me 50% of the work's price (minus the non-refundable fee) within 30 days of accepting the proposal, and I will make reasonable efforts to install the work within _____ days of receiving this payment.

 d. Buyer will pay me the remaining 50% within _____ days after I finish installing the work.

4. Buyer will promptly provide me (at buyer's expense) drawings, photos, maps and other information about the site that I need to create and install the work.

5. Buyer will cover the costs of:

 a. Travel expenses to _____, hotel accommodations, car rental, and a $_____ per diem fee for:
 i. My initial visit to the site, to last _____ days.
 ii. My installation visit to the site, to last _____ days.
 iii. _____ assistants, to accompany me during the installation visit.

b. Materials and labor for preparing the site, including any engineering.

c. Materials and labor for installing the work.

d. Insurance, shipping, and any storage needed for the work or its installation.

6. Buyer may only display the work in the manner and position I approve. Buyer may not allow any modification to the work during my lifetime without my written permission. A change in the work's position, or the manner in which it is displayed, is a modification to the work. If anyone modifies the work during my lifetime without my written permission, the work will no longer be attributable to me.

7. I do not waive my rights under the Visual Artists Rights Act. Buyer may not allow any damage to the work. If the work is damaged during my lifetime, buyer must pay for restoration by a restorer whom I approve, otherwise it will no longer be attributable to me.

8. I retain the copyright to the work. I grant buyer a limited, nonexclusive right to reproduce images of the work for non-commercial purposes, as long as they are credited as "Courtesy of [me], [my city]."

9. I continue to own any drawings, models, molds, digital renderings, and similar materials created for making and installing the work.

10. If I die before finishing the proposal for the work, neither I nor my estate will have any more obligations to buyer. If I die after buyer accepts the proposal but before I install the work, _____ will complete the installation. If the installation is not finished for any reason, the uninstalled work may not be attributed to me.

11. As long as buyer possesses or controls the work, buyer will release, indemnify, defend, and hold harmless me (and my successors and assigns) against all claims, demands, losses, and expenses connected in any way to the work (including, for example, injuries and property damage caused during shipping or installation of the work; legal costs; attorneys' fees; and settlements). The only type of claim this paragraph does not apply to is a claim that the work infringes a copyright.

12. This agreement states our complete understanding and replaces any earlier understandings between us. We may only modify this agreement in writing, signed by both of us. Buyer agrees that I will be entitled to specific performance and injunctive and other equitable relief to prevent or remedy any breach of this agreement. If a court holds any part of this agreement illegal, void, or unenforceable, the rest of the agreement will remain enforceable. The waiver of one right is not a waiver of any other right. This agreement shall not be interpreted for or against me (or for or against the buyer) because one of us (or our respective counsel) drafted a contested provision. In any proceeding to enforce this agreement, the losing party will pay the winning party's reasonable attorneys' fees.

_____ [State] law shall govern this agreement, regardless of conflict-of-law principles.

Dated: _____

_____ _____
Artist signature Buyer signature

——————— "There are certain clauses that we put into our contracts that are really specific to the artist that won't make it the next time, because that's just something the artist needed. For instance, an artist may live in Baltimore for the next six months to work on the project and needs child care. That's not a thing the last artist needed. It's not necessarily a thing we can afford every time, but in this case it's something they advocated for, so we're going to put it into their contract and we're going to make it work." **Deana Haggag, president and CEO, United States Artists; former executive director, The Contemporary, Baltimore, MD**

——————— "Working on larger-scale, site-specific installations has required me to plan further ahead, learn new skills that allow me to visualize and create my work, and communicate effectively with curators, art handlers, and gallery staff. Now that I am also running a university gallery that commissions artists to make temporary, site-specific installations, I am realizing how important it is that artists be focused, flexible, proactive, and forward-thinking when proposing and installing new projects." **Ann Tarantino, artist, State College, PA**

——————— "With the level of intensity and collaboration involved in a site-specific work, I found that contracts were helpful tools. They were helpful as ways of getting the issues out onto a piece of paper so they could be worked out beforehand. Neither party is likely to sue the other, and it is important to keep a contractual negotiation from souring a working relationship. Questions get answered in the course of those discussions if they are conducted properly and sensitively. Just in the course of having them, you build up trust and reinforce the artist's faith that the work is going to be respected and, on the curatorial side, that the artist will deliver the work and be happy with how it is displayed and installed." **Peter Eleey, curator, PS1 Contemporary Art Center, Queens, NY; former curator, Walker Art Center, Minneapolis, MN**

COMMISSIONS BY ORGANIZATIONS AND INSTITUTIONS

While commissions by nonprofit organizations, corporate entities, and governmental bodies are typically much more complicated than private commissions, the issues to consider are essentially the same. You'll need to figure out the budget, deadlines, payment schedules, and degree of creative control, just as with private commissions. Instead of working with a collector, you could be discussing these points with a museum curator, a committee, or, in the case of a government agency, a civil servant who may not have a background in the arts. In any of these

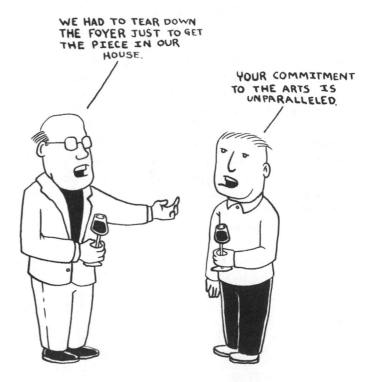

scenarios, the commissioning entity will almost certainly want to use its own form, so you'll need a lawyer to help you wade through all the legalese and understand the implications of everything you're agreeing to.

At the same time, there are a few areas where these kinds of commissions can vary greatly from private commissions, and from one another.

Creative Control

You can expect a lot of creative leeway from a museum or nonprofit arts organization. Other than broad goals, budget caps, and time frames, curators typically trust an artist's vision and the administration will generally trust a curator's choice. Not so much when it comes to corporations and government agencies, which have to consider the multiple interests and often-conflicting agendas among their many stakeholders and constitu-

——————— "Sometimes you have to kill your darlings. You have to know when it's not working or when it's impossible. As much as you don't like Plan B, have one. Sometimes Plan B ends up being awesome. And just because you don't end up using Plan B here, Plan B is still a project you can do somewhere else." **Denise Markonish, curator, MASS MoCA, North Adams, MA**

"The 'public' can vary dramatically depending upon where you live and work. When art is placed in the public realm, the commissioning body spends considerable time deliberating 'appropriateness' in all categories for that site. In the South they say, 'there is a lid for every pot.' Know your pot so you can be the lid."**—Kim Ward, principal consultant, RabenArt, Huntsville, AL; former director, Washington Project for the Arts, Washington, D.C.**

YOU CAN DO WHATEVER YOU WANT... AS LONG AS IT'S 24×30 ON CANVAS WITH LOTS OF BLUE, AND EVERYONE IN MY FAMILY LIKES IT.

—————— "Two of the biggest issues with public commissions are (1) issues revolving around site-specificity—can a piece be moved and to what extent can it be moved; if there are multiple elements to the piece, do they have to remain intact or can they take part of it away, and so on—and (2) indemnity issues—what happens when someone is climbing on a sculpture and falls and gets hurt and brings a lawsuit.

"I always try to get an indemnity from the time the work is installed and approved, forever. Because at that point it's out of the artist's hands." **Donn Zaretsky, partner, John Silberman Associates; writer, Art Law Blog, New York, NY**

"Who says that public art has to be permanent? However, if it wasn't, we would have nothing. We would have nothing in our parks. We would have nothing as memorials. The Vietnam Memorial would not exist if it was thought of as temporary. The reason why people suggest that artwork in the public sector be temporary is because you don't have to consider maintenance.

"I think it's inexcusable to have an art work permanently installed in a building using taxpayer money with no maintenance for it."—**Catherine Behrend, former deputy director, Percent for Art, NYC Department of Cultural Affairs**

"In the context of art as a business, one has to be very honest with oneself and say, "Is this hundred dollar drawing really worth me getting a lawyer to draw up a consignment agreement?" But when you have a public commission worth a hundred thousand or millions of dollars, then one really has to be wise and get legal advice."—**Sergio Muñoz Sarmiento, attorney, artist, educator, Brooklyn, NY**

"There is a lot of compromise in public art and the process is necessarily more collaborative because there are more people involved and that is not necessarily a bad thing but it is very different from working alone in the studio."—**Spencer Finch, artist, Brooklyn, NY**

ents. An artist often needs to pass the scrutiny of committees, the institution's leadership, and even groups of potential viewers. Public and corporate commissions therefore require a great deal of flexibility, patience, and diplomacy.

Ownership

With government and corporate commissions, the commissioning body will almost always buy the work outright. Museums and nonprofits are more case by case. When an institution does not take ownership, or commissions something for a specific show or a "semi-permanent installation," then you have the right to take the piece back at some point. Discuss ownership and timing from the start.

Copyright

All commissioning entities will ask for permission to use images of the work. Nonprofits and museums should only need to use those images for "noncommercial" purposes, unless, for example, you're also agreeing to let them sell posters and mugs in the gift shop (in which case you're either getting paid or have agreed to the arrangement as a fund-raising strategy to help pay for your commission). Government and corporate bodies—and sometimes museums, too—will expect to use images of the work for marketing purposes and revenue generation. Ask how they intend to use the images and discuss what limits are reasonable; whether, for example, you should be able to preapprove certain edits and uses. Maybe you trust a museum to get it right for their exhibition's brochure, but you'd want to see how the Parks Department used a cropped image of your work on a totebag before it starts handing them out at fund-raisers. (Read our explanation of licenses in chapter 6 before signing over image rights.)

Timeframe

Nonprofit commissions can take months to years; corporate commissions often longer than that; and public commissions take, on average, four to six years from proposal to completion.

VARA

Do not waive your VARA rights, unless of course your lawyer advises otherwise and you agree with his or her reasoning. VARA is the Visual Artists Rights Act, and it grants you, as an artist, several important rights: to have your work attributed to you, to *not* have other people's work attributed to you, to prevent your work from being changed or destroyed in a way that would hurt your reputation, and, if your work is changed, not to have it attributed to you anymore.

VARA's prohibition against "changing" work can be a problem for public commissions because removing the work from its initial site arguably changes it. (The exact language is "distortion, mutilation, or other modification of the work.") So you may need to give the commissioning body permission to remove the work—or waive your right to prevent "modification" necessary to remove the work—but you should not waive *all* your VARA rights. Make them specify exactly what it is they want permission to do, rather than say they can do whatever they want.

*"Advice to artist who want to pursue public art—Try to be open to compromise and collaboration with your fabricators without losing your vision for the artwork. Easier said than done!"—**Mary Temple, artist, Brooklyn, NY***

*"I think you have to really think about the audience, which is different from the normal art audience. And you really have to think on a practical level about work that can survive in a public environment. I have learned that when someone asks for something that is "A Big Wow" to run as fast as possible in the other direction."—**Spencer Finch, artist, Brooklyn, NY***

*"Number one: public art is not for everyone. Number two: it is not for a beginning artist, fresh out of school. Number three: there are many, many stakeholders. You pray for a good project manager who will be your advocate because you're going to go through a complex series of reviews. The project will take 3 to 5, or more years, so keep your day job. The building may get totally redesigned and your wall may be value engineered out. Yet, the artists who do chose the public art commissioning process find it a fascinating challenge."—**Catherine Behrend, Former Deputy Director, Percent for Art, NYC Department of Cultural Affairs***

"Working in the public realm requires willingness to listen to others and respond to needs and requirements of outside forces, willingness to collaborate and sometimes compromise. You also have to be willing to understand the systems at play in the public space and work within, or smartly against, those systems in order to make work."
*—**Eve Mosher, artist, Brooklyn, NY***

CHAPTER 12
———The Commercial Gallery Courtship

——————— "Figure out what kind of artist you are and what part of the art community you want to be a part of. Some artists' work is suited to grants and commissions—artists doing social-practice work for example—and they may not find commercial representation until after they have done several high-profile public or institutional projects. Other artists are much more suited to commercial galleries—and at this point there are galleries at every scale and interested in every discipline and career stage. Follow galleries and curators you like, get to know what they are interested in, their history and shows. Get to know them. The key is to get someone interested in doing a studio visit, but they are more likely to make one if there is an existing connection or interest in the kind of work you are doing." **Shannon Stratton, William and Mildred Lasdon chief curator, Museum of Arts and Design, New York, NY; founder, former director, Threewalls, Chicago, IL**

——————— "The art world is all about people and relationships. Once you are showing with a gallery, it is all about a good relationship. Try to remember what it was like before you were married and what you had to do to get in good with her. You had to impress her, but you had to be a real person. You couldn't present yourself as one thing and then be another thing later on. You couldn't be a cool, nice guy and then a classless slob once you were married. So, make a good impression and be a real person." **David Gibson, writer, curator, advisor, publisher, The Gibson Report, New York, NY**

Gallerists put a lot—financially and emotionally—into their artists. Sure, some are reputed to take advantage of artists or to only care about sales. But most do what they do because they love art and want to work with living artists. So it's only natural that they want to be careful, and take their time, when considering taking on new artists.

The time between a gallerist first hearing about an artist to representing him or her is measured in *years*, not months. We know artists whose gallerists knew them for five years before taking them on (and some for more than a decade). This is not a bad thing, in and of itself, because you should want to take your time, too. Signing on with a gallery is putting your career in its hands. Your reputation and your success, both short-term and long, will be linked to your gallery's. And while you can always walk away from a bad situation, that's a painful experience you're better off avoiding altogether.

This is why getting gallery representation is a little like a long-term romantic relationship: first you meet through friends or an app; then you go on a few dates, maybe meet each other's friends; if you like each other, you keep going out and eventually settle down. Sometimes the other person is flaky or hard to read; sometimes you feel like you're being toyed with; sometimes you

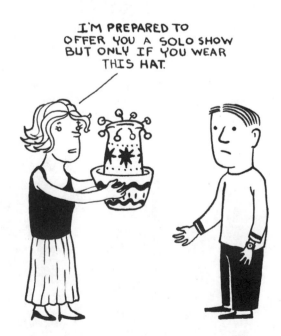

I'M PREPARED TO OFFER YOU A SOLO SHOW BUT ONLY IF YOU WEAR THIS HAT.

know where you stand; sometimes you don't. But there's usually a long stretch of time between your first introduction and your wedding day.

FRIENDS WITH BENEFITS: THE BACK ROOM

This is an easy way to test you as a new artist. The gallery keeps a few pieces in the back room (literally, a room in the back of the gallery, also known as the "office") and shows them to collectors when they come through the space. There's little risk for the gallery because it isn't associating with you in public or investing a lot of money in a show. And it can use your work to make collectors feel extra special, since they're getting "exclusive" access to work not available in the front space.

When you hand over work to go in a gallery's back room, you should get a consignment agreement from the gallery or write one up yourself (see chapter 10). This is exactly the kind of situation that you don't want to leave open-ended. At a minimum, fill out an inventory list.

Limit the consignment period to six months or less (the most common increments are three months and six months). You can always extend the time.

If your work sells or a curator shows interest, *and* you get along with the gallery, then—in theory, at least—the gallery will want more. Maybe it'll even start taking you out in public.

FLIRTING ONLINE

A gallery may ask you to be part of the "Works Available" section on its website, where it shows individual works from artists it doesn't represent, either from past shows or current consignments, or simply from artists the gallery *may* represent in the future. The benefits to participating are the public association with the gallery, exposure to the gallery's collectors, and, ideally, sales. So if you *don't* want to fully commit to one gallery, this

——————— "Never, ever put yourself in a position where you can't change your work. That would be the most important thing—to contextualize yourself in a place where they are interested in your evolution and your growth regardless of how profitable your first body of work might be. If you don't grow and your work is not changing, it's going to die." *Andrea Rosen, Andrea Rosen Gallery, New York, NY*

——————— "Artists get the art world they deserve. I want a relationship that I can live with for a long time—one where I would be happy to get the call when a gallerist rings me up. It's a very intimate relationship, like a marriage. It's one of the bigger relationships that I have, so the way my personality meshes with the gallery is really important to me. I also want a gallery that does all the horrible things I don't want to do. If they do their job, I won't have to do all the mundane tasks that come with running a small business." *Fred Tomaselli, artist, Brooklyn, NY*

arrangement can be perfect: you're able to maintain a positive relationship with the gallery while at the same time managing expectations and preserving your freedom.

When you want to be represented by this particular gallery, being part of the "Works Available" section can be frustrating, depending on who you ask, because you risk getting stuck in a holding pattern. The gallery has the work from you that it wants to sell, without the pressure to take things to the next level. You can create a little pressure (if not real leverage) by putting a time limit on the whole thing, so that if nothing has happened within a certain period, you can decide to extend the consign-ment or walk away.

More generally, you should treat this arrangement as you would any consignment: fill out an agreement that clarifies who will possess the work (maybe the gallery just needs an image for the website and you can keep the work in your studio); what the sales price and commission are; whether/how collectors will be allowed to view the work in person; what the gallery may do with images of your work, and for how long; whether the gallery may try to sell the work on third-party platforms, etc.

There are all sorts of other ways galleries might connect with you online. Maybe a gallery shows interest in what you're doing by "following" or "liking" your profile, or doing whatever it is people do on whatever app or platform you're on at the time. If that happens, *great*! Return the favor, in whatever way is appropriate for that platform, and see where things go from there.

By the time you're reading this, there may be some entirely new online space in which the gallery wants you to participate, separate from anything it does in its physical space and short of fully representing you. Whatever the actual format, the under-lying principles are the same: decide whether you want to be part of it; for how long; in exchange for what benefit; and at what trade-offs? And write it down.

DATING IN PUBLIC: THE GROUP SHOW

A group show is the most common "first" in a serious gallery relationship. Like a first date, the group show is a bit of an audition. You're putting your best self forward and hoping the gallery and its audience like what they see. It's not a one-way street, either: the gallery is on its best behavior, too. (Unless, well, it's just not that into you.)

This is still relatively low risk for the gallery, since it isn't banking on you alone. And unlike putting work in the backroom, curating you into a group show allows the gallery to gauge the reaction of the press and the general public to your work.

Group shows come together in a couple of different ways. A gallery might curate the show itself, selecting work from within its program and from people it knows either through its artists, open studios, art fairs, submissions, etc. Or a gallery will collaborate with an independent curator who will bring in artists the gallery doesn't know.

Some galleries make room in their schedules for group shows every year, usually in the summer. Others have them when they are looking to expand their roster. Either way, being successful in a group show—meaning sales, press, or just a lot of interest—will often lead to more shows.

As always, remember to get a consignment agreement.

Make sure your prices are consistent in all the venues showing your work. This is important for several reasons: you don't want collectors bargaining over your work, you don't want dealers competing over prices, and, because it's customary for prices to be consistent, it looks like something is wrong when they aren't.

SEEING MORE THAN ONE GALLERY

It's common for unrepresented artists to participate in overlapping group shows at different galleries in the same city. And it's usually in your best interest to have options and audiences all over the globe. Depending on your goals and the volume of work you produce, it can be critical to have multiple galleries supporting your career and publicizing your work. Funding opportunities, collector interest, and press opportunities will present themselves at different times in different markets. A good time to show in Chicago, for instance, may not be the best time for your work to be seen in Berlin.

As long as you're aboveboard with everyone, you won't inadvertently damage your relationships or hurt your reputation. Galleries actually like to see that other people are interested in you and that you've got a lot going on. The wider your reach, the more attractive you are to prospective galleries.

If you're already in a group show and a second opportunity presents itself, ask both galleries whether it's a problem. It shouldn't be, unless you're trying to show the exact same work in both places. If a gallery tells you not to show at a second venue, ask why and decide for yourself whether there's a valid reason.

While no one can stop you from showing wherever you want when you're unrepresented, keeping people informed is courteous and respectful. The galleries you work with will appreciate it and will be that much more likely to want to work with you again.

Whatever you do, don't show your work with two different commercial galleries in the same art fair or show the same piece in consecutive fairs. It undermines the fact that your work is unique, instead giving the impression that you have saturated the market with your work. It's also better to be publicly associated with one gallery so that people know whom to contact about your work. The galleries you work with should have enough sense to avoid this scenario, but they can't help you if you keep them in the dark.

WEEKEND GETAWAY: THE ART FAIR

Another way a gallery can test your work is to take it to an art fair. This allows the gallery to expose your work to many more collectors than would see it in their gallery space, in a short period.

Art fairs are expensive and galleries can't bring everything to their booths, so feel good if a gallery believes in you enough to

——————— "Sometimes we use that shorthand language for talking about the inclusion of an artist in a group exhibition and whether that experience will develop into something more—'Is it going to be a one-night stand? Will you continue to date? Is it a monogamous and long-term relationship?' The analogies are silly, but they're also really apt because we all understand the relationship thing, so it translates well. We also understand how difficult it is to navigate relationships and why it is important to enter into one that works and is characterized by mutual respect, honesty, and good communication."

Catharine Clark, Catharine Clark Gallery, San Francisco, CA

——————— "In times past it was probably more difficult for artists to go to art fairs. Today, the center of the art market appears to be the international art fair. Consequently, artists have become more accustomed to seeing their work in such a grossly commercial setting. Many actually love it and regard fairs as enabling them to be part of the international art scene. It's another indication of the commodification of art. Only the more idealistic artists these days still have difficulty attending them." **Rosamund Felsen, Rosamund Felsen Gallery, Glendale, CA**

——————— "Usually we like to take a few pieces, put them in the back room and maybe take them to a fair to show our collectors. You can tell how your audience and your artists react to them. It's like bringing a new wife in. What do you think about the sister wife?" **Lisa Schroeder, Schroeder Romero Editions, New York, NY**

ship your work to some other city and take time away from its own artists' work to try and sell yours. Also, curators and other gallerists will be scouring the fair looking for new artists. Having your work there is a real opportunity to end up in someone else's group show.

On the other hand, just as galleries differ, so do art fairs. Not every fair will make sense for you, so don't say yes without doing your homework and thinking about whether that particular one is a good fit. And keep in mind that when work sells at an art fair, it goes straight to a collector. No show, no press. Unless you have the clout to demand that a collector lend the work back for a show, it may never be seen in public again.

In chapter 7, we talked about whether you should go to art fairs in general. Whatever problems you may have with going to an art fair will only be compounded when you see *your work* at the fair, so think about that before you decide to go. It's not such

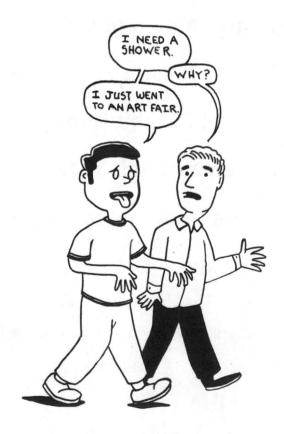

a big deal when you're the only one in a curated, solo booth because that's as close to a gallery show as it gets. But it can be traumatizing to see your work out of its context, competing for space with entirely unrelated work—not to mention watching glassy-eyed collectors spending all of three seconds taking it in before moving on to the next booth.

You should not have to pay for the shipping, insurance, booth fees, or similar costs related to participating in the fair. But you may need to pay your own way there unless you're the featured artist at your gallery's booth and the gallery needs you to install your work. (And, even then, it can be a negotiation.) When you go, whether on the gallery's dime or yours, don't sit in the booth all day. Pop in every once in a while, but otherwise let the gallerists do their job. You want them networking and promoting your work, not chitchatting with you.

TAKING IT TO THE NEXT LEVEL: THE PROJECT SPACE

You might be surprised to learn that a "project space" is a *space* with a *project* in it. The space could be anything: a closet, a windowsill, a locker, a random room. Think of a project-space opportunity as a mini solo show. A show in a project space won't necessarily come with gallery representation the way a traditional solo show would, but it can definitely lead to that traditional solo show in the future.

You can expect a commercial gallery to commit more resources to you and your work than it would if you were in a group exhibition. Discuss everything ahead of time (budget, materials, installation, expenses, etc.) and ask nicely for what you need. Just because the gallery hasn't offered to do something doesn't mean it won't.

If a nonprofit offers you a project-space opportunity, find out how much it's expecting you to cover out of your own pocket before you say yes. Make sure you're all on the same page.

——————— "A lot of times I'll just try out a few pieces. There's this one young artist in town and I think his painting technique is incredible and his subject matter is really interesting. But I told him I want to bring in three pieces and try them out with my collector base over a period of time. I hope it's going to develop into something larger." **James Harris, James Harris Gallery, Seattle, WA**

——————— "Someone once told me—how you go into a gallery is how you go out. For instance, if you go into a gallery and you're asked to deliver the work, you'll be delivering the work when you are seventy. Since it's still, by and large, a handshake, you need to be aware of any unspoken precedents you are establishing. Another problem is having your friend as your dealer. Boundaries can get blurred, and if you accommodate for the sake of the relationship you might find yourself still doing that later. And that's just not a place you want to end up." **Charles Long, artist, Mount Baldy, CA**

——————— "People could perhaps pay more attention to the historical model in which participation in a group show precedes the endeavor of a solo show. I think it's vital that an artist be allowed first to have a relationship with a gallery on a smaller, simpler level, and for the gallery itself to see if the artist is someone they want to work with. Not everyone might find it necessary, but it can be tremendously important. Call it a one-night stand before deciding to commit. It's how things in life happen." *Jasper Sharp, curator, Kunsthistorisches Museum, Vienna, Austria*

——————— "When I owned a gallery, I would never represent an artist I didn't know well. I considered the relationship to be a very serious and weighty one. For me, it was more than just liking the work—we needed to be able to work together." *Amy Smith-Stewart, curator, Aldrich Museum of Contemporary Art, Ridgefield, CT*

——————— "I try to be really open and honest with them, so I want them to say, 'So-and-so is really interested in giving me a show and I know I have pieces with you. What do I do? Do you want to give me a show or not?'" *James Harris, James Harris Gallery, Seattle, WA*

GETTING ENGAGED: THE SOLO SHOW

Many gallerists say that by the time they give an artist a solo show, they've already committed to full representation. Others will let an artist have a solo show and see how it goes before deciding to add them to their roster—but they obviously do so hoping that it'll work out.

Because a solo show is a big deal, and because there is so much overlap with full representation (which, to oversimplify, is a series of solo shows), we'll talk about both in the next chapter.

Can you hear the wedding bells?

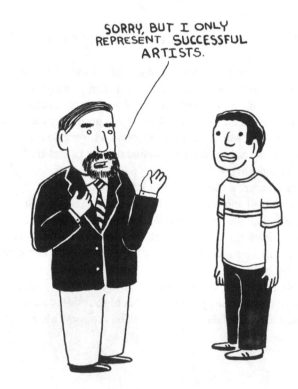

————— "You always remind yourself, no matter how close you get, it's still about business. Your heart will be broken or you will break a heart."

George Adams, George Adams Gallery, New York, NY

CHAPTER 13
Gallery Representation

—————— *"Once we represent an artist, we are going to spend all of our days working to further their careers. If someone calls the artist about a potential opportunity, he or she should direct the call to us. We're not just sitting here, waiting for people to walk in. We are writing and contacting other galleries, collectors, and press. That effort needs to be respected."* **Heather Taylor, art consultant, Heather Taylor Home; former owner, Taylor de Cordoba, Los Angeles, CA**

—————— *"I expect them to take it seriously and participate in the gallery. I risk as much as I can in terms of time and money. There is a commitment and a risk put up front with the hope of long-term success. I expect the artist to also be in it for the long term."* **Shane Campbell, Shane Campbell Gallery, Chicago, IL**

—————— *"I had been a picture framer for artists and galleries for many years. One of our clients was the wonderful Paula Cooper when James Cohan was her director. He was a really nice person and he would talk to me and all the woodworkers and treat us like human beings. A lot of the other dealers treated me really poorly back then, and eventually, some of them came around asking to represent me. They didn't remember me from when I was a framer and all of a sudden they were being really nice. But I knew they were phonies. James Cohan eventually approached me and I remembered how graciously he had treated me when I was his framer. I asked around and people said he was honest, solid, and museums liked him. Since I wanted a hardworking, competent, likable gallerist that wouldn't rip me off, I decided to go with him and I have no regrets."* **Fred Tomaselli, artist, Brooklyn, NY**

Okay, the courtship's over, and now it's time to say "I do." The gallery wants to represent you and you want to be represented by the gallery. So how do you make this relationship work?

As with any marriage, to really be successful you both need to be open and honest with each other; to trust each other; to collaborate and cooperate on major decisions; and to always keep the long-term perspective in mind. Don't let frustrations fester. Deal with them, discuss them, resolve them.

And while frustrations and misunderstandings are inevitable, you can minimize them from the beginning by knowing what to expect from each other. Talk about the arrangement *before* you agree to it. Ask questions. Understand what the gallery thinks you're embarking on together—it may not be exactly what you have in mind, and it's better to be surprised now than two years down the road, when the stakes are higher.

Oh—and don't forget that if representation is like marriage, you're getting hitched to a polygamist. No matter how much your gallery loves you, you'll never be the only one.

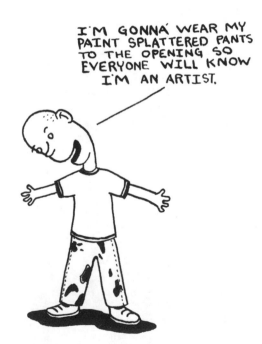

I'M GONNA' WEAR MY PAINT SPLATTERED PANTS TO THE OPENING SO EVERYONE WILL KNOW I'M AN ARTIST.

WHAT YOUR GALLERY WILL EXPECT FROM YOU

From your gallery's perspective, your job description is straight-forward: keep making your work. Your gallery expects you to make your work all the time, not just when you're preparing for a show; to constantly challenge yourself; to be dedicated and ambitious.

You're also expected to act like a professional: to communicate, to meet deadlines, to respect your end of the deal. That means a lot of basic things like replying to email and returning phone calls; telling the gallery if you're going on vacation; updating the gallery when you have a new body of work; treating the gallery staff with respect. It means coming to your openings on time (or only fashionably late). And it means being an ambassador for the gallery while being discreet with confidential gallery information.

Your gallery expects you to keep it updated on your direction and to share your ideas and intentions as you make your work. If you're experimenting and not exactly sure of what's happening, that's the information you'll need to share. Sometimes you'll want its feedback and sometimes you won't. Tell it that, too. It's only through an ongoing dialogue about the substance of your work and your process that your gallery can do you justice when it presents your work to collectors, press, and curators.

Once you have a gallery, you always need to mention it when you're interviewed for press. That includes noting recent and upcoming shows and attaching a courtesy line to your images when you email them to a journalist ("Courtesy of the artist and [gallery name, gallery city]"). Otherwise, people who like the image won't know where to look to find out more about it.

Let your gallery know when your inventory changes, especially when it concerns work it's shown interest in, so it can keep expectations and inventory up to date. Double sales and missing works are two problems easily avoided when inventories are in sync.

Finally, your gallery will expect you to support the rest of the artists in the program by coming to see their shows, either at the opening or later in the month. While no one's going to ask you to be a "team player," your gallery does quietly expect you to help

———— *"If you come to me and you are professional, prepared, and can present your work articulately and clearly, when asked, I'm going to talk about you as a great artist to work with. If you are late, unprepared, and cannot easily explain your work, I will be less apt to include you because in my experience, it always means more work for me."* **Kim Ward, principal consultant, RabenArt, Huntsville, AL; former director, Washington Project for the Arts, Washington, D.C.**

———— *"The artist community is really tight and everyone talks about who's doing what. I've heard about times when an artist has spoken too much about their relationship with a gallery and it got back to the gallery. The gallery canceled the deal. We don't talk about one gallery artist to another gallery artist because there is competition there and we use discretion. We ask our artists to do the same."* **Mary Leigh Cherry, Cherry and Martin, Los Angeles, CA**

———— *"One thing to remember: always promote your gallery—in person, via email, on social media—because they are always promoting you. If you're doing an interview with a publication, pound home the idea that you show at the gallery. Never fail to mention your recent show, your upcoming show, or where they can see more work. Send them to the gallery, or at the very least, your page on the gallery's website."* **Steve Zavattero, cofounder/ director, stARTup Art Fair; former gallery owner, San Francisco, CA**

——————— "I expect artists to work hard. I expect them to focus, be very serious, and not be last-minute. They can't rely on me for everything. There are sixteen of them and only one of me. I have a lot of artists who are very good at self-promoting and then sending people to me. I rely on that. They should not be selling out of the studio. It's a deal breaker for me. I don't sell the work and not pay them. I expect loyalty because I am trying to promote them on every level from sales to museum shows to press coverage and selling out of the studio undermines the trust." **Monique Meloche, moniquemeloche gallery, Chicago, IL**

——————— "Once you start selling out of your studio, it gets out and you get blacklisted. It is a very tiny, gossipy world. Communication is instant so you have to watch your reputation. If you are in a real financial bind, call your gallery! Maybe they can come up with something." **Andrea Pollan, owner, Curator's Office, Washington, D.C.**

out other artists when, for example, you have equipment you can lend, advice to give, or some other favor you can do.

There are also a number of things your gallery expects you *not* to do, now that your gallery will be representing you "exclusively." The scope of that exclusivity, and the corresponding limitations on you, can vary widely gallery to gallery, and artist to artist, and therefore requires a long and thoughtful conversation with your gallery.

On one end of the spectrum, a gallery may want to represent you exclusively worldwide for all sales of all your work, indefinitely. In that case, you may not sell work through any other galleries (unless it's arranged through and managed by your primary gallery), you cannot sell anything directly from your studio, and you probably can't participate in open studios or artist-run fairs or other public events without your gallery's permission. Your gallery will expect you to hand over the contact information for any collectors who've already bought your work, and to refer to the gallery any new collectors you meet.

At the other end of the spectrum, you could work out a limited form of exclusivity, where your gallery only represents you for a particular body of work, or work in a specific medium, or only within the gallery's city; leaving you free to work with other galleries, or handle your own sales outside of that exclusive domain.

Between those extremes are all kinds of other arrangements, and they depend on what the gallery and the artist agree to do. Here are a few questions to get you started thinking through all the aspects of exclusive representation:

- Do you want your gallery to handle "everything," or do you want to keep control over certain types of sales or specific collector relationships?

- Does your gallery get to sell everything you've ever made, or only artworks after a specific date, or only art you make once the gallery starts to represent you?

- Do you want to limit your gallery's representation to specific work in a specific medium?

- If your gallery represents you exclusively within a certain region, how do you want to handle collectors who buy from your gallery but happen to live outside that region? How do you want to handle online inquiries or sales from outside that region?

- Do you want certain work to be available on third-party sales platforms, in addition to (or instead of) through your gallery? Do you want to ensure your work is *not* on certain third-party sales platforms, that your gallery may have used in the past for other artists?

This is not an exhaustive list, to be sure. The theme should be clear by now: draw explicit lines between the categories of artwork and types of administrative responsibilities that your gallery will cover, and the ones that you will continue to handle yourself. The power dynamic and your footing to negotiate will change throughout your career, so in some situations you simply need to be comfortable with what the gallery is offering and understand why. At other times, you'll know when to ask for more.

When you're first brought into a gallery program, you should give the gallery updated copies of your:

—CV and artist statement
—press and press releases
—price and sales history
—collector list
—sales leads
—contact info for curators, consultants, or press who have expressed interest in your work
—images of recent work

Add your gallery's contact info to your website. Link to the gallery's website from yours and ask the gallery to do the same. Coordinate a big announcement with your gallery on social media, or on whatever online platform makes sense at the time. Shout it from the rooftops. Keep your website up to date—and

Pssssst . . . my work isn't "saleable." Why would a gallery want to represent me?
Most galleries would not represent an artist if there weren't some potential for sales. That said, galleries want to create a dialogue among their artists, put together an interesting program, and build a recognizable brand. Sometimes an artist's work, even if not the most saleable, brings a gallery critical feedback, academic attention, press, followers, fans, or something intangible that makes the artists look like a more interesting and cohesive group. If you're one of those artists garnering the gallery attention but few sales, you need to evaluate whether that situation gives you enough nonmonetary rewards as well.

————— *"There is this fiction out there that galleries only show work that they can sell. I think it's the oddest assumption because if we knew what could sell, first, we'd be very wealthy; second, it would be like looking into a crystal ball; third, it would assume that gallerists are motivated to show work based exclusively on its commercial viability, which has not been my experience. I want to work with art that I feel passionately about, which I believe helps me to sell it. Part of the excitement of working with an artist is that there is so much that is unexpected and you are responding to this feeling that the work is worthy and important."* **Catharine Clark, Catharine Clark Gallery, San Francisco, CA**

————— *"The artists I represent should expect that I will be there to help them, encourage them to remain curious and not be afraid to take risks in their work, and be there for advice." **George Adams, George Adams Gallery, New York, NY***

————— *"Someone once said to me that there are two types of galleries: galleries who are primarily focused on sales and the others who do weddings, bar mitzvahs, and funerals. I feel like we fall into the latter category. We are interested in supporting the artists at every level. It means different things for different artists, depending on where they are in their careers." **Catharine Clark, Catharine Clark Gallery, San Francisco, CA***

————— *"We need better tactics to talk about money. Better ways to navigate the difference between something being an incredible opportunity and getting paid. How do we talk really honestly about money without jeopardizing opportunities?" **Deana Haggag, president and CEO, United States Artists; former executive director, The Contemporary, Baltimore, MD***

————— *"The mistake I will never make again is to assume that an artist and a gallerist inevitably approach the concept of value in the same way." **Bonnie Collura, artist, Bellefonte, PA***

make sure your gallery adds your images, résumé, and other information to its website.

WHAT YOU CAN EXPECT FROM YOUR GALLERY

Ideally, your gallery will help organize your professional life, taking over most of the administrative tasks so you have more time to make work. It will act as your agent and manager, raising your recognition among collectors, curators, other galleries, and the press. It will promote and sell your work and give you emotional support. You should feel that your gallery is behind you for the long haul, not just when sales are good.

There are many more details to this arrangement, of course, which you need to discuss with your gallery before your first show. Many artists don't bother. They're just happy to finally get a gallery and hope that they'll be treated well. This is astounding, if you take a step back and think about what a consequential decision it is to put your career into someone else's hands.

You should, at a minimum, ask enough questions to know whether your expectations are realistic, since most places aren't going to hand you a stack of paperwork outlining their responsibilities. A gallery that is seriously interested in you will not walk away just because you ask about the relationship it envisions having with you. (And a gallery that does get skittish is probably one to be wary of in the first place.)

You can't assume that everything will "work itself out" as you go along or that a gallery will always put your best interests first. They have to juggle a dozen other artists and cultivate a variety of collectors. And then there are lots of little things that come up when a gallery is working hard to get your work out there and you should think about them ahead of time. Only you know whether you're going to care about a particular wrinkle—for instance, you're asked to install your own work—and if something is going to bother you later, then you should try to deal with it now.

You'll recognize many of these issues from our discussion of consignments in chapter 10. The difference, obviously, is that here you're thinking about a much more comprehensive relationship that will last well beyond the next show.

The Fifty-Fifty Split

With few exceptions, a U.S. gallery will take 50% of all sales. Some galleries take a smaller percentage for commissioned work, on the theory that there's less work for the gallery to do, since the work is sold before it's made (and, frankly, more hassle for you, as you know from chapter 11). Extremely successful, well-known artists may be able to renegotiate their cut to as much as 90% (meaning the gallery would only take 10% of sales).

Framing and Production Costs

Most galleries pay for framing once you're represented and sales are happening. Or they pay because it's in their best interest to keep all frames shown in the gallery of identical look and quality. If it fronts the cost, a gallery will recoup that money first and then take its 50% commission. This is easy to track because the gallery will bill a collector separately for framing. A $2,000 drawing that cost $300 to frame, for example, would retail for $2,300: the bill would show $2,000 plus $300 (before tax and shipping); you'd get $1,000 and the gallery would get $1,300. That should work in the other direction as well. If you paid for the $300 frame, you'd get $1,300 and the gallery $1,000.

Depending on your medium and how much clout you have, your gallery might front some of your production costs. The math works the same way—the gallery will recoup its costs and then you split the rest—except that, unlike framing, production costs aren't usually broken out on the bill the collector receives. Take a $2,200 photograph that cost $200 to print and $300 to frame. The bill would show $2,200 plus $300 (before tax and shipping), of which $300 would go to the gallery for the framing, $200 would go to the gallery for the printing, and the remaining $2,000 would be divided evenly between you and the gallery.

What if I brought the collector in? Shouldn't I get more than 50 percent?
The short answer is no. Should the gallery get more than 50% when it sells to "its" collectors?

——————— *"When I break down my costs, I shock artists. With most artists, the gallery doesn't even break even until the second or third solo show. I am artist-centric and supportive, so if it's clear to both parties that the artist is making the gallery a lot of money, I say renegotiate the 50/50 split. Until that point, the gallery is investing in you and it's not a bad deal." **Edward Winkleman, cofounder, Moving Image Art Fair, author; former director, Winkleman Gallery, New York, NY***

——————— *"Percentage can change based on value judgments. How much you need them, versus how much they need you. But, in my experience, the artist never gets less than 50%." **Sabrina Buell, partner, Zlot Buell + Associates, San Francisco, CA; former director, Matthew Marks Gallery, New York, NY***

——————— *"I work with artists at all different stages and I've come up against some very big galleries, so I understand that there is no one-size-fits-all 'deal.' Ever. Every artist has a different deal with their gallery. I see all the way from 90/10 to 40/60 (artist/gallery)." **James Walters, CPA, Walters & Skylar LLP, Los Angeles, CA***

Production Costs

Not all galleries will reimburse you for production costs. And the ones that do reimburse vary on what counts as reimbursable. It might be specialized services, such as printing, casting, or mounting. It might be especially expensive materials. Ask your gallery what its practice is so you don't end up counting on something that isn't coming to you. Even galleries that don't normally pay for production make exceptions, sometimes, to help artists make work that they couldn't otherwise. So it's still worth asking.

And keep in mind that there's a downside to having the gallery front production costs: you may have less control over the vendors you use. And, depending on your contract, you could owe that money to the gallery in order to get the work back if your relationship ends.

——————— *"Different situations require different strategies. When there is high production cost, we figure out how that got paid and it gets deducted off the top of sales. In some situations, the artists actually prefer to take care of their own production costs. Those are usually the more established ones who want more control."* **Steve Henry, director, Paula Cooper Gallery, New York, NY**

——————— *"My position on production has changed and evolved as my artists have gotten older. Early on, I thought it was imperative for artists to pay or partially pay the production on their work because I thought it was important for them to think about viability. They had to be responsible for what they were making. It is a deep responsibility. If early on they can't afford something, whether it is when it costs $1000 or $300,000, and they are not willing to invest in the work on that level, then their work is probably not viable on that level. But there are, of course, exceptions, and the standard for galleries taking on production has definitely evolved."* **Andrea Rosen, Andrea Rosen Gallery, New York, NY**

The opposite is also true. If you fronted the framing or production cost *and* told your gallery about it in advance, you should be reimbursed before the split is made. Most galleries will agree to this arrangement as long as you are clear with them long before the sale happens, so the gallery can consider those costs when setting the price.

Discounts

As we explained in chapter 10, galleries routinely agree to a 10% discount to close a sale and will expect you to split that evenly. Instead of getting 50% of the retail price, in other words, you get 45%. (The collector pays 90% of the original price; splitting that in two gives you and the gallery 45% each.)

Discounts are calculated after subtracting production costs. Say, for example, a photograph cost the gallery $100 to print and it retails for $800. A 10% discount would lower the price by $70 (not $80). The collector would pay $730, the gallery would get $415, and you would get $315.

You shouldn't have to split more than a 10% discount for an ordinary sale (meaning 5% would come out of your half and 5% out of the gallery's). If your gallery wants to give a collector a 15% discount because she is a friend of the gallery or is buying several works at once, you should still only have to split the first 10% of that discount (5% out of your half, 10% out of the gallery's). Museum sales, on the other hand, are anything but ordinary. They usually come with at least a 20% discount, and you'll be so happy you won't mind having to split the whole thing with your gallery.

That you *shouldn't* split more than 10% on ordinary sales doesn't mean you *won't*. You may find yourself working with a gallery that insists on splitting all discounts, no matter how large. Better to know that ahead of time so you can decide whether you want to make an issue of it. Maybe it's not a big deal to you at all. Maybe you "adjust" a larger discount into your original price. Regardless, talk through when and why your gallery would want to offer more than a 10% discount.

Payment

As we went over in chapter 10 on consignments, your gallery should commit to paying you within a certain number of days after it's paid. Thirty days or end of the month is totally reasonable, since it's more efficient for a gallery to deal with its monthly bills all at once, which means putting off cutting your check until the next "bill day." A smaller gallery may need more time, like forty-five or sixty days, because it has less staff to handle the paperwork. But more than ninety days is, to use a legal term, "crazy." Your gallery has no good reason to keep your money for months and months, earning interest on your sweat and tears while you sleep in your studio to keep the rent down.

As with everything else, though, when you're considering a gallery notorious for paying its artists late, you have to weigh the costs and benefits. We know plenty of artists who decided to show with a gallery, despite its reputation on this score, because they believed the boon to their careers would be worth the inevitable headaches over payment.

At the end of chapter 14, we'll talk about what you can do if you're not paid when you should be. (*Spoiler alert:* very little.)

Solo Shows

Solo shows are extremely important for your career. They allow you to develop a complete body of work, which is the best way for your ideas and intentions to mature. They raise your profile and increase your chances of getting press. And they typically generate more sales than you'll make at any other time of the year, aside from at an art fair.

So don't be shy about asking how often the gallery intends to show your work. On average, galleries give their artists one solo show (lasting at least four weeks) every one and a half to three years. Much longer than that is a red flag, unless your work takes an especially long time to complete.

Also find out what kind of announcements and other materials the gallery ordinarily prepares for its shows. The idea is to find out what the other artists get, not to demand special treatment. Cards? Catalogs? Ads? Does the gallery use the same

If a collector is taking a long time to pay for work, you can always ask your gallery for an advance. You're not entitled to one (and many galleries can't afford it), but sometimes a gallery will give you one if you need it. If a collector is on a payment plan, see whether your gallery will split each installment with you, rather than waiting until all of the installments come in before paying you your share.

What's the best month for my show?
There isn't one. Really.

The truth is that there are advantages and disadvantages to every month and you can't predict which one is going to be the best for your work. A month when an art fair is in town means there will be more collectors around, but they'll spend most of their time at the fair. The summer months are a little slower, but that makes it easier to get press.

It's your gallery's job to consider these factors when it plans out the next year's schedule—as well as, for example, which shows should come before and after yours (from a curatorial perspective) and whether museums or other galleries will have shows of similar work that year. Because the decision has as much to do with the rest of the artists in the program as it has to do with you, it's ultimately the gallery's call.

So in terms of picking your battles, this is not a very worthwhile one. You're better off going with the flow and asking a lot of questions, if you're interested, about what went into the decision to schedule your show for a particular month. That way, by the time you have enough clout to influence the gallery's schedule, you'll have a much better feel for which factors matter, for your particular work, and which ones don't.

format for every show? How big is the gallery's email list? Does it use social media to promote shows? How would they like you to participate in promotion? Some galleries appreciate consistent posting from the studio, leading up to a show. Others like it more Wizard of Oz–style where the curtain is pulled back at the last second, creating anticipation. Either strategy could work, but you need to collaborate on that strategy for it to work.

At a minimum, your gallery should send out some kind of press release, ideally six to eight weeks before your opening, and then a reminder and invite the week before the show opens, to give editors and writers enough lead time to write about the show. A press release for a solo show is essentially a project statement, which means your gallery will need your input and, depending on the gallery, may want you to help write and edit the statement. While you won't have final say on how it's written, you should be happy with it. Speak up if you're not. Ask to look at a draft early on and raise any points you don't like. Once you're at your opening, it's too late to change anything.

Most galleries send show announcements to their audience. They usually use the same style and format for every show because the gallery has a certain look (brand) and wants its audience to recognize its announcements when they get them. Although you can ask for a different size or format if it relates to your show's concept and it's really important to you, don't be surprised if the gallery says no.

Same deal with catalogs, brochures, and ads. You'll get what everyone else gets, which, in this case, is usually nothing. Because these items are all quite expensive—they don't usually make sense until you're more established (or there is a compelling reason, related to your work or your collector base, to do something different). But if you can pony up the cash yourself, the gallery will probably be willing to help you put the materials together and edit the content.

"When I got gallery representation, it was exciting and my work did change. Instead of trying to make huge, overarching statements in every work, I concentrated on the notion that each piece I made was a small part of a larger story. I could tell a very small part, one piece at a time, and let that build up over time. And with each successive exhibition, I was adding to the collective memory of my audience, particularly the community of New York City where I felt a sense of belonging." *Charles Long, artist, Mount Baldy, CA*

"Sometimes press releases are written by dealers who can't get artists to speak, so they speculate. I know a lot of artists don't have the ability to speak, but if you don't speak up, you can't complain about how your work is described." *David McGee, artist, Houston, TX*

"For big commissions, I ask an artist at least three years in advance and I tell them, 'The show is in three years. I'm going to leave you alone for a year. I'm here if you need anything, but I'm not going to bother you. When we get together in a year, you're going to have an idea for me. And then we're going to take it from there." *Denise Markonish, curator, MASS MoCA, North Adams, MA*

"Early on I'll go over FAQs and an overview of the space, but there isn't really a hard and fast rule about how to help an artist leading up to the install. I try to feel out the needs of each artist and think about technical issues that may arise. And in order to manage their expectations, I'm clear about what the gallery can provide." *Suzanne Kim, independent curator, consultant, Providence, RI*

"Post-exhibition blues is a real thing, so having something else to look forward to after the adrenaline drops from say, installing a show, will help you maintain creative momentum and prevent emotionally crashing after a big project. Balancing this with rest and reprieve is the secret to establishing a steady, continual rhythm of creative productivity." *Joyce Yu-Jean Lee, artist, Brooklyn, NY*

Countdown to the Solo Show: Your Tasks

1 year
 —confirm show dates

6 months to a year
 —tell the gallery your concept and whether you anticipate needing special equipment or installation help
 —meet with gallerist about expectations and plans
 —give the gallery images of finished work and details of works in progress (or have it take them)

2–6 months
 —give the gallery the title of your show, a statement and images for press release, listings, and collectors

4–6 weeks
 —announcements
 —secure equipment and any additional help

1–2 weeks
 —be ready to ship (no wet paint!)
 —give the gallery an updated résumé and statement

 —send out emails and personally invite people to the show
 —announce and invite via social media

3–6 days
 —install
 —be available for questions, walk-throughs, or previews

Day of
 —be on time
 —be professional

Day after
 —send a thank-you note or email to the gallery
 —send thank-you emails to people in attendance who would appreciate it
 —post images of opening and show

During show
 —encourage people to go
 —meet people for walk-throughs
 —promote online

Countdown to the Solo Show: The Gallery's Tasks

1–2 years
 —plan show dates, start contacting artists and collectors

6 months to a year
 —studio visit with artist to discuss work, expectations, and promotional strategy
 —begin planning catalog, if there will be one
 —contact monthly magazines and reserve ad space, if needed

2 months
 —write the press release and send it to listings, editors, and writers
 —design and submit any ads
 —secure necessary equipment
 —post show on website and other digital platforms

4–6 weeks
 —send out press reminders and listings
 —hire art handlers for installation

3 weeks
 —schedule shipping, contact collectors and curators

1–2 weeks
 —ship work to the gallery
 —ramp up social media
 —design and send email announcements

 —plan the opening and after-party
 —invite collectors, curators, and press to preview and party
 —update the artist's bio, statement, and résumé

3–6 days
 —deinstall the last show; install the new one
 —update website with new show
 —hold preview
 —document the work and take installation shots
 —complete the installation, checklist, price list, artist book, digital press kits

Day of
 —hold opening and after-party
 —develop press/collector/artist relationships

1–2 days after (or before)
 —update website with all new images
 —thank the artist
 —thank attendees

During show
 —approach/follow up with curators, collectors, and press
 —update artist on new developments
 —conduct walk-throughs and speak to visitors about the show
 —increase interest and understanding using social media, video, and other platforms

Show Costs

Your gallery should cover the costs of installation, deinstallation, and insurance for any show you're in. Some galleries pay for shipping and some don't. (Most galleries will eventually cover shipping for their artists, it's just a question of when.)

If you live far away, most galleries will cover the travel costs when you need to be at the show—to install the work, for example, or perform a piece. They'll also pay for accommodations or help you find a place to stay while you're in town. Just make sure the gallery knows well in advance that you need to be there. If you don't "need" to be there—that is, they can install the show without you—then you'll probably have to pay your way there (unless of course you're at a place with a bigger budget). All venues can probably help you find a place to stay.

Some artists offer to drive their work to a show if the gallery will cover gas or the cost of a rental car (or both). If you're going to offer this, make sure you're ready to pack as professionally as an art handler would (chapter 9). And keep in mind that your time may be worth more than gas money, so negotiate accordingly.

Opening and After-Party

The gallery should also organize, pay for, and host an opening. Once again, don't expect special treatment. If no one else gets hors d'oeuvres and champagne, neither will you. Many galleries will do a dinner or after-party. What they pay for and whom you're allowed to invite varies from place to place, so work it out ahead of time.

Don't be discouraged, by the way, if no one buys anything at the opening. Most sales happen before or after an opening, not during. Nor should you be discouraged if people at the opening aren't looking at your work. The opening is more about showing support for you and publicizing the show. Most people come to see you and to socialize more than they do to really take in the work.

Serious collectors and press, on the other hand, tend to pop in early and take off before the crowds arrive. Another reason to be there on time.

Three Reasons You Don't Want to Get Drunk at Your Opening

1. You could pass out under a security desk, wake up the next day locked in the building, and have to call the staff to come let you out.
2. You could barf onto your plate in the middle of the dinner with your collectors.
3. You could forget that you gave your credit card to the bartender at your after-party and wind up with everyone else's drinks on your tab.

And yes, all of these stories are true.

Although your gallery will appreciate you promoting your show while it's up, and probably expects to see you more often that month, you should still be sensitive to the gallery's needs. For example, given that Saturdays are the busiest days for many galleries, don't hang around talking to the staff for hours on a Saturday. Let them do their job and do right by your show. Ask when it's best for you to come and hang out. If you're bringing collectors, curators, or appreciative viewers, any time should be fine.

What if my gallery doesn't share collector information with its artists?

If your gallery doesn't share that information with its artists, try to raise the issue in a constructive way. Find out why—maybe it's just because no one's asked before—and see if you can reach a compromise. If the gallery is worried about you contacting collectors, you could promise not to do that without going through the gallery. If it's concerned about guarding the collectors' privacy, you could promise not to disclose the information to anyone else or put them on your mailing list. Whatever the gallery's reason, there should be a solution short of keeping the information from you altogether.

———————— "Artists have the right to have information regarding who acquires their artworks. This information should be provided at the time of the sale. Somewhere down the line an artist will have a museum exhibition. The organizing curator will need to know the location of artworks to be included."
Rosamund Felsen, Rosamund Felsen Gallery, Glendale, CA

Images

Your gallery should pay to photograph your work for its website and inventory and take installation shots during shows. Ask for copies.

Don't wait until the last minute to look through the images your gallery takes. If you have a problem with them, you'll need to raise it while there's still time to take new ones. If you're particular about your images or think you could take better-quality ones yourself, go right ahead. Once the show's down, it's too late.

Records

Your gallery should give you copies of the records it keeps about you and your work, either once a year or on request:

—the gallery's inventory list of your work
—images of your work, including installation shots
—price lists from your shows
—press releases
—promotional materials
—sales information
—collector contact information

The last item shouldn't be controversial—you're entitled to know who buys your work—but unfortunately it is. While many galleries are willing to give you that information, many aren't. They have various excuses for not disclosing the names of their collectors: to keep their artists from bothering their collectors; to prevent their artists from selling behind their backs; to discourage their artists from leaving them someday and taking their collectors with them. None of these excuses, however, justify withholding that information from you. It's just not right.

Although your gallery is theoretically taking care of all your paperwork, we recommend keeping your own records up-to-date.

————"The best artists communicate with their galleries and keep the lines of communication open so there are no misunderstandings. If they work with more than one gallery, they are open and honest with everyone. They look at the galleries as being on the same level they are: no better or worse. They are equals with their galleries."

Steve Zavattero, cofounder/director, stARTup Art Fair; former gallery owner, San Francisco, CA

Art Fairs

Your gallery should cover all fair costs, including shipping and insurance. As with a regular show, if you need to be at the fair, the gallery should cover your travel and lodging. With more clout, you may get a per diem. (You can stay in town after the fair ends but the extra days will be on your own dime.)

Consigning Work to Other Galleries

When your gallery represents you exclusively in a region, that means you can't show with other galleries in the same region unless your gallery consigns the work to them or you've made some other arrangement with your gallery. If you want your gallery to act as your primary gallery, then it will handle consignments to galleries in other regions as well. That means you consign your work to your gallery, and then it turns around and consigns it to a second gallery (with your permission, of course).

When your gallery consigns your work to another gallery for a group show, it will split its commission with that gallery; you still receive 50% of any sales. For example, if your piece sells for $2,000, you get $1,000 and the galleries split the rest. A standard 15% consignment would earn your gallery $300 and the other gallery $700; you'd still get $1,000. (More powerful galleries demand upwards of 20%.) Normally, the two galleries will work out an arrangement for splitting discounts between themselves, but you may need to split up to whatever percentage you agreed to when you consigned your work to your primary gallery.

The upside of letting your gallery handle everything is that your gallery will handle everything. It will deal with logistics; it will make sure the other gallery has insurance; it will make sure you get paid; it will make sure your unsold work is returned. The downside is that you have less control over the relationship with the second gallery. And you may never meet them or see the show, unless you make a concerted effort to do so.

When you have a solo show at a gallery in another region, it's customary for your primary gallery to take a percentage the same way it would with work consigned to a group show. If the

Galleries usually have standard written consignment agreements for consigning work to other galleries. If you used a consignment agreement when you initially consigned your work to your gallery, as we recommend in chapter 10, then there would be two written consignment agreements: one between you and your gallery and one between your gallery (where it states it can consign work with your permission) and the second gallery. You don't need to sign the second one, because it's just between the two galleries.

solo show goes well, your primary gallery may let you work directly with that gallery from then on, without taking a percentage of sales from future shows. Some artists prefer the control they have in a direct relationship; others would rather let their primary gallery do all the administrative work for them and continue to take a commission on those shows.

Your gallery should have a consignment agreement that it uses with other galleries (even if it doesn't use a consignment agreement with its own artists).

Online Venues

Multiple online platforms sell artwork to collectors, interior designers, art consultants, and the general public. Many of these sites work with artists directly; a handful only work with galleries. When galleries sign up to put work on these sites, they declare that they have licenses for the images and the ability to make sales. Some of these sites are prestigious and you're not going to have a problem when your work is found there. Other sites are less curated but have high traffic and sales. Some sites post price ranges or a "please inquire" button, while others let collectors see a price or buy directly from the site. Only you can decide which of these sites, if any, is right for your work, which is why you should ensure your gallery asks your permission before uploading your work to any third-party site.

Your gallery may have a clear rationale for certain partnerships, so hear them out and see if you agree. You can always ask to be left off a particular site because you don't like the company or its policies. For instance, some sites require permission to use your images for advertising and other purposes. Make sure your gallery has read the fine print. And you should not have to pay any fees associated with online platforms.

Museum Shows

If you're included in a museum show, your gallery will handle the relationship with the museum, dealing with all the issues we discussed in chapter 11. It might also need to kick in some money for the catalog, shipping, and other expenses. You'll still work

——————— *"The art world is like* The Sopranos, *but nobody gets killed. It's a power struggle. If a gallery has a long-term relationship with the artist and they've done a lot for them, then of course they should get a percentage of every sale. Usually there is a 10% kickback to acknowledge the relationship. It's money but it's also respect."* **Shane Campbell, Shane Campbell Gallery, Chicago, IL**

——————— *"Well, it is a good thing to diversify, I think. Galleries go up and down and I am lucky to not be dependent on one. A little healthy competition is a good thing. And they actually work well together on my behalf, so it's not a problem. It does require me to be more organized because I control everything rather than have one gallery control things."* **Spencer Finch, artist, Brooklyn, NY**

———————— "We let the collector know that there are unspoken expectations in the industry. When I started, when collectors resold work, they tended not to do it through the galleries. Not because it was more profitable at the auction houses but because they felt guilty. If they were not supposed to be selling, but collecting and saving something forever and ever, perhaps they thought it would be embarrassing when the artists found out they were going to sell their work, so the natural inclination was not to sell through the gallery.

"Everyone has the right to do whatever they like for whatever reasons, but there is an unspoken expectation of collectors that what would be appropriate for the artists is that the work be brought back to the gallery." **Andrea Rosen, Andrea Rosen Gallery, New York, NY**

———————— "We would never demand someone bring a work back to us, but we make it clear that we appreciate being informed and to have the opportunity to take something back. Most collectors do actually bring things back to us or at least let us know if they are going to sell something. Not all, but most." **Steve Henry, director, Paula Cooper Gallery, New York, NY**

closely with the museum's curator, especially if it's a solo show, but you can focus on the substance of the show and let your gallery tackle the logistics and paperwork.

Speaking of which, make sure the museum has a written loan agreement that you go over with your gallery together. Don't let your gallery loan your work on a handshake. Or worse, sign something you haven't discussed with your gallery.

WHAT YOU CAN'T ALWAYS EXPECT FROM YOUR GALLERY

Right of First Refusal

Say a collector runs into financial problems, suddenly needs cash, and decides to sell off part of her collection. If she's desperate enough she may sell her pieces for much less than they're worth—that is, much less than she'd get if she weren't in a rush to sell. This isn't good for you. Worse than just draining the value of the pieces sold, this kind of bargain-basement clearance can cut into the value of your other work and even hurt your reputation.

Or say a collector thinks she can get more money from putting your work up at auction than she would get reselling it privately through your gallery. If she's right, your prices could increase much more quickly than you or your gallery wants, given where you are in your career and who your collectors are. If she's wrong, your prices could plummet based on poor auction performance—a setback that can take years to recover from. Either way, you have no control over who buys your work at auction, meaning you might never be able to get it back for a solo show or retrospective.

To prevent these outcomes, some galleries ask their collectors for a "right of first refusal." This requires a collector who wants to resell your work to let your gallery try to resell it first or buy it back, giving the gallery more control over your prices and where your work goes.

You can't make your gallery demand more of its collectors than it already does for its other artists, but you might as well raise the question so you know what to expect.

Resale Royalties

The first time someone buys a work of art, it's a sale; every time the same work is sold again it's called a "resale." In California, there is a "resale royalty" law that entitles you to 5% of the resale price for your work (with a few caveats). The idea is that you, as the artist, should benefit directly from the value of your work increasing over time. If you're going to qualify for resale royalties, because, for example, a lot of your collectors live in California, make sure your gallery stays on top of this for you.

No other states prescribe resale royalties. (The European Union has a resale royalty law, but California is the only place in the United States to follow suit.) The issue is a controversial one. Many people in the art world don't think it makes sense for you to be paid more than what you get from the first sale of your work. The collector is the one taking a risk on your art, the thinking goes, so the collector deserves the upside. Big collectors may even help raise the value of artwork just by buying it.

There's also the theoretical economic argument that a collector will pay less today for a work that requires profit sharing in the future. If artists want full retail price now, they shouldn't expect a cut later. Since artists will have likely achieved some success by the time their work is being resold, it's not obvious

THIS IS A NICE PAINTING BUT IT WOULD GET A LOT MORE AT AUCTION IF IT WAS A REMBRANDT.

that they are better off foregoing the money early in their careers in exchange for the possibility of additional money later on.

On balance, we think resale royalties are the way to go. What you do and what you make as your career progresses directly affect the value of your old work, which is why we believe you "deserve" a resale royalty. And we don't believe that the pricing in the art world is so "efficient," as the economists say, that implementing resale royalties would actually impact prices for first-time sales.

Some galleries voluntarily give their artists a resale royalty whenever collectors resell their work through the gallery, regardless of the California law. But the vast majority of galleries outside of California (and, to be candid, quite a few galleries *in* California) do not bother trying to establish or enforce a resale royalty.

SOME GOOD THINGS MUST COME TO AN END

Not every marriage is a success. Sometimes you discover that you're better off going separate ways. If that happens to you, end the relationship in the same professional way that you began it. Talk to your gallery. Explain what's going on. Chances are it won't come as a complete surprise. You may even be able to work things out. But even if you can't, it's better to acknowledge what's happening and bring closure to the relationship than to just walk away and disappear.

If the gallery is the one asking to end the relationship, you probably saw the signs.

Whether you were keeping your records and images up to date, ask your gallery for copies of everything right away. You don't want to have to approach it six months later, when you will not be its first priority, only to find your records have been deleted or misplaced.

Take a thorough inventory and make sure you have all of your unsold work. Report any damaged or missing work immediately. You won't have much of a leg to stand on if you claim damage months after something was returned.

If you and your gallery are communicative and professional, you will be able to count on each other far into the future, even if the representation relationship did not work out.

——————— "I believe pretty strongly that change is beneficial to all concerned. When I started I thought 'I'll represent these people until I die!' But it doesn't happen. It's unrealistic to think that happens." **Greg Kucera, Greg Kucera Gallery, Seattle, WA**

——————— "If an artist comes to you and they explain why they are leaving and where they are going, and they are up-front and honest as soon as they know, then there is nothing to complain about. Of course you might be disappointed, but the artist handled it respectfully and professionally." **Heather Taylor, art consultant, Heather Taylor Home; former owner, Taylor de Cordoba, Los Angeles, CA**

——————— "Because I survive on the business, it has to be financially successful for both of us. I may love an artist's work, but if I just don't have the collecting base for that work, then I think the artist needs to find the right dealer to match up. It's better for them and better for the dealer, too." **James Harris, James Harris Gallery, Seattle, WA**

——————— "Every gallery has its own direction. If artists feel a particular gallery isn't the right place for them and believe they would be better off someplace else, they should go." **Rosamund Felsen, Rosamund Felsen Gallery, Glendale, CA**

——————— "The worst mistake I've made is being too trusting and ignoring bad reputations and red flags in working relationships with gallerists. I've learned the hard way that when multiple people in a community consistently have negative things to say about a gallerist/venue, that I cannot be lazy. . . . I need to take heed and conduct first-person research seriously." **Joyce Yu-Jean Lee, artist, Brooklyn, NY**

——————— "Breakups happen in very different ways—just like when you get an artist. I've had breakups when it was face-to-face and the artist understood. It wasn't easy, but we left in a good place. We were able to be friends and colleagues. Now that I know more gallerists, I know that people work with artists in different ways. Just because we might not be as successful with an artist as we would want to be doesn't mean that someone else can't take their career on. It doesn't mean they are not good artists. Our relationship might not be the right relationship." **Mary Leigh Cherry, Cherry and Martin, Los Angeles, CA**

——————— "If someone wants to leave, they are just going to tell me they are not happy or they are happy but they want to explore other options. I'm fine as long as they do it the right way. What irritates me, after years of support and hard work, is to get an email or a certified letter.

"I gave a well-known artist her first show in this gallery. She came to my office many years later and told me she was moving to another gallery. It was respectful, courageous, and well mannered. I had such an appreciation for her courage." **Shoshana Blank, Shoshana Wayne Gallery, Santa Monica, CA**

——————— "In any business relationship there's a lot of trust involved. Even if you're in the very corporate world, if you don't trust each other, it's not going to work." **Rafaël Rozendaal, artist, New York, NY**

CHAPTER 14
Representation Agreements

As you remember from chapter 10, a basic consignment agreement explains the details of a one-time consignment: It describes the understanding between you and the gallery about specific work you're consigning for a specific period of time. Now that you've read chapters 12 and 13, you know that there are additional issues that come up when you consider a long-term relationship with a gallery. (Exclusivity, solo shows, and direct sales, to name a few.)

Since a basic consignment agreement doesn't cover these issues, we think that when a gallery decides to represent you, you and the gallery should use a comprehensive "representation agreement," instead of a basic consignment agreement. A representation agreement covers your consignment arrangement, meaning that you won't need a separate consignment agreement once you have a representation agreement in place. You'll just fill out a new inventory list every time you deliver work to your gallery; the consignment terms will already be spelled out in the representation agreement.

Unfortunately, most galleries do not use representation agreements with their artists, so tread carefully here. Galleries don't have problems with consignment agreements, but the majority of them are quite hostile to the notion of using a representation agreement, although this is slowly softening as artists feel more empowered. While some galleries use representation agreements without question, and a few others told us they'd be happy to use them if their artists asked them to, other gallerists said they would *never* work with an artist who handed them a representation agreement.

This resistance to representation agreements is a little puzzling, given how normal they're considered to be in every other creative industry. Novelists, playwrights, musicians, actors, and just about every other creative type you can think of use written representation agreements with their agents and managers. There's no good reason your gallery, which acts as your agent (*and* manager *and* dealer), shouldn't also use a written representation agreement with you.

——————— "The number-one reason galleries and artists go their separate ways is that they haven't thought things through and discussed it. Then something comes up and they had very different thoughts about how something should be handled."

Edward Winkleman, cofounder, Moving Image Art Fair; author, former director, Winkleman Gallery, New York, NY

—————— "'Contract' sounds sort of divisive and oppositional, whereas 'agreement' sounds more harmonious, but they're of course the same." **Tad Crawford, arts lawyer, author, publisher, New York, NY**

—————— "I like calling them gallery-artist agreements. Contract seems to be a big word with emerging artists. I didn't mind using it until I saw how scared they got. Their eyes would get wide and they'd get really quiet." **Lorraine Molina, owner, LM Projects; former owner, director, Bank, Los Angeles, CA**

—————— "Agreements? Those are contracts. What's the other term they love to use? 'MOU' and I'm like, 'It's a contract.' And they're like, 'No, it's a Memo of Understanding.'" **Sergio Muñoz Sarmiento, attorney, artist, educator, Brooklyn, NY**

There are plenty of bad reasons, though, and we heard a lot of them in the course of researching this book—even the second time around! It turns out there is some fundamental confusion in the art world about representation agreements: what they are, what they're for, what they mean, what they're called, why so few people use them. To clear things up, we'll go through the most common explanations people gave us and show you how each one is grounded in a misperception or incorrect assumption.

1. *"If an artist wrote me a letter that said 'this is what I understand our basic relationship to be,' that is perfectly fine. If an artist made me a contract, I probably would not work with them."*

A letter that describes the "understanding" between an artist and a gallery—that is, the obligations each has to the other—*is* a contract. The fact that it's in the form of a letter, rather than in the form of a traditional legal document, doesn't matter at all. (Lawyers would call it a "letter agreement," but it has the same legal force as a traditional contract.)

The words *contract* and *agreement* mean the same thing. An oral agreement *is* an oral contract; a written agreement *is* a written contract. Thus, a letter agreement *is* a contract, and it doesn't make sense to say you are okay with a letter agreement but not a contract. From a legal point of view, they're the same thing, even though they look different.

A lot of artists and gallerists think *contract* is a dirty word. So call it an "agreement" instead. Call it a "letter" or a "form." Call it "Dragon" if you want to. What matters is what the thing says, not what it's called.

2. *"I don't want to write anything down because I don't want to be bound by a contract."*

You can be bound by a contract even if you don't write anything down—it's just an oral contract instead of a written one. That's because a contract is essentially a promise (more technically, it's an *exchange* of promises) and you don't need to go to law school

to know that you're supposed to keep your promises even if you don't write them down.

When you get gallery representation, the gallery promises to represent you, to sell your work for you, etc.; you in turn promise to give the gallery a 50% commission, not to let another gallery represent you in the same city, etc. When you don't write down these promises, you have an "oral contract." An oral contract is still a contract, and you and your gallery are still bound by it. Think about it: if you find out your gallery sold a piece of yours but never paid you, you're not going to say to yourself, "Oh well, that's okay because the gallery never promised *in writing* to pay me."

The problem with oral contracts is that they're vague. Instead of having an explicit conversation about a particular task, you might simply assume your gallery will be willing to perform it, only to discover later that your gallery never thought it was part of the deal. Or you might misinterpret something your gallery tells you, or remember a promise your gallery made that your gallery says it never even discussed with you. So given that you're entering into a contract, it's better to write it out.

3. *"I'd use contracts but they don't want to."*

Gallerists say artists don't want to use contracts. Artists say galleries don't want to. The truth is that there are artists and galleries who do, and artists and galleries who don't. Don't assume that the gallery you're working with is categorically against writing down a representation agreement. If you want one, ask the gallery whether it's open to that.

4. *"Artist-gallery relationships are built on trust. Introducing a contract breaks that trust."*

You don't stop trusting someone just because you write down the nature of your professional relationship. In fact, writing an agreement prompts discussions that can actually *build* trust, because you each get a better feel for how the other person thinks through issues and reacts to differing expectations.

—————— *"I think it's really important to look at where you are going and deal with people in a way that's not ever soft, but suits the relationship. That is, as long as it is true to your goals and, more important, to your nature.*

"I don't have anything specific in writing with my gallery, but we could. There's room for it. We've kept a dialogue open and because there are lines of communication open, I don't feel uncomfortable proposing that. I think that's another thing to look for in a relationship with a gallery—either professionalism or dialogue or whatever you want to call it. It balances the more murky, unclear aspects of the relationship." **Michael Joo, artist, Brooklyn, NY**

—————— *"I really can't think of any situations where you'd be better off not writing something down, because writing something down merely makes explicit the parties' understanding. The whole purpose of the contract is to have a meeting of the minds. Writing something down helps to make sure that meeting takes place. And the failure to write something down makes it likely that the meeting doesn't take place. So it's really to protect everybody."* **Tad Crawford, arts lawyer, author, publisher, New York, NY**

—————— *"The art world is closest to organized crime in terms of lack of moral structure."* **Anonymous**

—————— "At the end of my gallery contract it says, 'Either party can dissolve this contract with thirty days notice.' If you don't want to work with me, it's best we not work together. If I don't want to work with you, it's best we not work together. I would always want it to be easy to get out of. I don't just have a contract so I can wave it at an artist and say 'You said right here!' and then make their life difficult. And it's not going to save me from having someone defect from the gallery—It's just going to make it easier for us to have a framework by which we live, minimizing the possibility for misunderstandings." **Greg Kucera, Greg Kucera Gallery, Seattle, WA**

—————— "For Bank, agreements are customized for the artists because each artist does unique work. For example, with new media artists, issues of equipment, installation, and maintenance are addressed. These points are not always relevant for an artist who's working on paper, for example, especially when a sale occurs. Agreements are amended by both the artist and gallery before they're signed." **Lorraine Molina, owner, LM Projects; former owner, director, Bank, Los Angeles, CA**

5. *"That would be like asking my fiancée for a prenup. It's a sign you don't really believe the relationship will last."*

Remember when we said in chapter 12 that the marriage analogy only goes so far? This is a perfect illustration of why. You may love your gallery, but you are *not* getting married. You are not living together, you're not raising a family together, you're not moving to Florida together when the gallery gets old. You're doing business together.

You can still be friends. You can still care about each other. And you had better trust each other. But that doesn't mean "until death do us part," nor should it.

6. *"I wouldn't want to be bound to a contract for years and years. I want to be able to walk away if things don't work out."*

You *shouldn't* agree to be bound for years and years—and a contract doesn't mean you have to. There's no minimum time requirement. A contract can last for as little time as you like. Or it can last until one side decides to end it.

We recommend writing that either you or your gallery can end the relationship at any time, for any reason. It's good for you and the gallery to have a "notice period" of thirty or sixty days, so that, for example, your gallery can't pull the plug on you the day before a solo show (or vice versa).

7. *"Every artist is so different and every relationship is so different. A contract can't cover it all."*

The point of a representation agreement isn't to predict every possible mishap. It's to make sure that you and your gallery agree on the major issues and to minimize surprises. You can still cover a lot in one or two pages, with the understanding that when things come up that the agreement doesn't specifically address, you'll work them out—just as you would if you didn't have any written agreement at all.

8. *"Contracts are impossible to understand."*

This one is sort of true. Most contracts are filled with technical jargon, arcane phrases, and convoluted constructions. ("Whereas," "hereunder," and "in witness whereof" are just the beginning.) But it doesn't have to be that way. You're allowed to write a contract in plain English, and don't let any lawyer tell you otherwise.

9. *"I can't afford a lawyer to draft a contract."*

You don't need to pay a lawyer to draft a representation agreement from scratch because there are already a number of samples out there that you can use (including ours at the end of this chapter). You just need to show your final draft to a lawyer to make sure it covers your specific situation and works for whatever state you live in.

10. *"I would never sue my gallery, and my gallery would never sue me. So what's the point of a contract?"*

The point of writing down a representation agreement isn't to arm yourself for a lawsuit. It's to make sure you and your gallery are on the same page (literally). It's to help you identify your expectations, to prevent you from making unwarranted assumptions, and to minimize misunderstandings.

It's also to help you deal with any disagreements that crop up along the way, since people's memories are generally bad. We tend to remember things in ways that are favorable to us, and we tend to think of our memories as ironclad. When it comes to some detail of a discussion from three years ago, you and your gallery may genuinely remember it differently. If you wrote down your agreement, you can refer back to it for guidance.

There's also a moral component to having a written agreement. Sometimes it's enough to show people that they promised something in writing to motivate them to keep their promise.

———————— *"I did get in a big fight with a large gallery when an artist left. They said, 'Hey, we advanced all this money. We own the work and we'll sell it when we get around to it.' And as with many artists, there wasn't a contract. It was all done through emails. It is very important to make sure you document the arrangement either in your emails or with an actual document."* **James Walters, CPA, Walters & Skylar LLP, Los Angeles, CA**

———————— *"It is important to make clear who is responsible for what costs involved with representation. Whenever there is a dollar amount involved, there are miscommunications. Go dutch to dinner with a friend who is cheap and you'll see: the bill comes and they assert that they owe fifteen dollars and ninety-five cents, with tip, while you owe sixteen dollars and forty-two cents. Let's face it, most of us would just throw a twenty not to have the pain of counting pennies. There are always misunderstandings about money."* **Leigh Conner, CONNERSMITH, Washington, D.C.**

11. *"Emerging artists don't make enough money to justify writing up a contract."*

It's true that the more money there is at stake, the more likely people are to want a written agreement. But that doesn't mean you shouldn't want one just because there isn't a lot of money at stake, for a couple reasons.

First, it *is* a lot of money—to you. Your gallery will probably want to represent you for *all* your work. So no matter how much you're selling—whether it's $5,000 a year or $500,000—the arrangement you're talking about covers *all* of it. One hundred percent is "a lot."

Second, as we've already said, the point of a written representation agreement is to confirm expectations and avoid misunderstandings. Those goals definitely justify writing up an agreement.

SAMPLE REPRESENTATION AGREEMENT

Now that you understand why representation agreements are good, not evil, you're ready to see a sample. Note that it doesn't include a resale royalty or a right of first refusal.

Just as with our sample consignment and commission agreements, you should add, cross out, and edit the language in our sample representation agreement so that it applies to your situation. There may be other issues you want to address in the agreement. Or there may be some promises you or your gallery aren't willing to make. The sample we're giving you isn't all or nothing, it's a starting point. It's meant to be tailored.

Given that the majority of galleries do not use written representation agreements with their artists, we understand that you may never actually use this. But we've seen more and more galleries warming to the idea, so it's a good idea to get comfortable with these issues well in advance of negotiating them.

Our sample contract is geared toward a traditional gallery with physical space, as opposed to online galleries, or other digital platforms you may end up working with. Digital entities are more likely to use written agreements and to have their own

form. And most of the issues in either scenario will be similar, if not identical: commission rate, payment terms, roles and responsibilities, scope of exclusivity, etc. A few issues will differ for obvious reasons or not apply at all (you don't physically "install" your work for an online gallery's exhibition, for example, but you may want some control over how the gallery arranges and presents images of your work on its site).

Below are a few details to think about when an online gallery is looking to fully represent you, as opposed to consigning a single piece or body of work (which would be covered by a consignment agreement per chapter 10).

Just the exercise of writing down your arrangement will encourage a healthy conversation about your hopes and expectations for the relationship.

Exclusivity

Will the entity be your exclusive sales agent throughout the world, or can it only close sales within a certain geographical region? If it's regional, how will that be determined—by where the collector lives, where the work is shipped, or some other way? If there are multiple copies of a work, can you (or another gallery) sell any of those?

Commission

Whatever the percentage, ask the online gallery what it will do for you to earn its commission. Will it bring you to art fairs, hold pop-up exhibitions, run ads, print catalogs, shoot videos, etc.? If it is *only* offering to do things digitally, such as email promotion, online ads, and digital "shows" on its website, then it may not be incurring the same level of overhead costs that traditionally justified brick-and-mortar galleries taking 50%. And you should ask, separately, whether it will provide you (or allow you to take) any offline exhibition opportunities.

Terms of Use, Terms of Sale, and Copyright

What rights does the online gallery grant collectors, and does it limit those rights in any way? For example, does a collector receive any rights to use or share digital images of artwork she or he buys from the gallery? How does the gallery explain this to

collectors—is it part of the invoice in plain language, or buried deep within the website's Terms of Use (and almost certainly never read)? What about *your* rights with respect to sales? How much information will the gallery give you about a buyer?

Business Model

Ask the gallery about its business model. How many other artists does it represent? How many more is it looking to take on? How many regular collectors does it sell to? Does it make any money from things *other than* sales of artwork? Who owns it, and are they planning on raising additional money from investors, or expanding into other areas? Does it have an "exit strategy," meaning it hopes one day to sell the business to another company, or is it more interested in running the business for the long term? If it's the former, you should ensure you have the right to walk away (and take your art with you) if you don't like the new owners.

"Dear Gallery"

You can always write a representation agreement as a letter (or an email) to your gallery. That makes it look a little friendlier and a little less formal. But you should still ask the gallery to sign the letter (or reply "agreed" by email); otherwise the gallery might turn around later and claim it never agreed to what you wrote.

This applies to smaller things along the way, too. After agreeing to something over the phone or in person, type up a thank-you email outlining the points you want to remember from the conversation (including deadlines, dates, and dollar amounts). This gives the gallery a chance to reply with any changes or clarifications, and now you both have a record you can refer to later if necessary.

OF COURSE THIS CONTRACT WILL BE VOID IF YOU MAKE ANY WORK THAT IS TOO CHALLENGING FOR OUR COLLECTORS.

Gallery Representation Agreement

between

_____ ("I/me") _____

Artist Address

_____ _____

 Email / Phone Number

and

_____ ("gallery") _____

Venue Address

 Email / Phone Number

1. I appoint the gallery as my exclusive agent in _____ [city/region] for the sale of my original artwork ("work").

2. Either the gallery or I may cancel this agreement by writing to the other, in which case the agreement will end within ____ days, the gallery will return any unsold work to me at the gallery's expense within ____ days, and we will settle any outstanding debts within ____ days. This agreement will last for ____ years and automatically renew unless one of us cancels it. If the gallery cancels this agreement, I will not owe the gallery for any production costs associated with my work. If I cancel this agreement, I will pay the gallery back only for unrecouped production costs, fronted by the gallery, directly related to my unsold work.

3. The gallery will make best efforts to sell and promote my work and to manage my career. The gallery will be responsible for all costs related to the sale and promotion of my work. In addition to the show-specific commitments in Section 15 below, the gallery will pro-mote my work, and my participation in any gallery shows, in the following ways: _____

4. I will list the gallery as my representative on my website and in any public displays of my work. I will update the gallery in writing when-ever there are changes to my resume, biography, statement, or similar materials. I will let the gallery know of any exhibition opportuni-ties before committing to them. The gallery will add me to their website and any published list of represented artists.

5. The gallery will sell my work on consignment. Whenever my work is delivered to the gallery, the gallery will sign a receipt similar to the attached inventory list and give me a copy. The gallery will keep records of every work I consign and give me a list of my work in the gallery's inventory once a year (or on request).

6. The gallery will cover the costs of photographing every work of mine that it offers for sale, and taking installation shots of any shows that include my work. The gallery will provide me high-resolution digital copies of these images, as well as any other high-resolution digital images that include my work.

7. Whenever I give work to the gallery, it will be considered a consignment (not a sale) unless specifically noted in writing. The length of each consignment will be for the duration of this agreement, unless noted otherwise on the receipt when I consign the work. We may agree at any time to change the consignment period for particular work.

8. The gallery will offer consigned work for the prices noted in the inventory list describing that work. Unless we agree in writing to a different arrangement before the sale of a particular work, for any sales, including work the gallery consigns to another venue:

 a. I will receive _____ % of the retail price, after subtracting production costs.

 b. I will split up to a _____ % discount.

 c. Whoever pays for production costs for a particular work will be reimbursed 100% when that work sells.

 d. [The gallery may rent any of my work / The gallery may not rent any of my work without my prior written approval.] I will receive _____ % of the rental fee paid to the gallery for any rental of my work. Between the gallery and me, the gallery will be responsible for repairing any damage to my work from a rental arrangement (and, if the damage is irreparable, paying me my share of the sale price had the piece sold).

9. I will notify the gallery of any donations, loans, rentals, or consignments I am planning outside the gallery's exclusive territory.

10. The gallery will let me know the details of any sale within one week of the sale being finalized. The gallery will let me know the details of any donation, consignment, rental, or loan of my work (that the gallery makes) before closing the transaction. The gallery will keep records of every sale, donation, consignment, rental, or loan of my work (that the gallery makes) and give me a summary once a year (or on request). The summary will include, for each sale, donation, consignment, rental, or loan, the date, title of work, price, name, and address, and email address of the buyer (or recipient or borrower) and any amounts due to me and to the gallery.

11. The gallery will not deliver work to a buyer until the buyer fully pays the gallery. Within _____ days of receiving payment from the buyer, the gallery will pay me my share of any sale and give me the name, address, and email address of the buyer. The gallery will not make any sales on approval or credit without my permission. The gallery will return any unsold work to me when the consignment period for that work ends.

12. Unless I give permission in writing in advance, the gallery may not upload any of my images to 3rd party digital platforms, or otherwise make my images available through any such platforms (whether for sales, or exhibition, or any other purposes).

13. I will pack my work before shipping it to the gallery and the gallery will pack it before shipping it back to me (or to the buyer if the work sells). _____ [The gallery is or I am] responsible for shipping the work to the gallery, including insuring the work for risk of loss or damage during shipment. _____ [The gallery is or I am] responsible for shipping the work from the gallery, including insuring the work for risk of loss or damage during shipment. The gallery is responsible for shipping the work to and from any outside venues, including insuring the work for risk of loss or damage during shipment.

14. The gallery is responsible for safekeeping the work while it is in the gallery's possession. The gallery will insure the work (to its retail price) for any loss or damage while the work is in the gallery's possession. The gallery may not remove consigned work from its premises without first getting my permission. If, for any reason, any work is lost or damaged beyond repair while under consignment to the gallery, it will pay me the same amount of money I would have received had the work sold at its retail price. If any damaged work is not beyond repair, the gallery must pay for restoration by a restorer whom we agree on.

15. The gallery will give me one solo show, lasting at least one month, every _____ years. For each show, the gallery will:

 a. Provide a press release, announcement, and tailored outreach.

 b. Install and deinstall the work. (I will provide installation instructions, if needed.)

 c. Consult with me on curating and installing decisions that may affect the integrity of the work.

 d. Host an opening reception.

 e. Cover the costs of taking installation images of my work during the show and provide me with high-resolution images.

 f. Provide these additional sales and promotional materials, at the gallery's expense: _____

16. The gallery will do whatever is necessary to protect my copyright in the consigned work. Although I retain all reproduction rights to my work, the gallery may take images of consigned work and use them to publicize it or any show I am in, crediting me as the artist. Images reproduced in the press should include the line "Courtesy of [my name and the gallery]."

17. This agreement only applies to work I finish while the agreement is in place. I warrant that I own the work (and all proprietary rights to it) that I consign to the gallery and that I have the right to appoint the gallery as my agent to sell it. I retain title in each work I consign to the gallery until I am fully paid for any sale, at which time title will pass directly to the buyer. I shall not be subject to claims by any creditors of the gallery. If the gallery becomes insolvent, I shall have the rights of a secured party under the Uniform Commercial Code. The gallery agrees not to encumber consigned work, or incur any obligation based on it that I could become liable for. The gallery will hold my share of the proceeds from sales in trust. I understand that the gallery does not promise any particular outcome from its sales efforts on my behalf. This agreement will automatically terminate if I die or the gallery becomes insolvent. This agreement states our complete understanding and replaces any earlier understandings between us. We may only modify this agreement in writing, signed by both of us. The gallery may not assign its rights or obligations under this agreement without my written permission. If a court holds any part of this agreement illegal, void, or unenforceable, the rest of the agreement will remain enforceable. The waiver of one right is not a waiver of any other right. This agreement shall not be interpreted for or against me (or for or against the gallery) because one of us (or our respective counsel) drafted a contested provision. In any proceeding to enforce this agreement, the losing party will pay the winning party's reasonable attorneys' fees.

_____ [State] law governs this agreement, regardless of conflict-of-law principles.

Dated: _____

_____ _____

Artist signature Venue signature

 (print name)

Inventory List

Work by _____
(Artist name and full contact info)

TITLE, YEAR *MEDIUM, EDITION* *DIMENSIONS/DURATION*	RETAIL PRICE *FRAMING/PRODUCTION COST*
1.	
2.	
3.	
4.	
5.	
6.	
7.	
8.	

_____ has received on consignment the works described above.
(Venue name and full contact info)

The consignment will last from _____ [date] until _____ [date].

_____ _____
Venue signature Date

(print name)

RECOURSE

So what can you do you if a gallery screws you over? Not very much, unfortunately, unless you have some real clout or you're owed a serious amount of money.

Legally, of course, there are things you can do, which we'll talk about in a minute. But you could end up paying a high price for taking those steps, because other galleries may decide not to work with you when they hear that you threatened (or sued) a gallery. And they *will* hear about it.

Ideally, you and the gallery will work things out with a few conversations. When urging the gallery to do the right thing doesn't work, offer to compromise. Do whatever you can to resolve the issue informally and privately.

If you can't come to a resolution with the gallery, you have to decide whether to let it go or push back. That's a decision only you can make, since it turns on your style, your leverage, and what's at stake. If you don't want to leave it alone, the next thing to do is see a volunteer lawyer for the arts and find out what your options

When Certified Letters Attack!

We know an artist who, whenever he had problems getting paid by a gallery, would write the gallery a letter demanding the overdue payment—and send the letter by certified mail. Somehow the official look of that certified letter was all it took to get his check right away.

————————— "The question of recourse becomes a practical one. It's very expensive to litigate. You have to weigh the potential recovery against the cost of litigation and what may happen to your reputation in the art world if you're heard to be someone who rocks the boat and is hard to work with.

"The point of a contract is that most people will follow things that they agree to, and you won't have to litigate. And when you're dealing with crooks, they're going to be crooks whether you have a written contract or not." *Tad Crawford, arts lawyer, author, publisher, New York, NY*

————————— "We typically put in a provision that says 'In any lawsuit to enforce the agreement the loser pays the winner's legal fees.' You're in a stronger position with that sort of provision, because the dealer can't just say, 'Well then go sue me. It'll cost you more to litigate than you could possibly win.' With this kind of fee-shifting provision, you can say, 'No, it'll cost you more if I litigate.' But it ups the ante in both directions because the artist has to realize that if he breaches the contract and gets sued, he could be on the hook for the gallery's fees." *Donn Zaretsky, partner, John Silberman Associates; writer, Art Law Blog, New York, NY*

are. That's not a commitment to go to court; it's just to learn where you stand so you can make an educated decision about the most effective next step.

Every situation is different and will call for a different approach. You might write a letter to the gallery—with the attorney's help—again urging the gallery to do the right thing. (Sometimes putting the request in writing gives it a little more force.) Or you might decide to have the attorney write a letter on your behalf. That's akin to throwing a punch, though, so don't do it if you ever want to show in that gallery again. If the problem is systemic (you're not being paid versus there was a mishap once and your work was damaged), chances are you are not the only one with the problem. In this case, you can and should reach out to the other artists in the program to see if they're having the same issue. We've known large groups of artists to sign a letter. Again, this is not going to endear you to the gallery owners, but it will probably elicit a response.

Your ultimate option is going to court, which is huge bummer. Sometimes walking away, "moving on," is better for your health than a nasty legal fight. When the stakes are high enough, though, hopefully your written agreement will put you in the strongest position possible to make your case.

———————— "You could have the best contract in the world, but if you're doing business with somebody you don't know, don't trust, and haven't spoken to that much, that great contract is going to get you a one-way ticket to a courthouse. That'll cost you time, money, and your soul."

Adam Holofcener, artist, executive director, Maryland Volunteer Lawyers for the Arts, Baltimore, MD

AND YOU'RE OFF

We end this book with the same plea from the beginning: Don't listen to everything we say! The art world is a vast and sprawling place, and you, the artist, are its vital center. We envy your talent and admire your decision to pursue an art career, and we encourage you to do this on your own terms.

There are many ways to be an artist and many definitions of success. A lot of people are out there testing new models and tweaking old ones to achieve their goals. The rules have *slowly* started shifting since the first edition of this book, and technology continues to offer more and more tools for artists to run independent, professional practices on their own.

As you chart your path, remember that your greatest resource is your community: the one that happens to be around you, as well as the communities you join and create. They are your support system. They will help you make your work, show your work, talk about your work, inspire you, and challenge you.

We hope that what we've shared in this book will make your life easier, save you time, and let you focus on what's most important: your art.

We congratulate you on getting this far—and wish you good luck!

———— "What's unique about artists is that they don't retire. Artists spend a lifetime making work. Being an artist—which has resiliency and creativity at its core—is truly a model for aging. Evident in Joan Jeffri's work at the Research Center for Arts and Culture, we've learned that professional artists identify as artists, no matter their discipline, over their lifetime. Older artists are well networked, continue to take creative risks, adapt to new art forms, and develop deeper creative experiences over their lifetime. It's important for the field to recognize the importance of supporting artists over a lifetime. Artists, regardless of age, don't stop exploring the imagination. It's the support structures and cultural policy that need to catch up." *William Penrose, executive director, NURTUREart, Brooklyn, NY*

ACKNOWLEDGMENTS

Words cannot express our gratitude to Alexis Zimbalist and Rishi Bhandari for their love and support. And for making everything 22 to 25% better.

We are forever indebted to Richard Liebner and Paul Fedorko for leading us to our phenomenal agent (and fast friend) Melissa Flashman. We are equally grateful to Wylie O'Sullivan, our first editor at Simon & Schuster, and Emily Graft, who steered us through the second edition. Many thanks also to Rishi Bhandari, Ari Melber, Barbara Melber, and Ann Tarantino for their meticulous edits of early drafts.

We are grateful to:

Kammy Roulner for her perspective, Michael Greenblatt and Jessica Wexler for their vision. Our families for their advice and support, especially Dan Melber; Linda, Kevin, Marissa, and Erin Darcy; and Natasha, Anil, Rohit, Riya, and Reyna Bhandari.

Rob Carter, Monica Herman, Steven Sergiovanni, Courtney Strimple, and Paige West for their input and understanding during the writing of the first edition; to all Mixed Greens artists who taught Heather invaluable lessons as they grew and flourished; to Wendy Edwards, who put Heather on the right path and inspired her to keep going; to NURTUREart and Smack Mellon for their heart; to Do-Ho Suh and Bonnie Collura for making Heather want to work with artists always; to Erin Sircy for listening and understanding on walks through Chelsea.

Peter Parcher and Steve Foresta for mentoring Jonathan and teaching him how to focus on the right details without losing sight of the big picture; Jen Bekman, for an unforgettable experience at 20 x 200; Alex Kruglov and Robert Schildhouse, for training and mentoring Jonathan in the world of entertainment negotiation.

Brij, Darcy, and Ava for putting everything in perspective and demonstrating, on a daily basis, why the arts are central to a joyful and fulfilling life.

Finally, thank you to everyone who generously made time for an interview:

Joshua Abelow	Cornell DeWitt	Jamillah James
George Adams	Stephanie Diamond	Kevin Jankowski
Helen Allen	Peter Eleey	Stephanie Jeanroy
Nathalie Anglés	Anne Ellegood	Paddy Johnson
Marco Antonini	Alessandra Exposito	Michael Joo
Taryn Arnold	Rosamund Felsen	Kelly Klaasmeyer
Chris Ballantyne	Spencer Finch	Suzanne Kim
Catherine Behrend	Lauri Firstenberg	Greg Kucera
Shoshana Blank	Howard Fonda	Jason Lahr
Christa Blatchford	Laura Fried	Knight Landesman
Tim Blum	Francesca Fuchs	Jessica Lanzillotti
Sabrina Buell	Alison Gass	Melissa Levin
Ian Campbell	Caesar Garcia	Sarah Lewis
Shane Campbell	Tamara Gayer	Charles Long
Bill Caroll	David Gibson	Denise Markonish
Rob Carter	Massimiliano Gioni	Heather Marx
Mary Leigh Cherry	Micaela Giovannotti	David McGee
Catharine Clark	Michelle Grabner	Monique Meloche
Bonnie Collura	Deana Haggag	Jackie Milad
Leigh Conner	Shoghig Halajian	Lorraine Molina
Sarah Corpron	Jane Hammond	Shamim Momin
Tad Crawford	James Harris	Eve Mosher
Michael Darling	Joy Harvey	Sergio Muñoz Sarmiento
Bill Davenport	Joe Havel	Sarah Murkett
Gabriel de Guzman	Steve Henry	Jonathan T. D. Neil
Matthew Deleget	Ben Heywood	Leah Oates
Donna Dennis	Krista Hoefle	Cara Ober
Lisa Dent	Cecily Horton	Stas Orlovski
Blane De St. Croix	Kerry Inman	Murat Orozobekov

Larry Ossei-Mensah Rafaël Rozendaal James Walters

Flannery Patton David Salmela Kim Ward

William Penrose Lisa Schroeder Benjamin Weil

Emilio Perez Jonathan Schwartz Eleanor Whitney

Joachim Pissarro Howie Seligman Hillary Wiedemann

Andrea Pollan Jasper Sharp Tony Wight

Melissa Potter Franklin Sirmans Eleanor Williams

John Rasmussen Amy Smith-Stewart Dexter Wimberly

Trevor Reese Jessica Smolinski Edward Winkleman

Naomi Reis Joseph Smolinski Caroline Woolard

Sarah Reynolds Shannon Stratton Michael Yoder

Mayela Rodriguez Ben Sutton Joyce Yu-Jean Lee

Victoria Rogers Heather Taylor Donn Zaretsky

Sara Jo Romero Mary Temple Steve Zavattero

Andrea Rosen Fred Tomaselli

Lauren Ross Brynna Tucker

INDEX

renter's/homeowner's insurance, 52

studio. *See* Studio

taxes. *See* Taxes

Group shows, 291–92, 295

 etiquette for, 235

Haggag, Deana, 55, 125, 142, 195, 235, 248, 254, 274, 276, 282, 304

Hammond, Jane, 2, 20, 27, 37, 109, 117, 183, 192, 252

Hanging flat work, 112–14

Harris, James, 112, 195, 203, 233, 250, 295, 296, 319

Harvey, Joy, 39, 53

Havel, Joseph, 8, 34, 64, 150, 208, 276

Henry, Steve, 213, 277, 306, 316

Heywood, Ben, 90, 189

Hoefle, Krista, 188

Holofcener, Adam, 54, 240, 337

Homeowner's/renter's insurance, 52

Images

 copyright and. *See* Copyright

 digital, 63, 65

 documentation and organization of, 29–30

 gallery representation and, 312

 licensing of, 170–73

 moving. *See* Video

 presentation of, 65

 printing of, 64–65

 public domain, 171

reproduction of, in agreements, 254–55, 274

 in submission materials, 62–65

 of 2-D and 3-D work, 62–63

 watermarks on, 92

 on website, 91–92

Income, 2, 168–73

 from art. *See* Sales of artwork

 contributed. *See* Financial support

 diversification of, 132

 from grants and residencies. *See* Grants and residencies

 from licensing, 170–73

 and myth of the struggling artist, 23

 from nonart sales, 169–70

 tracking, 40

 See also Day jobs

Indemnity, 274–75

Inman, Kerry, 8, 55, 202, 259

Instagram, 95, 98, 100

Installation art, 115

Installing shows, 233–37

 consignment agreement and, 2 53–54

Insurance

 commissions and, 275

 consignments and, 252–53

 invoices and, 46

 renter's/homeowner's, 52

Inventory, 30–35

Invoices

 for art sales, 42–51, 122

for freelance work, 28–29

 sample, 50–51

James, Jamillah, 38, 91, 108, 129, 193, 194, 240

Jankowski, Kevin, 22, 100, 177

Jobs. *See* Day jobs

Johnson, Paddy, 9, 105, 153, 182

Joo, Michael, 5, 45, 109, 164, 215, 325

Kim, Suzanne, 214, 231, 309

Klaasmeyer, Kelly, 8, 32, 71, 91, 93

Kucera, Greg, 246, 319, 326, 328

Labels, 32

Lahr, Jason, 18, 205, 232

Landesman, Knight, 27, 76

Lanzillotti, Jessica, 39, 41, 42, 53, 155

Lawyers, 54

Lee, Joyce Yu-Jean, 140, 309, 319

Legal fees, 263, 275

Legal issues

 assistance in, 54

 consignment, 241, 256–64, 263–64

 copyright disputes, 36–38, 171

 choice of state laws in, 263–64

 disputes with galleries, 335–36

 indemnity, 274–75

Legal title, 44–46

 in consignment agreement, 258

Levin, Melissa, 103, 142, 198, 208

Lewis, Sarah, 55, 78, 128

Sarmiento, Sergio Muñoz, 37, 54, 170, 240, 254, 284, 324

Scams, 179

Schroeder, Lisa, 128, 294

Schwartz, Jonathan, 200, 218, 227, 228, 231, 233

Sculptures, 115

Secondary art market, 5, 24

Sergiovanni, Steven, 34, 55, 111, 119

Sharp, Jasper, 116, 122, 199, 200, 296

Shipping, 232–33
 with art shippers, 226, 232
 with commercial shippers, 232–33
 consignments and, 250–52
 estimated costs for, 227
 gallery representation and, 311
 getting advice on, 230
 packing for. See Packing
 planning ahead for, 228

Showing your work, 175–205
 at art fairs, 185–87, 292–95, 314
 at collaborative and artist-run spaces, 181–83
 nonprofits and, 183–85
 online galleries and DIY platforms, 179–81
 registries and other digital collections, 178–79
 researching venues for, 176–78
 and saying no, 192–93
 scams and, 179
 at venues outside the art world, 187–91

Shows
 announcements for, 102, 308
 best month for, 308
 costs of, 311
 going to, 198–99
 group, 291–92, 295
 group, etiquette for, 235
 installing, 233–37
 openings and after parties, 311
 overlapping, 291–92
 packing for. See Packing
 shipping work to. See Shipping
 solo, 296, 307–8
 solo, countdown for tasks in, 310
 See also Galleries

Signing work, 31–34

Sirmans, Franklin, 81

Slide registries, 178

Smith-Stewart, Amy, 70, 128, 202, 296

Smolinski, Joseph, 19

Snapchat, 98, 100

Social media, 95, 98–100, 101

Solo shows, 296, 307–8
 countdown for tasks in, 310

Sound, 63, 115, 235

Specificity, in setting goals, 15

Sticky marketing, 95

Stores, 190

Stratton, Shannon, 55, 78, 185, 252, 288

Struggling artist, myth of, 23

Studio
 assistants in, 40

and balancing time, 19–20
 home, 20–21
 need for, 22
 separate, 21–22
 sharing space, 21–22
 studio programs, 133

Studio visits, 107–29
 common questions asked during, 113
 contact list in, 116–18
 curating work for, 111–12, 113
 hanging flat work for, 112–14
 hosting, 116, 123
 individual, 22, 122–25
 open studios, 110–18
 preparation for, 111, 123
 and pricing and selling your work yourself, 119–22
 sculptures and installations in, 115
 sound and video in, 115
 studio groups, 108–9
 studio group visits, 109–10
 takeaways from, 118, 124–25
 talking about your work during, 118, 124
 virtual, 125–26
 without objects to display, 115

Submission materials, 59–85
 artist statement, 76–79
 cover letter, 80–81
 creativity in presenting, 71
 dimension listing in, 62
 images, 62–65

ABOUT THE AUTHORS

Courtesy of Alex Hoyer

Heather Darcy Bhandari is the Director of Exhibitions at Smack Mellon, a nonprofit exhibition and studio space program in Brooklyn, New York. Its mission is to nurture and support emerging, under-recognized midcareer, and women artists in the creation and exhibition of new work. Heather is also an independent curator, adjunct lecturer at Brown University, and a consultant to several for-profit and nonprofit arts institutions. She lectures and participates in portfolio reviews and panel discussions across the country. She is on the board of directors of visual arts at Art Omi (an artist residency in Ghent, New York) and the advisory boards of Art F City (an online, art-related publishing platform) and Trestle Gallery in Brooklyn. She was on the board of NURTUREart for nearly a decade. For the last fifteen years, she was a director of Mixed Greens gallery, where she curated more than one hundred exhibitions while managing a roster of nearly two dozen emerging to midcareer artists. Heather received a BA from Brown University and an MFA from Pennsylvania State University. Her career began at contemporary galleries Sonnabend and Lehmann Maupin, both in New York City.

Courtesy of the Author

Jonathan Melber began his career as an arts-and-entertainment lawyer in New York, representing artists, galleries, collectors, and a host of creative individuals and companies. He eventually left his legal practice to join the art e-commerce startup 20x200 as head of business development, later moving to Los Angeles to run content acquisition business affairs at Hulu. Today, Jonathan handles monetization strategy and digital licensing for Turner's entertainment networks. Jonathan graduated from Brown University with a degree in philosophy and received his JD from New York University School of Law, where he was an editor of the *Law Review*.